archeology of elegance

Thames & Hudson

archeology of elegance . 1980–2000 . 20 years of fashion photography

marion de beaupré . stéphane baumet . ulf poschardt . thames & hudson

archeology of elegance . text by ulf poschardt

The shores of the twentieth century now seem far behind us, an age when our culture was transformed into an almost entirely visual one. Design, fashion and the surface impressions of every kind now influence personal attitudes and control the way we live under the notion of style. The existentialized aesthetics of the self have come to define a life style that increasingly depends on dealing with surface appearances. Photography has become the guiding light in this new visual culture. It has emerged from being the servant of fashion to become the source of ideas and the muse for popular culture.

A glance at the last twenty years of fashion photography exposes our visual culture: it explains the roots and distortions, shows radiant beauty and bloody detail, both in the banal and the sublime. This book and the exhibition that it accompanies not only present the best pictures of their time – they also show pictures that represent their time. The selected photographers present the broad spectrum of artistic endeavour, the aesthetic status, and focus on fashion, yet they do not constitute a complete list. The concept of archeology was chosen because nothing in the world of fashion and visual culture is covered with as much dust as the recent past. Current archeology tries to save traces before they are lost in the sandstorms of the present. Yet current archeology only wishes to salvage things for the present: it does not aim to place things in museums or to create fat history books. Instead, it takes and analyses the pictures of the last twenty years as artefacts of their age.

'Paradise to lonely eyes,' sang the British New Wave historicists from the band Zoot Woman on the title track from their album *Living in a Magazine* with which they debuted in 2000. The musicians, all of whom

grew up in the 1980s and 1990s, describe their lives largely as photos and layouts in magazines of their choice. Their biography – as their first video clip shows – is a melancholy recollection of the glamour and rebellious codes of those two decades. When plundering the archive, they discovered the antecedents for their own sensitivities, collected them almost deliberately, and brought them respectfully up to date. And the trip to the archive is rewarding musically, too, as their cover version of Kraftwerk's *The Model* shows. The song was originally released in 1978 – at the time pre-empting the age of the magazine and cold sounds, the model as its icon.

Although Kraftwerk's music – unlike that of Zoot Woman – seems futuristic, this acoustic futurism is relativized by historical quotes from film. While the musicians themselves appear in their spaceship-like studio and like inhabitants of the future, the models are shown in black-and-white of sections cropped from the weekly news. In other words, the music attempts to seize the future, while those images which focus on fashion look back into the past. Respect for the practical skills of fashion compelled Kraftwerk to take this step, whereas in the Zoot Woman video acoustic and visual signals function in harmony. Models and musicians are guests and inhabitants of the same 'harmonious landscape', or 'syntaxcape', as British media philosopher Kodwo Eshun calls them.

Kraftwerk and Zoot Woman both take the stage as archaeologists of elegance. Both look back on how elegant they longed to be as adolescents. The syntaxcape of the archive offers the historical plasma in which they construct continuities and avoid discontinuities. To this extent, today's fashion photography is more a story of similarities than

of differences – not in the sense of discernibly different aesthetic approaches but of lineages that constantly crisscross and interconnect. The Zoot Woman video represents one of those points in contemporary culture where all four important force-fields of the last twenty years interlock: Punk, Glamour, High-Tech futurism and Art.

The history of fashion photography is also a history of the media in which the photos appear, above all print magazines, whose editorials took stock of the potential symbiosis between fashion and photography. The early 1980s marked a new beginning in magazine journalism. In the wake of punk and New Wave both in England and in the United States a new form of fashion journalism grew up which defined itself more by stance than by labels. The codes had a strong cultural and social force: fashion photography came charging out of its usually decidedly bourgeois closet and into the rough everyday world which had set out to influence style and elegance as strongly as the catwalks in Paris, Milan and New York. Not much later, this new style – infused with what used to be called 'ugly' – entered the domain of the prêt-à-porter: young designers such as Alaia and Montana, Stephen Sprouse and Vivienne Westwood made it clear that the old definition of fashion had come to an end.

Wherever definitions come to an end, the media and arts have work to do. Fashion photography found itself on the front line. Once the old had been overthrown, the restless desire for the new swiftly created the basic formations for a new visual identity that went beyond the brash fanzines and provocative album covers. Kraftwerk probably had to sample historical fashion photography in their video for *The Model* if only because at that time there was no fashion which would have functioned

in the context of futuristic pop music. Fashion photography and the media in which such photos were published thus clearly obeyed an inevitable logic.

Surveying the last twenty years means focusing on an aesthetic upheaval: fashion photography liberated itself from its immaturity, in part its own fault, and found the courage to accept a new pictorial complexity and variety which during the 1990s increasingly perforated the boundaries of art. Towards the end of the twentieth century, some fashion photographers had become celebrated artists, and art had in part become the fan and imitator of fashion photography, as shown in the works of Karen Kilimnik or Vanessa Beecroft.

Who pointed fashion photography in a new direction when and why? 'Redundant photographs', as Vilém Flusser calls them, are – as ever – not of interest.[1] All the photographers represented here search for still unexplored possibilities, for hitherto unseen pictures, and most of all for a visualization of attitudes, for attitudes are the most precious commodity of an internalized style and grace. At the end of the twentieth century, almost every haute couturier could be quoted on how attitude took priority over what was worn – and in this sense attitude has become the common currency of fashion photography. Pictures salvage those moments when attitude preserves itself by means of sheer intensity. Capturing these moments of intensity constitutes one pole of fashion photography – that is, authenticity in the traditional meaning of the word, namely the emphasis on the realistic, documentary gesture of the photographic medium.

Thanks to technical advances over the last two decades, the belief that pictures were apparently real, already shaken, was shattered fur-

[1] Vilém Flusser, 'Für eine Philosophie der Fotografie', in Hubertus v. Amelunxen (ed.), *Theorie der Fotografie IV, 1980–1995*, München 2000, p. 57 ff.

ther. For this reason, at the opposing pole to authenticity, we see artificially created gestures and attitudes emerge. They interpret what Jeff Wall has termed 'artificial realism': a contemporary concept that integrates the idea of artistic creation and agency into a more complex form of depicting objects. Produced with the assistance of computers or with surreal backdrops arranged in the studios, the purportedly inauthentic, fictitious pole of fashion photography approximates art and its virtual worlds. The belief in reality is just as apparently naive as the belief in total artificiality. The authentic as posed – for example in punk's 'great Rock 'n' Roll swindle' dreamed up as a marketing ploy by ex-situationists – prompted only a few photographers to become more pious and truth-loving, whereas most allowed for a deliberate lack of focus when depicting apparent authenticity and forced naturalness. The fictionalists, on the other hand, consider their monstrous fantasies to be an authentic description of a reality constructed by floods of images. However, a second nature emerges from the simulation of reality, one that finds a realism of its own in the works of Guy Bourdin right through to David LaChapelle.

Art directors and stylists feel their way into the most different of pictorial world in order to bring out the force of complex visual photographic codes. Countless new or advanced pictorial languages arise, and a new grammar allows more linguistic possibilities than ever before. The boom years of the 1980s and 1990s, with the increasing market for luxury goods and the attendant advertising, certainly encouraged variety. The new refinement of fashion photography was a direct result of the coupling of prosperous liberalism with an aestheticization of everyday life in almost all Western industrial nations.

The archeology of elegance aims to expose as many strata as possible. It attempts to identify semantic depth and flexibility. This is the reason for dividing the work of those twenty years into four key categories: Glamour, Punk, High-Tech and Futurism, and Art. Glamour, which arose in the 1980s, runs like a red thread through the entire history of fashion and fashion photography. Its modern, postmodern and nostalgic variants display the most luxuriant and shimmering variety of the last twenty years. In punk, the images pulsate with the rebellious energies of 1977 and the classic Sex, Drugs and Rock 'n' Roll fantasies, couching them in the finest nuances of Trash, Anti-Glamour and a devastating, authentic sort of poetry. At the turn of the new millennium, High-Tech and Futurism have been not only the all-defining motif of fashion photography, but have prompted changes in the production technology itself: new digital processing techniques have stood the aesthetics of images on their head. This marks the caesura of fashion photography in the age of multimedia networking. The fourth concept – Art – brings together all those pictures whose free, untrammelled staging and intellectual thrust have moved into the domain of the visual arts or have even stemmed directly from it. Art designed for consumption has changed into autonomous art that is both independent and innovative, and this change has set the entire culture alight.

Photographers are sometimes represented in more than one section. Viewers will draw their own distinctions and create their own typologies. What all the photographs have in common is an extremely sharp point, highly emotional, precise, and outstanding reflections of the spirit of their time and the mind of their maker – and telling us more about our world, its dramas and beauties than we had been aware of before. It is a

way to travel into the immediate past by picture, to an era that cries out to be rediscovered.

The idea of fashion as a kind of second skin or armour impressively alludes to human happiness and pain without trying to get beyond the surface to explain it psychologically. Attitude and disposition are both especially influenced by the sub-cultures on which fashion photography has focused.

Contemporaneity defines a community of those who understand their time, respond to it aesthetically and thus represent it. This body-related form of self-expression as the representation of the now, in keeping with Rimbaud's demand that we be absolutely modern,[2] can be seen as a leitmotif throughout fashion photography. Once established, innovation comes to a halt. In this way, the last two decades of fashion photography also document the history of different attitudes and their success or failure. Fashion photography popularizes attitudes – even where it purports to be purposely elitist. It thus propagates an image of its time that has to be asserted in the face of other concepts and notions of time. Fashion photography's greatest success is to express the force with which to define our age. Fashion photography's power is that it can define what the here and now means. In line with the general sentiment of the day, this can on the whole be an intuitive and contradictory matter – in other words, it embraces far more than those elites who, as the self-appointed fashion world, are in the throes of infighting.

In an age of self-design, photography has renounced the innocence connected with merely being decorative. Floods of images come

[2] Arthur Rimbaud, 'Adieu', *Une saison en enfer,* 1873

crashing down on us and wash away any kind of critical thinking: so the desire for models grows. Art, meaning both free and utilitarian art, no longer simply wishes to view the world, but to shape it as well. Style, to adopt Malraux's definition, is that 'which an age seeks most profoundly and for which the living form only has meaning as raw material. Thus, to the question "What is art?" there can only be one answer: "That through which forms become style." '[3] Time congeals in forms which are distilled by both fashion and photography to style. Both thus become part of the imaginary museum of our age, the last decades of the twentieth century. Each exhibit assures us that the most recent past can only thrive so vigorously in our present because this past is driven by the energy of so many images. The four currents in fashion photography in the last twenty years are different force-fields that draw on different resources and are synergetically linked to one another. In the form of a powerhouse they take visual culture almost to the point where it overheats: yet that juncture just before flashpoint is normality, overdrive is customary. And all this occurs more or less beyond the pale of intellectual contortions and artistic strategy: the flood of images gushes almost to the point of zero meaning, where it hunts for humour and beauty, both of which modern art has more often than not abandoned owing to its imposed seriousness. Precisely at the point where we do not immediately understand the decorative and time collides with us, comes a yearning for consensus and insight. And in this way we are instilled with the classical wish to absorb culture. We puzzle over pictures that seem decorative and yet can reveal and tell more. The meaning and signification of the image increases in the reading and interpretation of the beholder. The

[3] André Malraux, *Le Musée imaginaire*, Paris 1947, p. 114.

more seductive the image – and seductive images will be almost our exclusive topic here – the more enduring the interest in pinpointing their meaning and sensuous appeal, in tracing them and grasping them. The wealth of images, their luxury behind all luxury, stems from their deliberate indifference, the way they radiate meaning and signification right on the edge of irresponsibility.

Where beauty becomes shameless, it culminates as much in genius as it does in kitsch. Everything in-between must interest us: 'must' because we are compelled to communicate in the information society. Communication, Baudrillard admonishes, is 'no longer a matter of message, but it communicates and does not cease to communicate.'[4] Communication becomes a game with no background: fashion photography is the most direct embodiment of such communication, which can but need not signify. But it is communication that certainly wishes to be seen. Fashion photography is not seeing, but causing to be seen – just as communication is not speaking but causing to be spoken, and information is not knowledge, but causing to be known. All needs are served visually – nothing in this society is meant to be inconceivable, all is open to consumption. Everything is there – just look around! Fashion photography is the polydiscursive time code of our visual culture.

4 Lecture given by Jean Baudrillard in the Kunstmuseum Bern, 5 February 1989; published (in German) by Benteli Verlag, Bern, 1989.

glamour

1979: *American Gigolo*, the first film of the 1980s. Buying and posing with branded articles heralds the age of social restoration. At one fell swoop the emancipation movements of the 1970s seem old. Not so much liberation from the supposed corset of social norms, more a case of which style of corset to choose. As a male whore, the 'American Gigolo' embodies the amorality of the male signifier accumulating capital. Employed by women and gays, he discharges all the conceivable notions of male heterosexual sovereignty in order to be able to enjoy the sovereignty of the man-about-town who drives a Mercedes sports convertible and wears Armani and Halston. The way he sacrifices the classic heterosexual role model implies just what gratification is gained from the status symbols.

The luxury and glamour of the 1980s democratized the last aristocratic insignia of urban elegance. In this context, Modernity meant being able to swiftly don a new identity in late capitalism. Everything becomes a question of looks. 'If you judge a book by the look of the cover', sang ABC in April 1982, 'then you judge the look by the lover.' The song couldn't answer the question as to who had the right look nor where it was to be found, let alone what this look was or what constituted it. What the song did make clear, however, was the significance of the look for the moment of happiness, starting with love through to privileged status: *How To Be A Millionaire* (another ABC song title dating from 1984). Similar facets of materialist hedonism run through the entire pop music scene of the day: from bands like the Pet Shop Boys and Spandau Ballet up to Hip Hop crews like Two Life Crew or Sir Mix-a-Lot.

The 'American Gigolo' transmogrified in *9½ Weeks* into a broker as the idol of the swift wealth one could acquire in Reagan's America. The

modishness of luxury signified its change and a purported animosity toward tradition, visualized in both films by the nouveau riche male's no-frills modernist, tasteful apartment. It is no coincidence that in *American Gigolo* the female lead, intended to embody the element of seduction, is played by a model, namely Lauren Hutton. A rich woman had to be glamorous and could therefore only be portrayed by a top model. With the growing significance of fashion, so, too, the significance of the fashionable definition of beauty increases. *American Gigolo*'s lead actor Richard Gere, friend and model for Herb Ritts, has the feel of a fashionable pin-up, and in *9½ Weeks* Mickey Rourke plays his vulgar version, while in 1985 Kim Basinger was meant to bring to mind the naturally erotic models photographed by Peter Lindbergh. Both films make use of angles inspired by fashion photography. The scenes of clothes shopping in both films conform to patterns familiar to us from the commercials of the day. Prior to shooting *9½ Weeks* director Adrian Lyne had worked above all producing commercials of this type. Shopping as a theme was presented in as enjoyable a form in the film as in *Breakfast at Tiffany's*, but the identity-forging element of buying clothes has become more important. In *9½ Weeks* the man transforms the woman into a beauty such as he imagines her to be against the blueprint of fashion magazines. He challenges her to mimic glamour.

Photography becomes an instruction manual. The ostensible withdrawal of the camera in the face of subjective sympathy eradicates any empathetic element from our view of the glamorously staged world. This world of conspicuous consumption of commodities and bodies, i.e. of things, is cold and matter-of-fact. Faces are smoothed like consumer articles; the age of the supermodels begins. The bodies of men and

women are frozen in muscles and streamlined bones and silhouettes. 'Full lips, bone-thin, big breasts (implants), long muscular legs, high cheekbones, large blue eyes, flawless skin, straight nose, waistline of twenty-three inches, a smile that never becomes a smirk, a cellular-phone bill that runs to $1,200 a month,' is how Bret Easton Ellis describes a protagonist of the glamour age in *Glamorama*. And: she 'hates herself but probably shouldn't.'[5] The basic price for ten days modelling is $1.7 million. In his description, Ellis mixes data from the commodity 'model' with data on the body, on labour power as an accessory of beauty and finally what Chloe herself wears on her body: a black Prada evening dress. If everything has become a commodity, then the differences between sunglasses, skin colour, credit card and the model's dreams are pointless. The text and the film version soberly affirm the dissolution of any dividing lines. In the description of the outside world, everything bows down to a syntaxcape. Everything appears like major fashion photography: in this sense, in particular the glamour photographs of the 1980s and 1990s are the global images and symbols of materialist excesses. The figures stumble lonely and helpless through the world, even the Hollywood stars and top models, and the world is now only theirs because they have themselves become commodities.

The purely glamorous photos have elided humanness as a category in order to relocate it in its transcendence into a commodity. Existence is not inhuman, just neo-human – the commodity is the polished mirror of the surface of the human body which was once defined by virtue of having a soul at its core. The beauty of these images becomes an agency of socialization for the youth growing up in the 1980s and 1990s. The pictures are a breeding ground for desires and wishes. After the photo-

5 Bret Easton Ellis, *Glamorama*, New York 1999, p. 32.

graphs of Herb Ritts, Steven Meisel and Patrick Demarchelier desire is given a new guise. In Chloe's loft, the model model in *Glamorama*, there are any number of picture books by Matthew Rolston, Annie Leibovitz and Herb Ritts. The models are themselves accomplices and friends of the apparatus of reification. This is a sign of the desire for alienation.

In the neo-cool, glamour-celebrating TV series *Miami Vice* the double life of policeman and fake criminal Sunny Crockett ends in retrograde amnesia and the loss of all identity: his lifestyle, with its mint-coloured jackets, white Ferraris, bright yachts and postmodern villas of South Beach Miami, has diluted the traces of identity. The TV episodes (also complicit with fashion photography and commercials) seem to be the truly endless preparation for a state of loss of individual identity: the placement of ever more luxury and an ever greater number of consumer goods seems like an exercize in self-dissolution.

Glamorous fashion photography is the shadow of the alien Ego which an increasing number of people bear within them as desire. The wish no longer to have to be an ego but to dissolve into a staged scene, to don an alien identity – this also reveals the lack of political alternatives in the closing decades of the twentieth century. Glamorous fashion photography entails the search for the greatest possible beauty. As a modern phenomenon, glamour opts for the false rather than the true, for transition rather than truth, for the occasional rather than the durable.[6]

The implied emptiness in a world of luxurious opulence is only rarely alluded to in the pictures: their basic affirmative structure does not allow it. Nevertheless, the opulence of the setting functions as a proactive prophylactic, blocking even the suspicion of emptiness behind the surface and trappings. The star models and celebrities in the pictures, whose

[6] See Michel Onfray, *Libération*, Supplément 'Mode', summer 2001, p. 63.

aura of fame unleashes power, are managed and used like labels. Faces are the currency of the media society that is not interested in the reality of the masks, but only seeks a guaranteed impression that there are personalities concealed behind the masks.

Films and Hollywood are themselves quoted in order to imbue the faces, these empty facades, with the impact of great stories: Lindbergh's bike gang and the Russ Meyer sample used by Max Vadukul are intended to instil the empty faces of the models with certainty by virtue of the image of readily tangible film references. Lindbergh entered new territory with his narrative stories, above all the now famous story with Helena Christensen and the extra-terrestrial. These stories did not leave things at the level of quotation, but themselves constructed stories in order to emphasize that fashion photography can of course even create storyboards for blockbuster films by means of a photo sequence in a magazine accompanied by editorial copy. Specifically, the self-empowerment of fashion photography is shown precisely when it abandons quotation and redefines pictorial stories. The connections to video clips are as obvious as those to new Hollywood movies which, in the course of the 1980s and 1990s, have increasingly taken their cue from commercials and images from fashion photography.

Boredom becomes super-sexy. The equanimity with which the privileged regard their own lives is celebrated as an ability not to participate, and that permits all forms of beauty. No one in the photographs actually does anything, wishes to do anything, can do anything. The frozen gestures, even when they are part of the script, indicate the point of zero action at which the figures become statuesque. Robert Mapplethorpe's women are columns rather than statues; their bodies seem to be drawn

from classical antiquity and yet, with their muscular nature, they are grotesquely modern, without trying to conceal that millennia-old dreams are being dreamed here for us. Strength and impenetrability is directly proportional to the figures' rigidity: the body is altogether corset, the skin armour.

Younger photographers such as Elaine Constantine or Ellen von Unwerth have endeavoured to break open this rigidness and expose the elan innate in glamour. Yet it is precisely this vitality that prevents the pictures simply being labelled glamorous. Glamour comes after the action: in the frozen images, with exposure times as short as possible, the event is concentrated to form an image and indicates what comes after, but without any real guarantee that after this picture anything will actually happen. In fact, or so the pictures claim, every one of these glamorous moments is an end of the story. Its serene, radiant, superficially pure zero-point. The dissolution of all movement since the very first motion (the origin of the world) in one, final and finite gesture.

In this sense, the picture 'Versace Dress' by Herb Ritts (1990) is like a sort of shadow painting with a black-and-white contrast reminiscent of a woodcut, a manifesto of that sculptural rigidity which must surround and animate the body that is fit for glamour. In this way, the body is reduced to a compositional element, denying all the vital impulses of its muscles and sinews.

In these rigid images, photography comes into its own with the still picture. Glamour mimics that silence and immobility which photography necessarily imposes on the world by tearing movement from it. The course of the world stagnates: glamour causes the world to freeze in

[7] 'Moment' derives etymologically from the Latin *momentum*, which in turn derives from *movimentum* and thus from *movere*. The concept of moment therefore etymologically includes suspending time.

order to be able to photograph it. It is the moment of hesitation that makes the pictures so troubling and in part so frightening.[7] What is not everyday about this frozen moment, what is untypical about this chaos of action and reaction, is what makes it utopian. Instances become moments of special importance.

The static quality of the pictures is supposedly ornamental, and beneath the surface shimmers the fear of social apocalypse: the stationary as the zero-point of social development. In their misfortune, the top one per cent, 'the consumer camorra', have started to feel at home as 'pure exploiters', as Walter Benjamin would call them, without having gained anything in terms of inner security. In Steven Meisel's photos the lost order of things and ideas is stuck back together in a perfect arrangement: the flawless mise-en-scène. This illustrates the hidden disappointment for the wasted life and incarceration by one's projected life and self. The women while away their time as dolls. Mimicry and body language are a matter of resigned stoicism. Flawlessness excludes the possibilities of an alternative style of life. There is no space to breathe between the figures and the things: movement is inconceivable. Like Marcel Proust with his *In Search of Lost Time*, Meisel documents, if less bitingly than Testino, the saturated society in the form of a phenomenology of hegemonic poses and attitudes in a setting purpose-designed for them.[8]

[8] See Walter Benjamin, 'On Proust', *Illuminations*, London 1969.

The houses in Beverly Hills in which Meisel shot his Versace campaign in 2000 shrank along with the almost carnivalesque hairstyles of the models to normal proportions that are so frighteningly awful simply because they are total. The stage as vacuum presented a finished world (in both senses), which even as a scrap heap of luxury does not show

the slightest crack. The broken is presented as completely intact. The bourgeois as the non-aristocratic which aspires upwards meets with little approval for its ambitions despite its transfiguration. Meisel describes the desire for noblesse with all its brash vehemence. This is why Meisel was so enthusiastic about California: in LA everything has become a dream factory for this desire, and each dream comes true beyond all history, tradition, or old civilization. The houses in which the two top models Amber Valetta and Georgina Grenville pose so nicely are real. In fact, Meisel wanted to change a few details, but he soon noticed that this was impossible. Like his pictures, the houses were simply not up for compromise.

Meisel's reflection of the present shows the Now in a mirror positioned infinitely far away. The more classical the images appear, the greater the distance. Meisel uses fashion's transience to combat that fleeting character. What is eternally new in fashion becomes the yardstick for classical glamour. The rigidity of the figures is not only bourgeois realism, but also derives from the will for form which, in Meisel's case, is always full of historical references. His knowledge of the history of fashion photography is as profound as his expertise in fashion journalism. He draws on a wealth of images created by the grand masters such as Richard Avedon and Horst P. Horst. The fact that his works may extend beyond their oeuvre is a product of the perfectionism, whose radical thrust and exaggeration look operatic.

Rigidity is the exaggeration of attitude. Attitude is cemented in place, disposition becomes an example for others to follow. What attitude is intended to signify in terms of emotional identification with the age is relative: with glamour, attitude goes beyond witnessing the age. In glamour

the proportion of the eternal, what transcends the zeitgeist is greater than in other types of fashion photography. True eternity in Schelling's sense – overcoming and subjugating time – is above all the driving force behind the classic school of glamour, whereas younger photographers have not wished to forfeit the identification with the age and the disposition of various sub-cultures, nor have they been able to do so. The lack of rigidity also stems from this openness toward time.

The rigid is not far removed from the stereotypical. So-called party people, who hang out by the pool, are moving statues, the dummies of a thin-skinned joy, portrayed in its threatened state. The decadence of glamour must therefore reach well beyond the mainstream and the gradual decay of the bourgeoisie. At first sight, these photographs seem classic, eternal and indestructible (which the *images* are, too), yet at second glance we soon recognize that the world we see is destined to decay for all its vain beauty. The younger photographers have specifically emphasized the engulfing aspect of these worlds.

The new concept of glamour tolerates the impure. It locks into the tension between the pure and the impure. Just as in a Wolfgang Tillmans photo the model's accessories and pose can be glamorous, the surroundings and clothes can themselves be soiled, dirty, base or trashy. The picture is nevertheless defined as glamorous by dint of the pose and accessories. This tension is typical of the contemporary concept of glamour. Glamour does not present purity, but the lascivious hegemony of the photo's glamorous core over the non-glamorous components. The fashion photography of a Juergen Teller, Mario Sorrenti or Stéphane Sednaoui knows, interprets and cites the gestures of glamorous existence and images – without superficially falling prey to them. In their own specif-

ic ways they absorb compositional elements and arrangements used by photographers before them and bow down humbly before them, just as punk and the DJ culture do with their decomposition or unorthodox sampling, scratching and looping of these elements. Whether glamour as a concept, attitude and conception is destroyed or modernized by this is arguable. It is of no importance as regards the interpretation of the pictures: they can be read both within and against the tradition of glamour.

Indeed, the images open glamour up to dialogue once more. This is how new connections become possible, and only thus can glamour continue in a lively tradition instead of freezing up due to incestuous anaemia. Glamour has become freer in the course of the last two decades and allows sceptical viewers who have grown up with other ways of seeing and thinking a chance to understand fashion photography. The loss of rigidity and radiant stereotypes keeps the glamorous contemporary and animated in the sense that it is fuelled by dreams or becomes a dream. The loss of sensory experience owing to the mediatization of experience contrasts the new and the old glamour with a galvanized brilliance and refinement that is far less open to attack since glamour has itself started to go on the attack. Where glamour reproduces itself, whether through offspring on a par with it or through bastards bursting with energy, it shows a merciless propensity to pour scorn on inferior forms of aesthetic and sensory reception.

Glamour is the last bastion of poetic sensibility that has otherwise slowly dissipated in the flow of images. Glamour photography also rescues the elements of poetic pathos for the present, elements that have otherwise long since ceased to have a place there. The prosaic level of pictures by Teller, Richardson or Sorrenti is closely related to the poetic

such as has been perfected by David Seidner or Steven Meisel. Glamour becomes the reserve of a refinement in the throes of extinction, and the images reveal the necessity of their existence, as representations of what would be lost without them. The engine of this rescue attempt – as Benjamin also pointed out in Proust – is curiosity and flattery. The tender melancholy that surrounds the pictures intensifies the sensibility for perceiving them.

Photography becomes the comrade-in-arms of fashion through the melancholy of leave-taking, for fashion itself equally courageously and cheerfully endeavours to perpetuate glamour where it has actually already become impossible. The drapes presented by Balenciaga, the stringent glamour of Helmut Lang or Tom Ford's Gucci rely just as much on being staged by fashion photography as the photographers depend on the sensitivity of the designs that enable them to address these glamorous signs so playfully in the first place. The mutual translations performed by fashion and photography contextualize the glamour and integrate it into the lifeworld and into the worlds of art. Recent photography has done fashion a great service here in working towards integration. The balance achieved stems not only from this interdependence, but also from the stable romance between fashion and photography. Where Galliano is re-interpreted by Testino, where Lang is newly discovered by Teller, where Nick Knight hyper-poeticizes Yamamoto, the photographic medium achieves an interpretative hegemony over fashion on the basis of the staged set made by the photographer, stylist, and art director. This is also the result of the lost modesty of the photographers who no longer wish to be the slaves or salarymen of the fashion houses or magazines, but in an age of lost orientation consider their interpretations or

vision imperative, thereby wishing to see their own role re-appraised. Fashion photography has also grown more discerning – particularly because fashion itself has seen an equal rise in importance over the same period.

The classic definition of glamour arose in the 1930s and particularly in the 1940s as a result of studio photography in Hollywood – it shied away from any subjective angle and instead opted for a perspective beyond the almost monumental empowerment of the person illustrated. Glamour in the last twenty years has, by contrast, eschewed any full frontal perspective and the purported objectivity of the camera. Only neo-classicists such as David Seidner, Javier Vallhonrat and occasionally Herb Ritts and Peter Lindbergh, have exploited the ostensible rigidity of the old concept.

Glamour is most convincing where lies blend with truth. In particular, the routine glamour-makers such as Mario Testino and Helmut Newton, whose mastery of the medium allows them the scope for a casual touch, have instrumentalized their own obsessions and idiosyncracies, superimposing a touch of perversion or eccentricity over the customary pictorial scheme of women's legs, high heels and semi-transparent underwear.

Testino creates new stereotypes. The power of his representations is closely connected to the libidinous core of fashion photography. Lasciviously, and always only a glance away from obscenity, he formulates his erotic dream sequences quite overtly by means of tableaus of physical flawlessness that almost seem unerotic. The glamorous specifically rejects any corporeality through which, for example, punk manifested its authenticity. In glamour, the corporeal is avoided in a particularly tasteful

manner. All that remains of the pores of the skin, the muscles and sinews, of pubic hair, is some polished, made up and retouched shadows. The compulsion for perfection removes the corporeal from a domain where it is threatened by age or decay. A world without wrinkles and blackheads transcends any real reference to what is portrayed and creates an almost Platonic radical world of the idea of the 'body', 'corporeality', 'beauty', 'femininity', etc. All matter has been erased from it – it is permeated by light and shadow, as if unleashed by magicians and left to its own devices.

When Patrick Demarchelier has blossoming flowers spring out of women's heads and Paolo Roversi makes the shadow of a hat into the setting for staging a deliberately over-exposed face, when Herb Ritts has Madonna's neck grow like a swan's up out of her black leather jacket, and when David Seidner made the silky mounds of fabric start to dance, then glamour functions as dream factory. Even in its most fractured redefinitions as critique of ideology, glamour always has this basic conception of itself as dream factory to thank for its radiance. Fleeing the world entails a categorical obligation. Female sexuality is evoked not in coital terms but as narcissistic self-embrace. It has become unsure of itself down to the very last fibre. The nakedness so proudly displayed, illuminated by reduced fashionable accessories, now only justifies some purely compositional interest on the part of the photographer, even if in Testino's oeuvre it knows of and fosters sexual undertones.

When libido threatens to become fully formed, then glamour has emerged victorious over life, and each of these triumphs make it all the

more immortal. Its hubris works for it and against reality. Taking leave of the world is the last hope left for a vision that entails transfiguration as the elimination of the real. Dialectically speaking, this of course also means initially that reality has to be present as the platform of rejection. In the end, glamour occurs and represents reality in the presence of the absent – the renewed triumph of the real over its rejecter and yet the first step towards forgetting it for good. The better you look, the more you see.

glamour

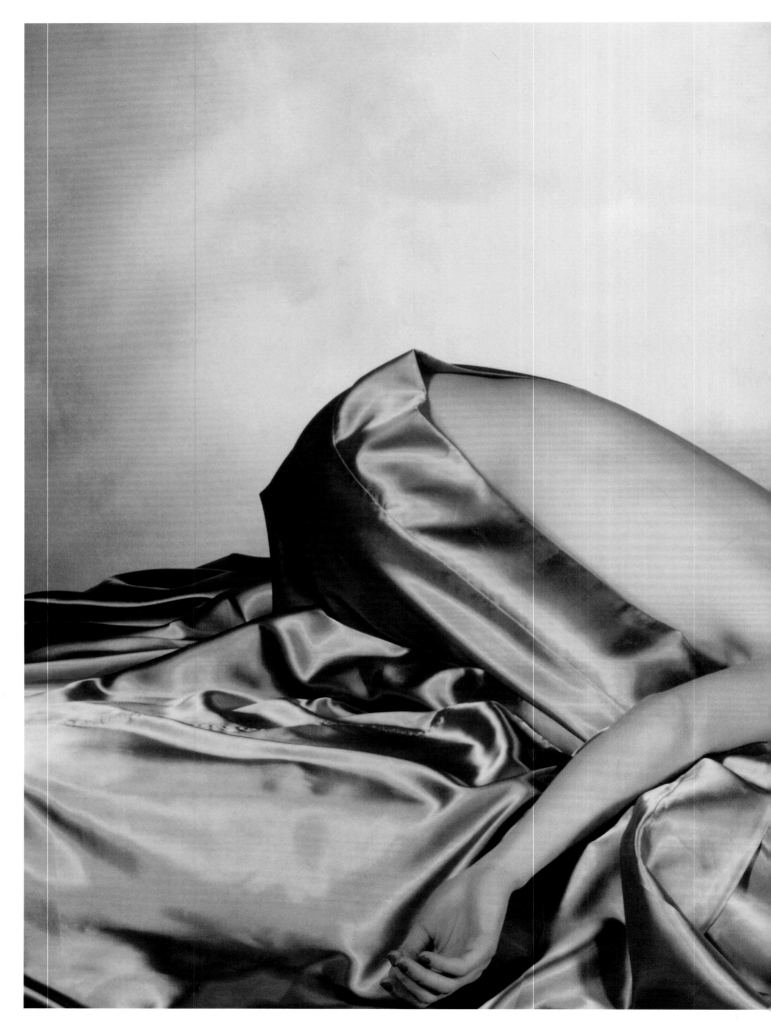

1 . guy bourdin . calendrier pentax . tokyo, japan . 1980

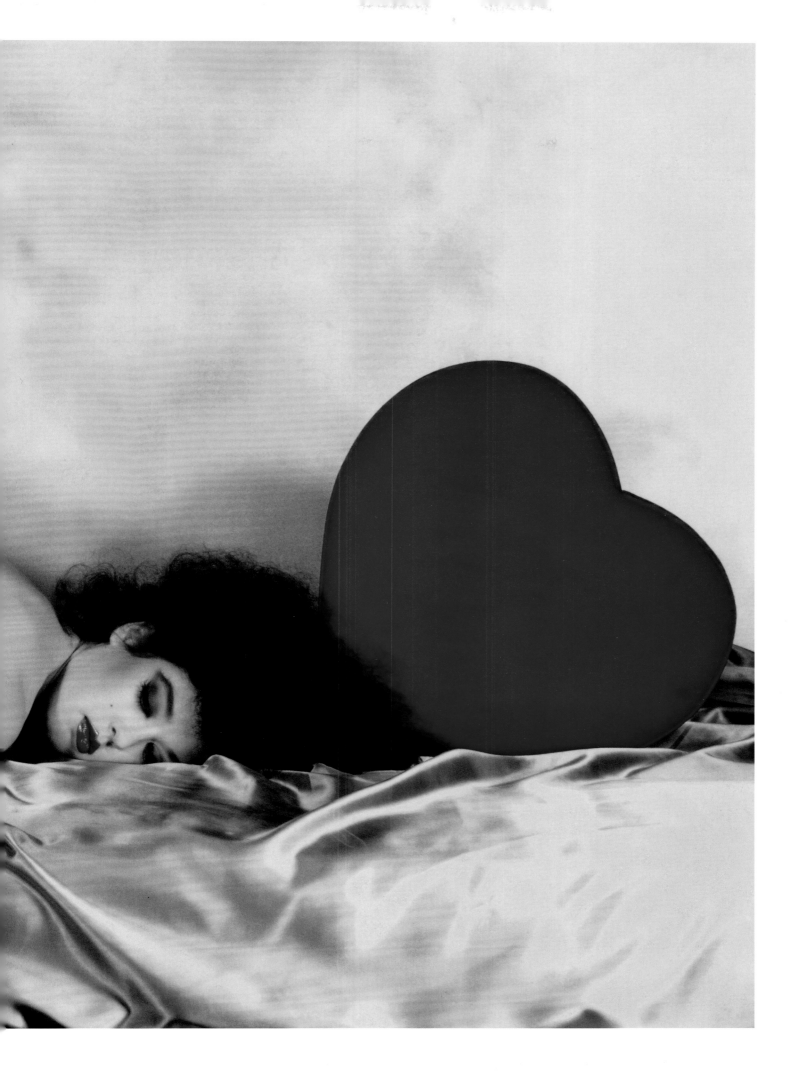

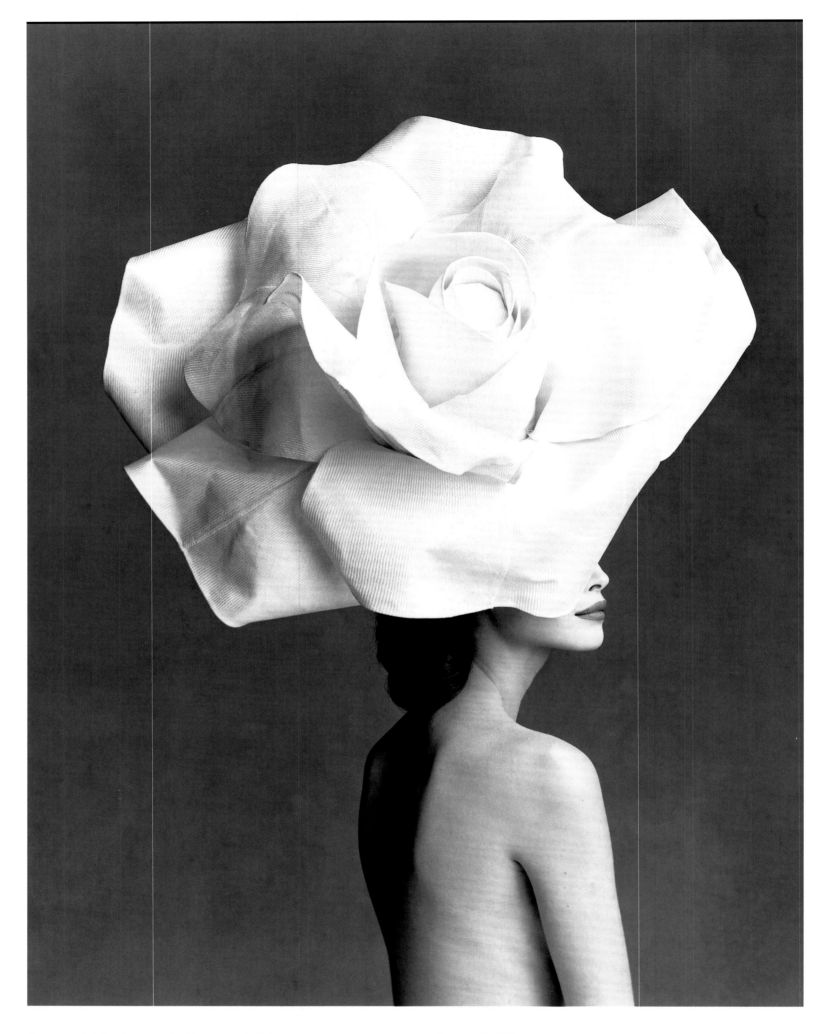

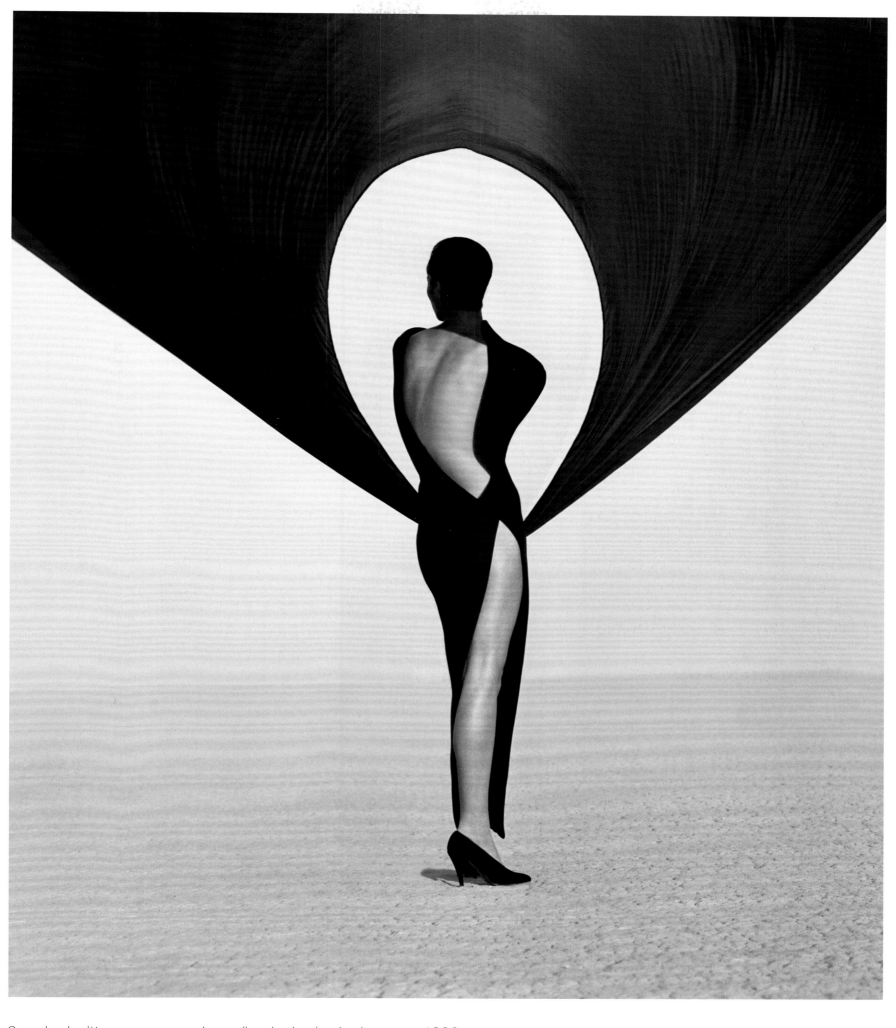

3 ▪ herb ritts ▪ versace dress (back view), el mirage ▪ 1990

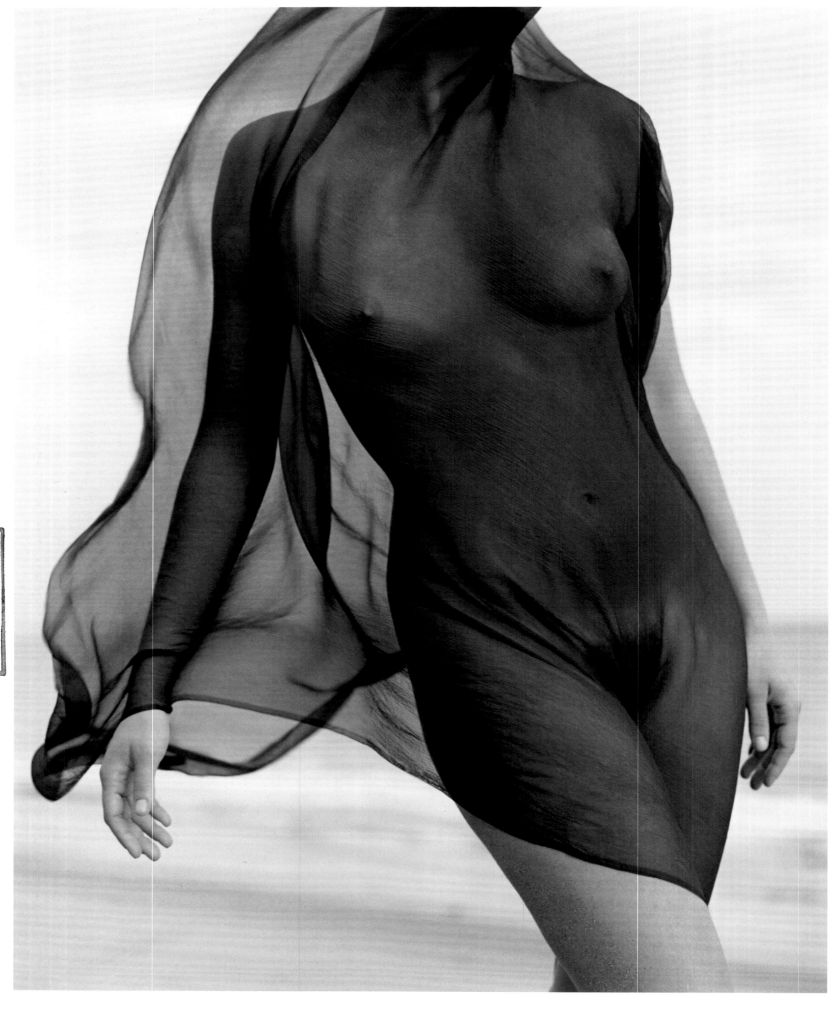

4 . herb ritts . female torso with veil, paradise cove . 1984

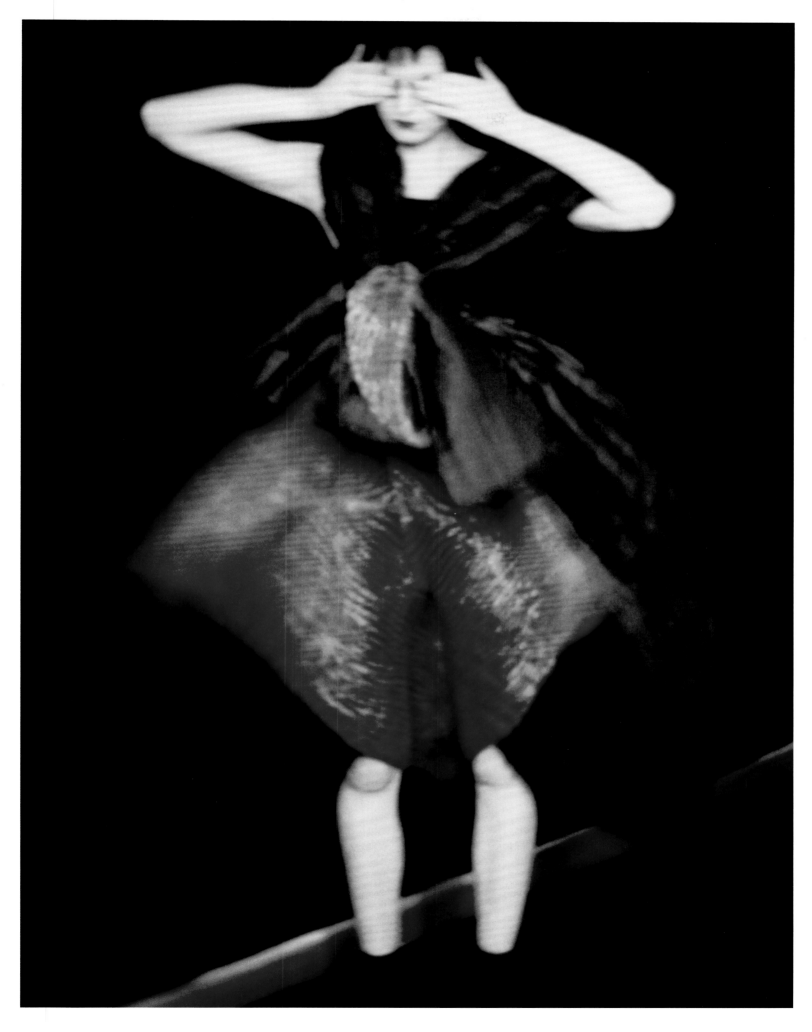

5 . sarah moon . theresa stewart, issey miyake . 1995

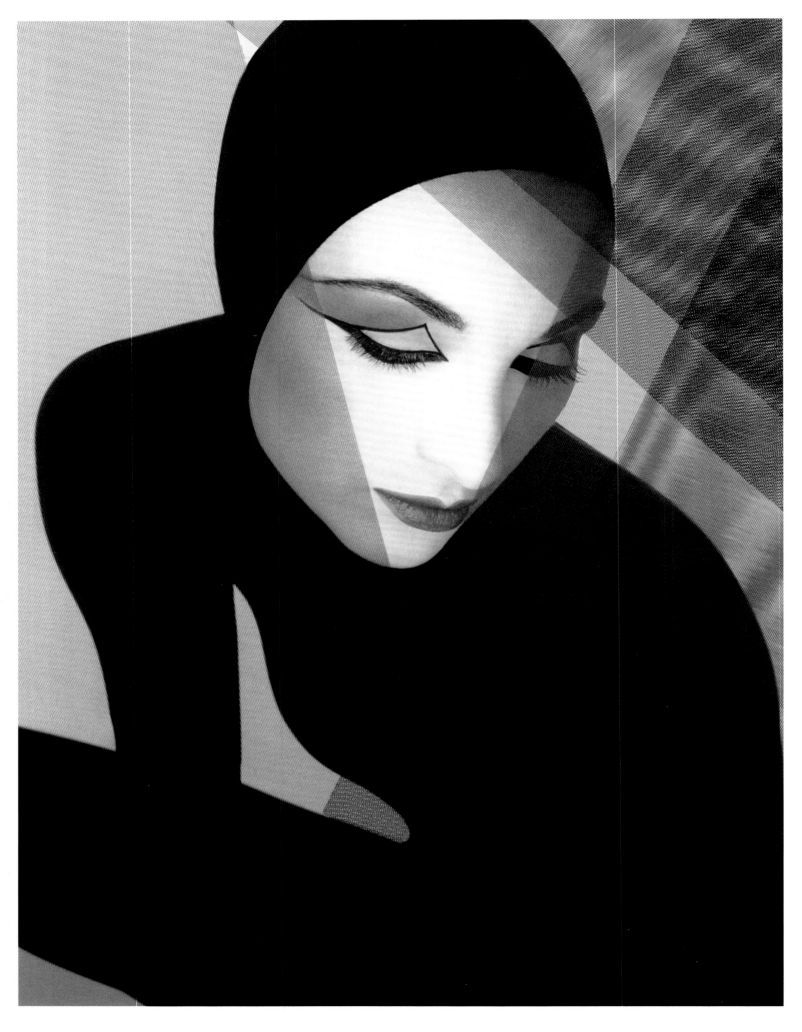

6 . serge lutens . ombre lumière, tulles découpés, elena . 1995

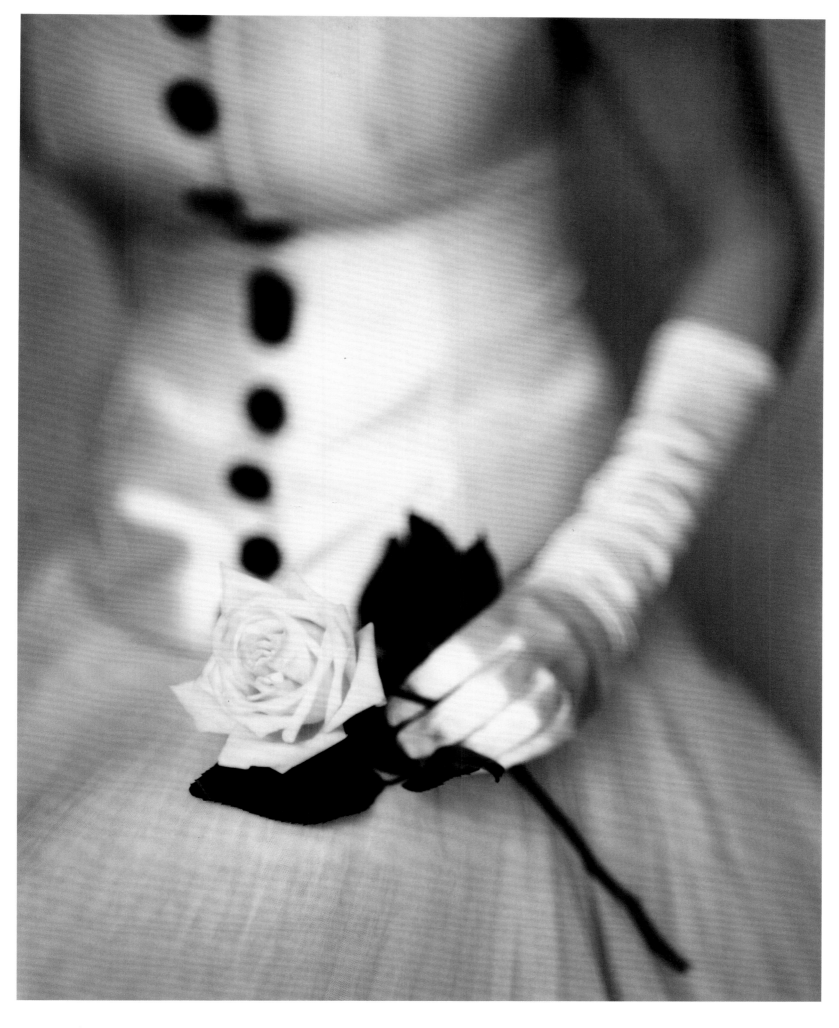

7 . paolo roversi . olga, paris . vogue uk . 1994

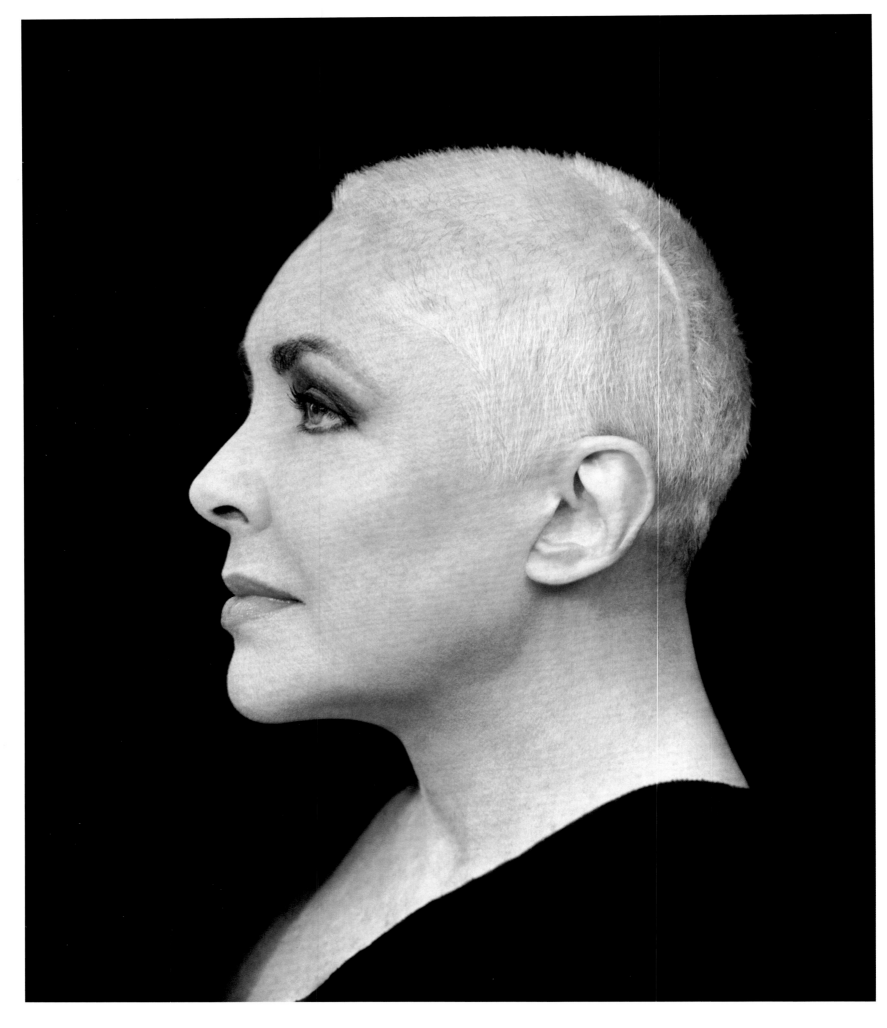

8 . herb ritts . elizabeth taylor, bel air . 1997

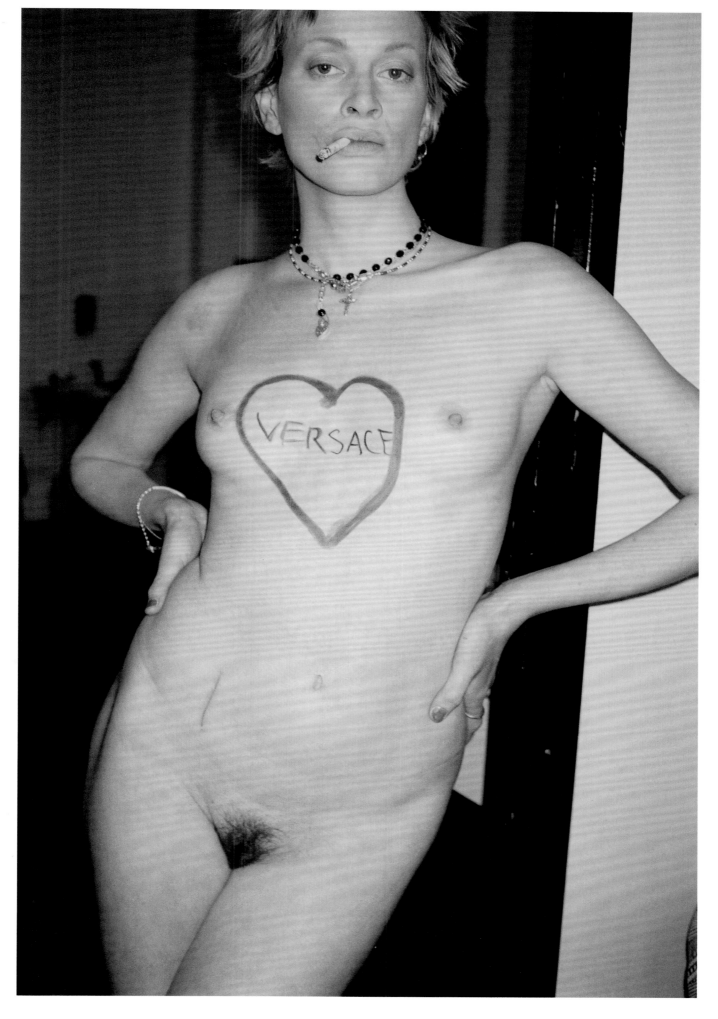

9 . juergen teller . kristen mcmenamy, london . 1996

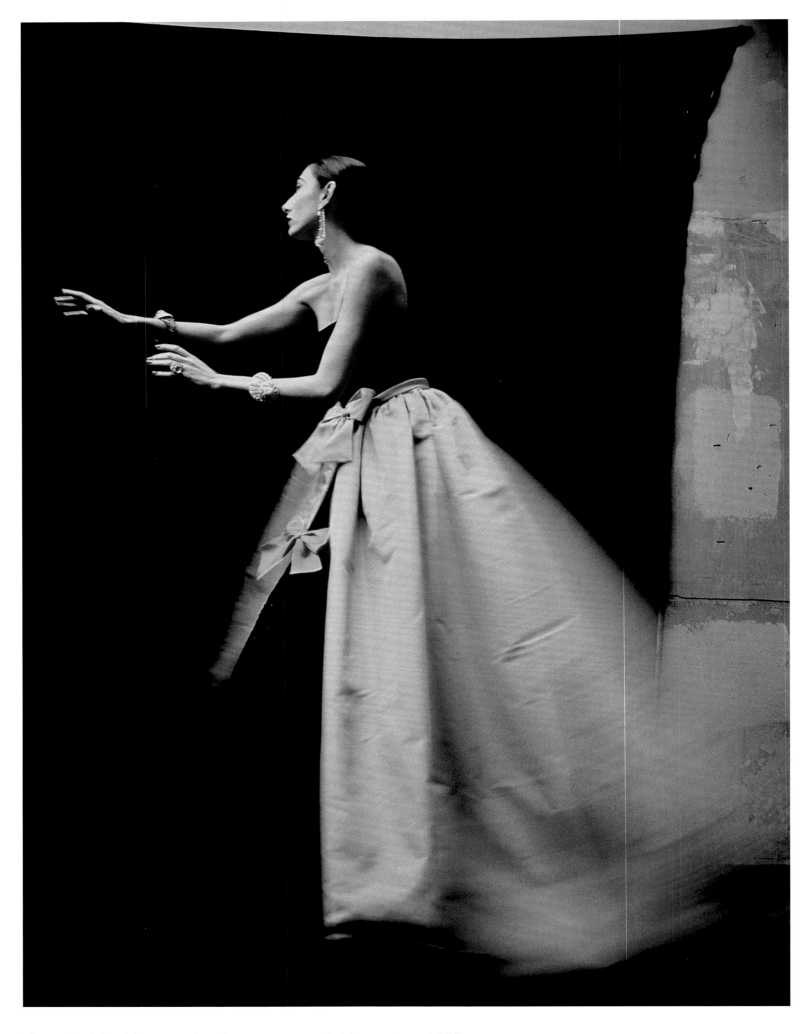

10 . david seidner . ahn duong, yves saint laurent . 1986

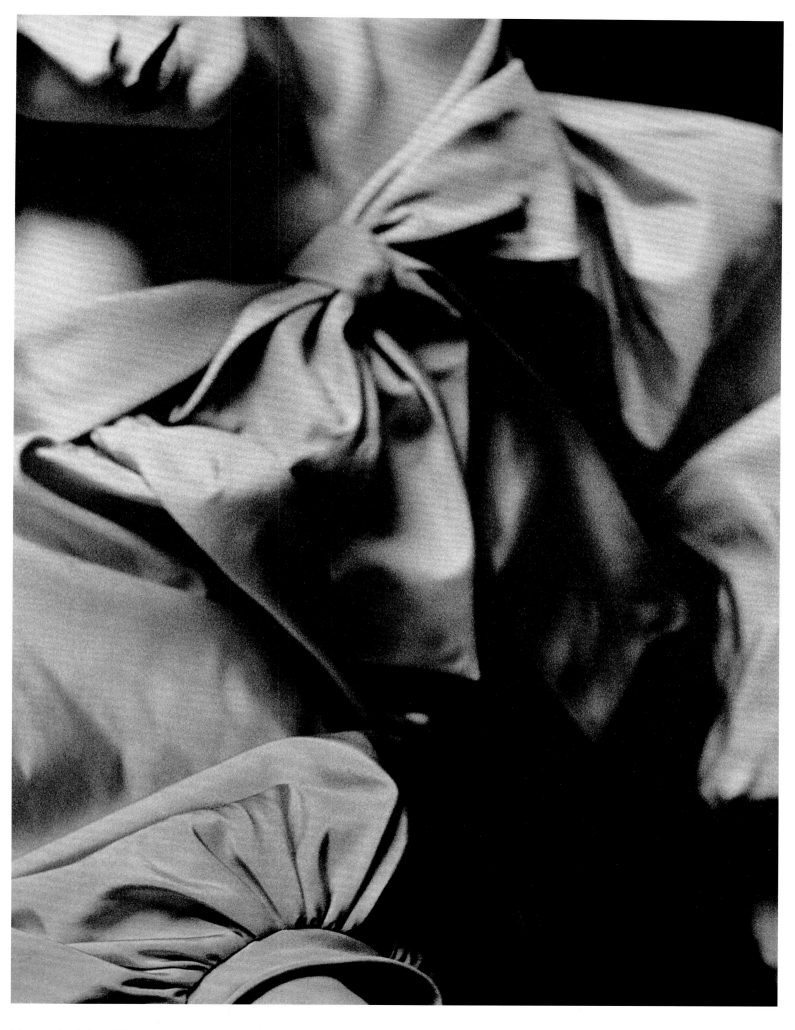

11 . david seidner . anne rohart/domino, yves saint laurent . 1983

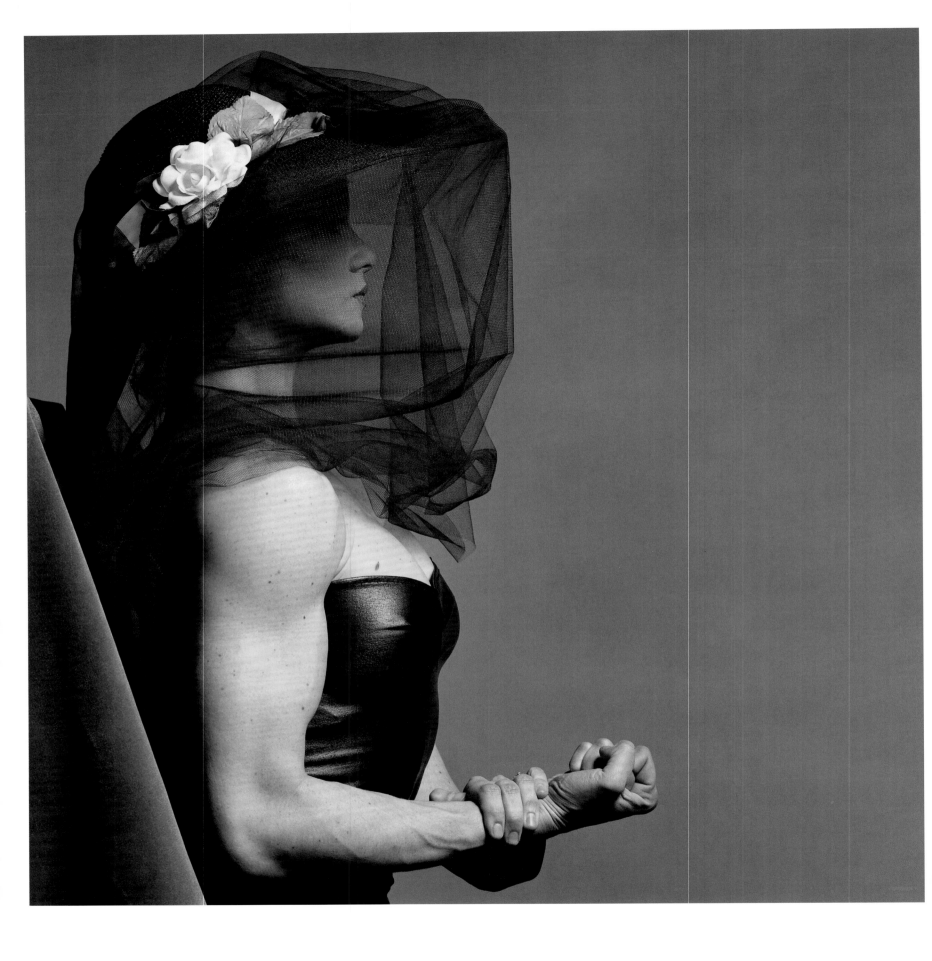

12 . robert mapplethorpe . lisa lyon . 1982

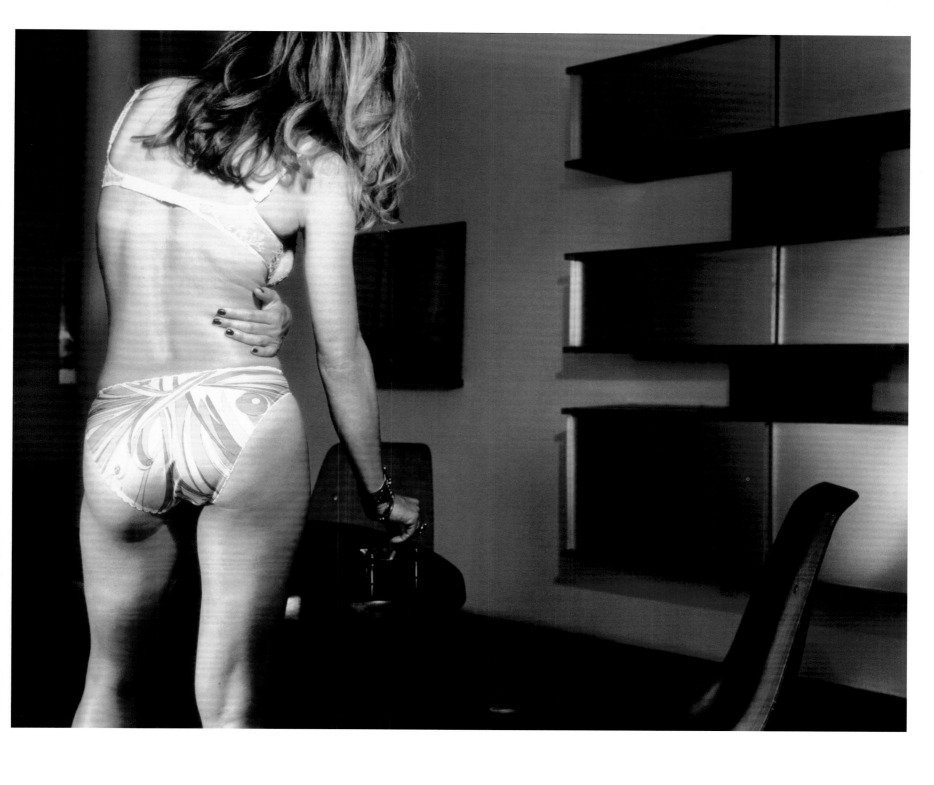

13 . bettina rheims . le dos de cordula, new york . english nova magazine . 2000

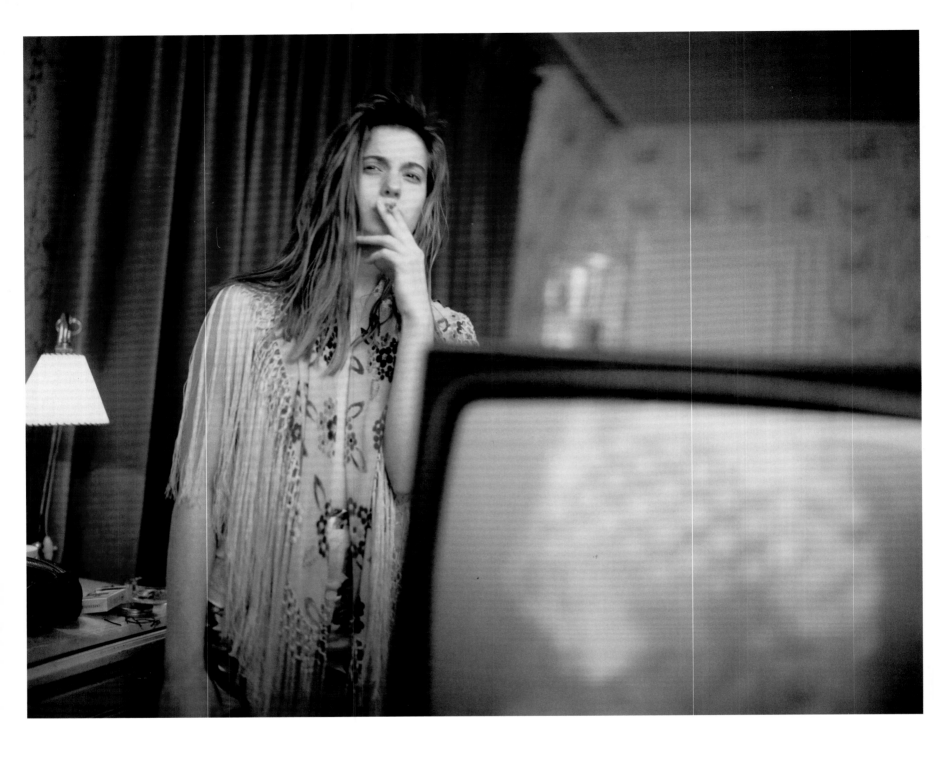

14 . jean-françois lepage . suzann . jill magazine . 1983

15 . jean-françois lepage . claudia . lei . 1985

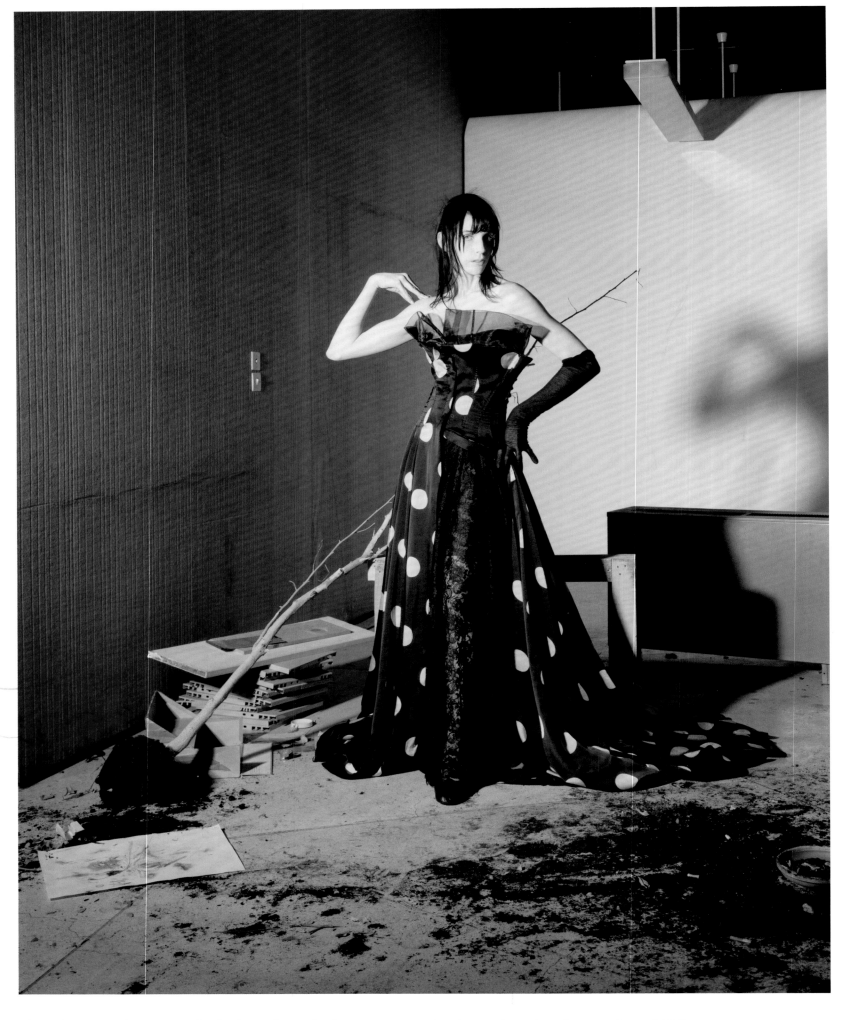

16 . inez van lamsweerde & vinoodh matadin . yamamoto, hannelore (postgrunge) . 1998

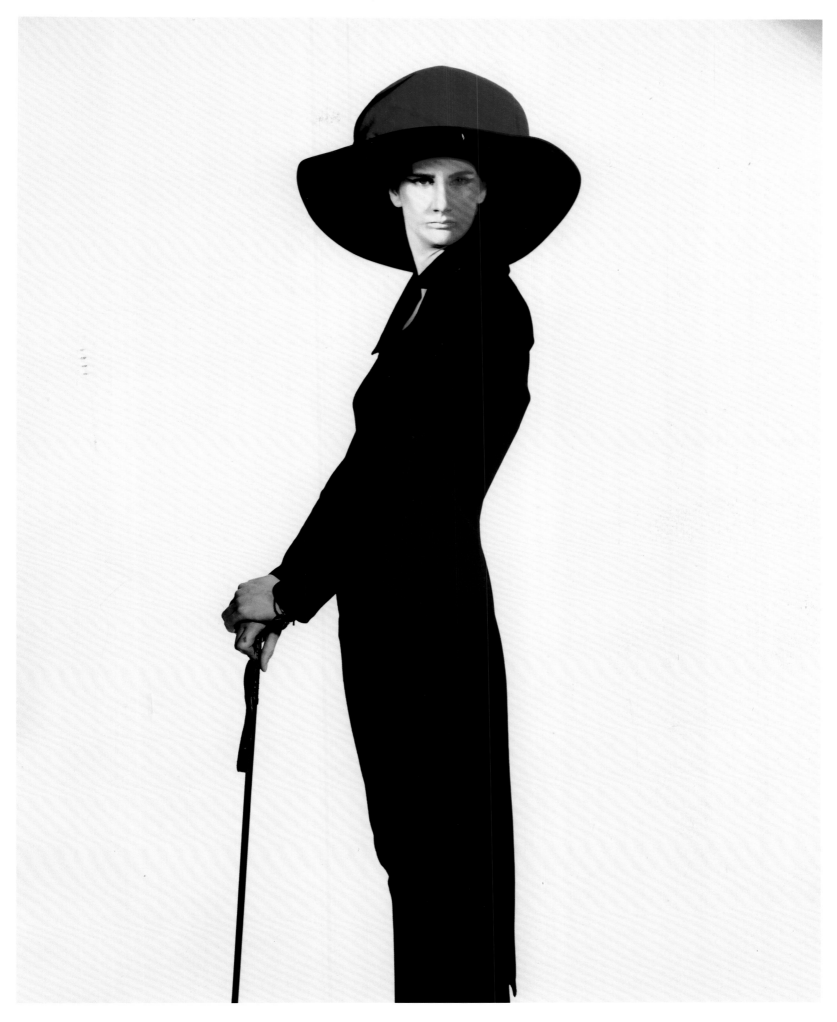

17 . paolo roversi . sasha . yohji yamamoto, paris . 1985

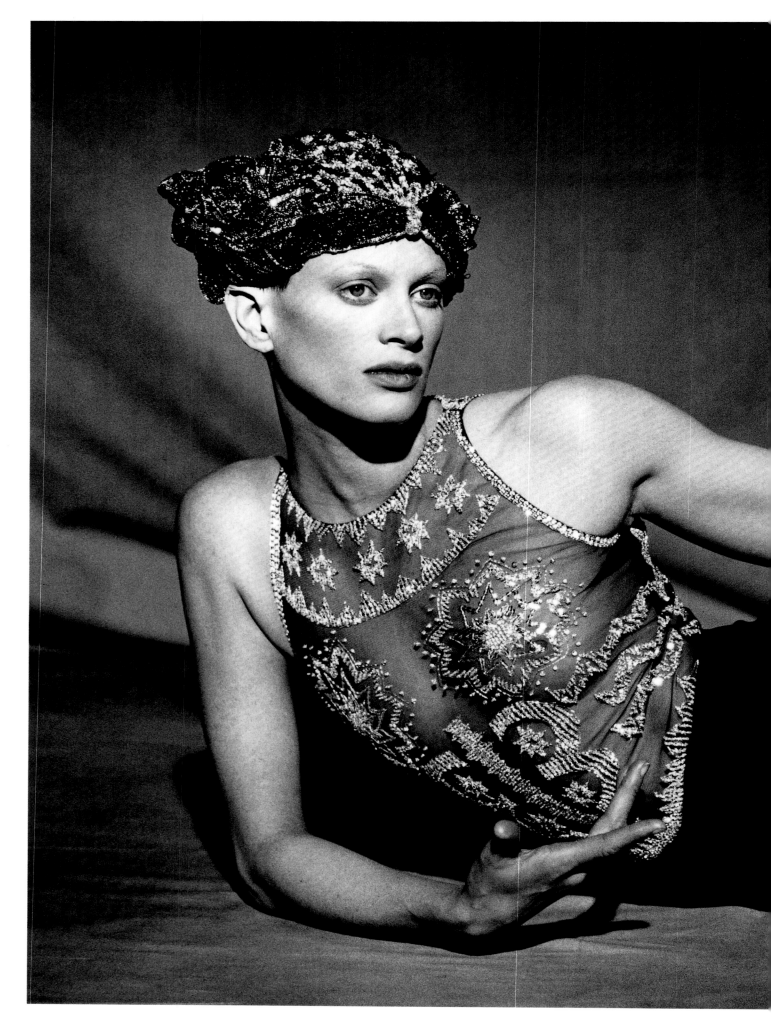

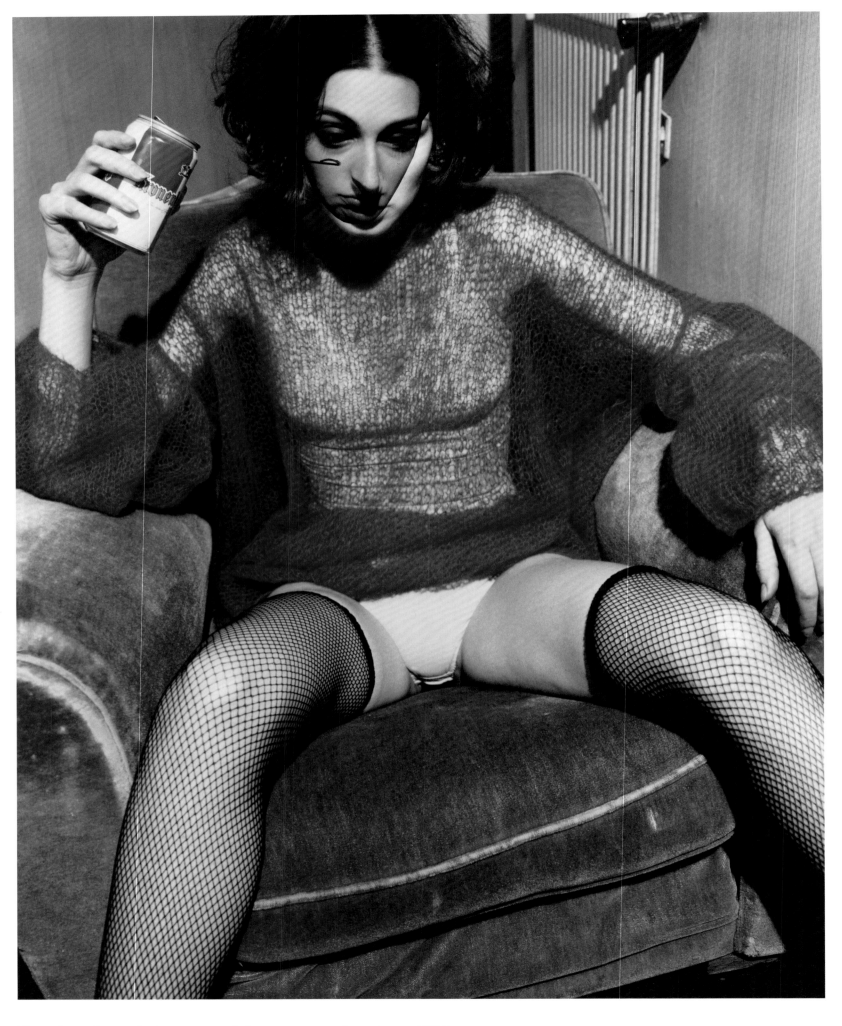

19 . jean-françois lepage . felix . personal work . 1992

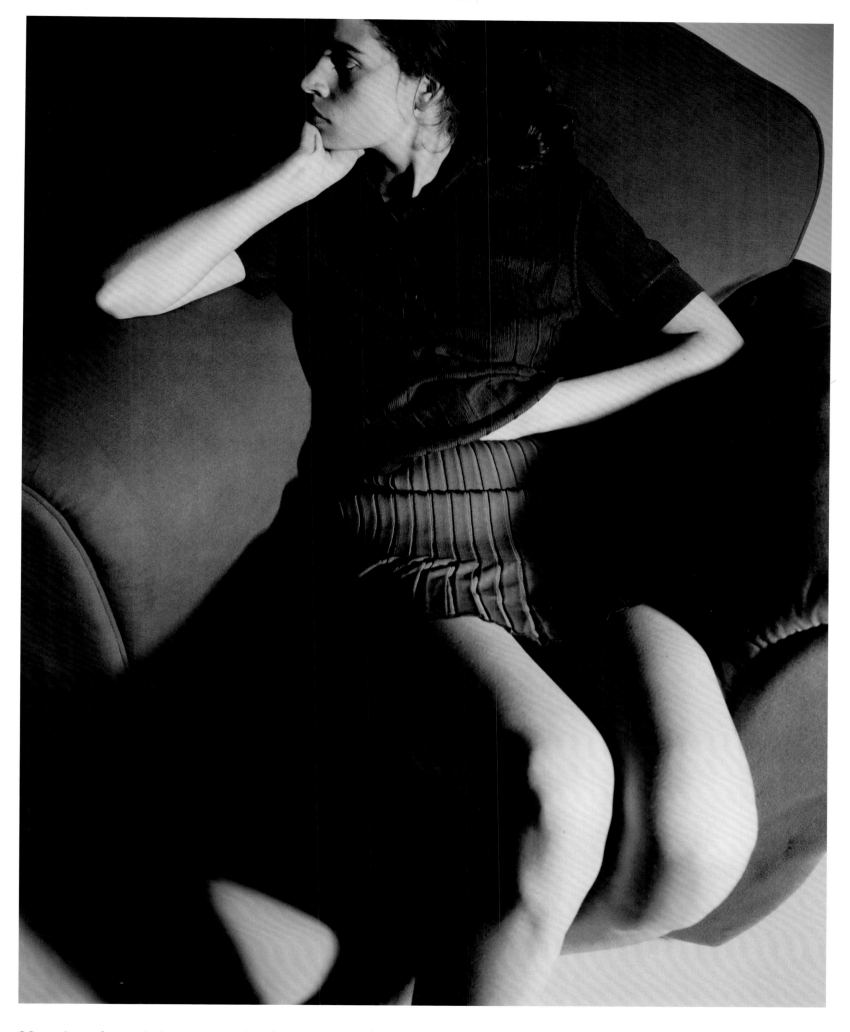

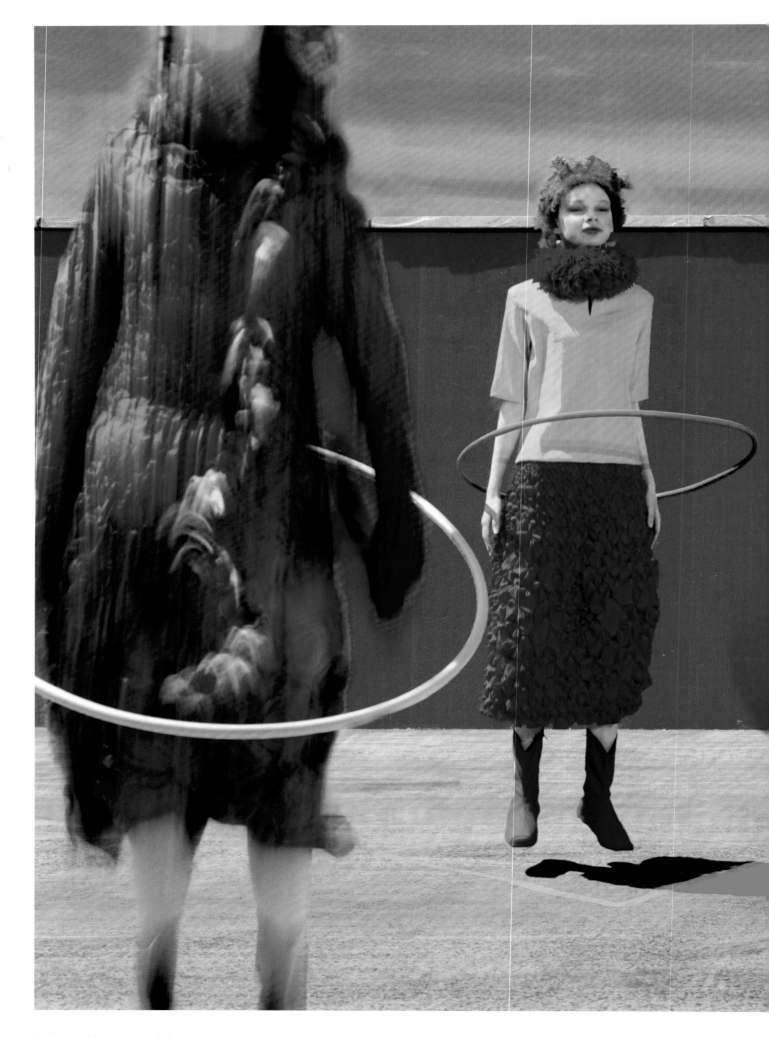

21 . thierry van biesen . houps! . elle japan . 2001

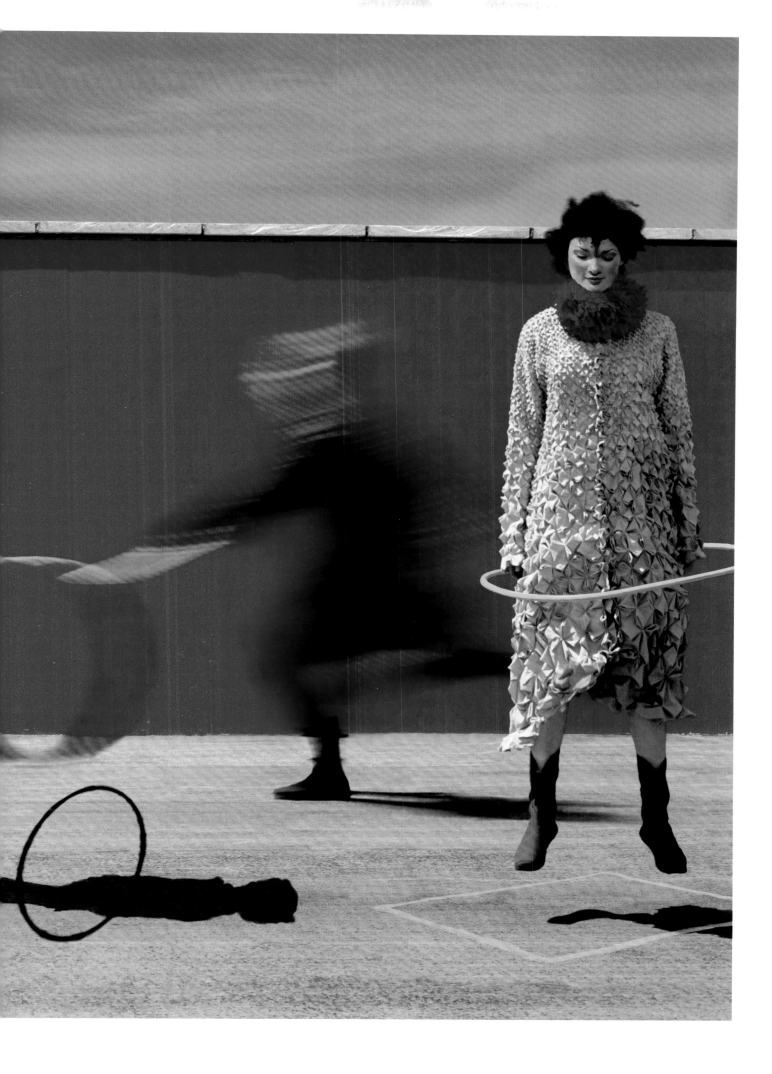

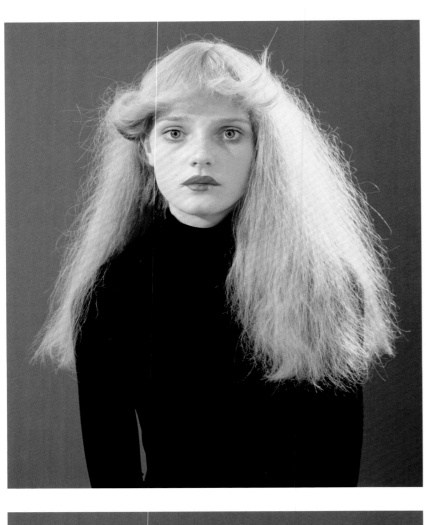
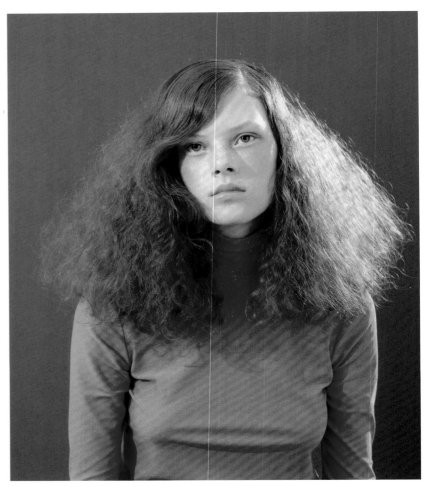
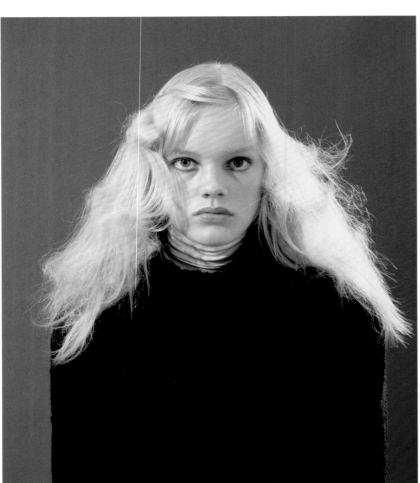
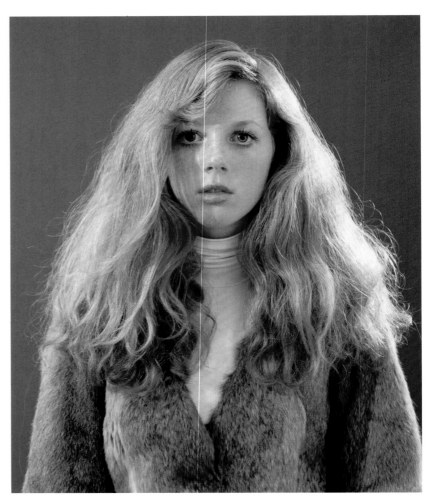

22 . anuschka blommers & niels schumm . class of 1998 . self service . 1998

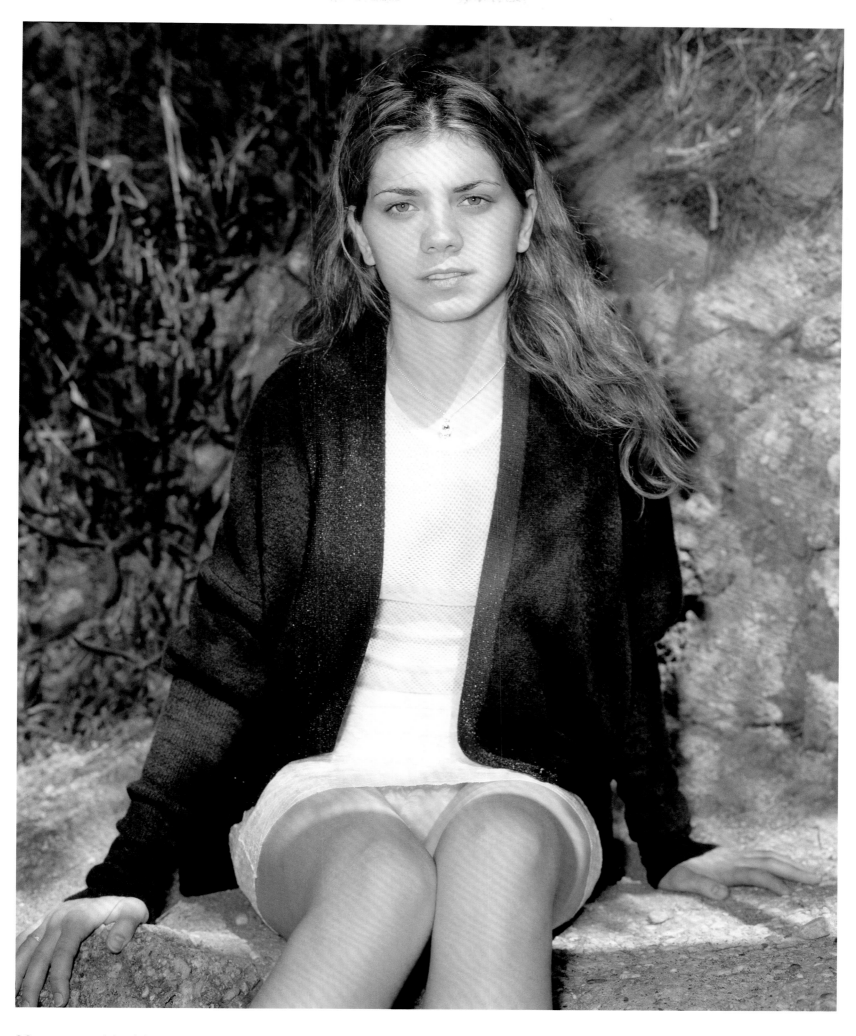

23 . anuschka blommers & niels schumm . allexandra . dutch . 2001

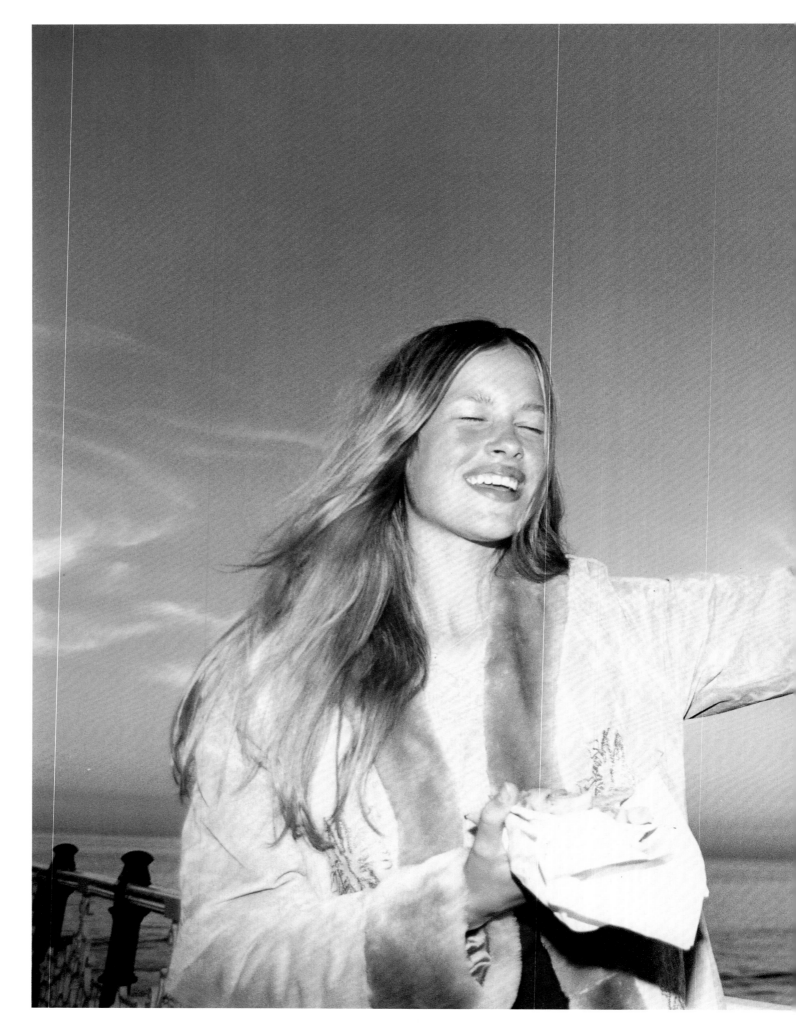

24 . elaine constantine . seagull . the face . 1997

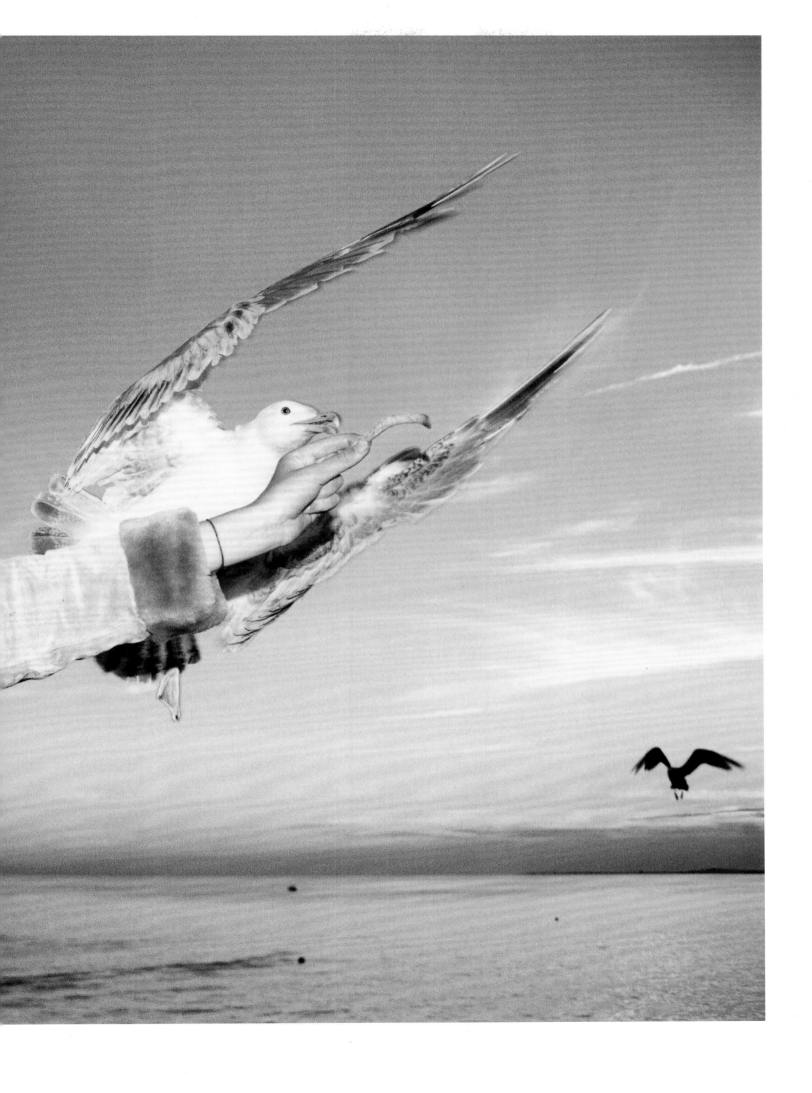

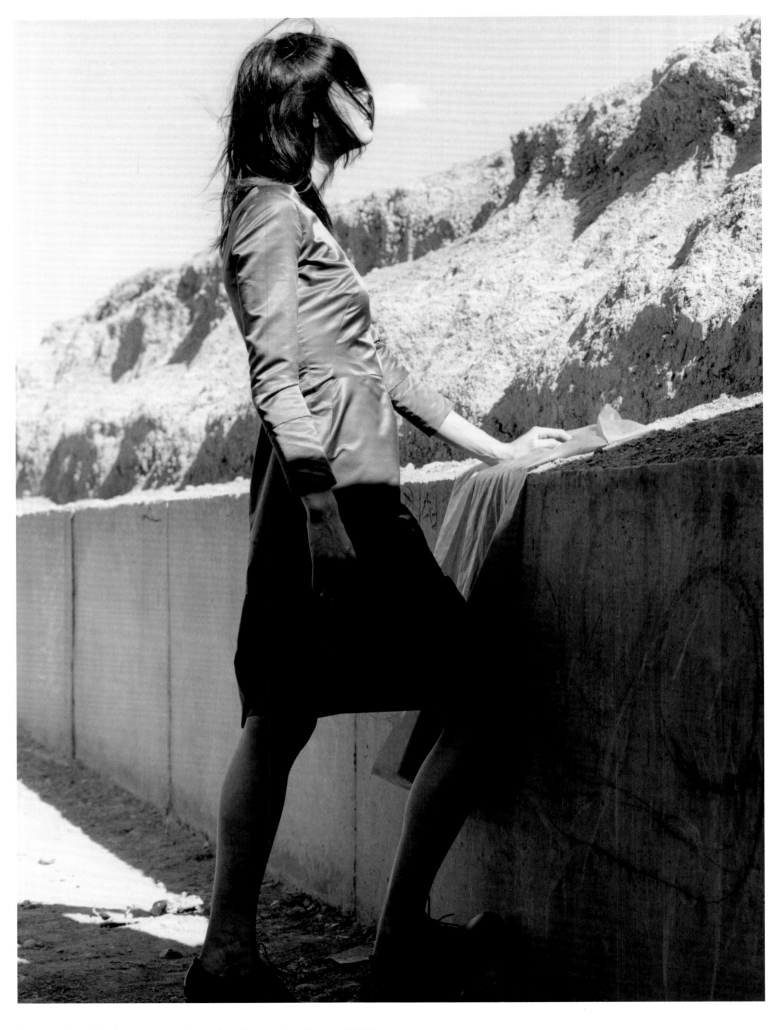

25 . david sims . malgosia, jil sander I . 1999

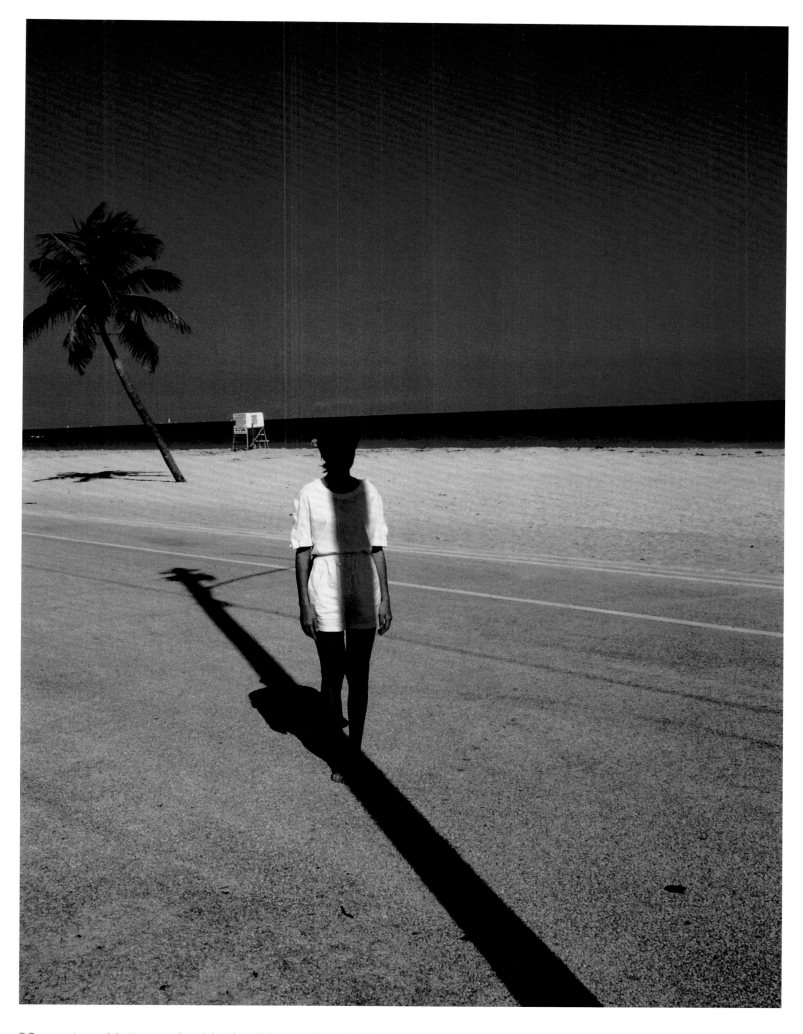

26 . steve hiett . miami in the 70s . linea italiano . 1978

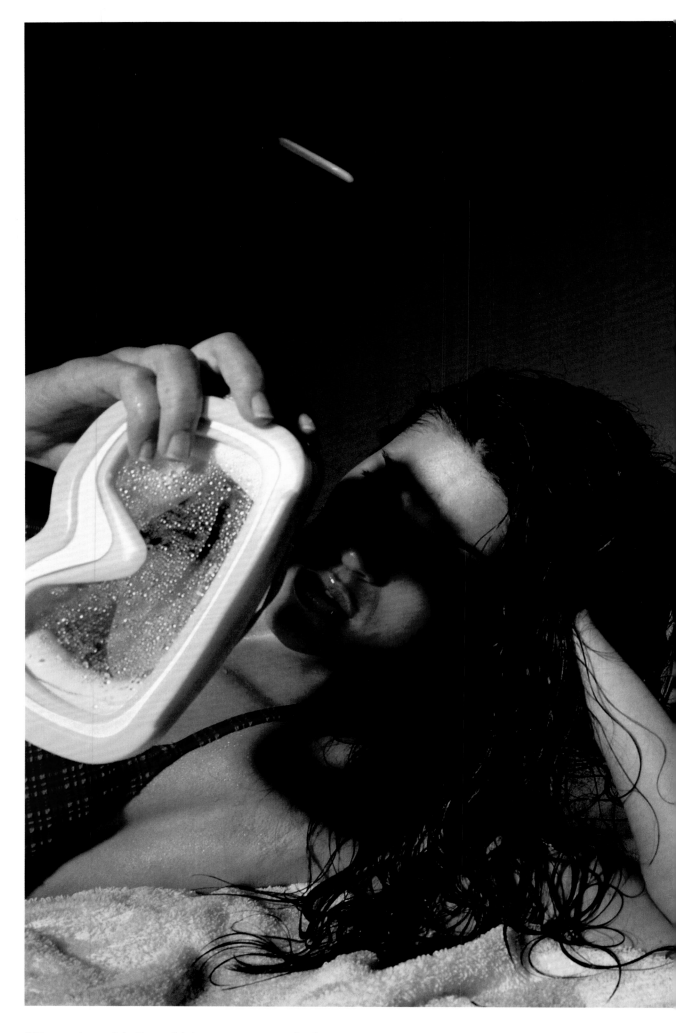

27 . steve hiett . frisbee . vogue italia . 1999

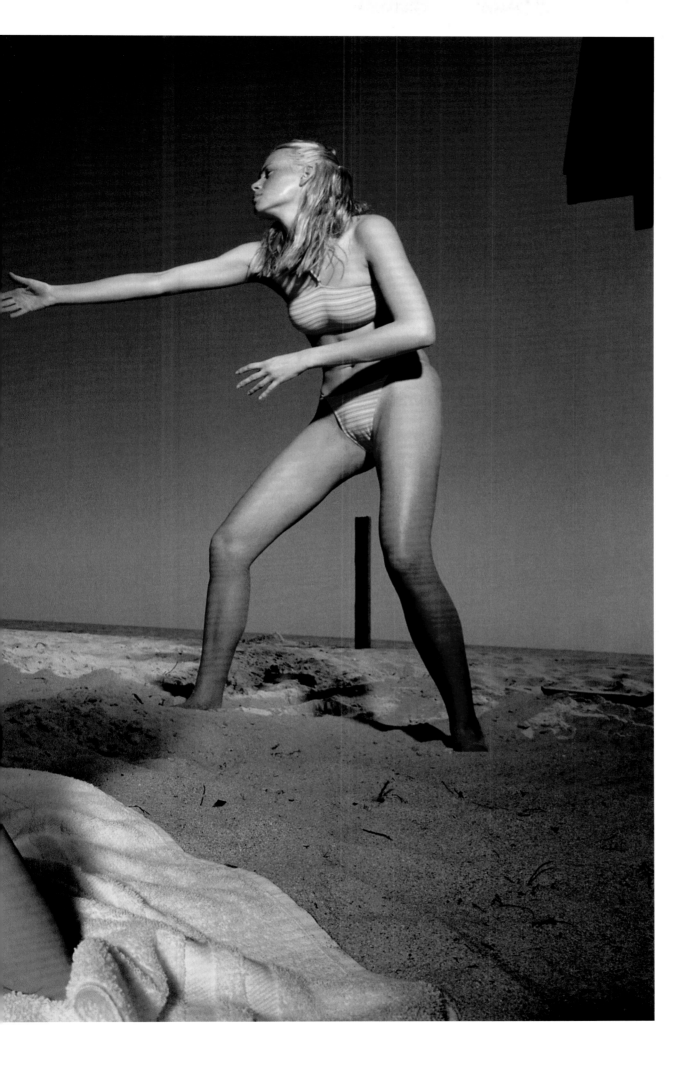

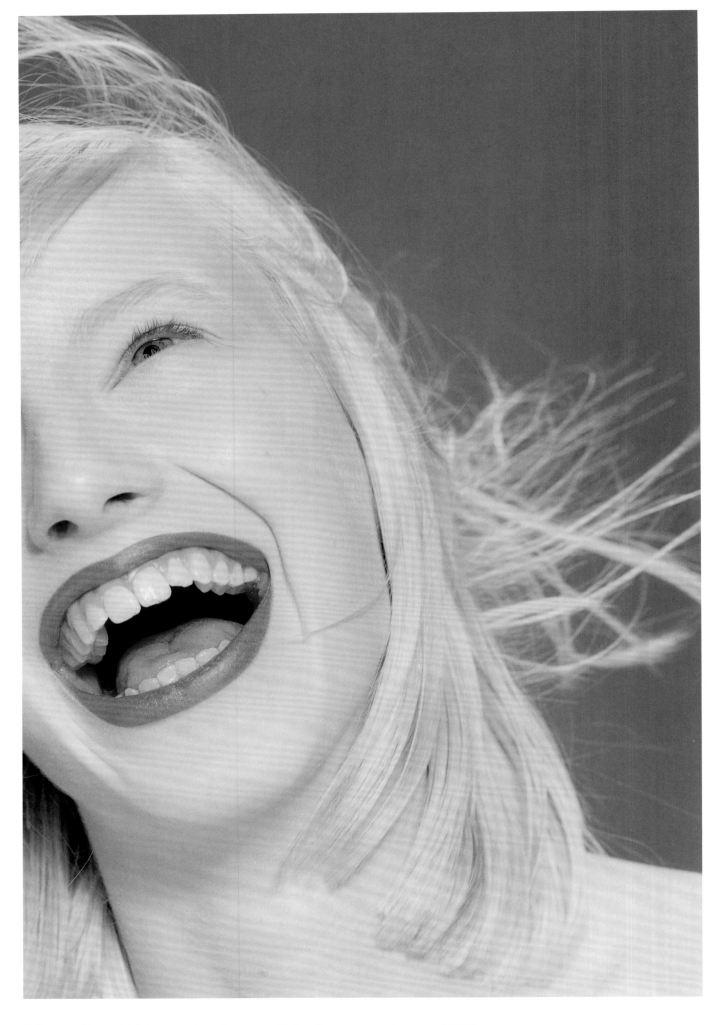

28 . miles aldridge . heather . libération magazine . 1999

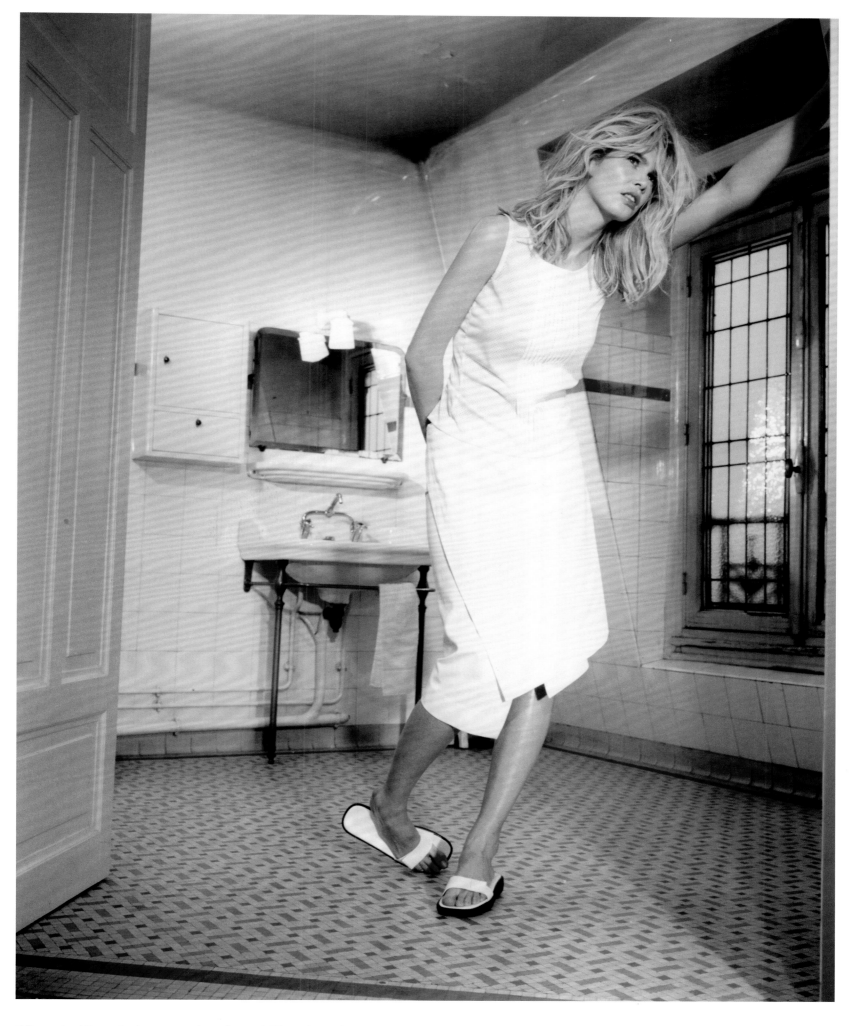

29 . bettina rheims . claudia schiffer dans la salle de bains du terminus est, paris . detour magazine . 1999

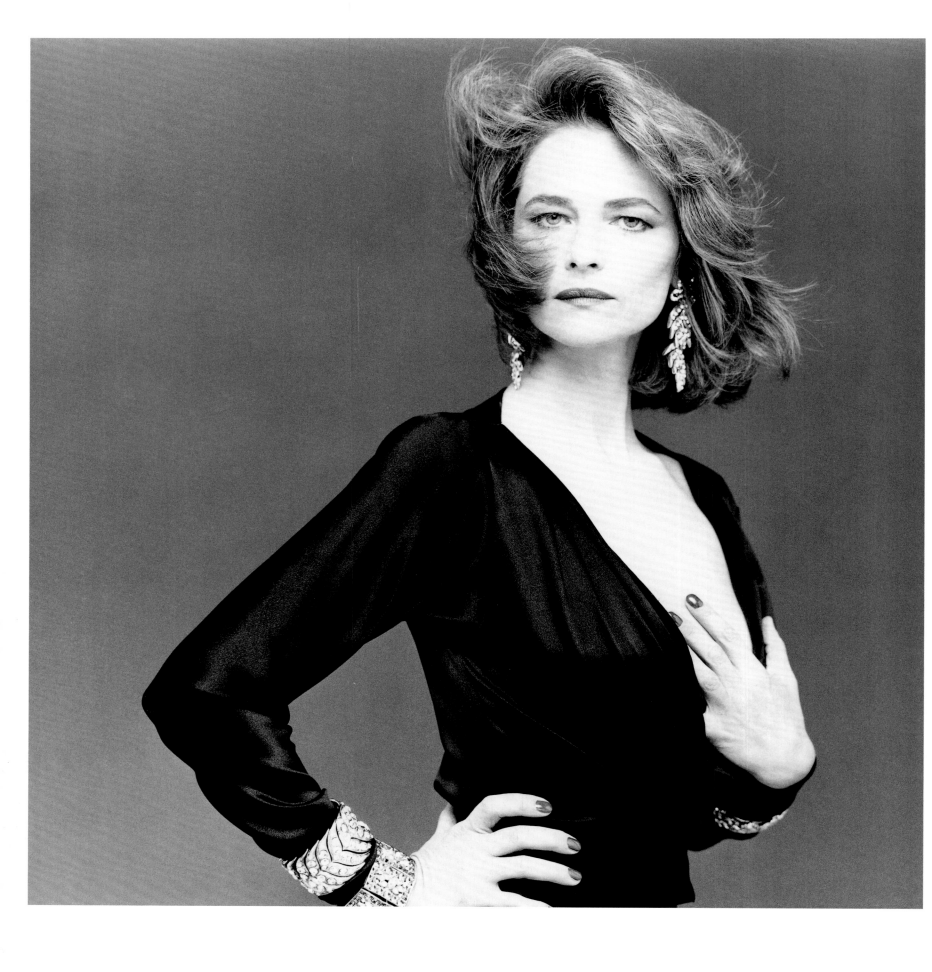

30 . bettina rheims . charlotte rampling, paris . female trouble . 1985

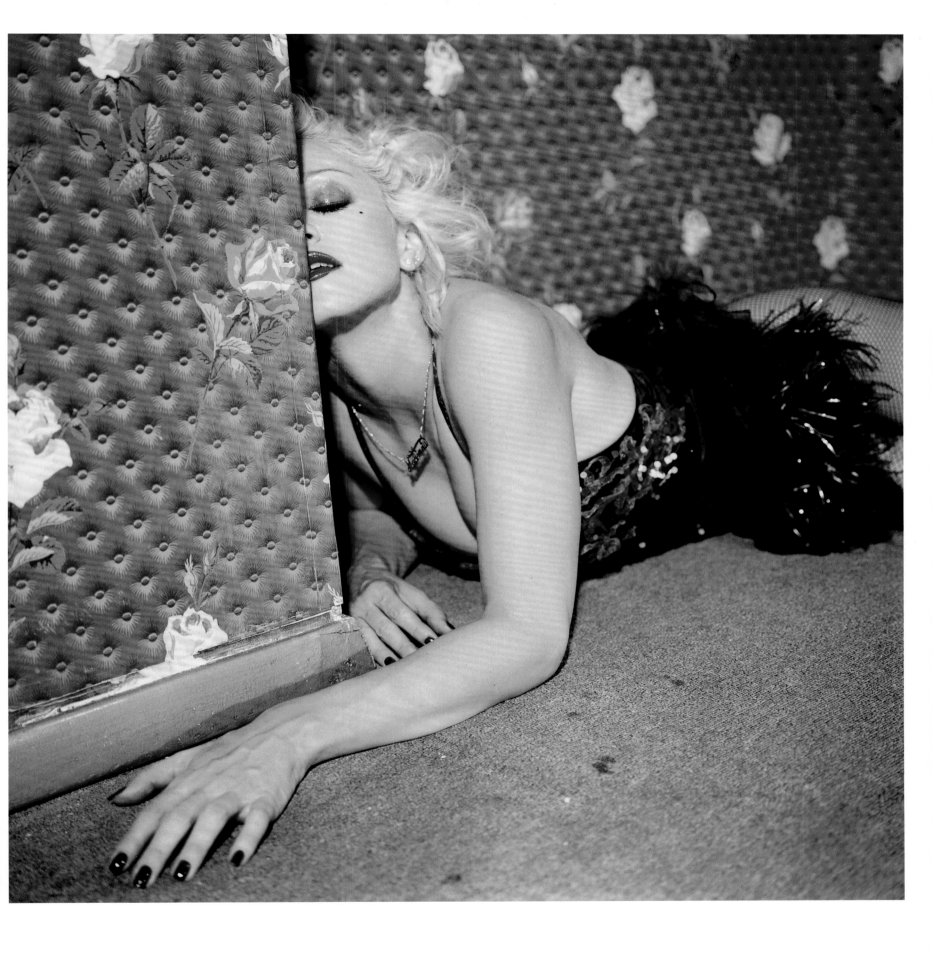

31 . bettina rheims . madonna lying on the floor of a red room I, new york . 1994

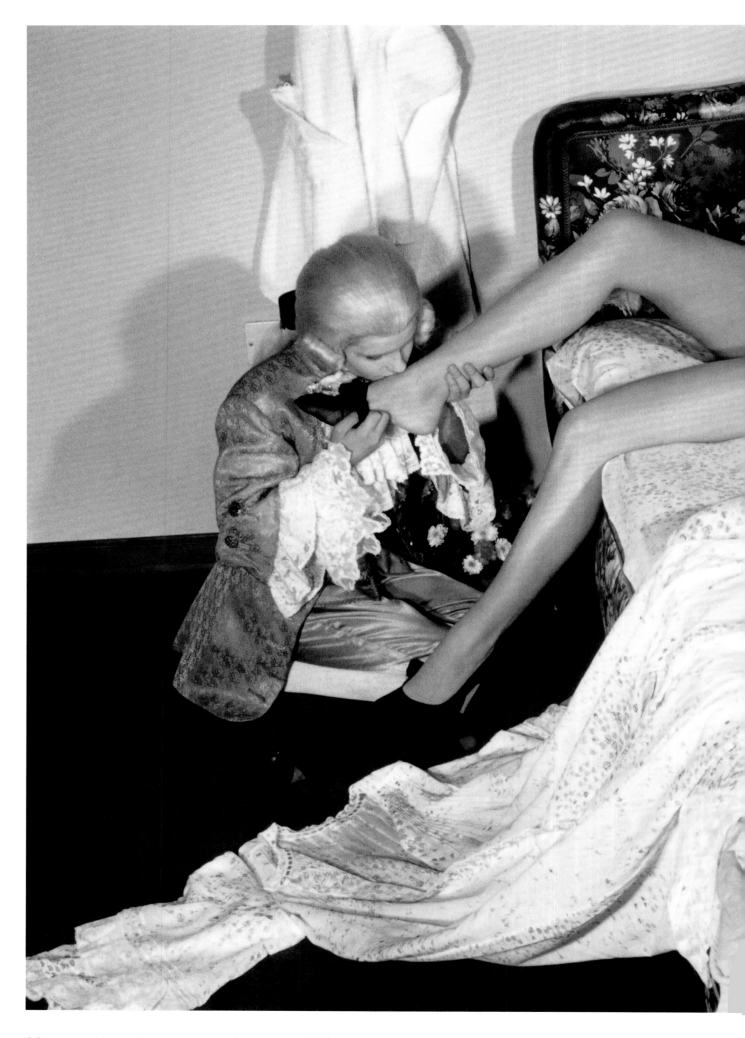

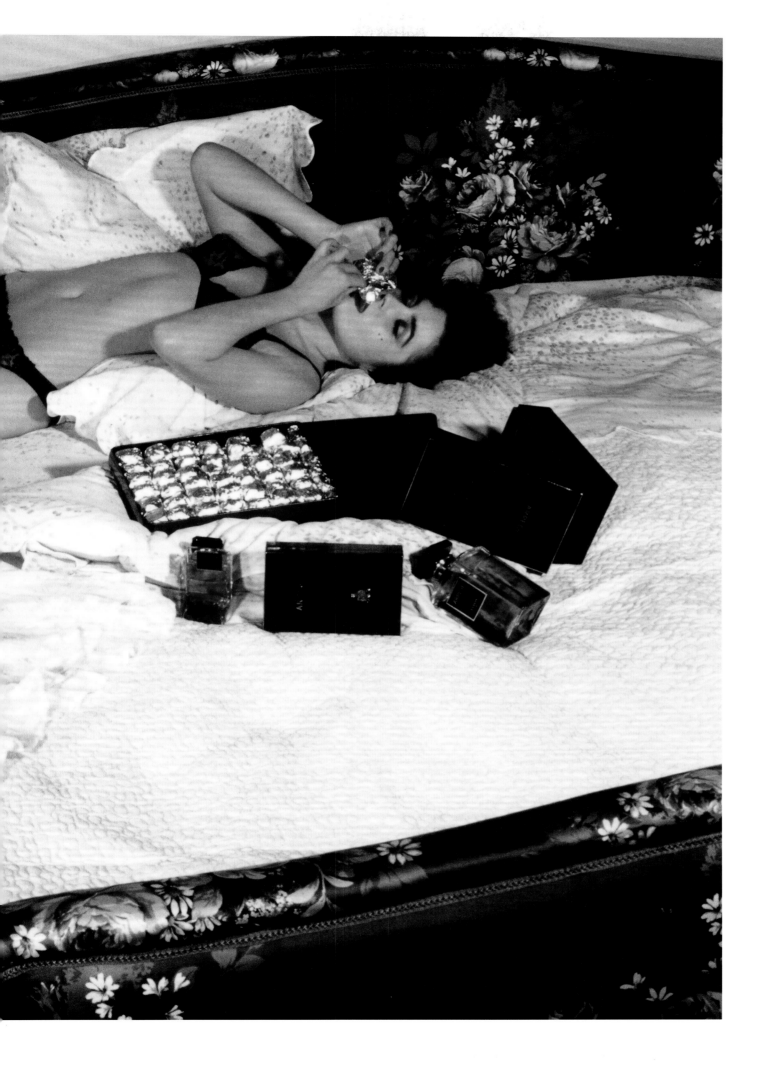

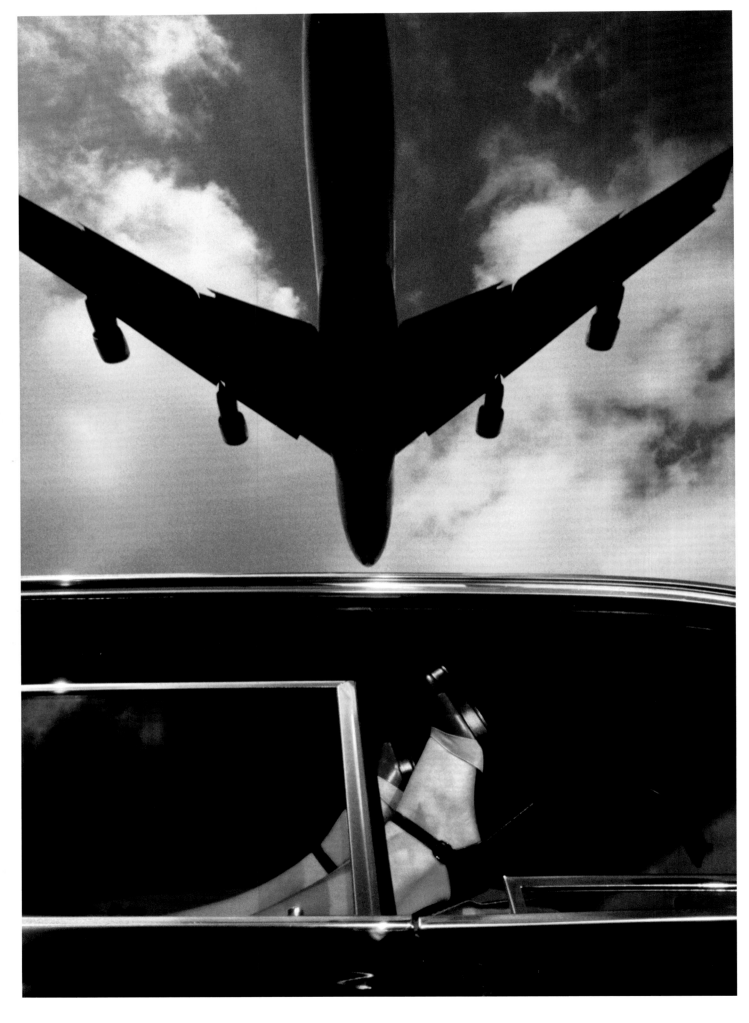

33 . guy bourdin . charles jourdan . 1972

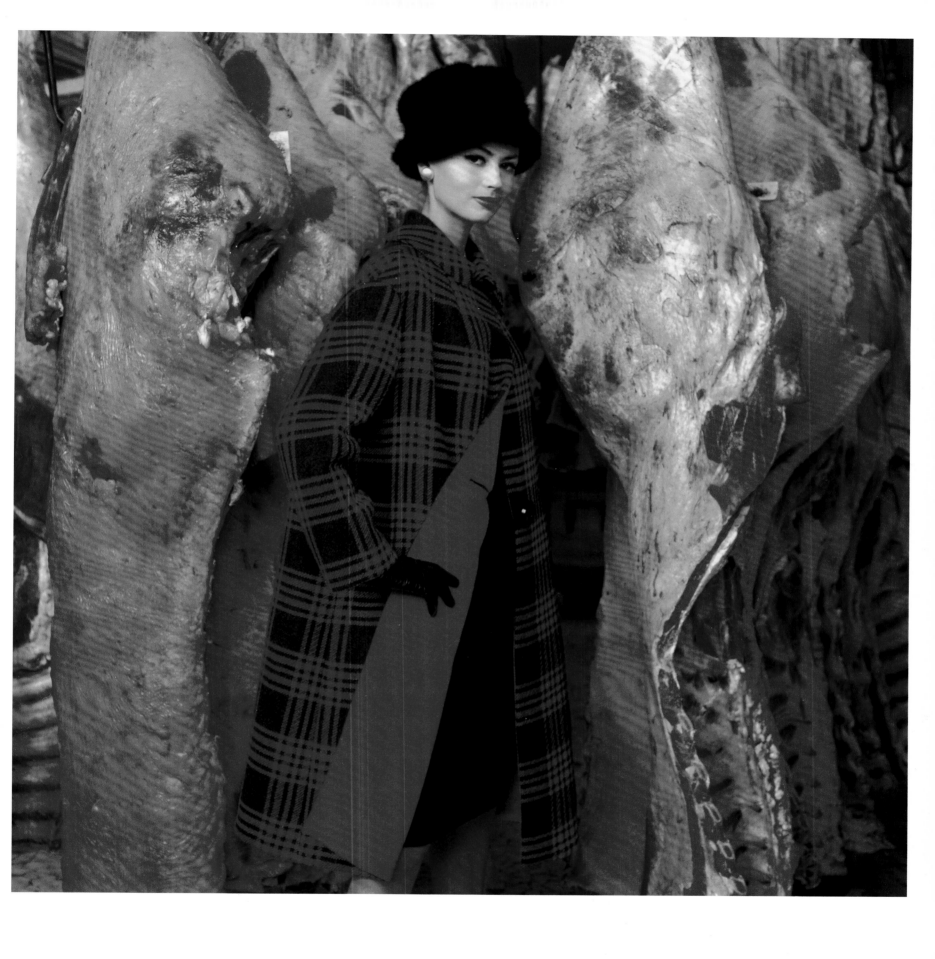

34 . guy bourdin . vogue france . 1960

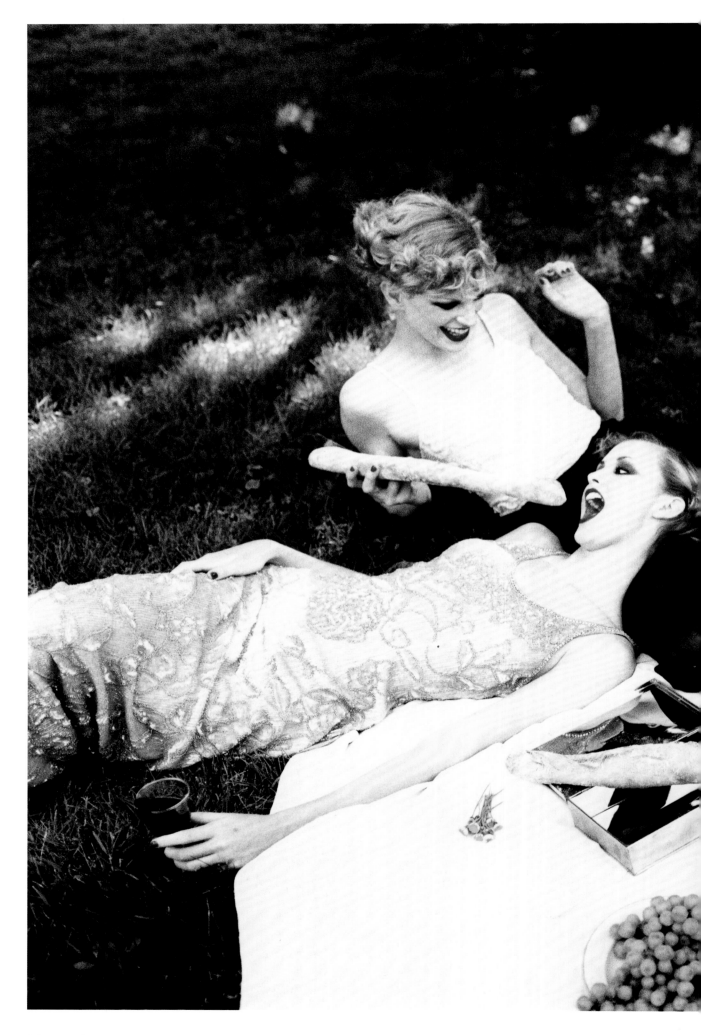

35 . ellen von unwerth . picnic, long island . 1996

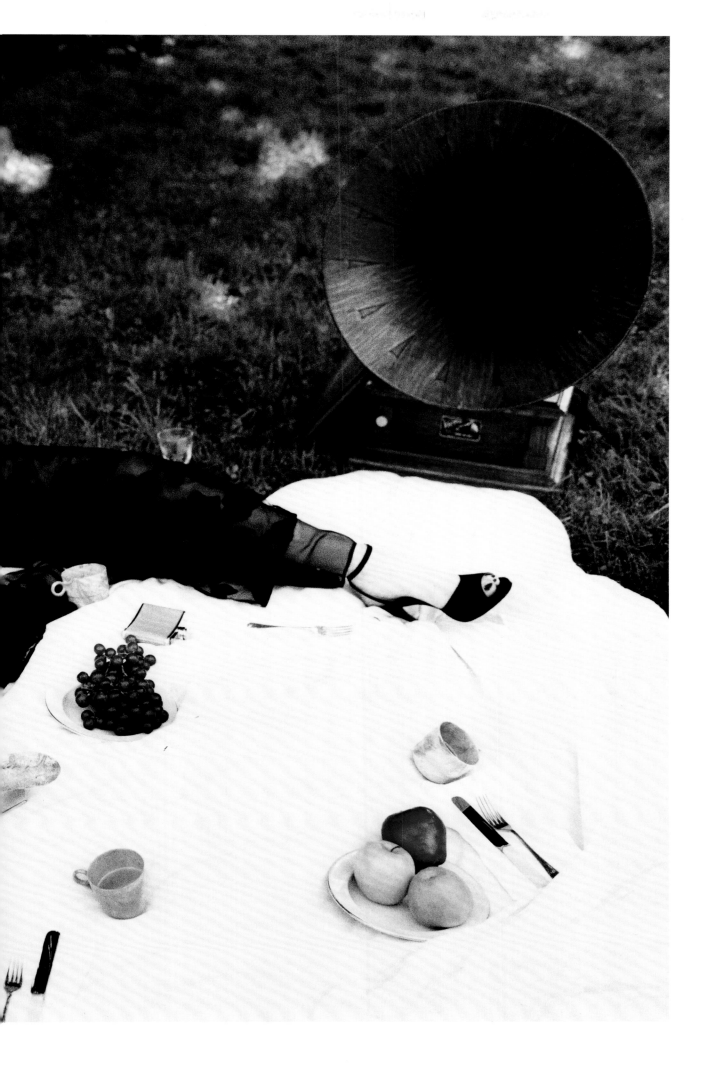

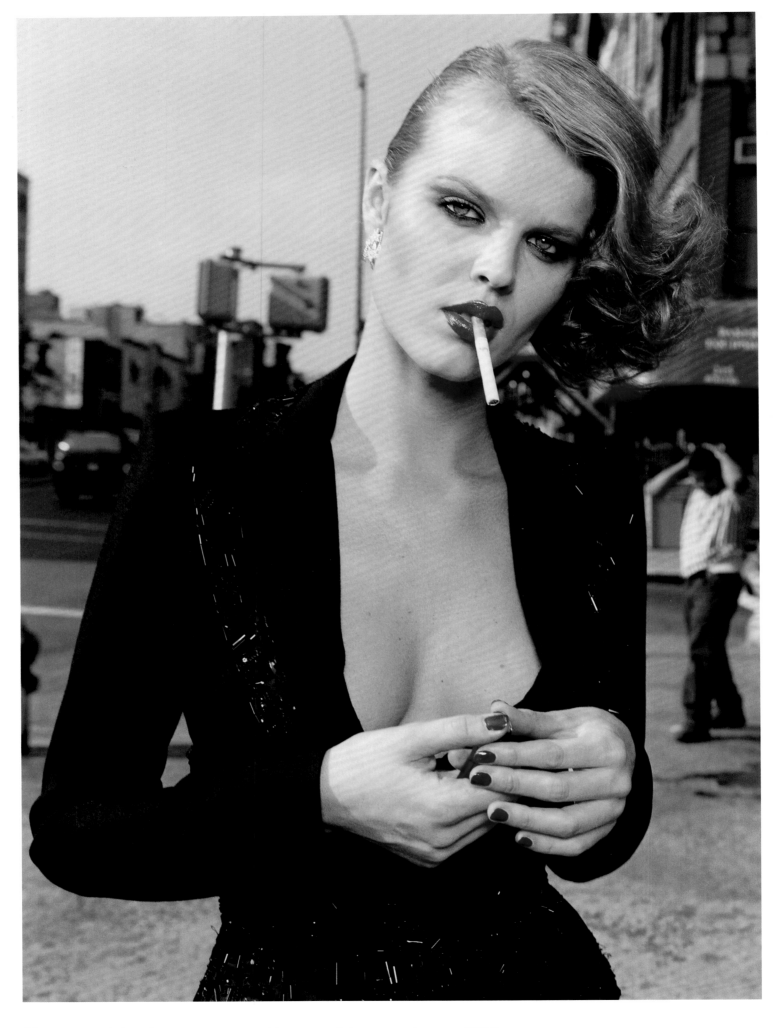

36 . terry richardson . eva smoking . mixte magazine . 1999

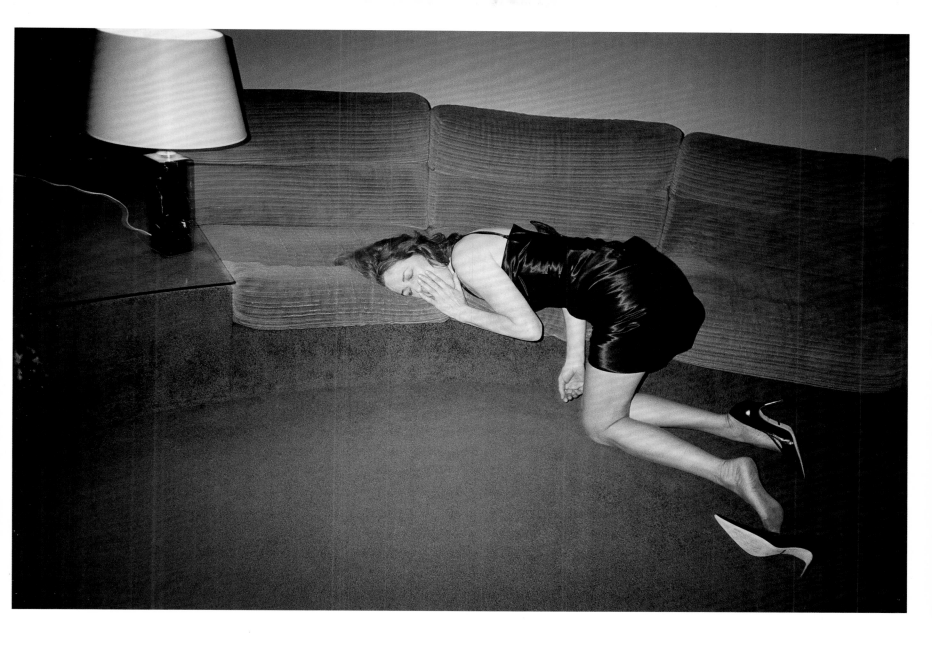

37 . juergen teller . charlotte rampling, paris . 2001

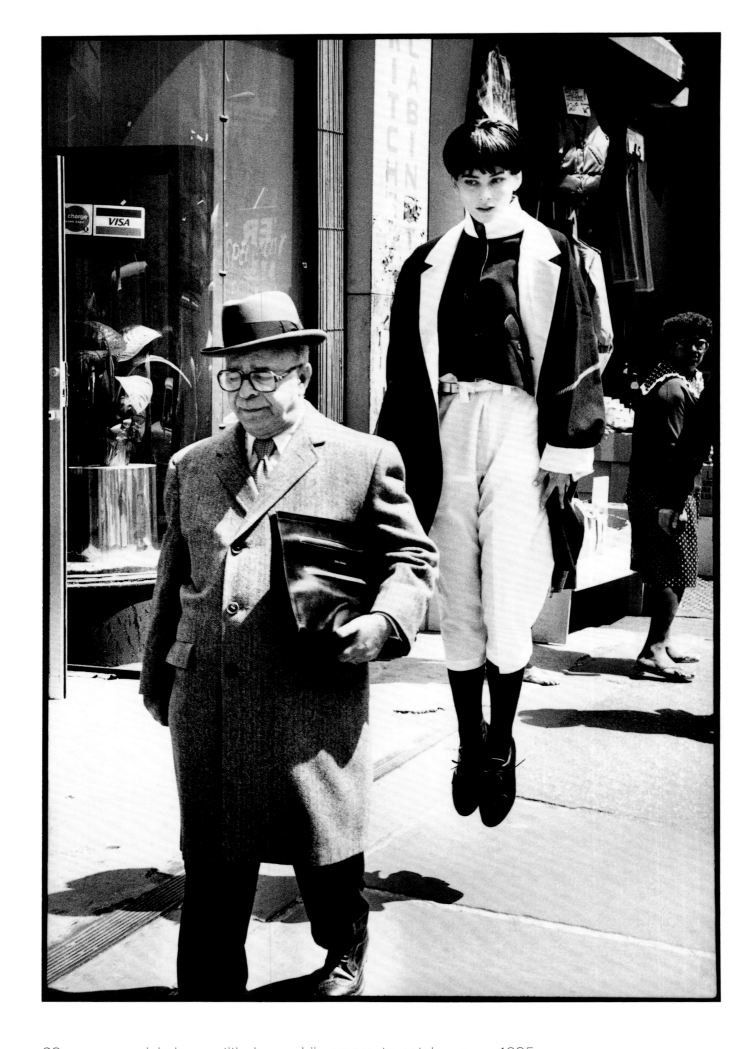

38 . max vadukul . untitled . yohji yamamoto catalogue . 1985

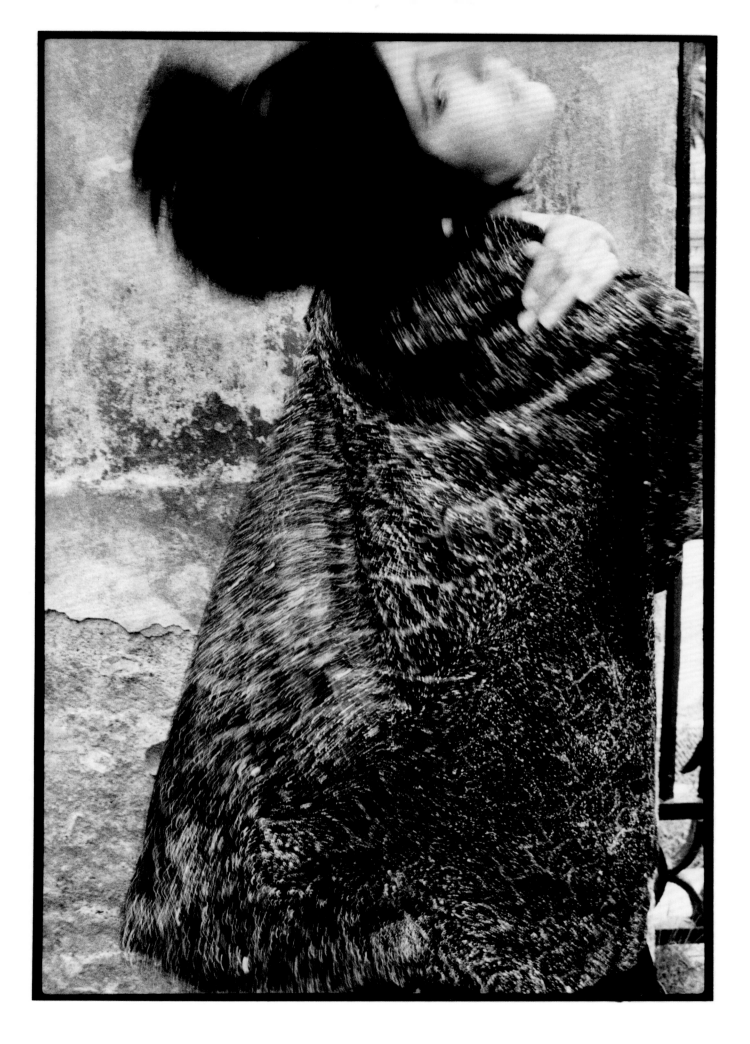

39 . max vadukul . untitled . yohji yamamoto catalogue . 1985

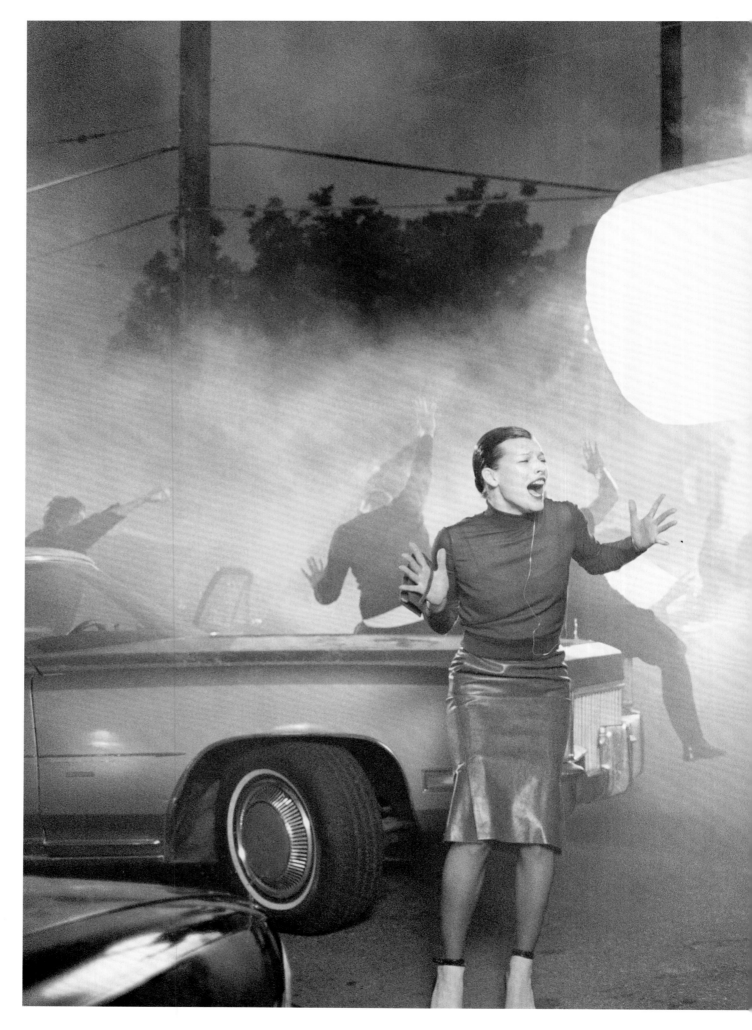

40 . peter lindbergh . milla jovovich, rush hour, downtown los angeles . vogue italia . 2000

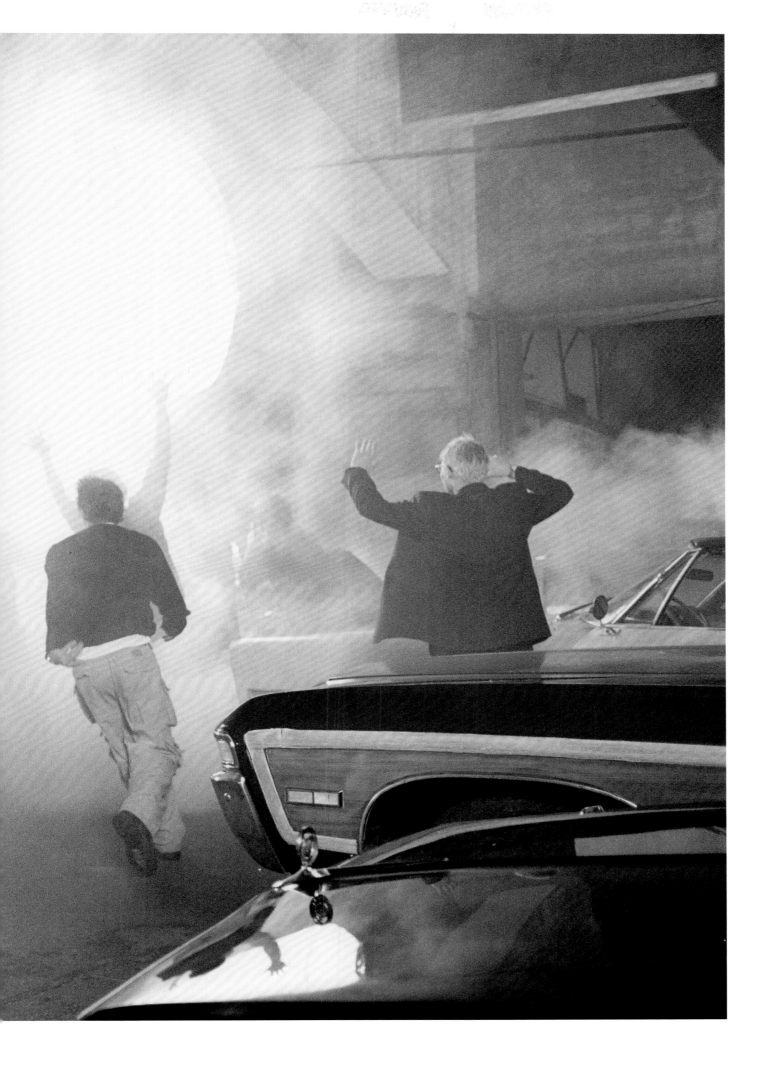

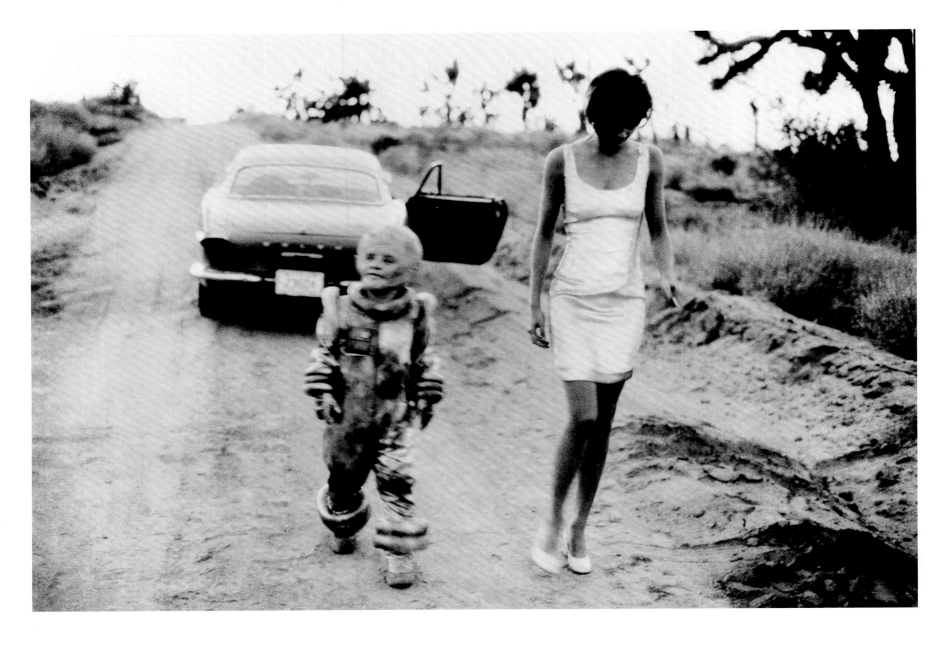

41 . peter lindbergh . helena christensen, e.t., los angeles . vogue italia . 1990

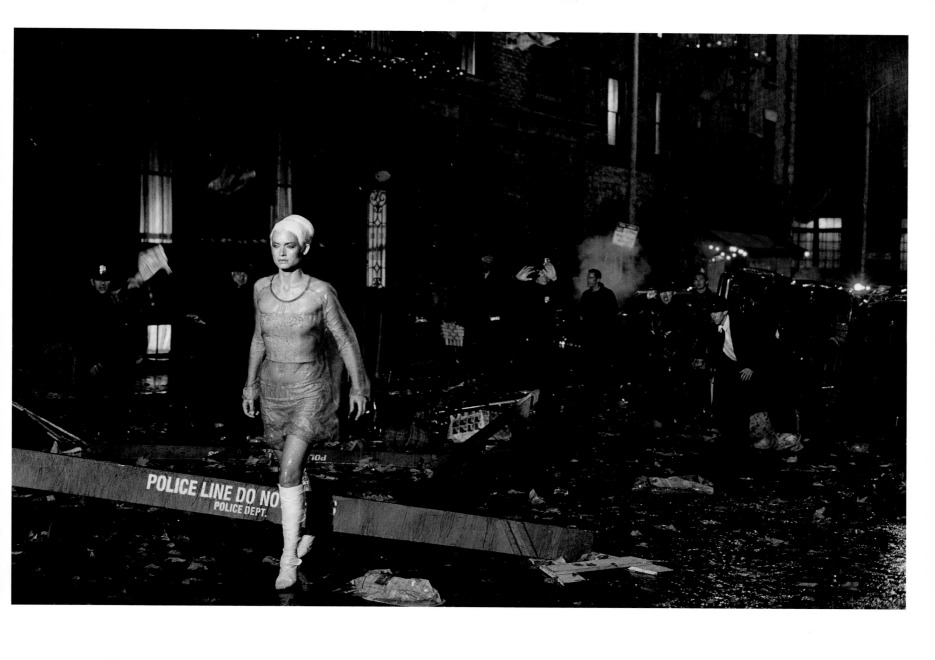

42 . peter lindbergh . amber valletta, los angeles . vogue italia . 1999

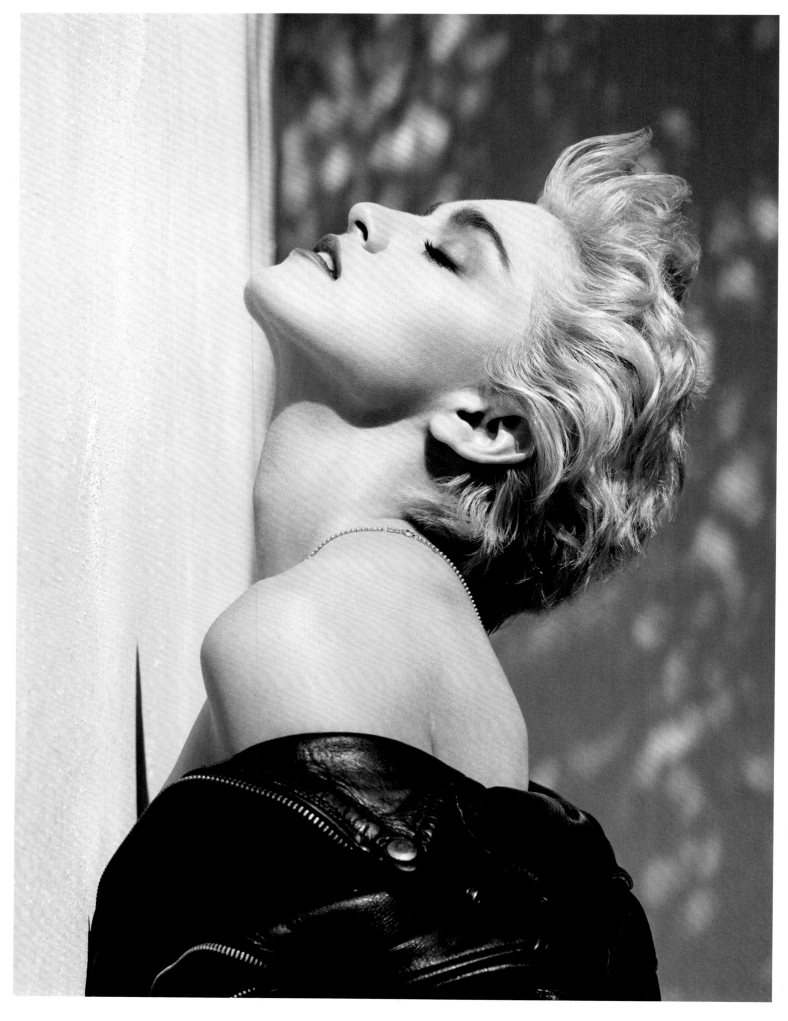

43 . herb ritts . madonna (true blue profile), hollywood . 1986

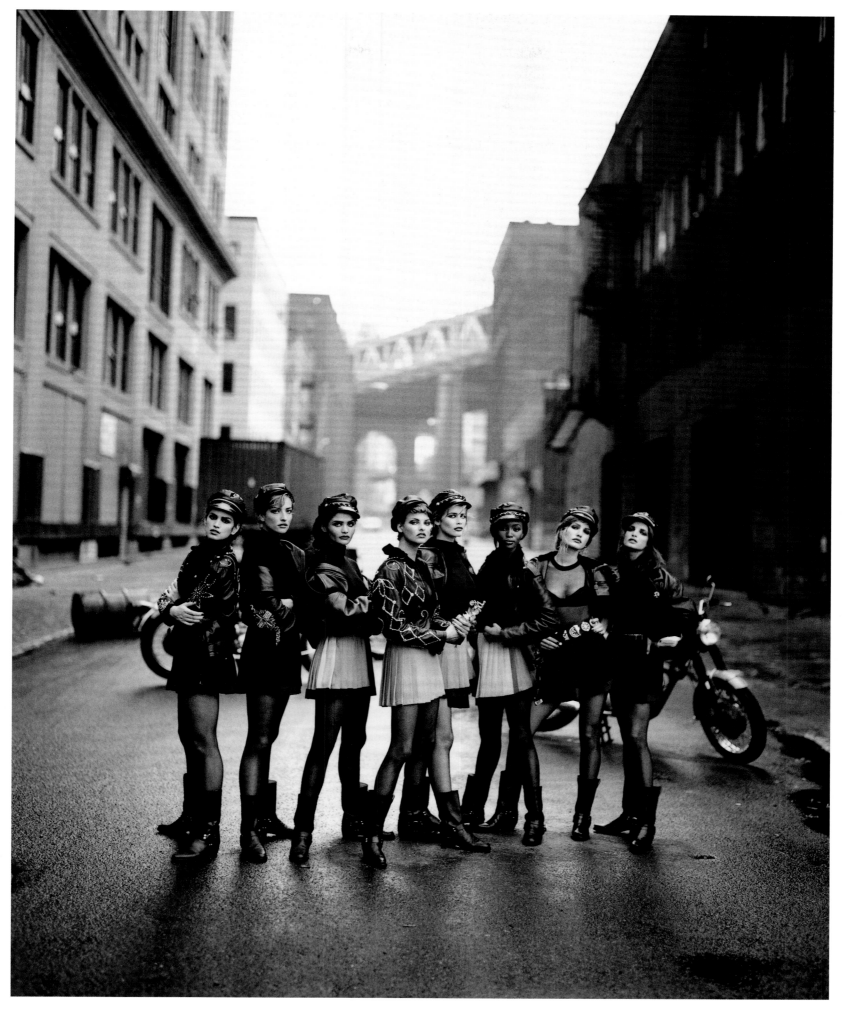

44 ▪ peter lindbergh ▪ the wild ones, brooklyn ▪ vogue usa ▪ 1991

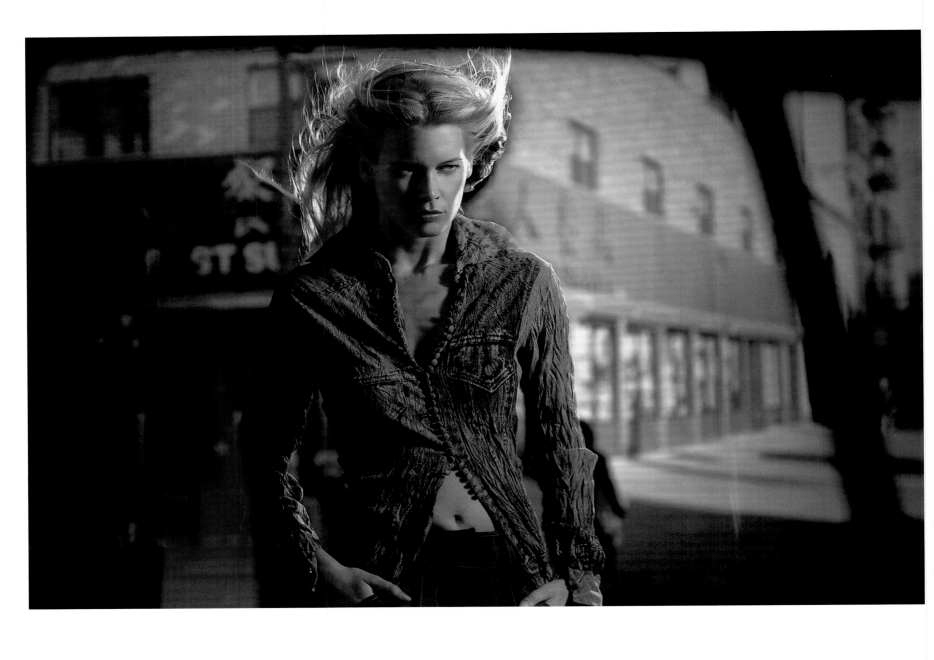

45 . stéphane sednaoui . claudia schiffer . 1999

46 . matthias vriens . untitled . dutch . 1999

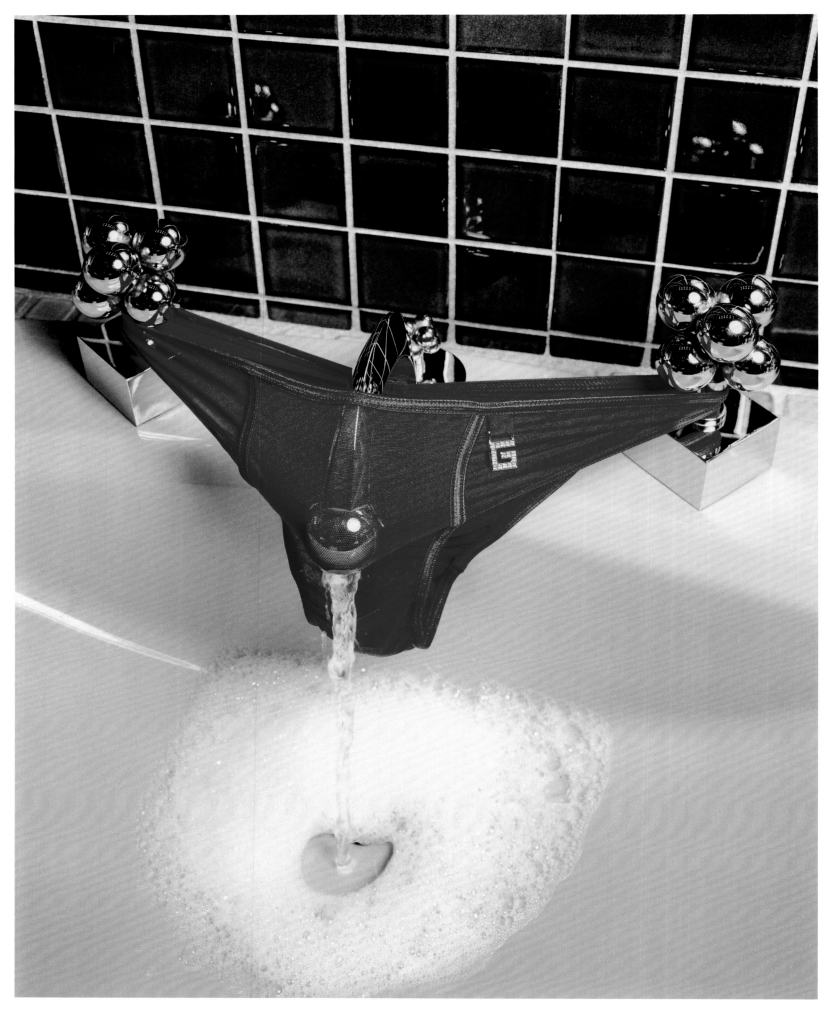

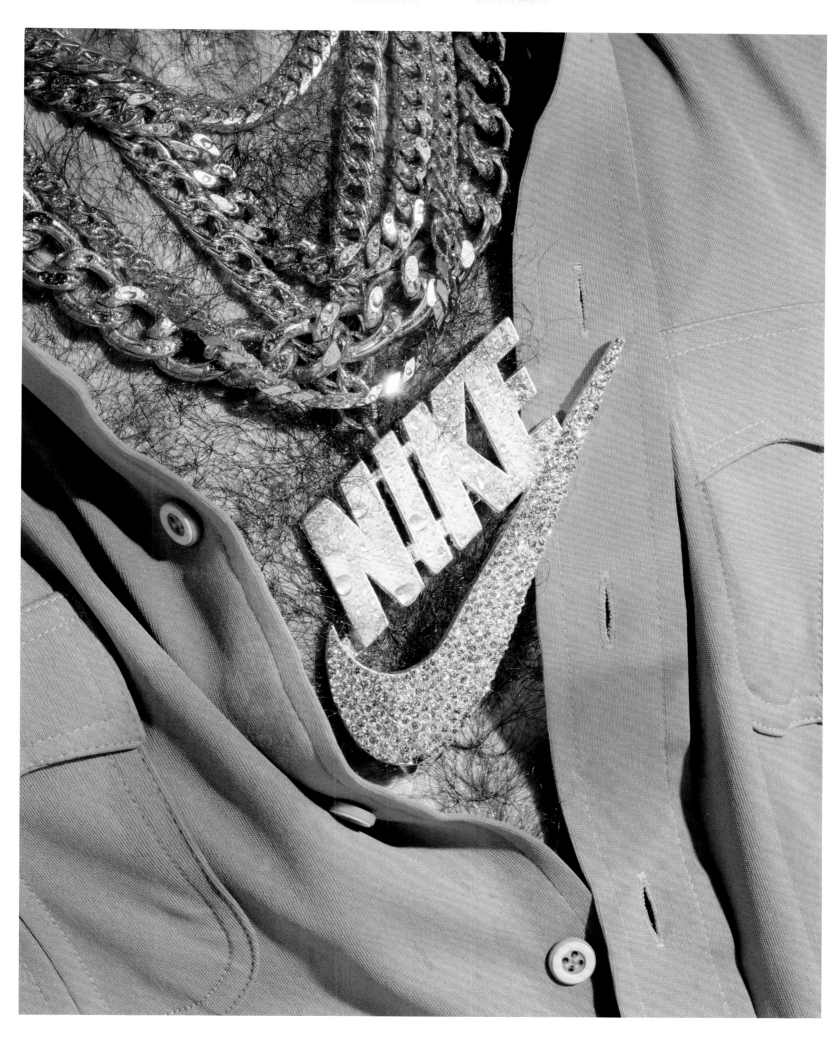

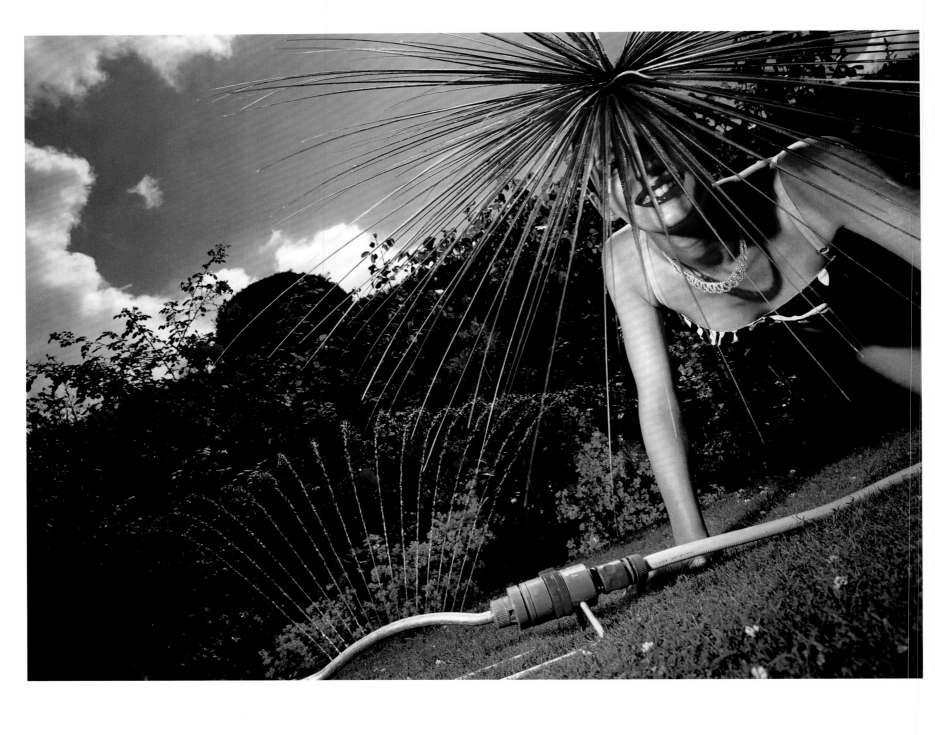

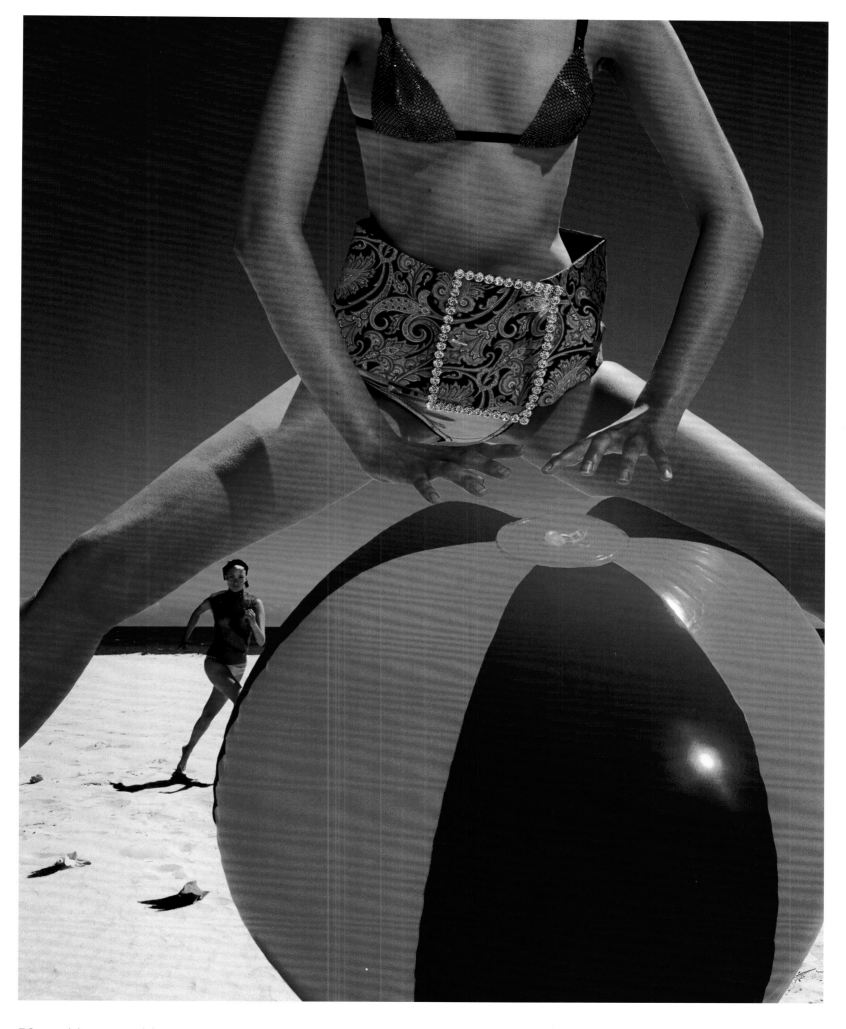

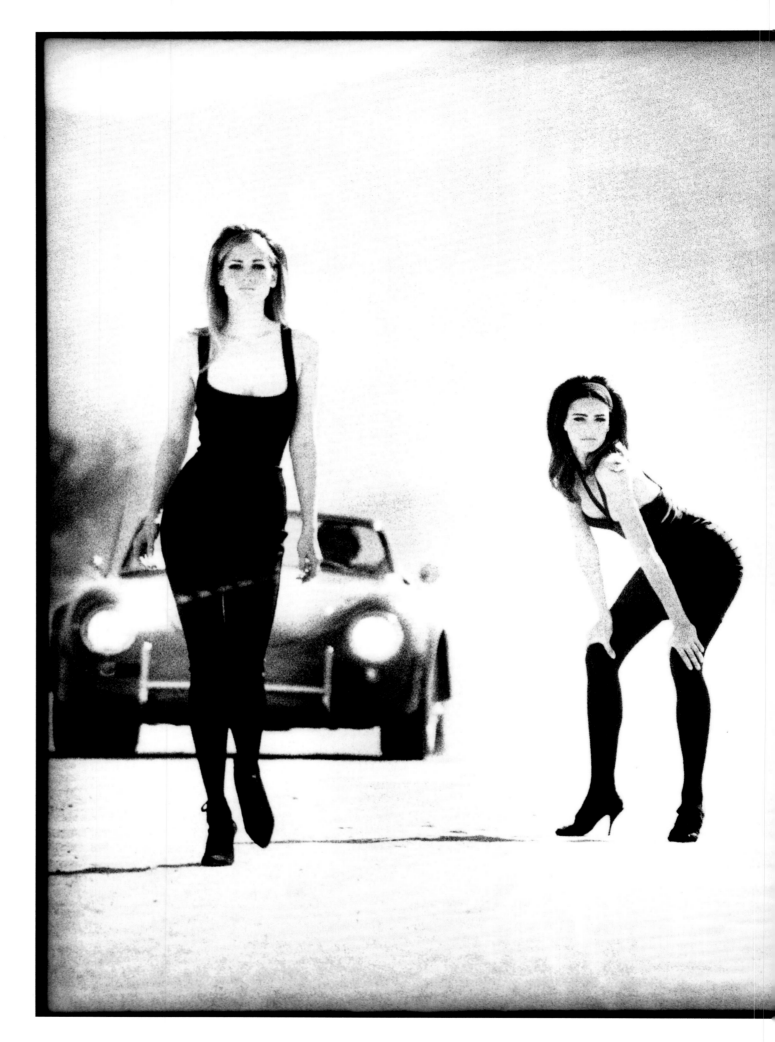

51 . max vadukul . faster pussycat . vogue france . 1992

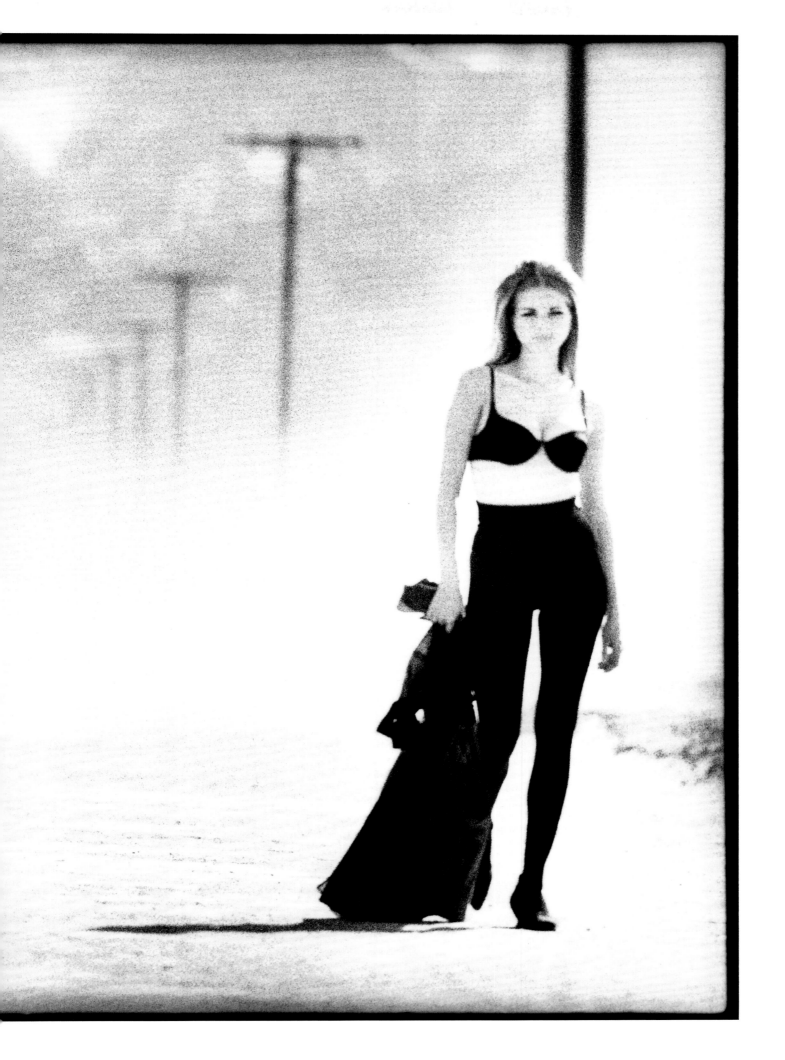

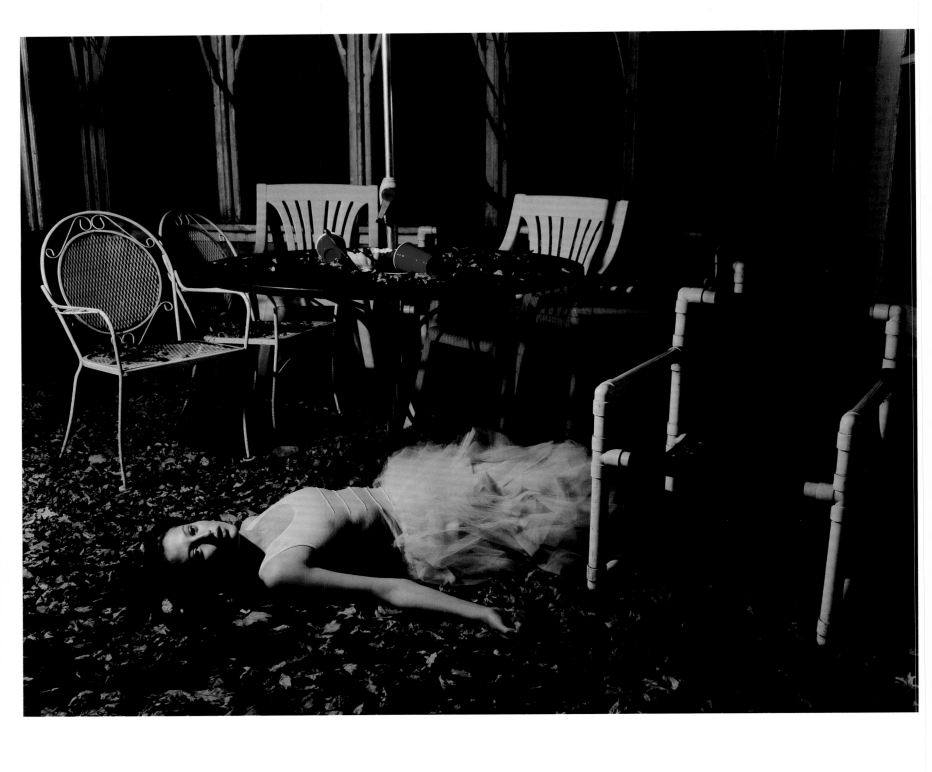

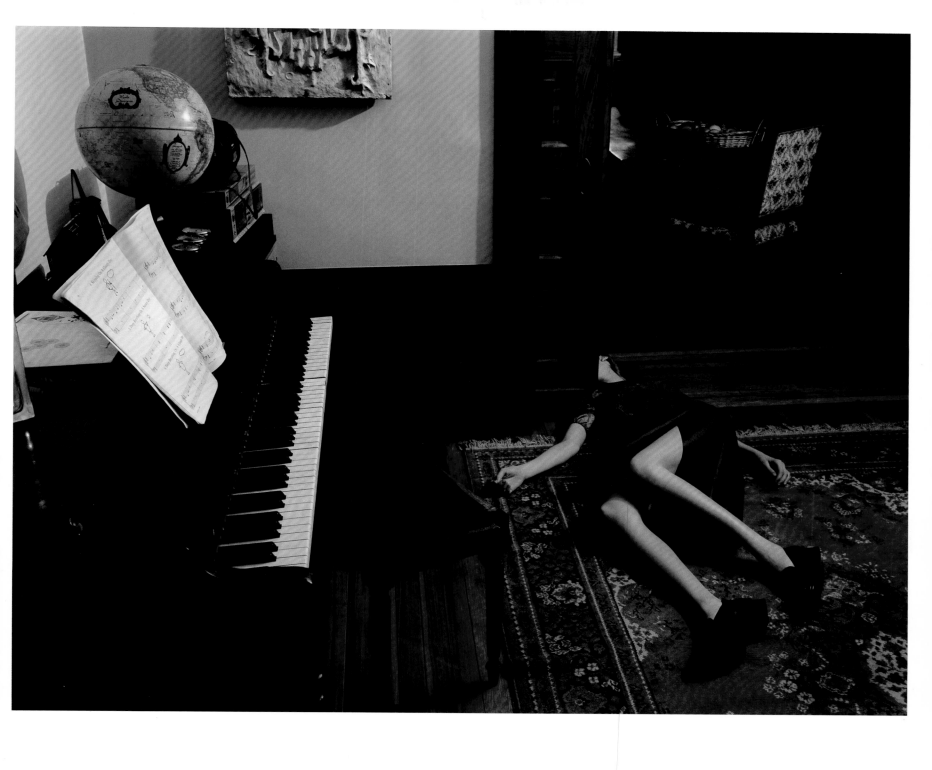

53 . mario sorrenti . dead story II . the face . 1999

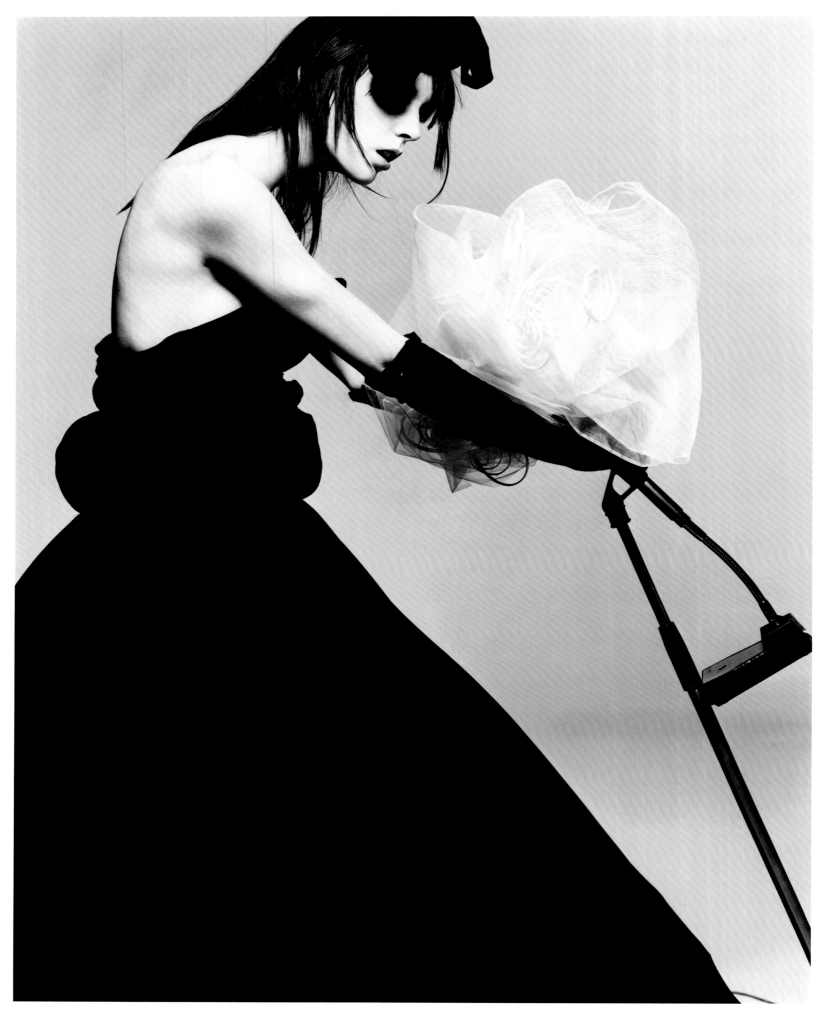

54 . inez van lamsweerde & vinoodh matadin . yamamoto, hannelore (mic) . 1998

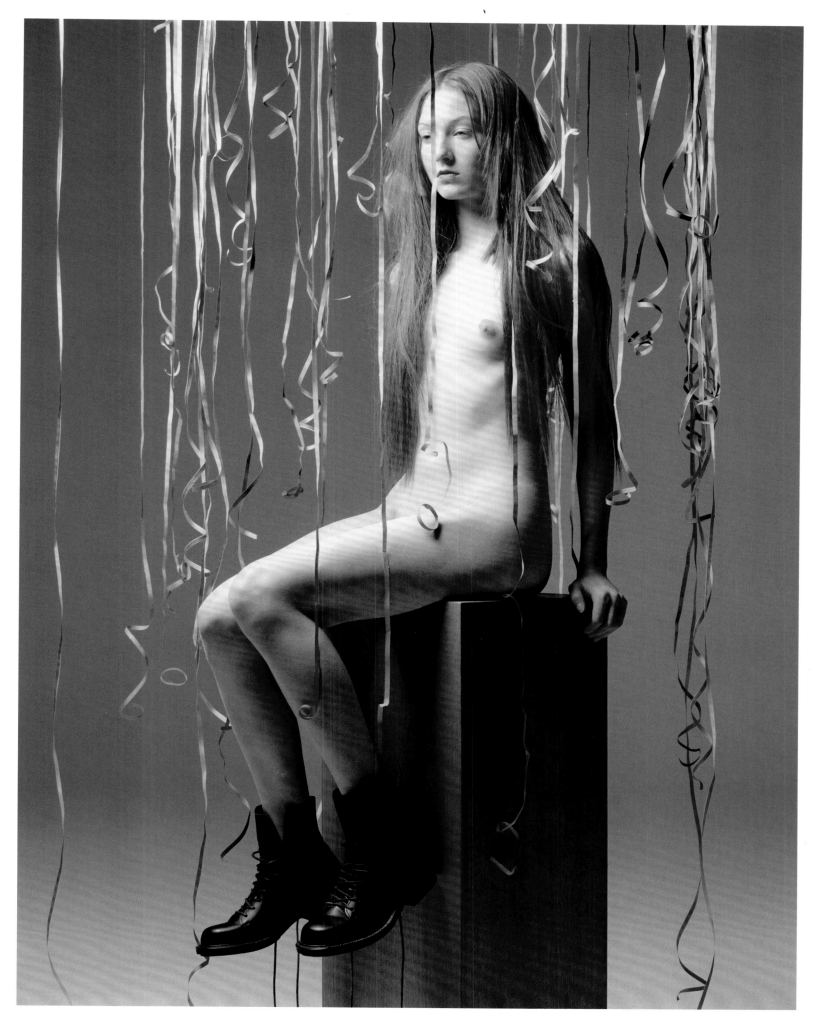

55 . inez van lamsweerde & vinoodh matadin . yamamoto, maggie nude . 1997

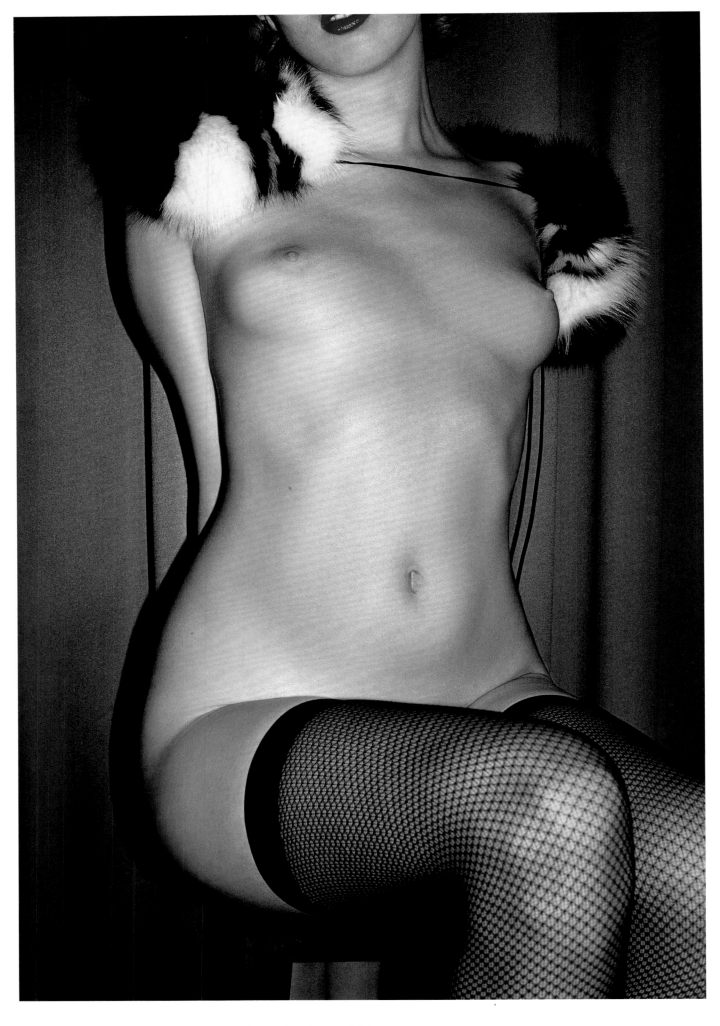

56 . matthias vriens . untitled . dutch . 2000

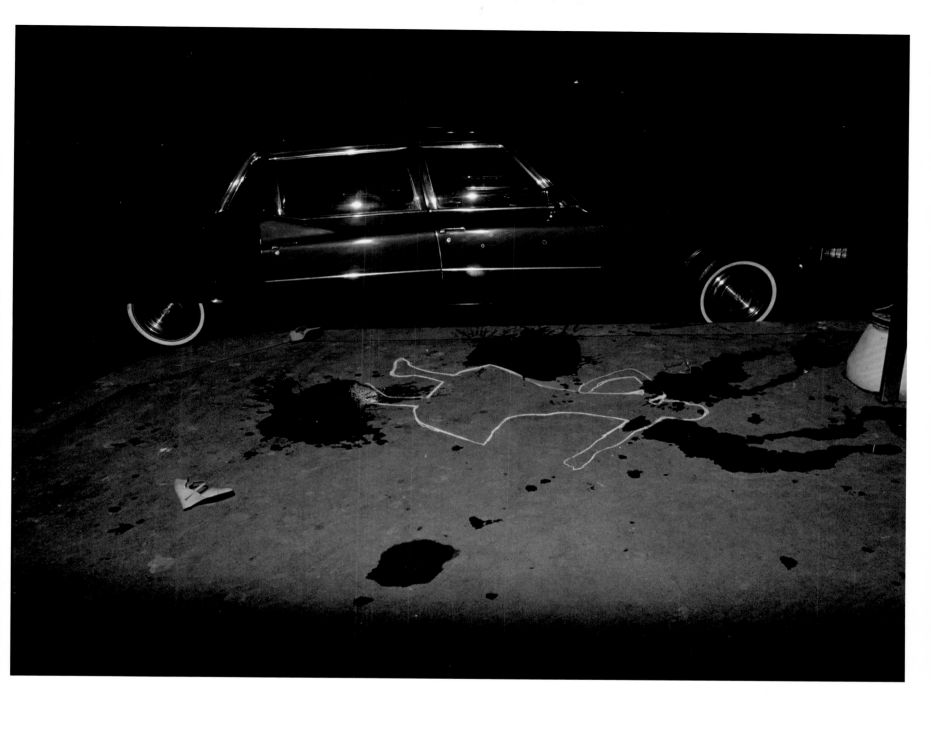

57 . guy bourdin . charles jourdan . 1975

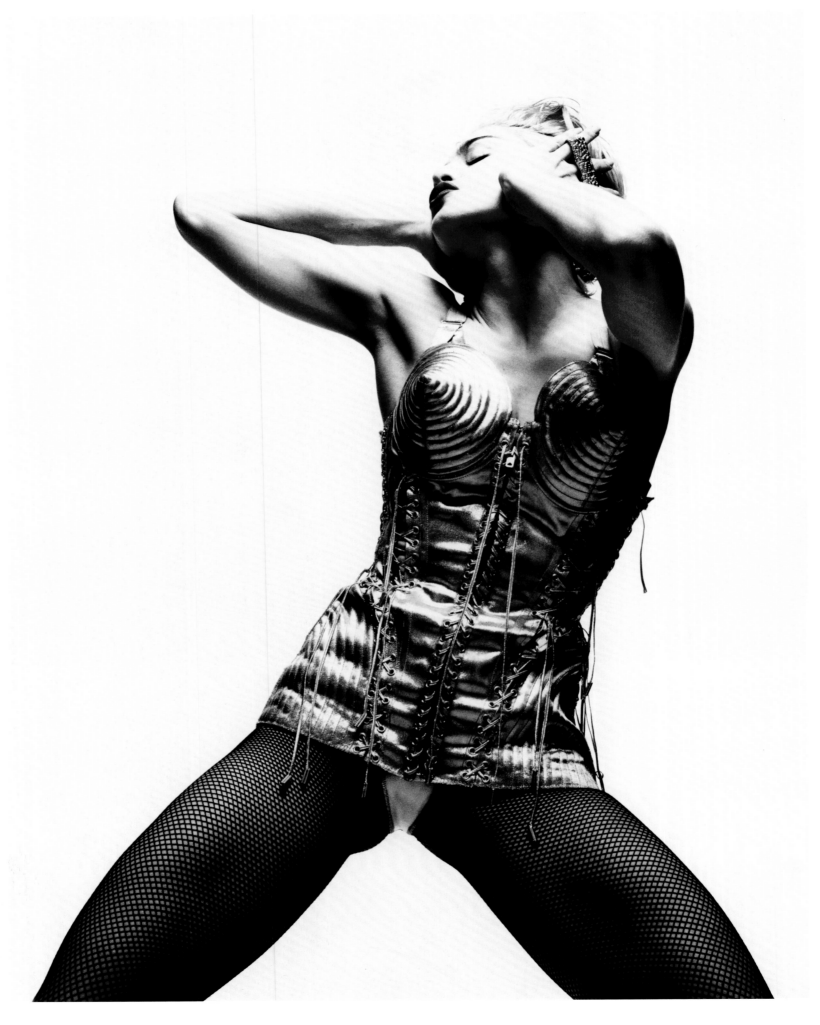

58 . jean-baptiste mondino . madonna . jean-paul gaultier bustier . 1987

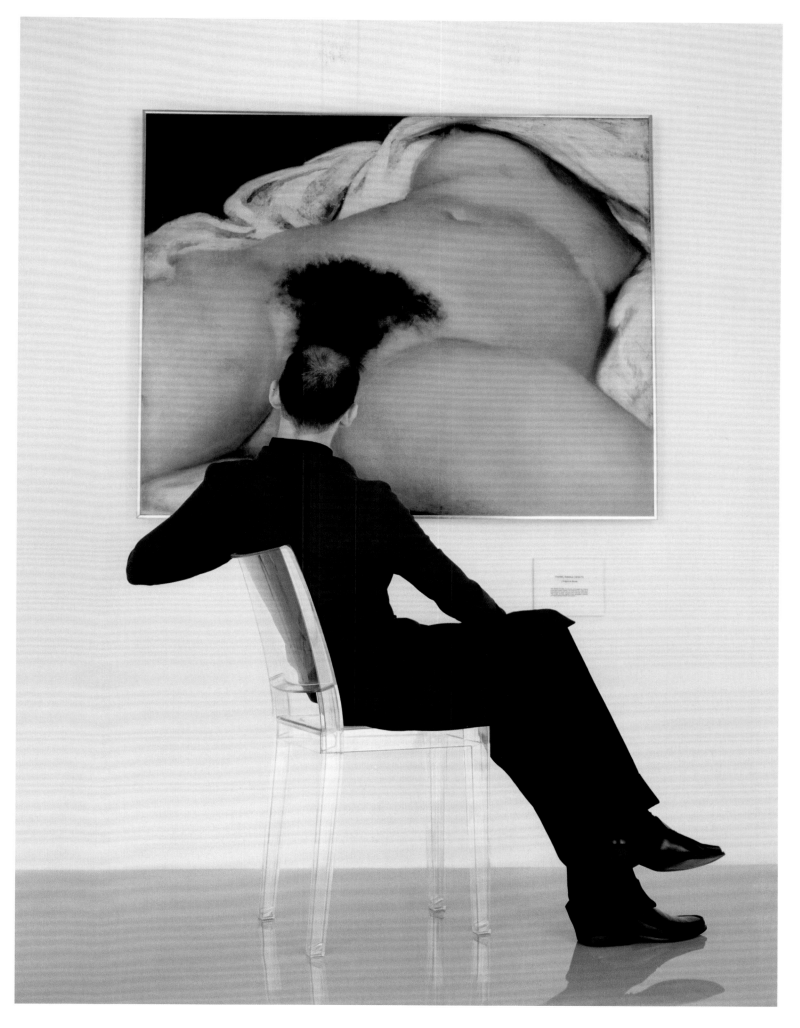

59 ▪ jean-baptiste mondino ▪ staring at the origin of the world of gustave courbet ▪ vogue france ▪ 2000

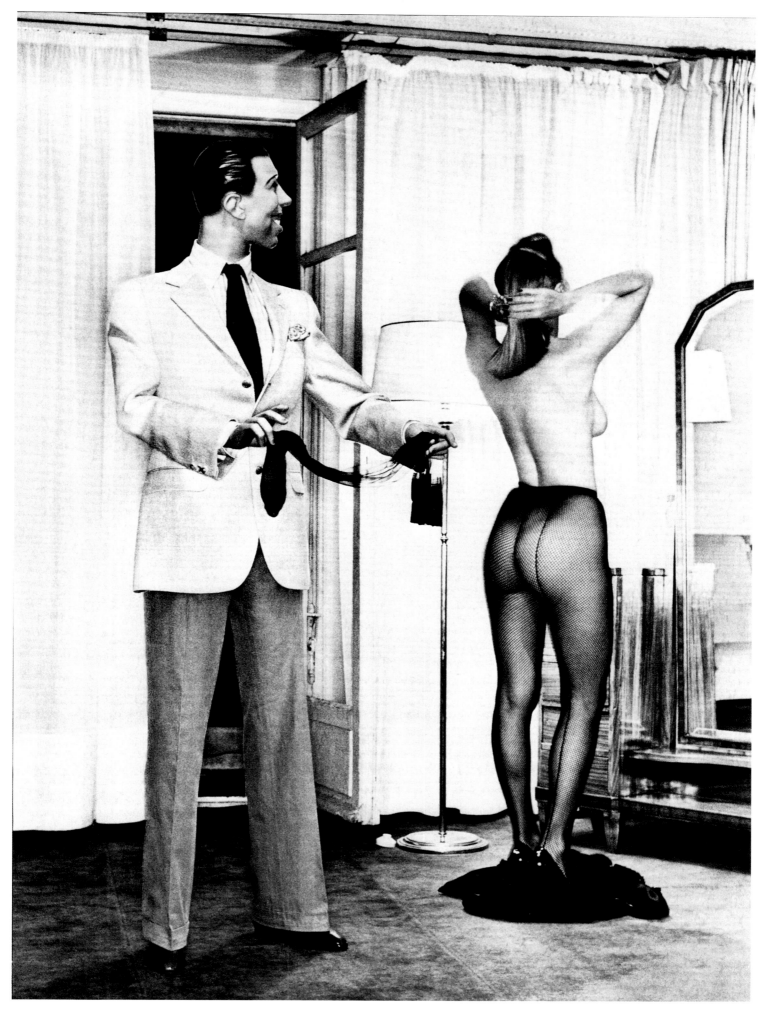

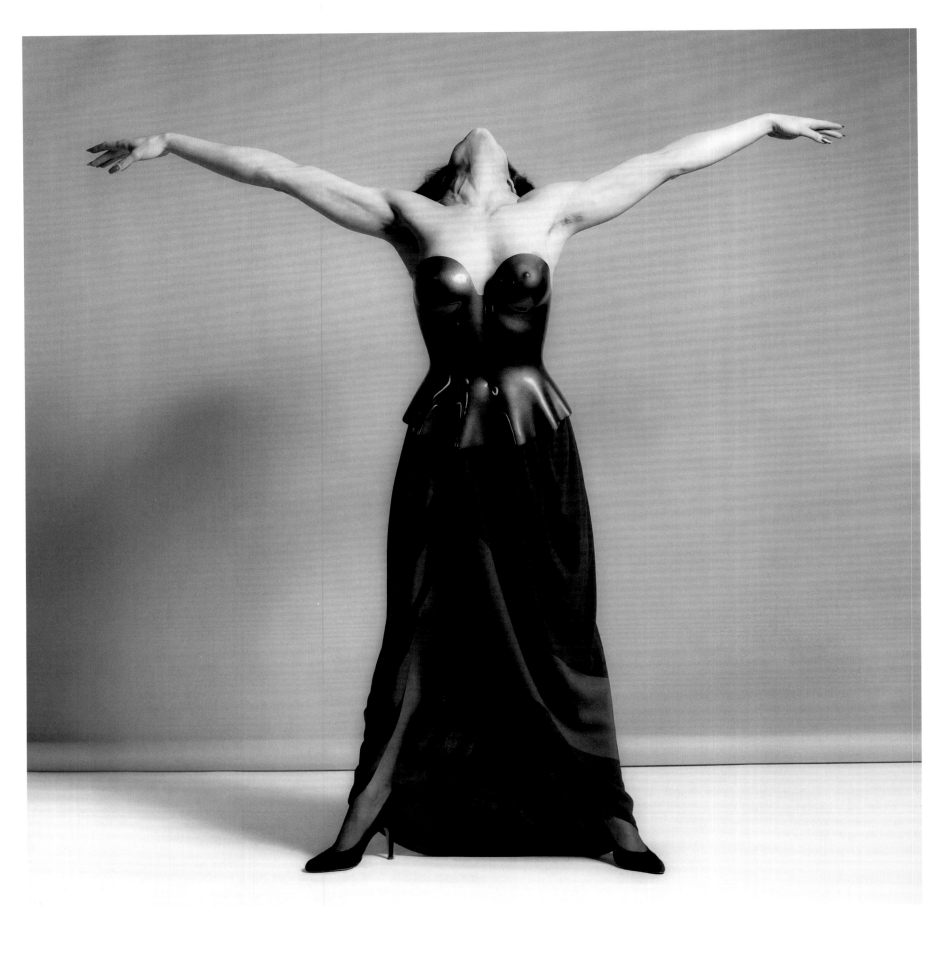

62 . robert mapplethorpe . lisa lyon . 1982

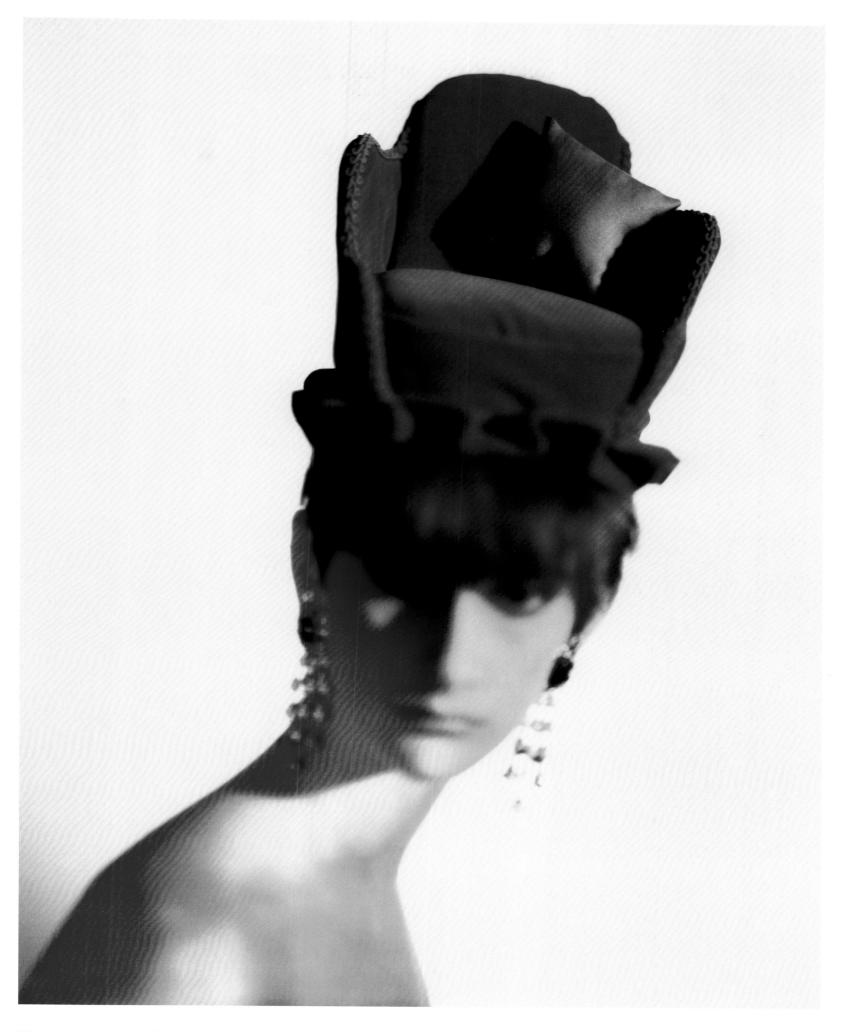

63 . paolo roversi . audrey, paris . max mixte . 1998

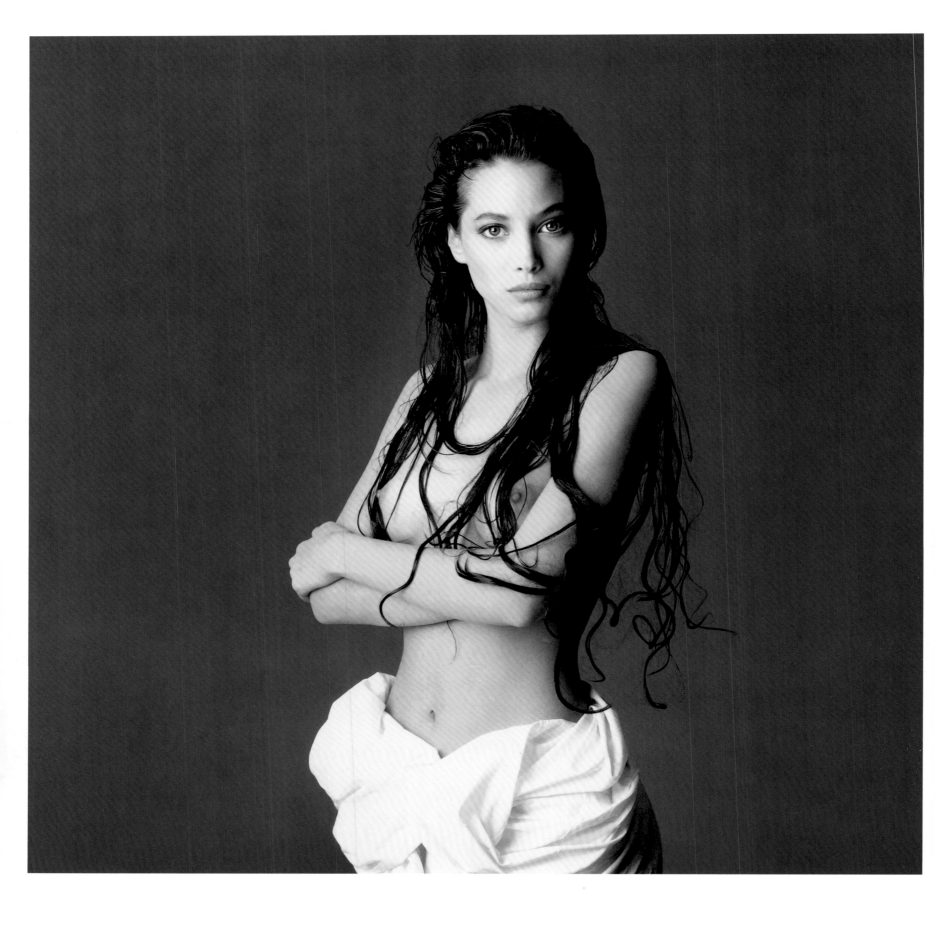

64 . patrick demarchelier . christy, new york . 1986

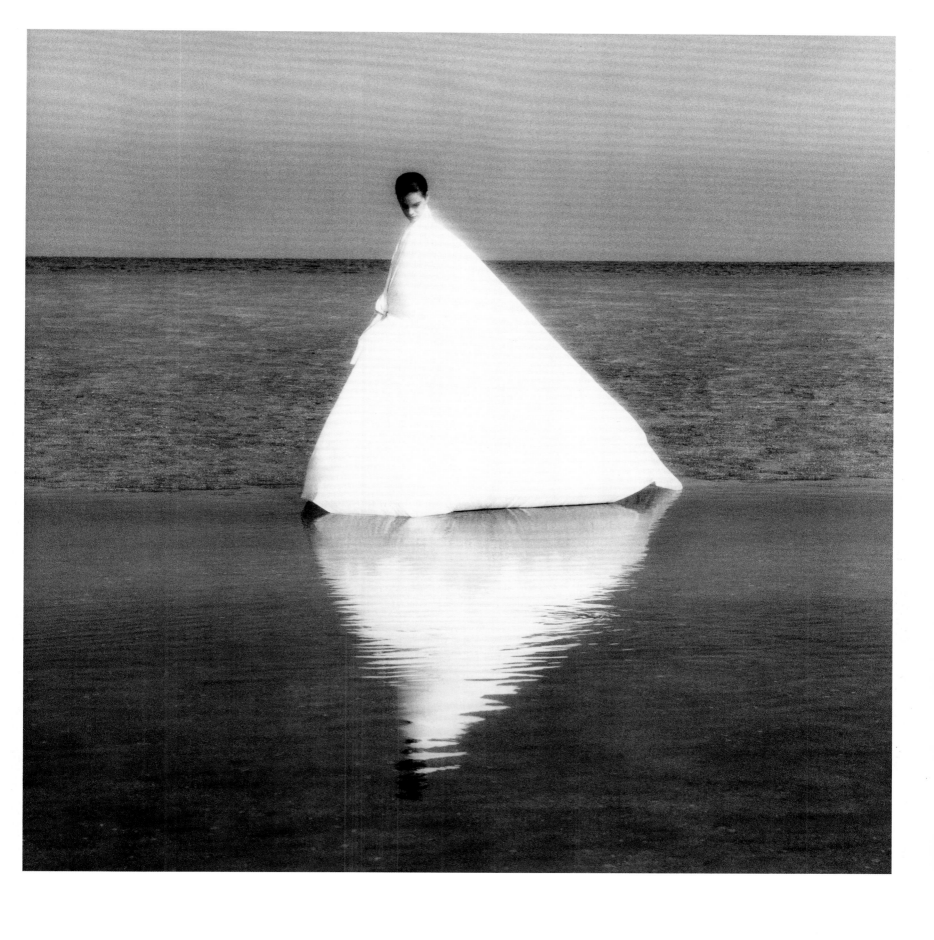

65 . dominique issermann . susan hauser . parko calendar, japan . 1985

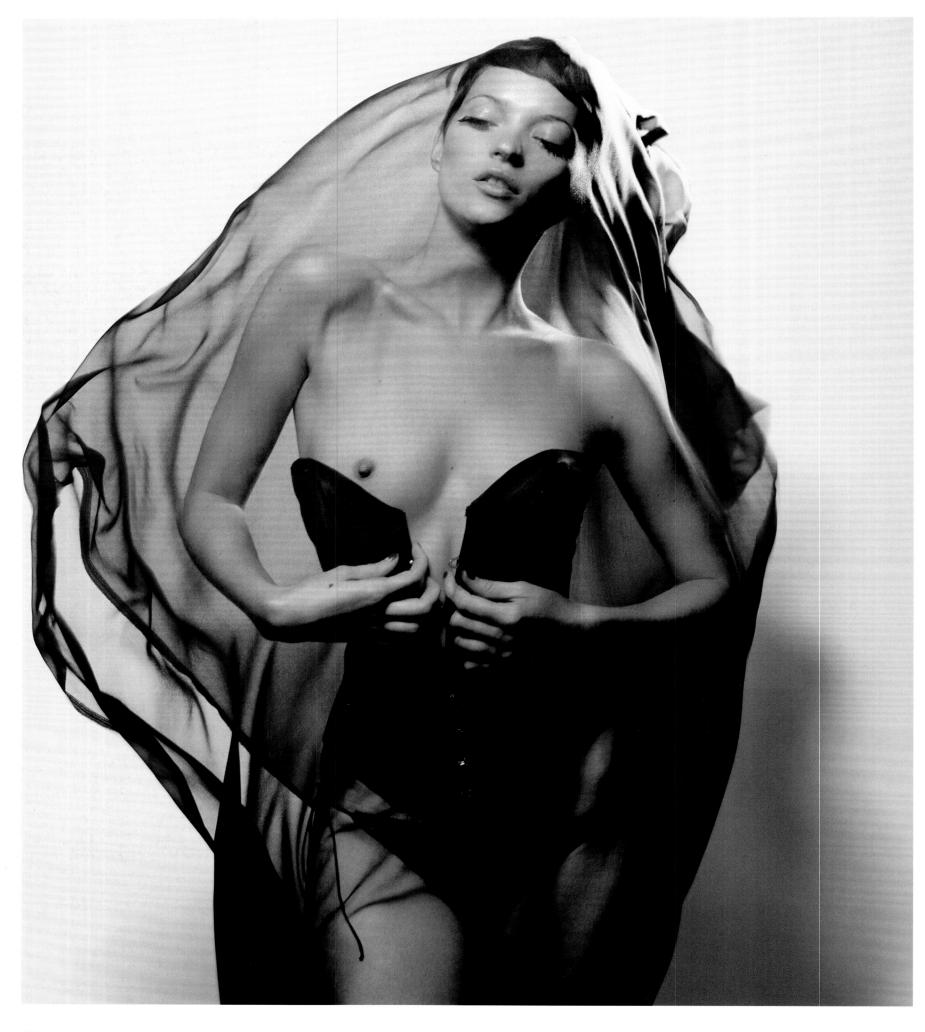

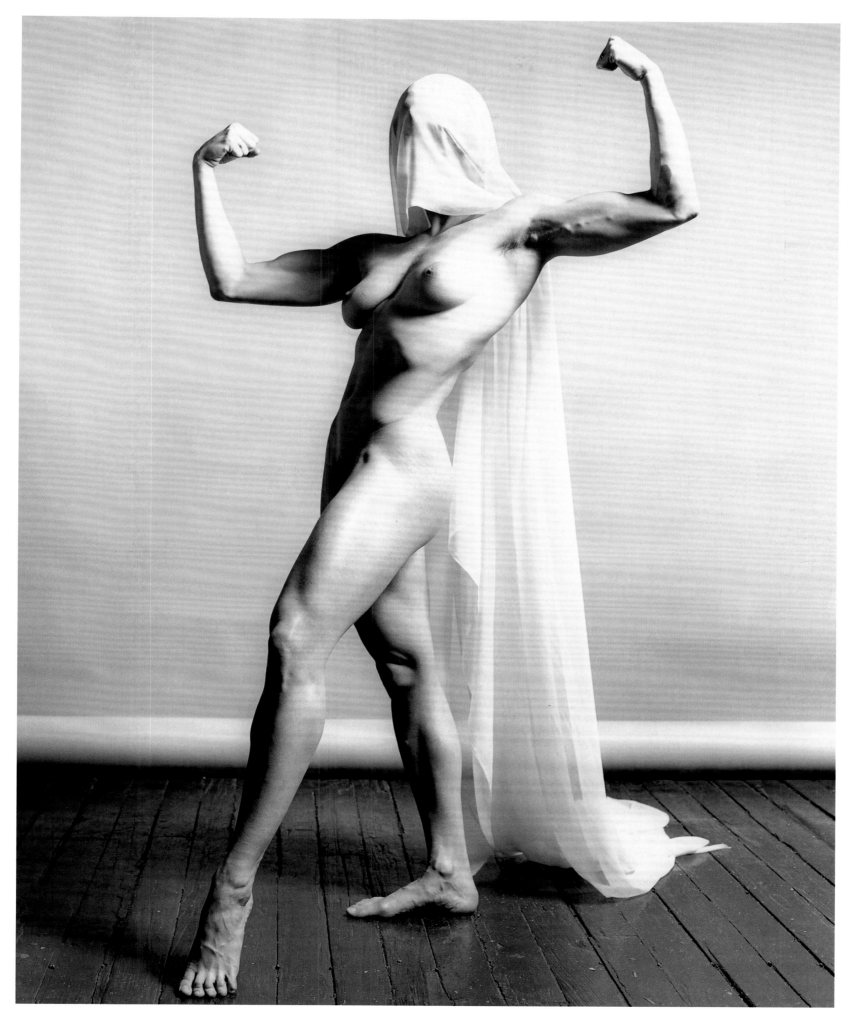

67 . robert mapplethorpe . lisa lyon . 1982

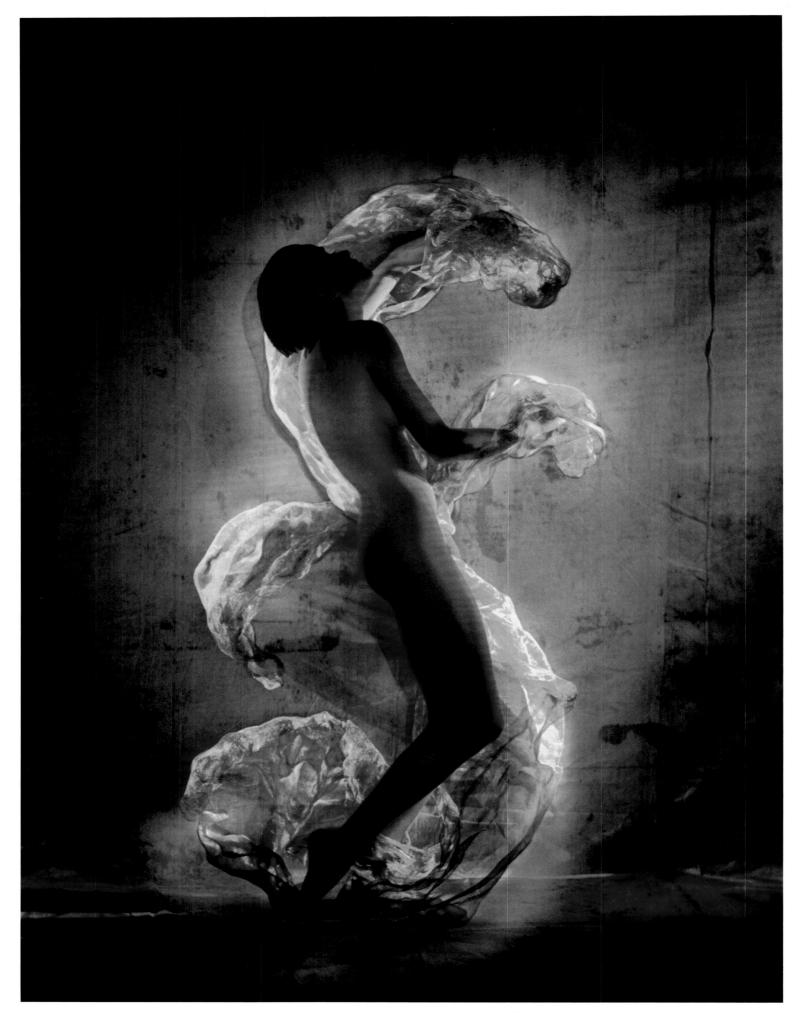

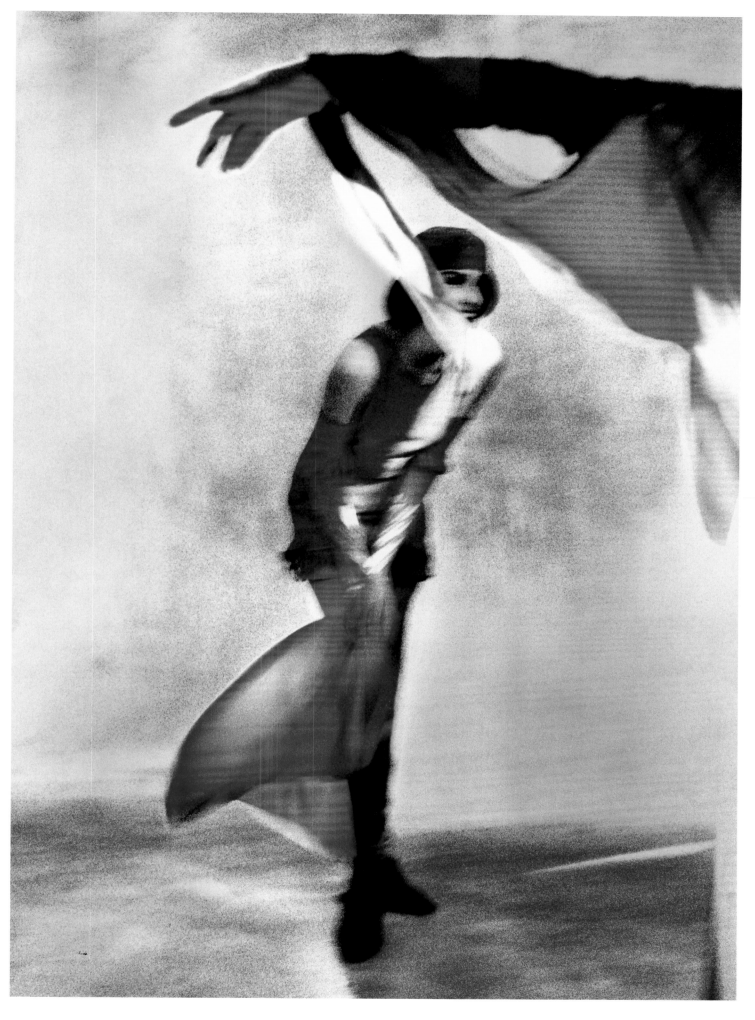

69 . javier vallhonrat . john galliano, red . press international, catalogue . 1988

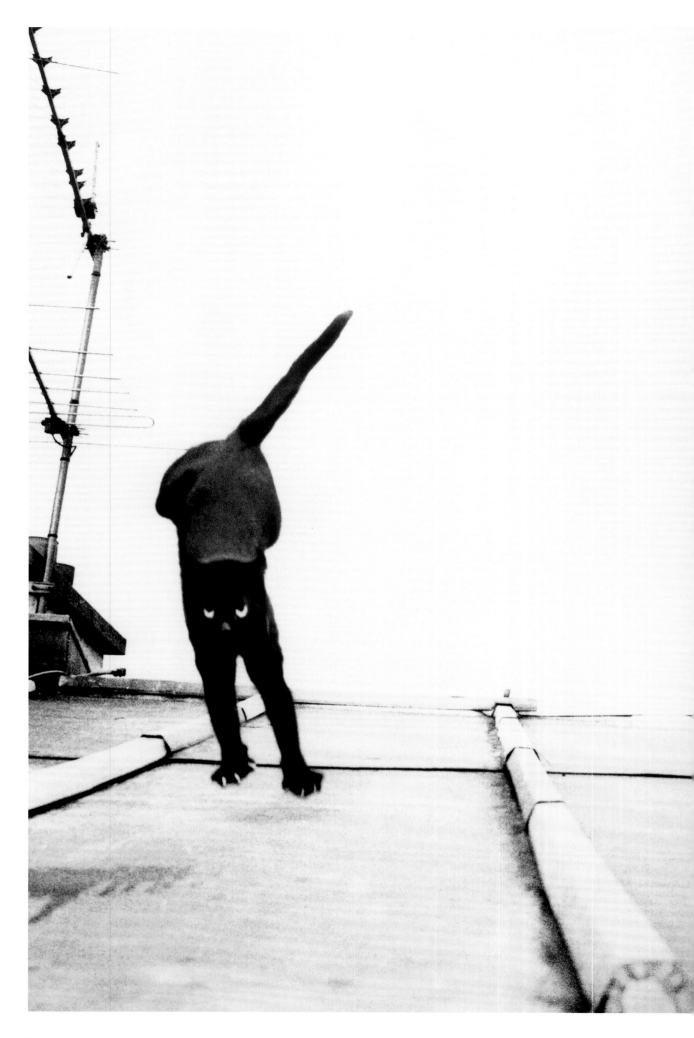

70 . max vadukul . cat on the roof . vogue france . 1992

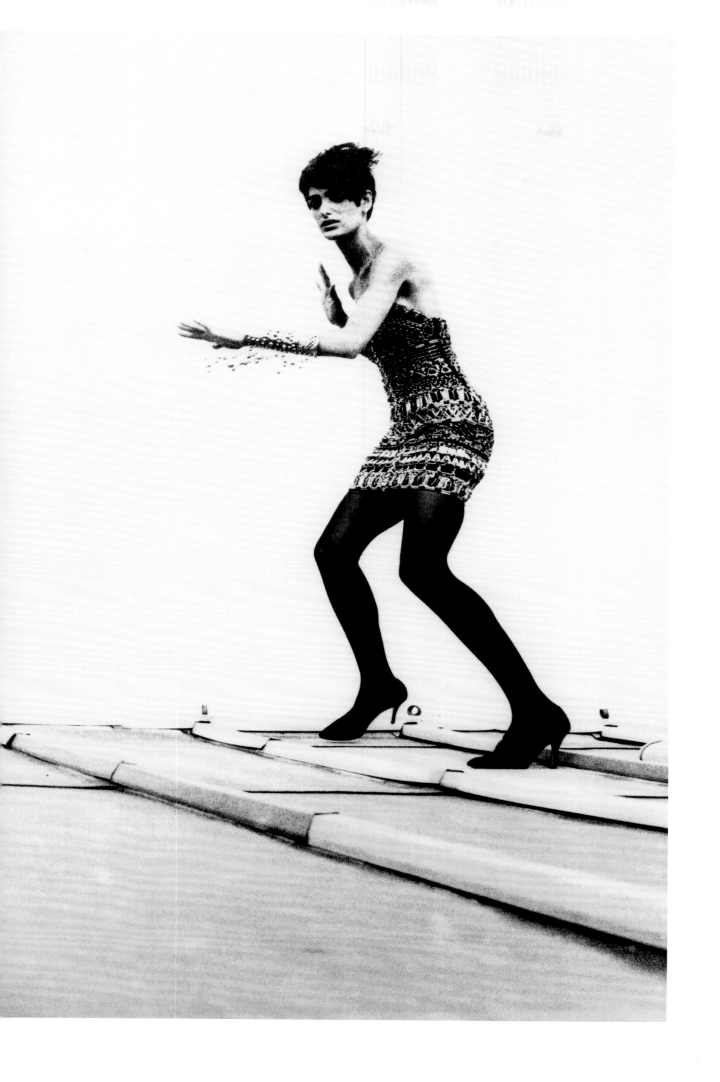

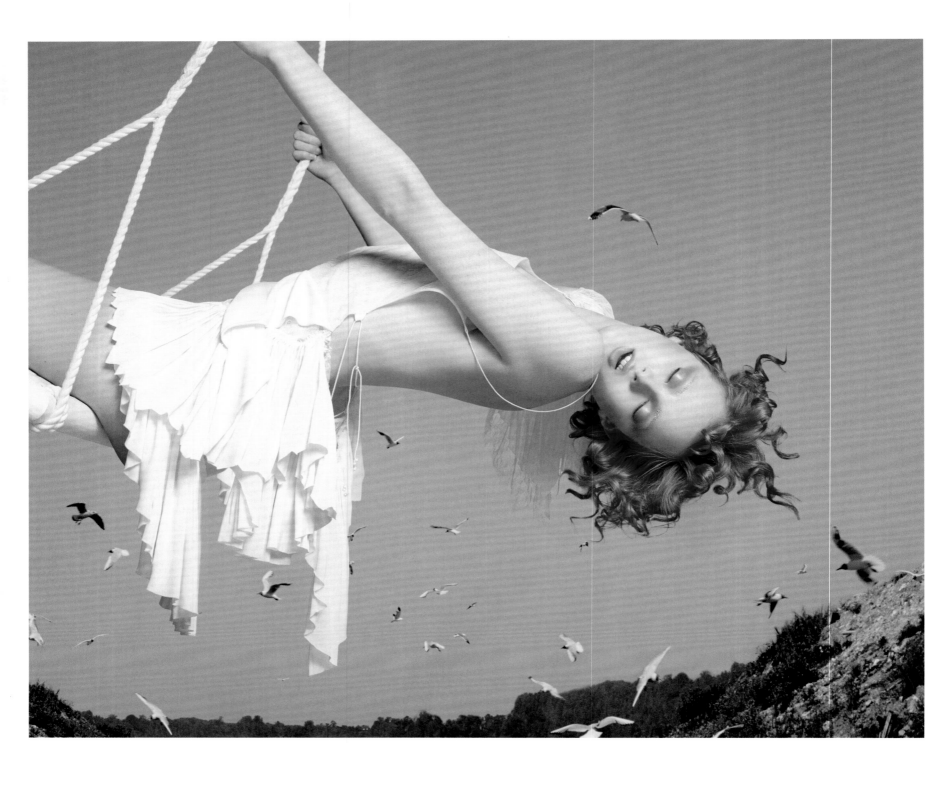

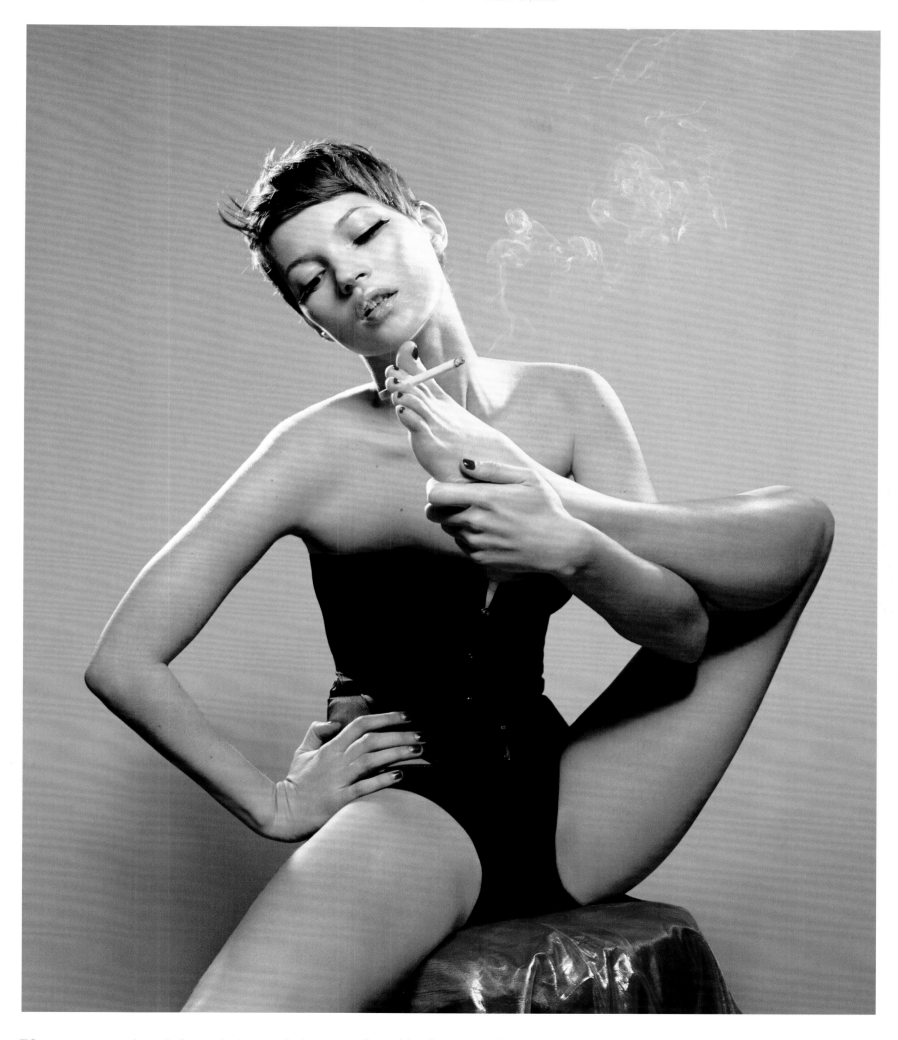

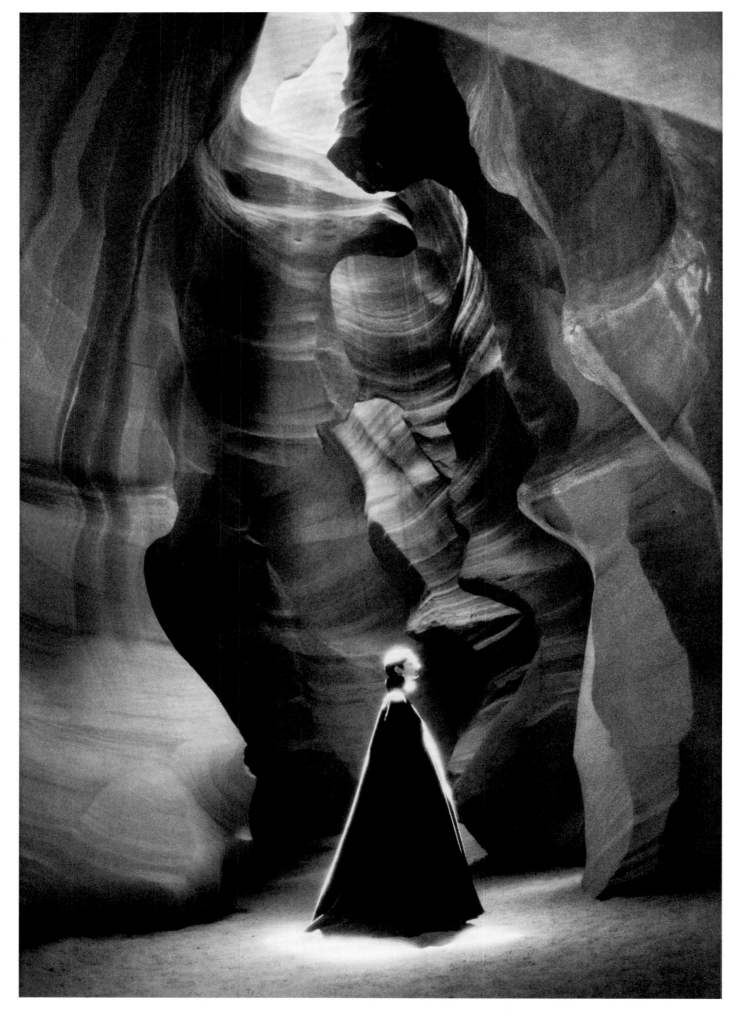

73 . dominique issermann . honor fraser . the new york times magazine . 1996

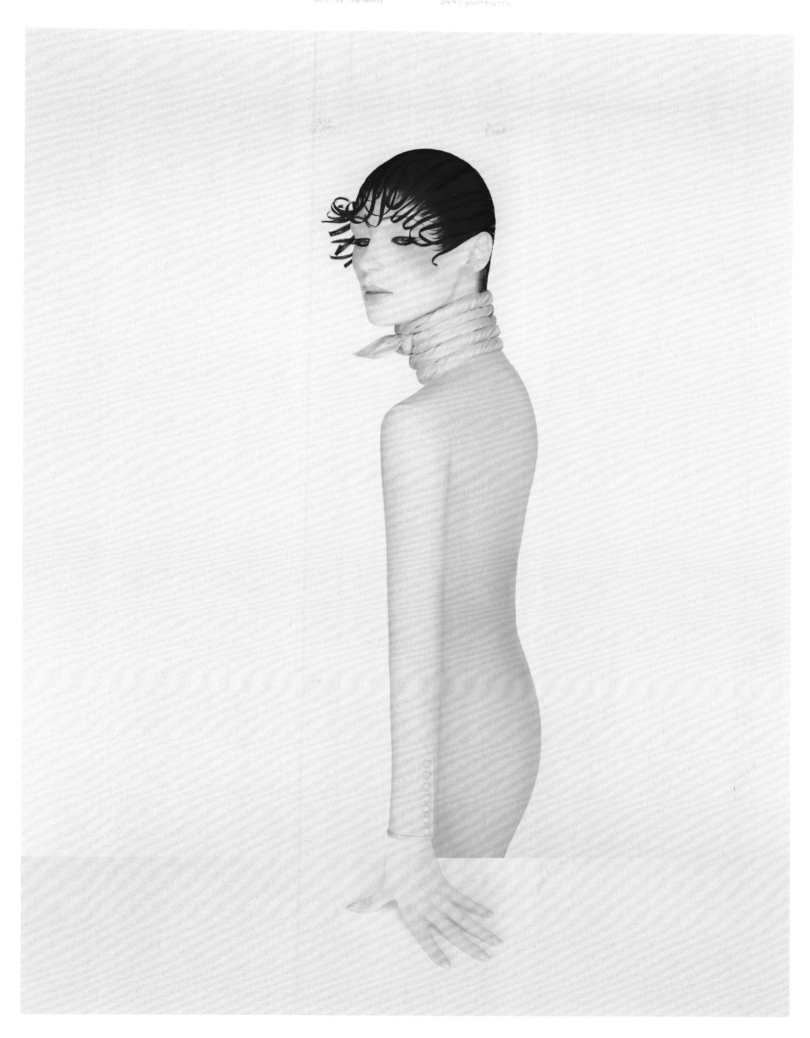

74 . serge lutens . incroyablement merveilleuse, olga . 1997

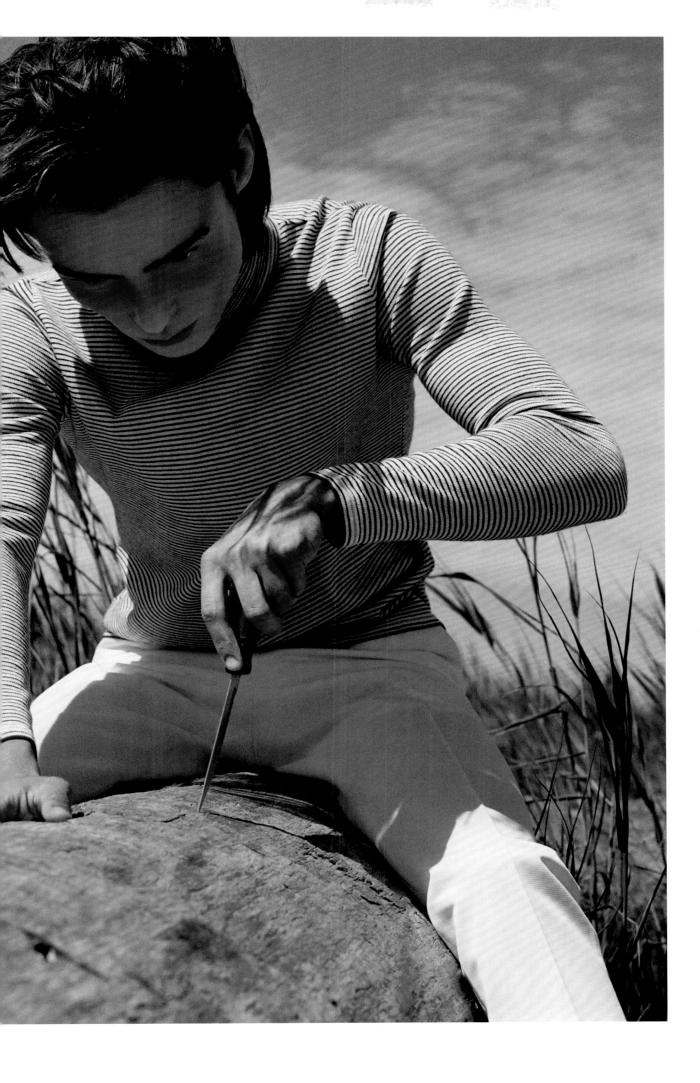

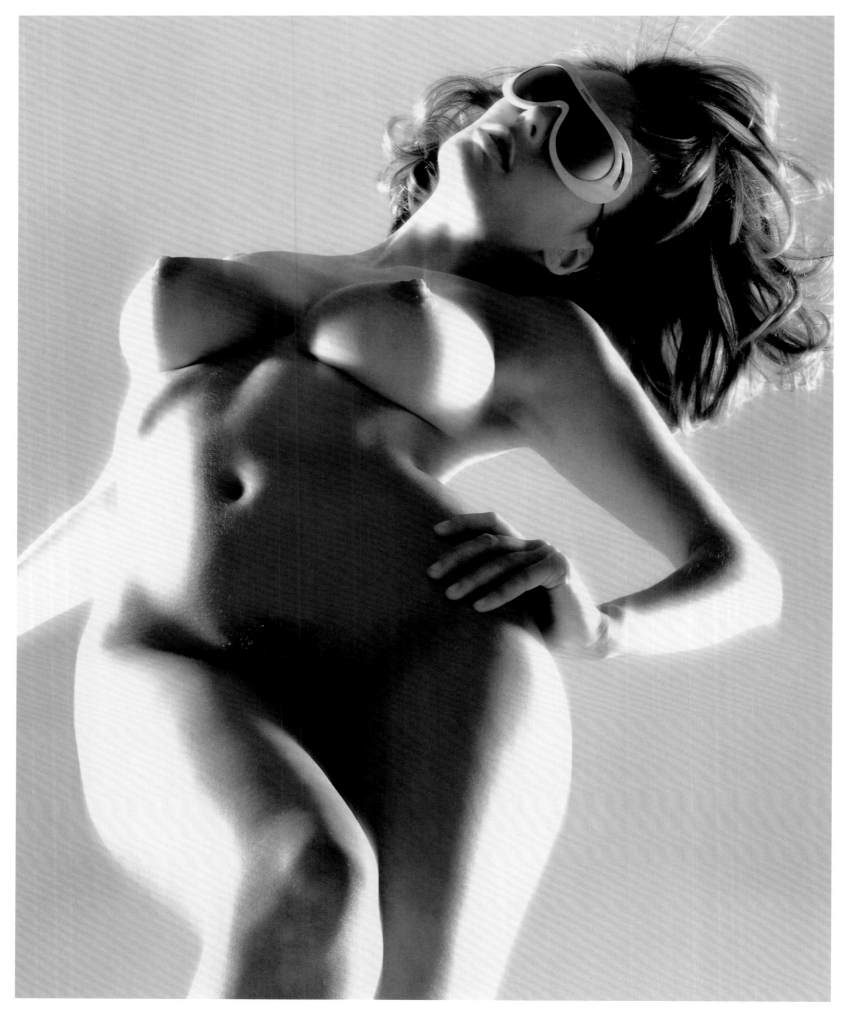

76 . sean ellis . korovamatic nude, glasses . the face . 2000

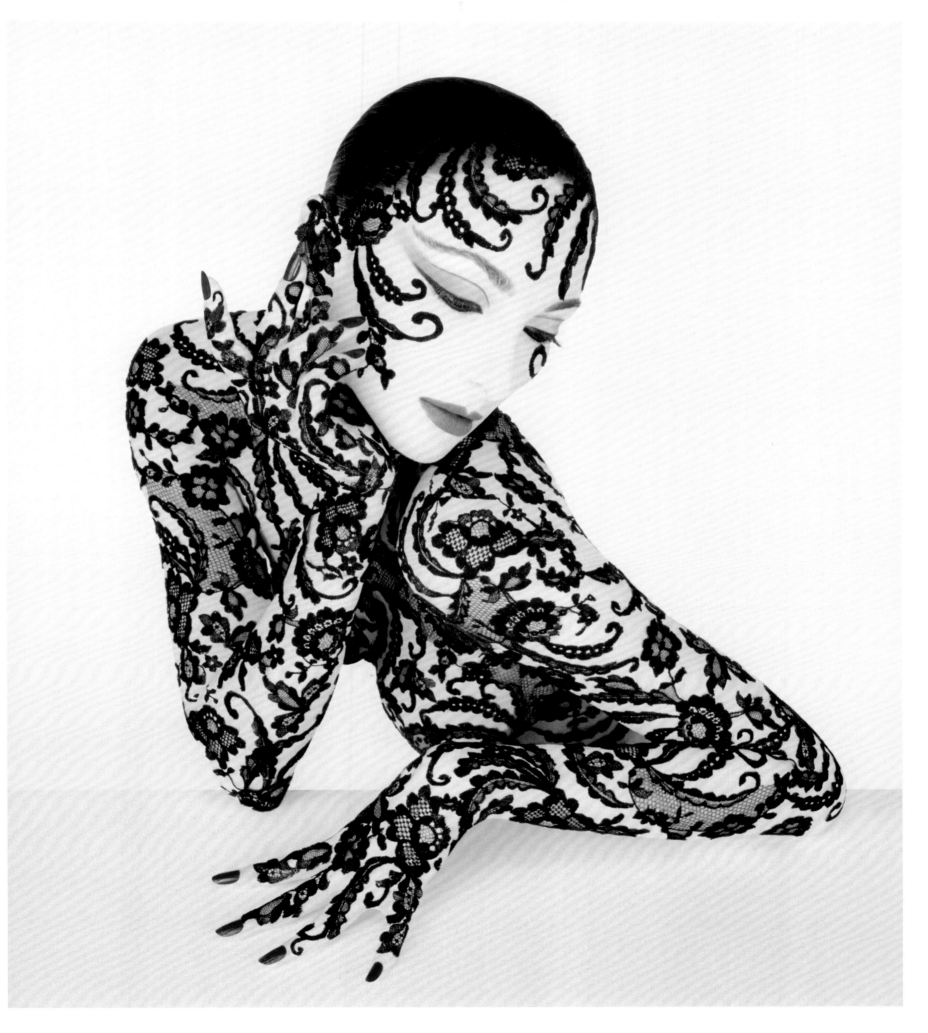

77 . serge lutens . dentelles éphémères, elena . 1995

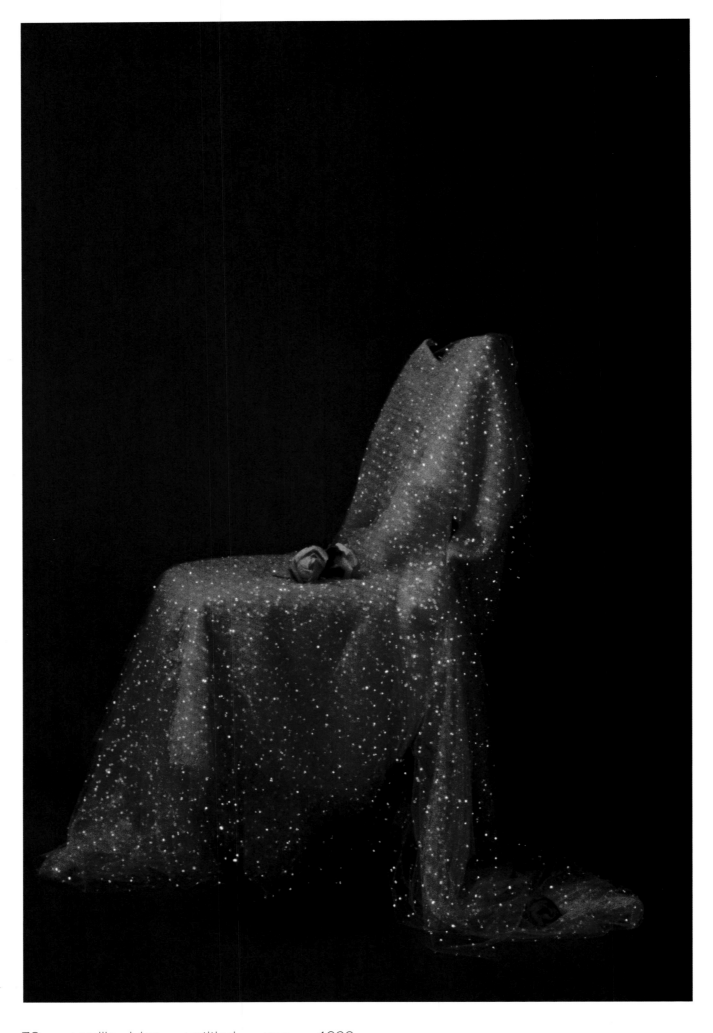

78 . camille vivier . untitled . zoo . 1999

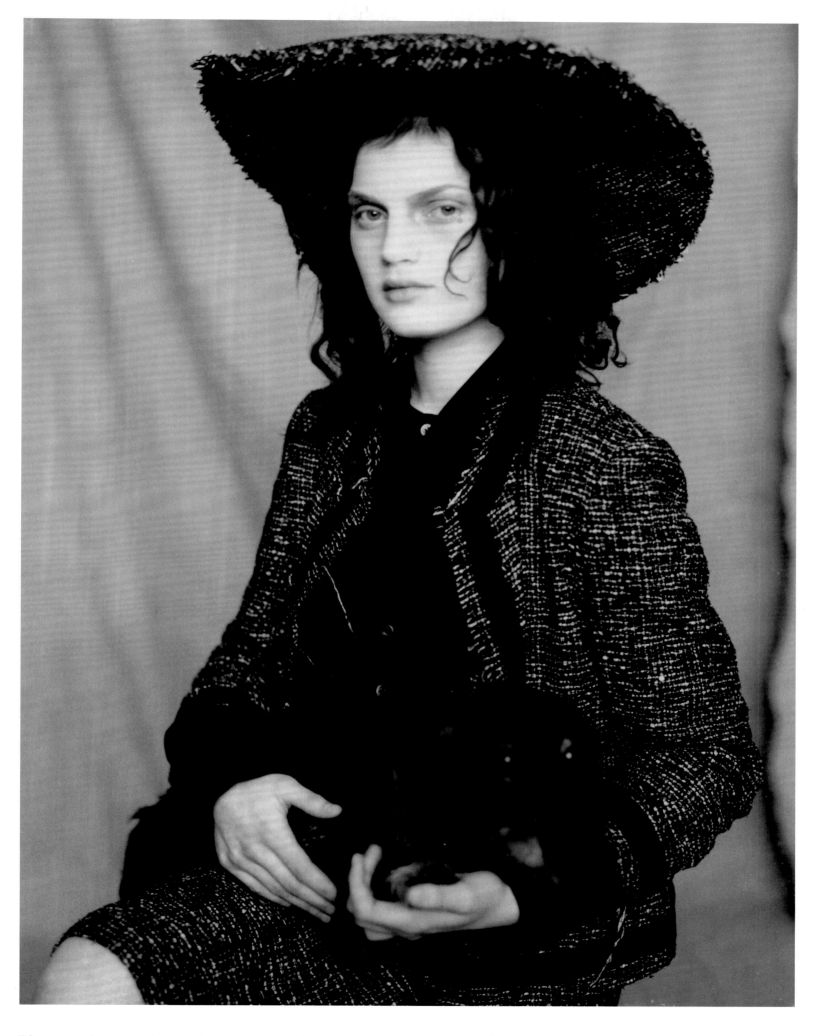

79 . paolo roversi . guinevere . yohji yamamoto, paris . 1996

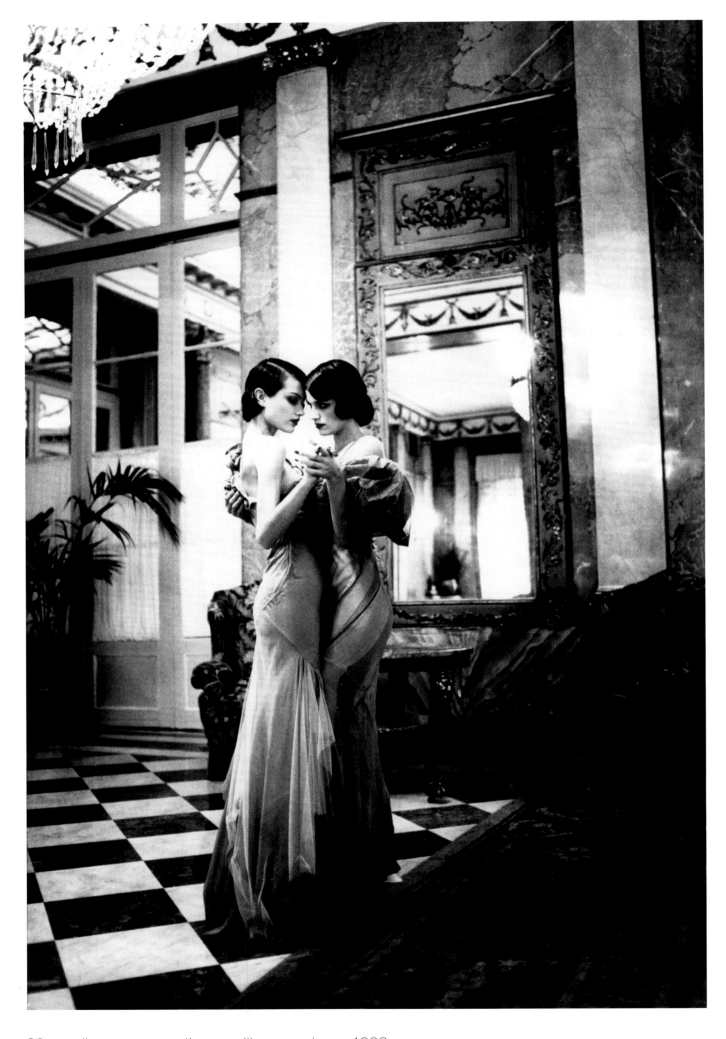

80 . ellen von unwerth . galliano, paris . 1993

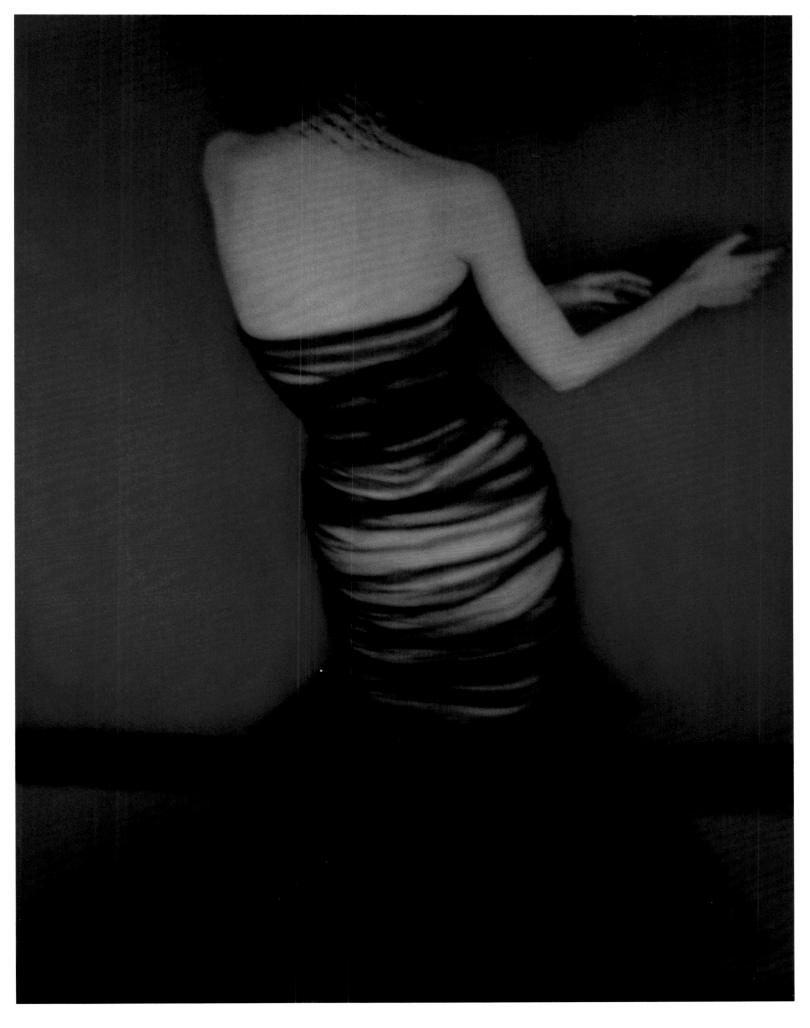

81 . sarah moon . fashion 3, chanel . 1997

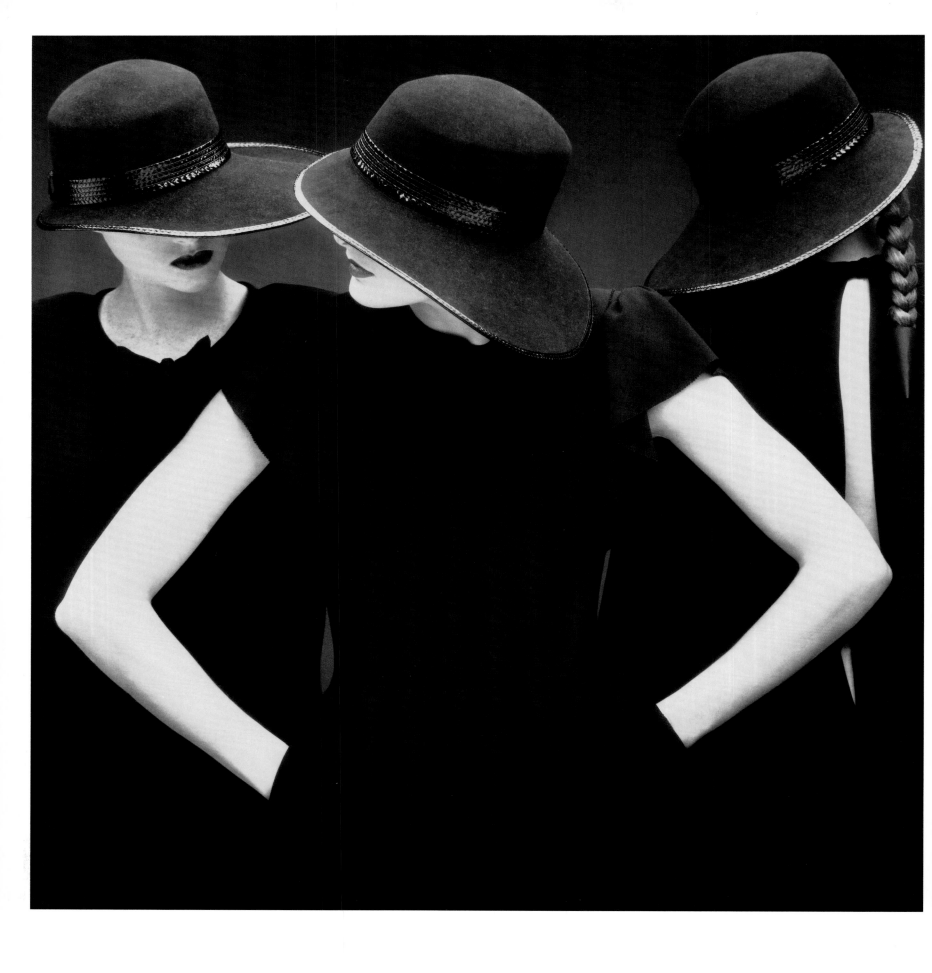

82 . dominique issermann . collection printemps-été sonia rykiel . vogue france . 1981

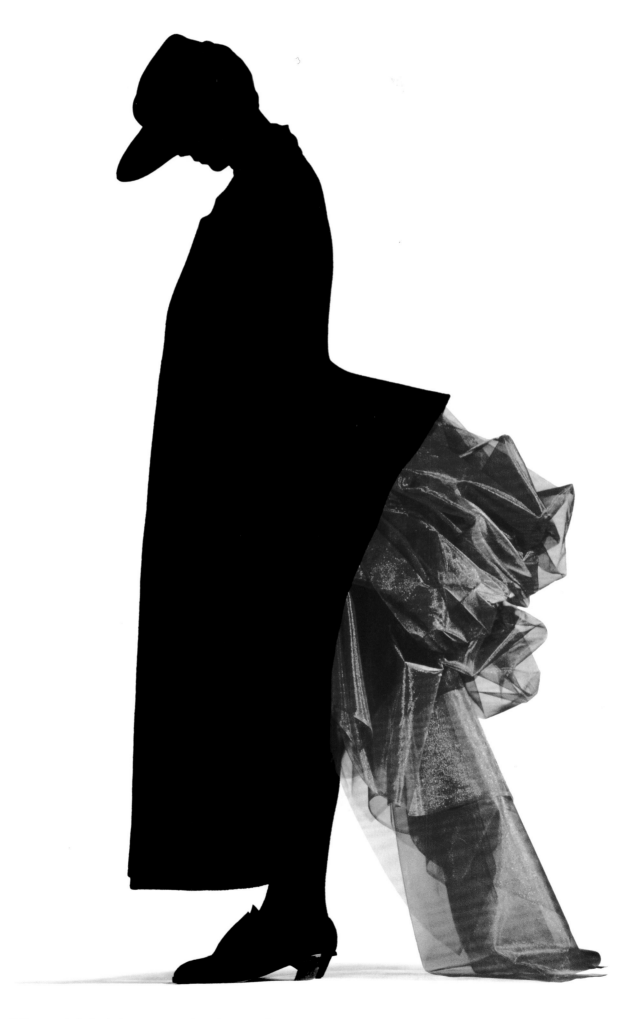

83 . nick knight . sarah wingate for yohji yamamoto . 1986

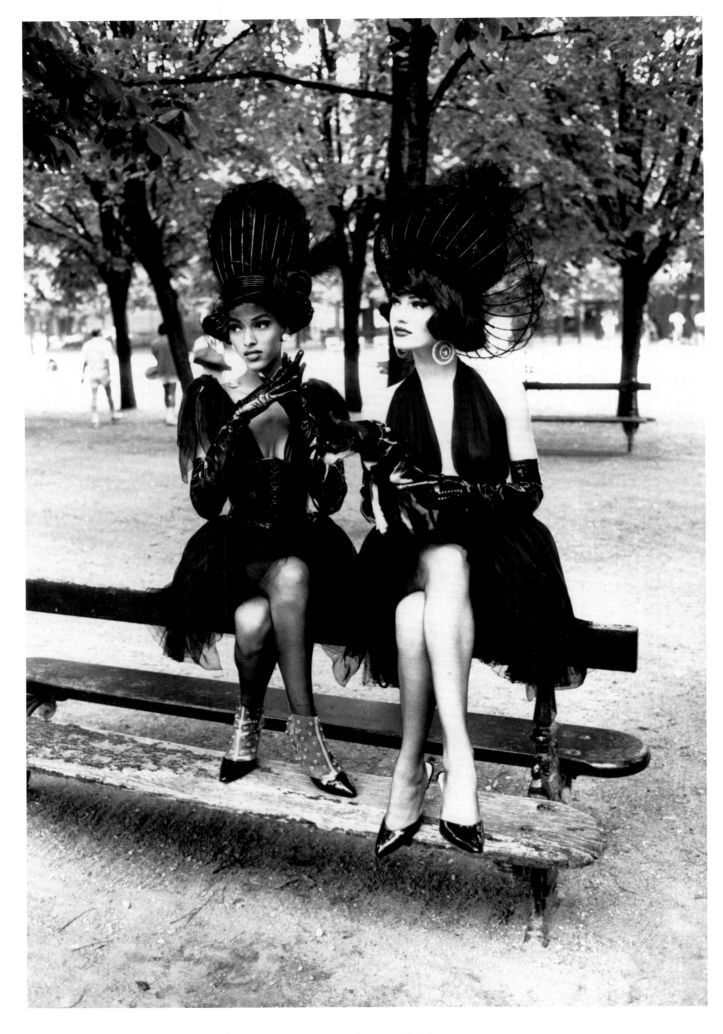

84 . ellen von unwerth . haute couture, paris . 1991

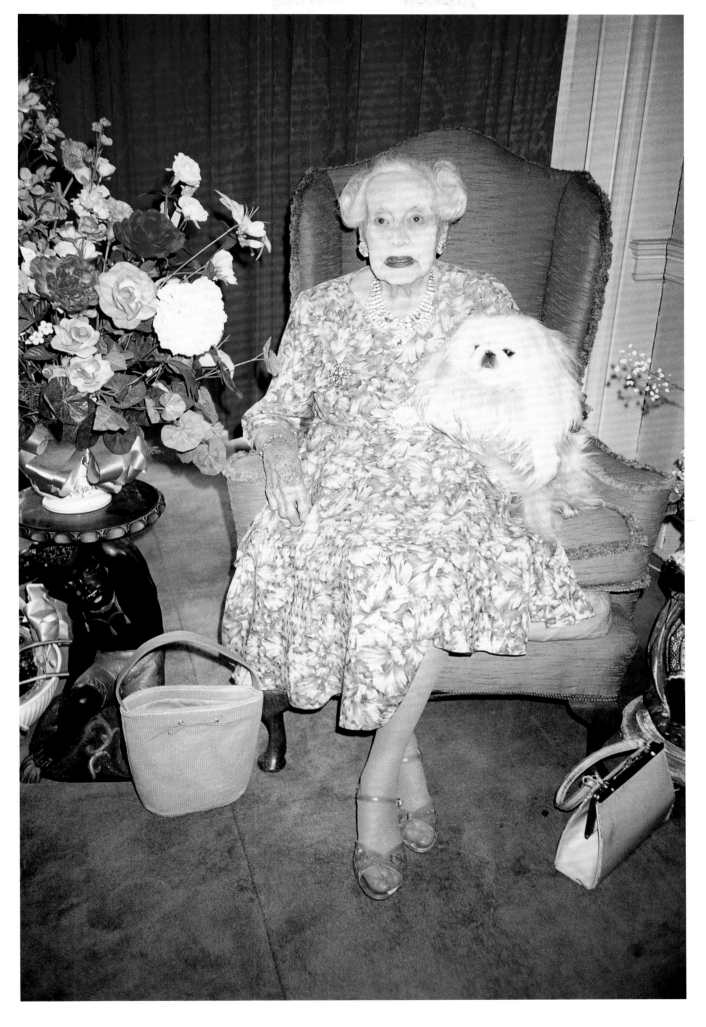

85 . juergen teller . dame barbara cartland at home, hertfordshire, england . 2000

punk rock

Photography that emerges from the spirit of punk searches for the greatest possible emotional authenticity. An organic outgrowth and yet rebellious, punk was to be kept alive as the desire for freedom. Owing to its political impotence, social indifference, and yet its aesthetic-cultural dominance, photographers above all used punk's wish for freedom for their artistic efforts. At the same time, images of freedom, of lived and (ostensibly) non-alienated emotion and of good cheer in the midst of indifference towards norms and rules, were to give birth to a cosmos of tender forces that did not bow down to the rigidity and frost of contemporary life. To this extent, images in the wake of punk form an antithesis to the other force-fields of fashion photography mentioned here.

While other pictures hunt for the wondrous either in the technoid coldness of Futurism, in the opulent splendour of glamour or the surreal inversion of the quotidian, photography that came from punk discovered the wonderful in the smallest unyielding gesture, in the raw and the rough. With their images, Teller, Richardson or Borthwick mystify the social margins that commonly bear the trappings of outlaws. The heroes are figures who at first sight do not conform with social norms: they are down and out and/or rebellious. They are thus the doubles of the photographers themselves, who, as in the case of Richardson, Teller or Davide Sorrenti (he died in 1997), gladly cast themselves in the role of bad boy, homeboy or punk.[9]

When these photographers work with the most beautiful women in the world, they search for the true core of beauty regardless of the transfiguration created by their colleagues. The pictures have the look of made-down images in order to retain the notion of a real living warm person in the flesh. The pictures are thus old-fashioned, with their battle

[9] The one is often meant to signify the other, as the example of the Beastie Boys shows.

against the death of the categories of the human and humanism. Indeed, they are documents of an unbroken joie de vivre that is quite shocking for the bourgeois majority and may seem all the more ragged – yet for artists like Richardson, who love life, they are the expression of passion and non-conformity.

Pictures make us aware. Initially, they kindle the awareness of the fashion industry for youth and pop culture, from whose energy boosters the marketing departments had cut themselves off. The interest in fashion among the photographers and stylists in the punk world was informed by the manipulative codes of punk and the directness of DIY. Punk was a raw force that nevertheless possessed a great symbolic sensitivity. The cultural terrain in which punk bore fruit strengthened both trends, namely forceful expression and the fine contradictions of internally inconsistent codes. Adolescence and fresh beginnings gave free rein to errors, follies and exaggerations, but it was good protection against the threat of repetition and rigidity. Fashion photography became lively again in the most basal sense.

Happiness was measured in terms of intensities: elegance had to bow down to this. Beauty as the leading currency was sold off cheap and replaced by concepts and categories such as authenticity, substance, credibility and charm. 'With its terror, beauty takes us to the verge of what we can endure,' said Jean-Luc Godard in 1983 as the psychiatrized director in *Prénom Carmen*, at a time, in other words, when punk was generating phenomena that tore back into it and countered it. Yet instead of letting negative dialectics take their course and setting about deconstructing the old concepts of beauty and elegance, photographers went for indifference to these concepts. The surfeit of

the life to be celebrated could not care less about the old categories. At the same time, the effervescent and passionate nature both of the motifs and the aesthetics of such photography was deeply nostalgic. This cut to the threatened heart of the primordial human love of life. Yet each detail of these pictures attests to the distrust with which we should meet it. A sceptical generation tries its hand at happiness, is serious with the project, and yet knows that it will fail.

Punk became New Wave and punk became history. Johnny Rotten reverted back into Johnny Lydon. i-D magazine carries on in the spirit of punk: preserving it as a stance and energy, robbed of its original irritating and destructive powers. The rebellious note, now sounded on the surface, becomes all too evident. The symbolic uprising against the symbolically active and dominant senses the pointlessness of the effort to change non-symbolic realities.

Punk fashion – like all fashion trends – started off elitist in SEX, the London shop of Vivienne Westwood and Malcolm McLaren. In 1980, there were so-called Postcard Punks, who re-animated the old surfaces as illusions. They designed and lived a superficial punk traditionalism that is and was intrinsically contradictory. In this way, punk was freed from having to nurture some tradition in a superficial sense. The non-superficial, that which could not be copied visually, was extricated from the mass of aesthetically bankrupt categories and refined further. Even if punk, or so we could assume, had become a visual cliché, then the project was at least to advance the non-clichéd or the genuine that could be mistaken for it – the so-called 'soul' or 'spirit' of punk.

The last twenty years of fashion photography have been strongly

influenced by magazines such as *The Face* and *i-D*. They arose in the spirit or in the wake of punk, and the fashion pages in *i-D* or *The Face* not only presented the photography that professed to be punk or claimed to continue its authenticity (or rather its specific artificiality), but also glamorous and high-tech photography (particularly *The Face*) or photography that followed and furthered art. The links between the four different levels of association are more a matter of overlap than of mechanisms of exclusion. The lines connecting the visual arts to punk run direct through the shared font of Situationism, with which both Jamie Reid and Malcolm McLaren were directly networked.

Glamour was networked no less directly with the attitude of punk. Terry Jones was for many years art director at *Vogue* in England and Germany, where he experienced all the gaps, blinkered attitudes and stereotypes of the old concepts of glamour. Jones's professional ability to reach compromises, put to the test for many years, came to an end when the old forms of representation not only ignored everyday reality and social conditions, but were not even able to understand fashion anyway. In order to prevent fashion, photography and magazine journalism from becoming blind to the present, Jones severed his links with the old world of glamour, electing instead in a world that was its opposite to discover its core intentions in a new vein rather than destroy them. The history of *i-D* magazine was initially antithetical and then increasingly synthetic, as at the outset the endeavour was to liberate a new aesthetic with a vengeance, establishing it against the backdrop of punk and helping it win its spurs. To opt for pathos, the idea was to open people's eyes in a new way and to breathe fresh air.

The way Terry Jones designed layouts signified a challenge for

photography that went well beyond the ambit of the old ideas of port-folios. 'If a picture cried out to be a full page,' former editor-in-chief of *i-D* Dylan Jones recollects, 'then Terry liked cutting it in half, printing it standing on its head and had 30 per cent cyanide blue run right through the middle. The best photo in a sequence was printed in a minute size, the worst blown up to a double spread.'[10] This hard-hitting and aggressive redefinition of values signified not only overthrowing the old values but a normative and/or semantic reevaluation. At the same time, this led to photographers themselves turning the screw of normative inversion still further. They took the spin of the magazines a step further, giving the photographs an unforeseeable twist in the layouts and context of the magazines.

Following the corset of the old order, photographers were now condemned to freedom, as were designers, art directors and stylists. The degree of coarseness and simple genuineness stemmed from the degree of suffering or estrangement from the old concepts. 'Reduced and degraded essence tenaciously resists the magic that transforms it into a facade,'[11] wrote Adorno at the beginning of his *Minima Moralia*. Toughness essentially defines that stance with which punk severed the outdated cultural and aesthetic bonds or, more modestly, loosened them. The coarsest versions of punk made its aesthetic into an apologia for coarseness and genuineness. The innovations that came into fashion photography from punk implied a fractured and intrinsically uncertain notion of the genuine that construed the authentic as a variant rather than a dogma, as possibility rather than as mission.

Photographers working in the idiom of punk rock are a lot less cynical and ironic than those who produce glamour. Formally speaking, the

[10] Dylan Jones, 'A wink says more than a thousand words', in Terry Jones, *SMILE i-D, Fashion and Style: the Best from Twenty Years of i-D*, Cologne 2001, p. 567.

[11] T. W. Adorno (tr. E. Jephcott), *Minima Moralia*, London, 1974, p. 13.

photography of the last twenty years is an attempt to reduce the means of representation. For this reason, photography in the spirit of punk exhibits strongly minimalist tendencies, yet it only rarely gains such a formal incisiveness, instead always casting an emotional glance at the so-called essentials. The rejection of the hyper-perfect typical of glamour, art, and high-tech photography is just as much part of the ascetic trend as is the elimination of any staged superstructure. The motto of the photographs could easily be: Keep it simple, keep it real.

Jon Savage's monumental historical epic on punk, *England's Dreaming*, ends with the (dialectical) assertion that history is written precisely by those who say 'No' and that this utopian heresy of punk formed its gift to the world. This is true, and yet this overlooks all too easily that those who win the war against heresy refine the latter's aesthetic to create an art system that ensures the heresy is disseminated by the mass media to the most remote nooks and crannies of all discourse machines. The year 1977 marked an upheaval in various ways. It was the moment when in three different places – England, Germany and New York – the history of current music began. Only punk thrived on 'No', whereas Kraftwerk and Hip Hop thrive on 'Yes'. The synchronicity of punk, Kraftwerk's LP *Menschmaschine* and the beginning of Hip Hop is quite essential. In actual fact, coarseness in the Modernist tradition – art brut and primitive or Tachist painting – was brought to an end. Digital vandalism knew and developed different forms of the (supposedly) direct and untreated. The touching gesture of 'No' as an actual 'Yes' to the existing state of things is just as necessary today. All discursive systems must provide protective spaces not for naivety, but for tenderness and the non-ironic if these are to be kept intact. Fashion photo-

graphy in the spirit of punk rock not only organizes an economy of forms of representation, but also preserves the shattered souls of an otherwise pleasurably kaput, debased, cynical and amoral fashion world intact. The broken world shown in the pictures signifies the unscathed world just as the opulent and (superficially) intact world presented in other pictures by Meisel, Testino or LaChapelle communicates the broken with an inexorable harshness. In this way, the world can remain an enigma unto itself, without requiring of anyone that the puzzle be solved. Fashion photography can help in the process and sharpen the way we look at things.

punk rock

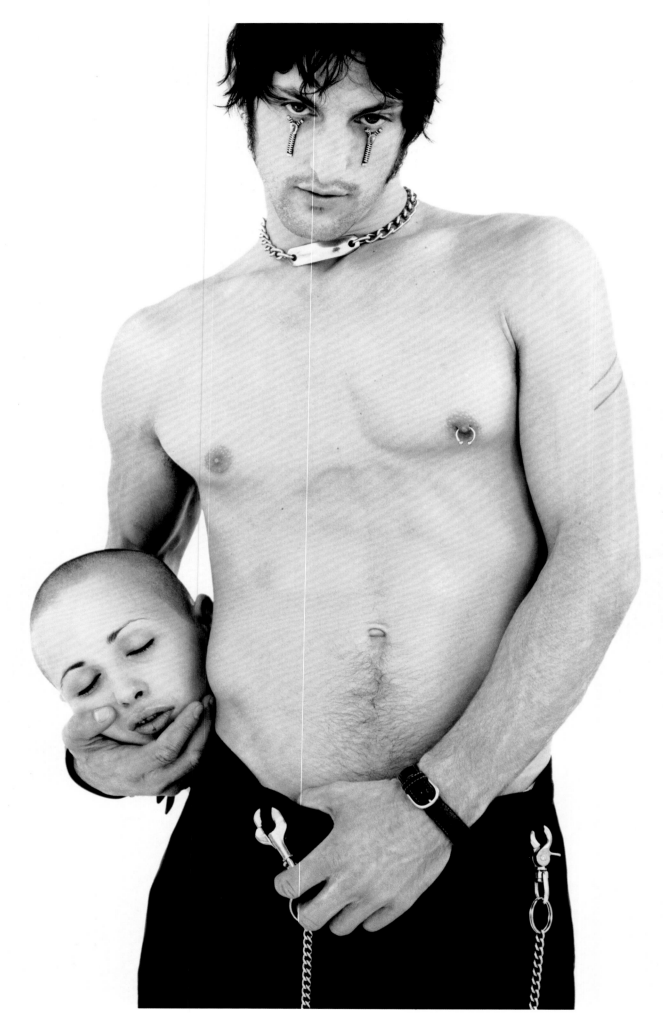

88 . laurence sackman . the seam . 1973

89 . dino dinco . untitled (heather-comme des garçons) . *surface magazine . 1998

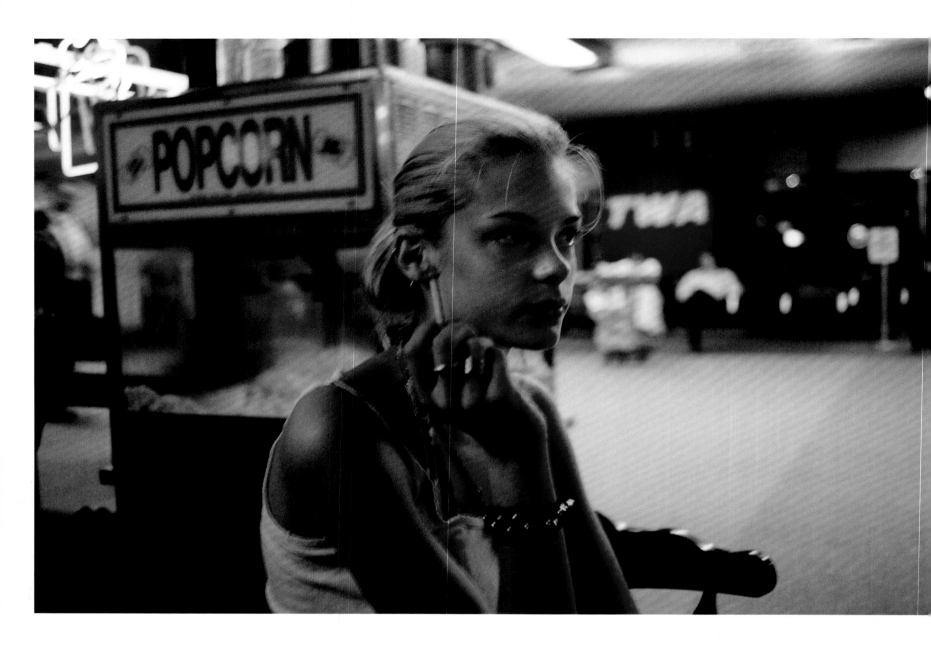

90 . davide sorrenti . popcorn . 1996

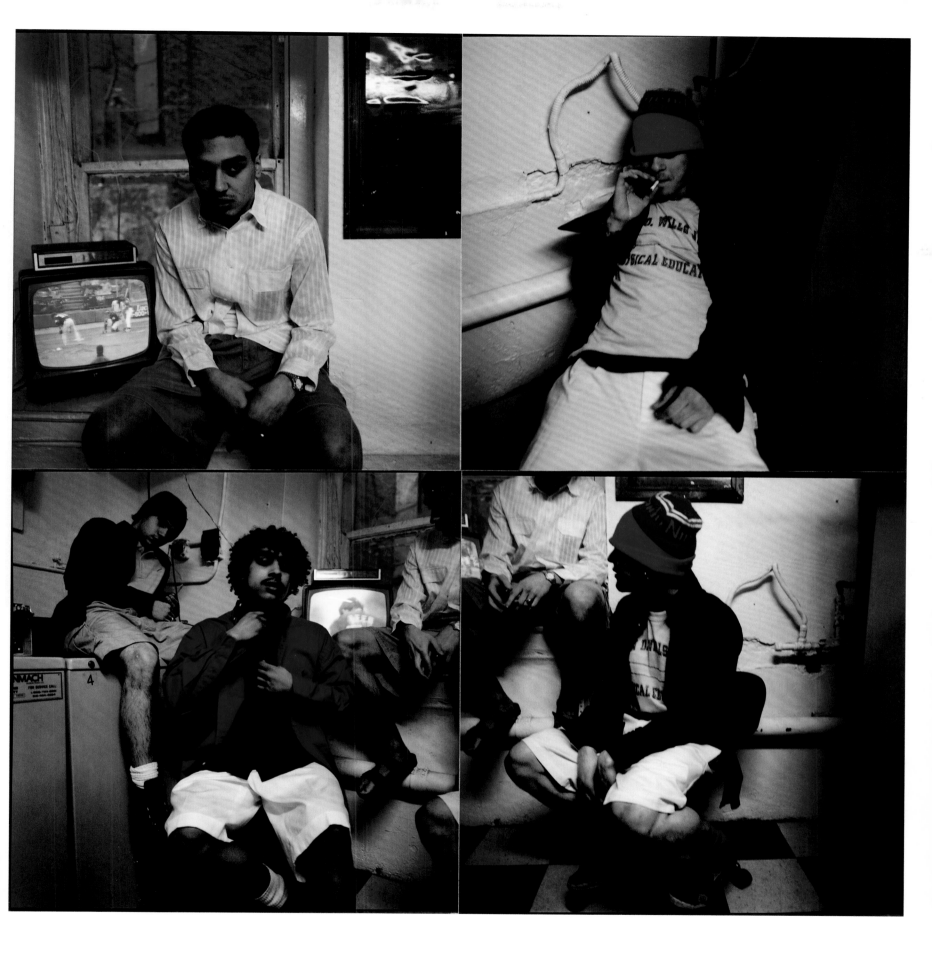

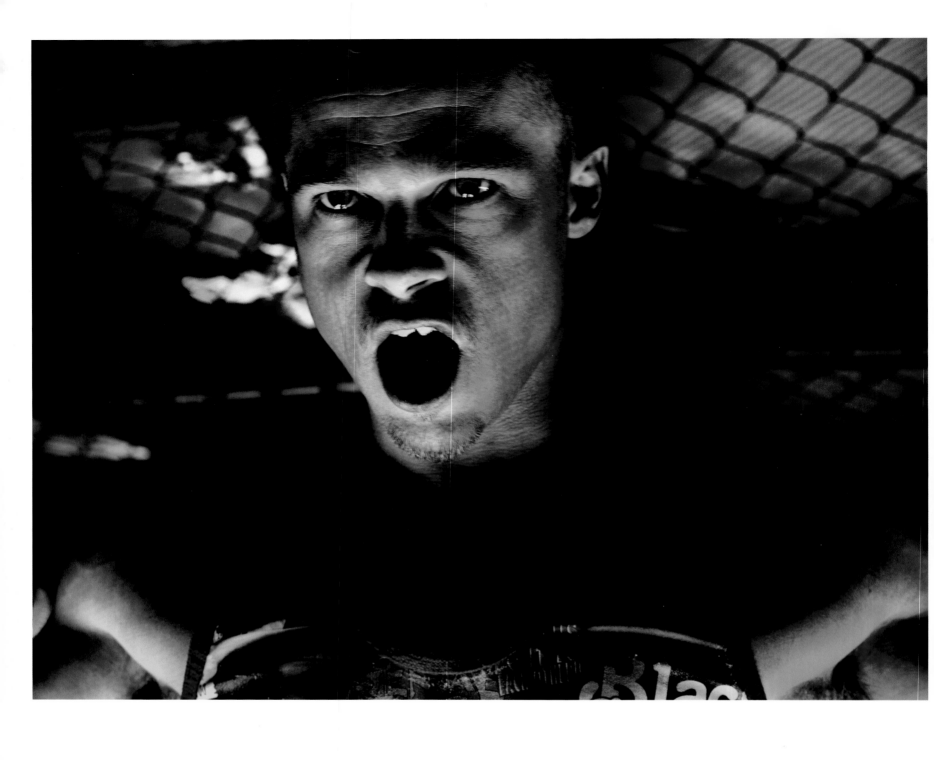

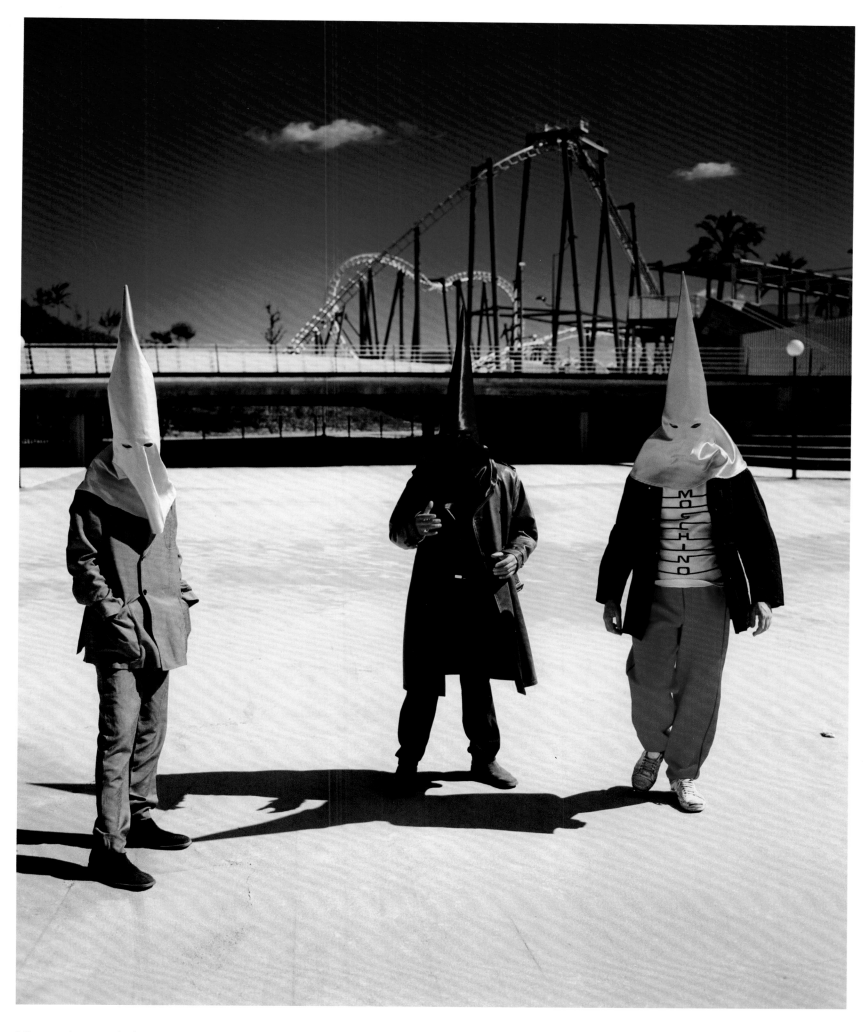

93 . pierre winther . this is not america . dutch . 1998

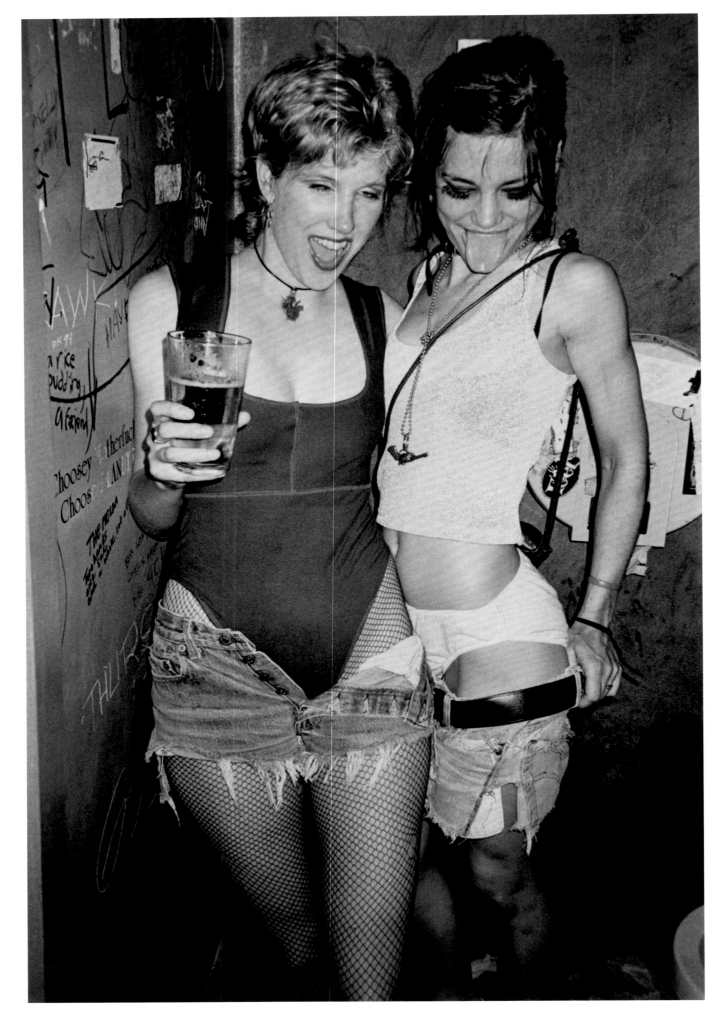

94 . terry richardson . girls dancing . 1995

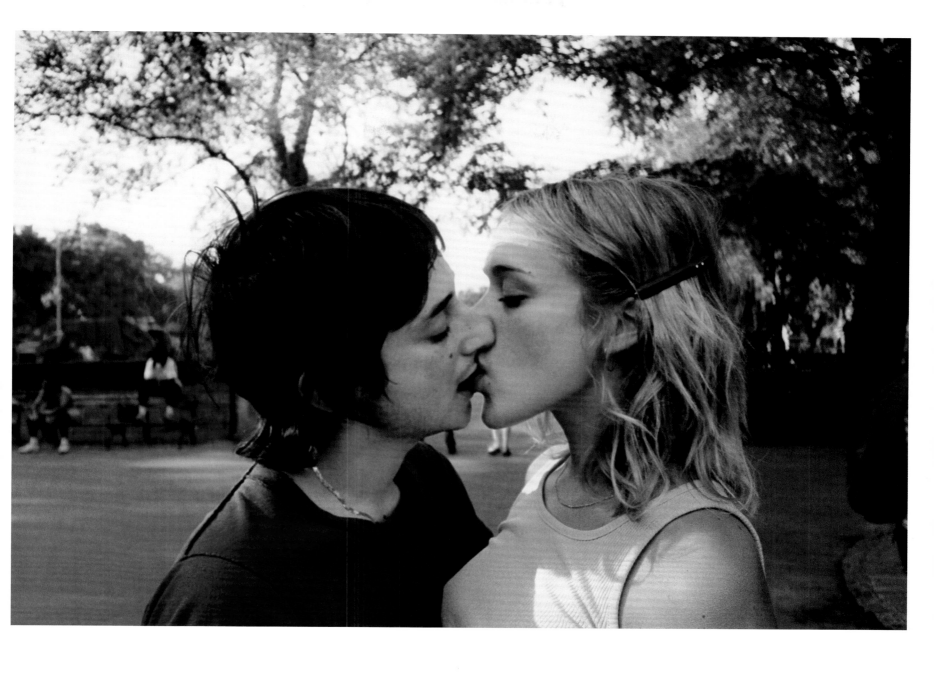

95 . terry richardson . chloe and harmony . 1997

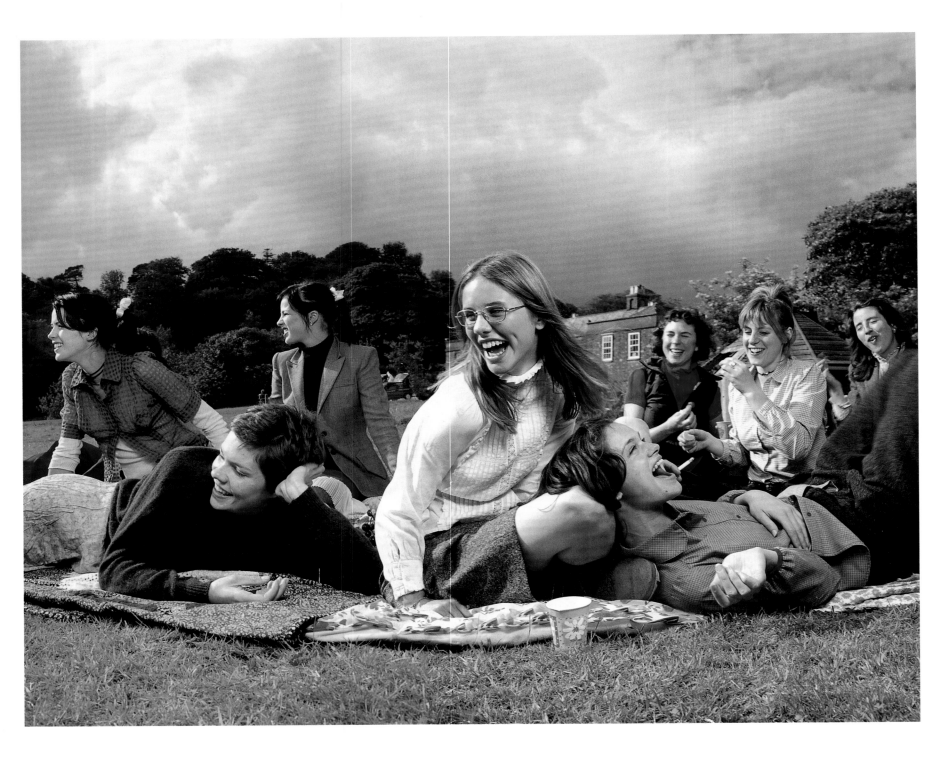

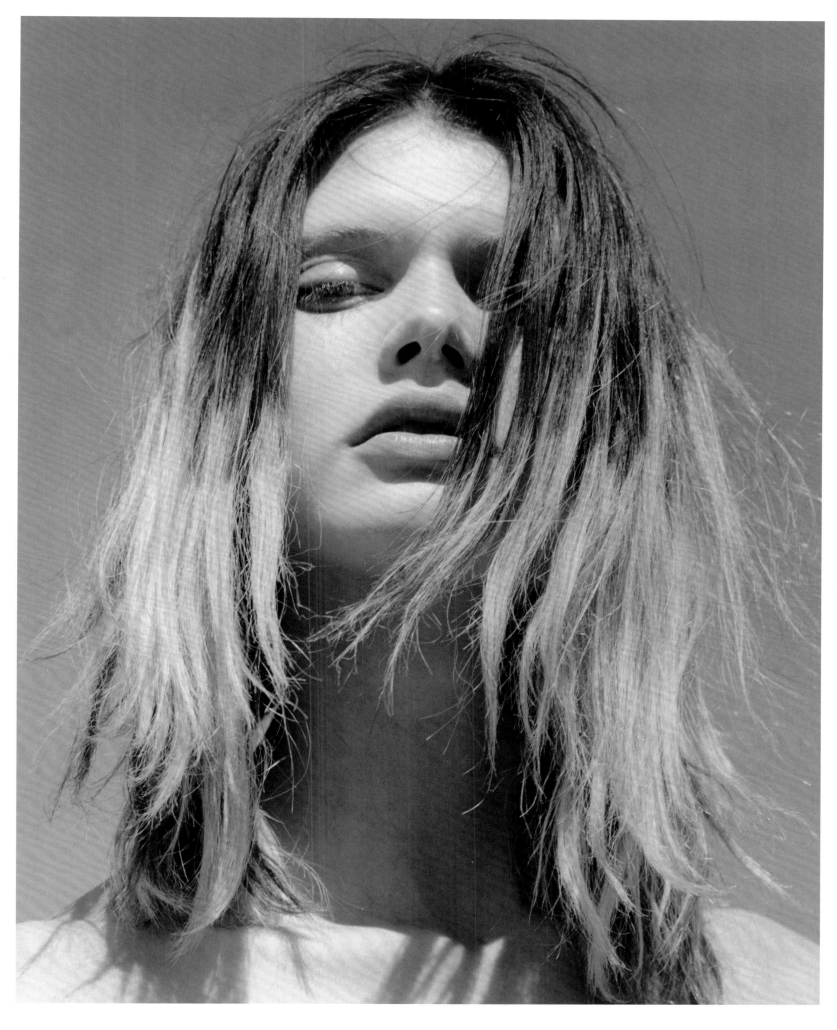

97 . david sims . malgosia, jil sander ll . 1999

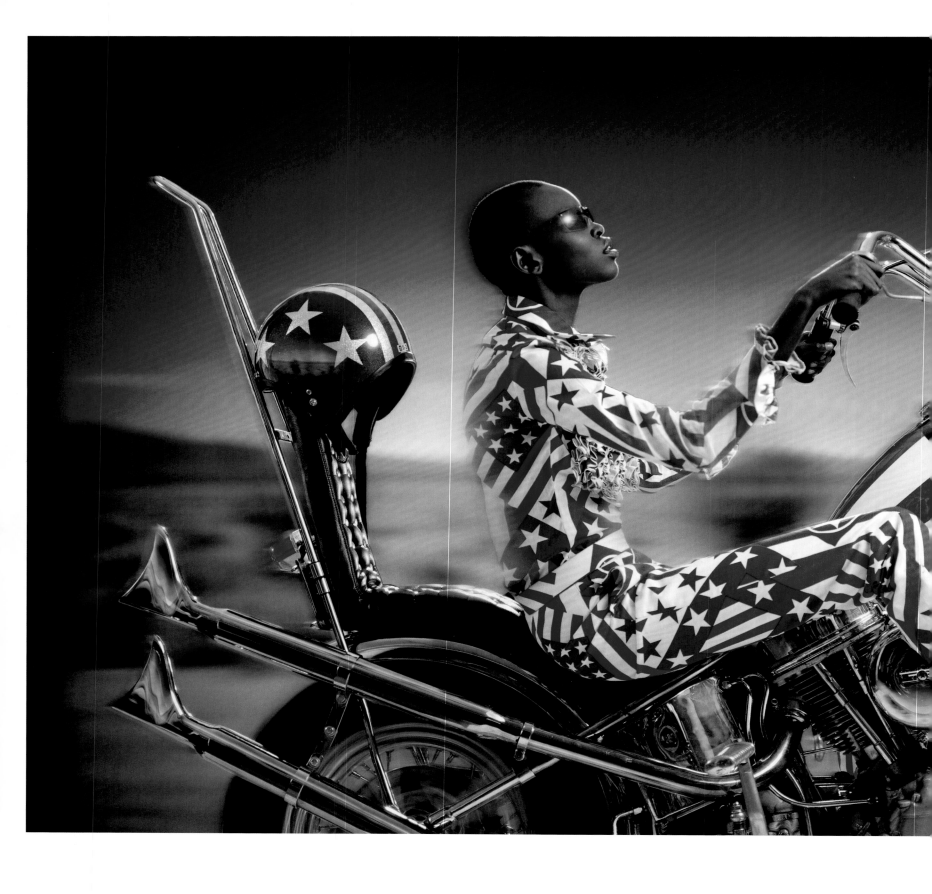

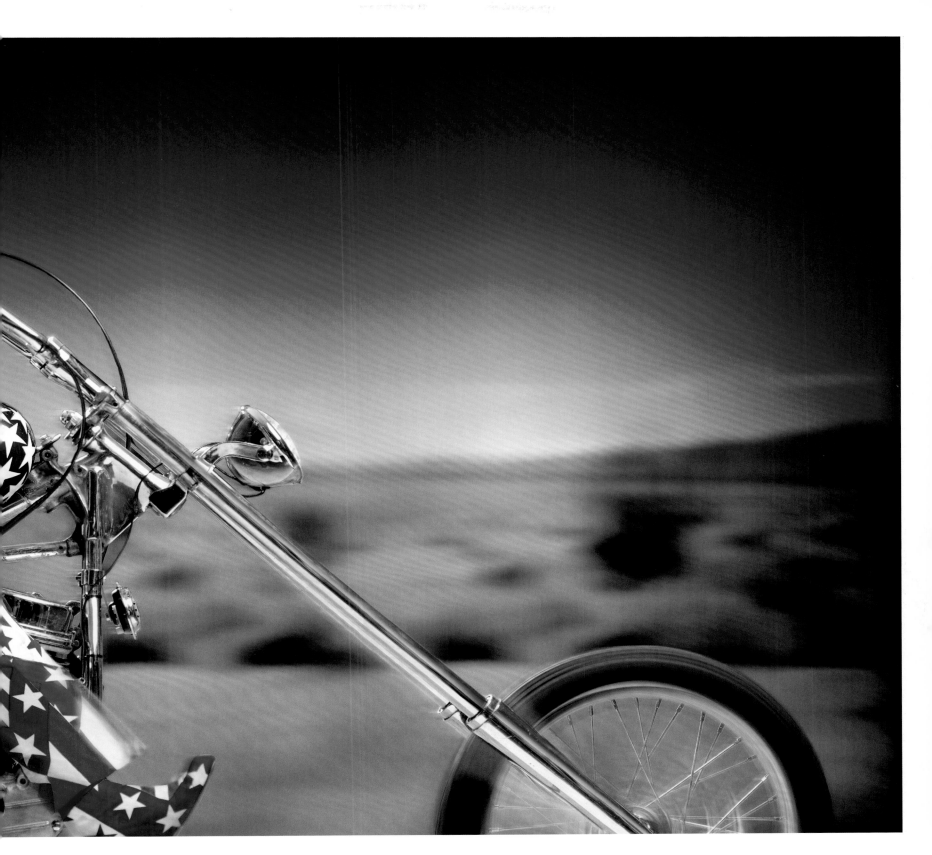

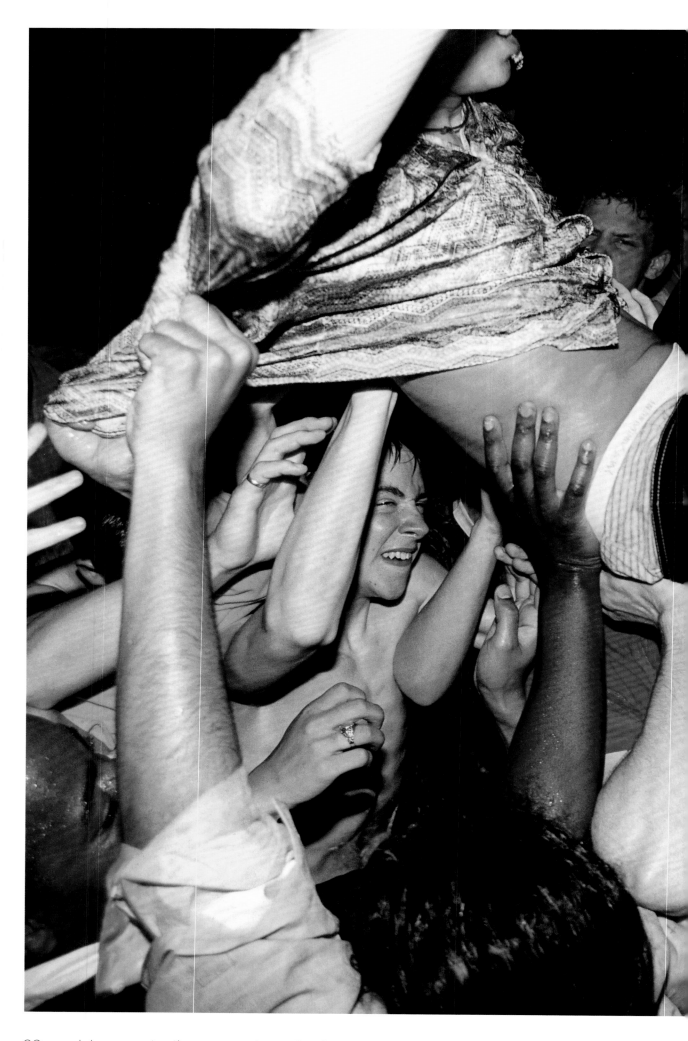

99 ▪ elaine constantine ▪ mosh ▪ the face ▪ 1997

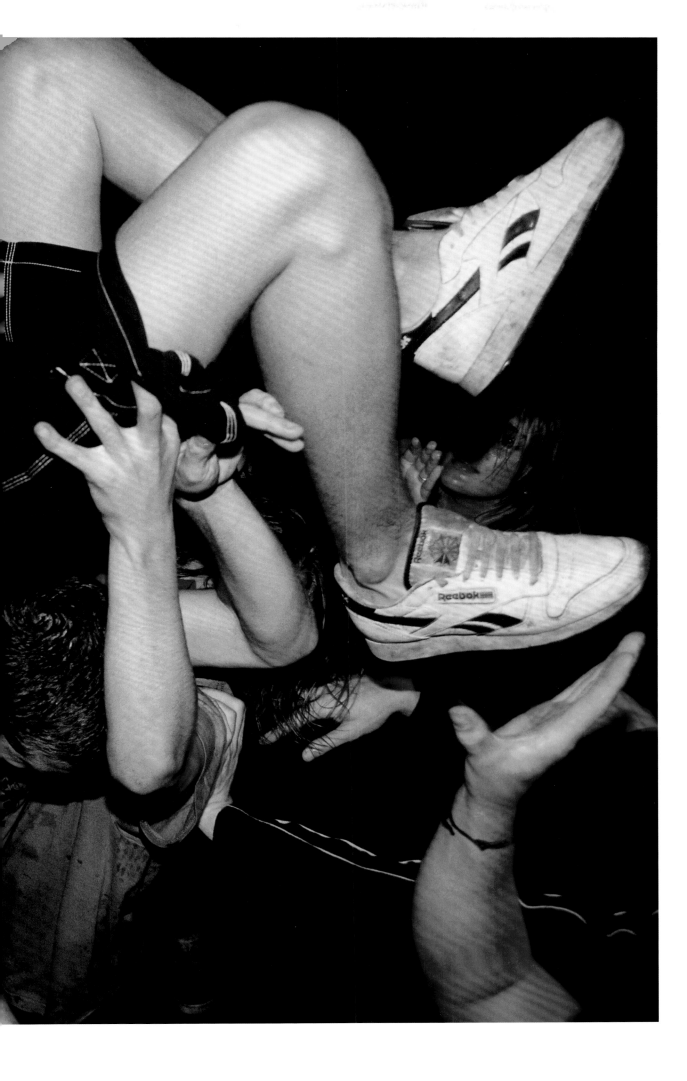

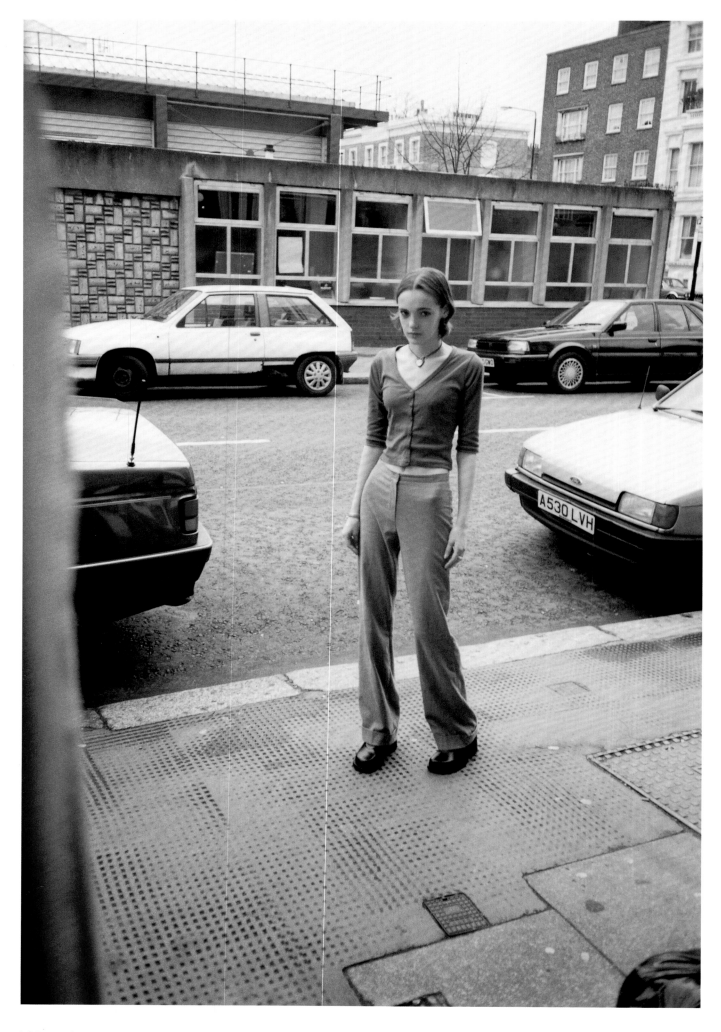

100 ▪ juergen teller ▪ go-sees, lauren, 18th february ▪ 1999

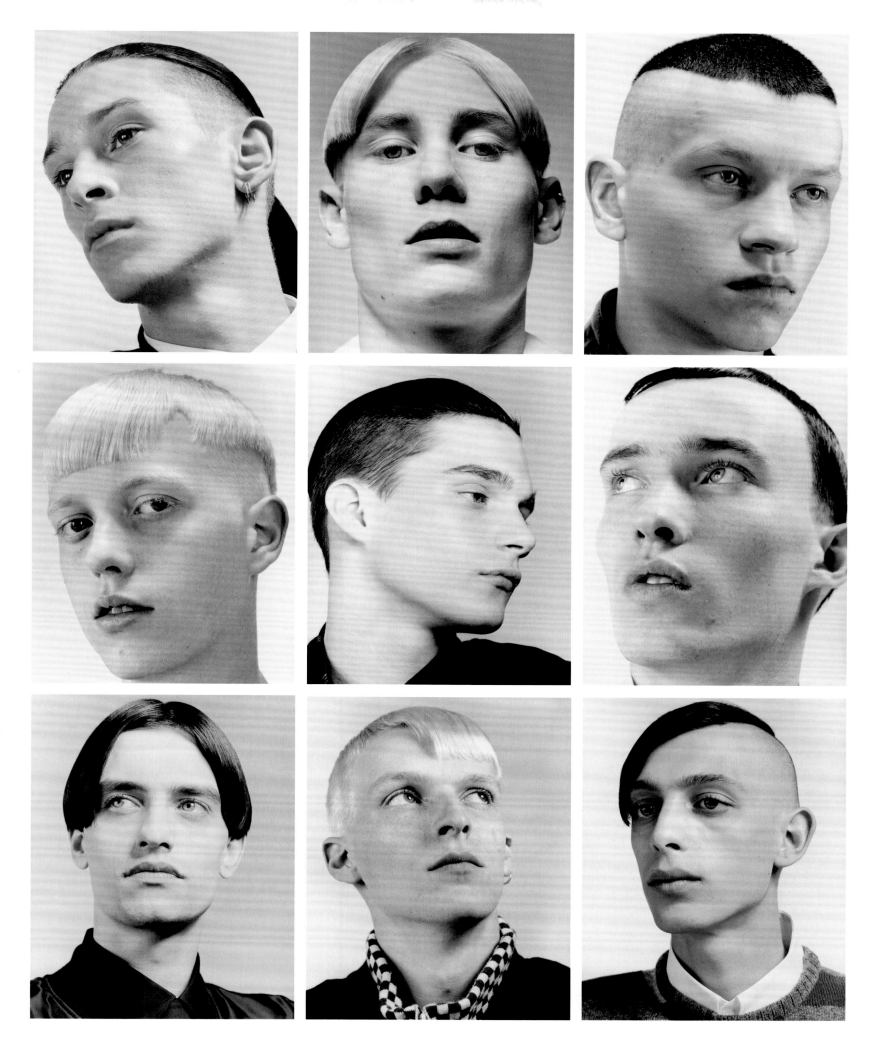

101 . raf simons & david sims . isolated heroes . 1999

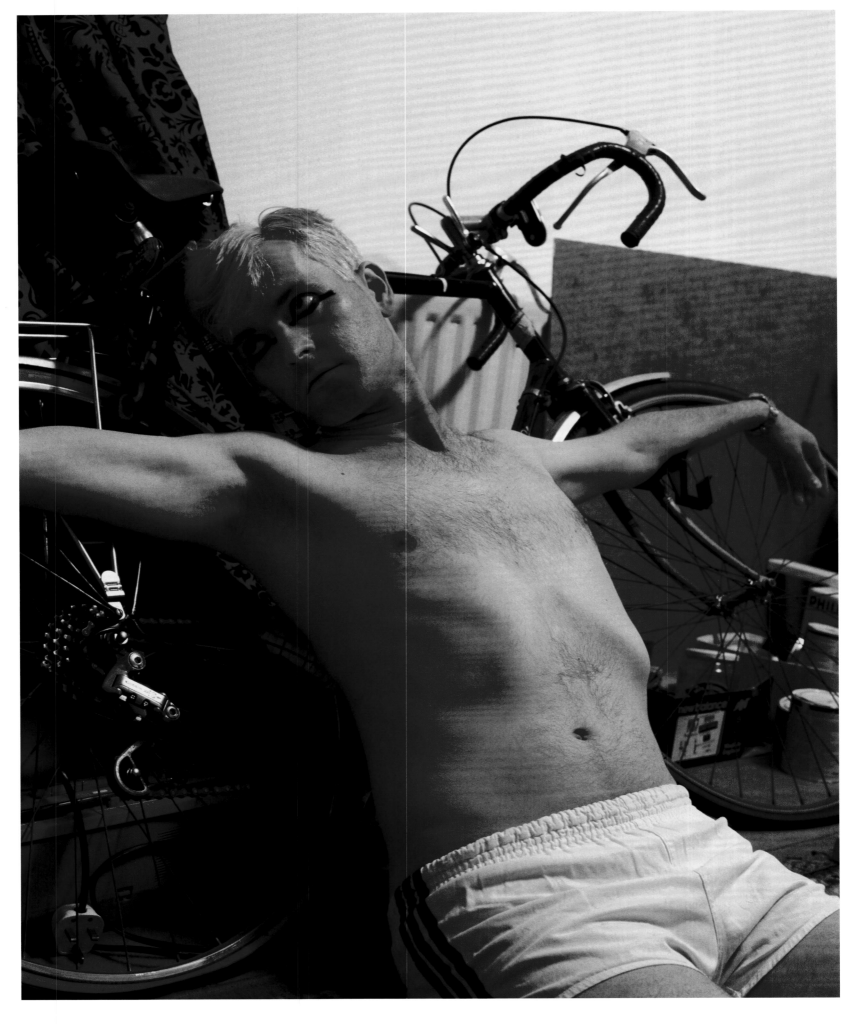

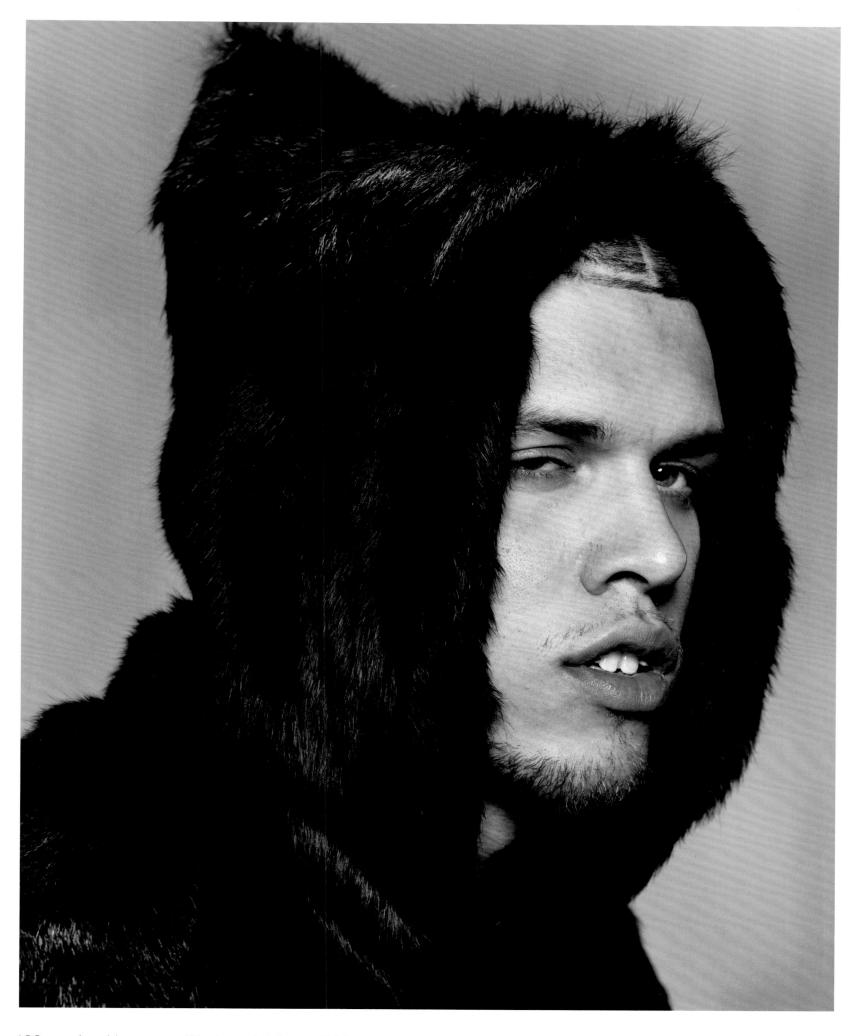

103 . alexei hay . untitled . dutch . 1998

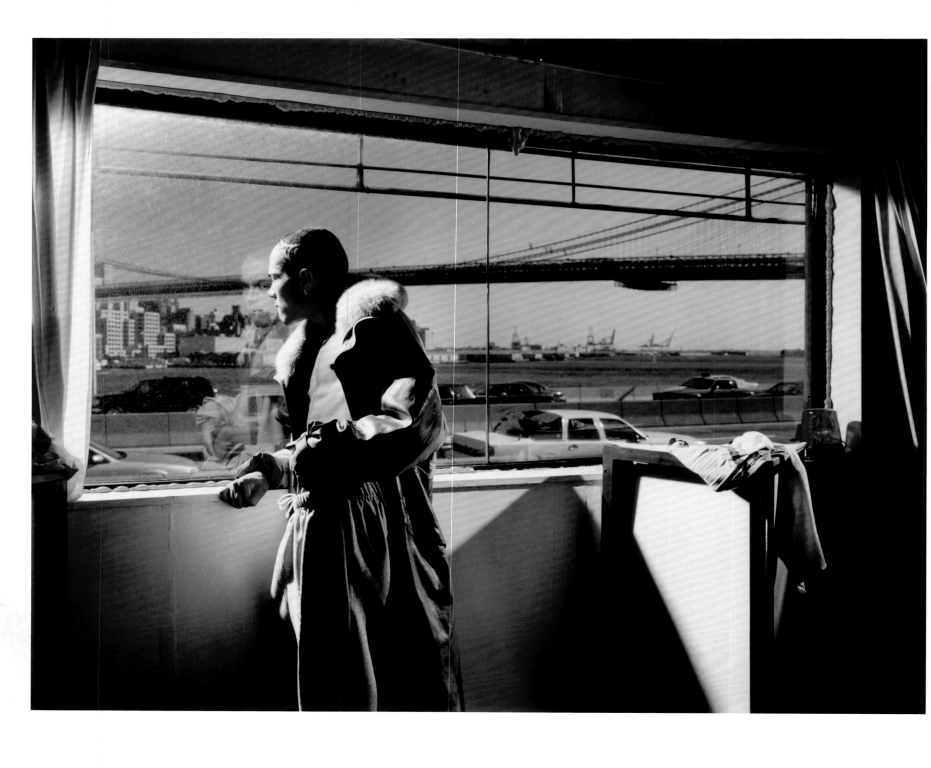

104 . alexei hay . untitled . dutch . 1998

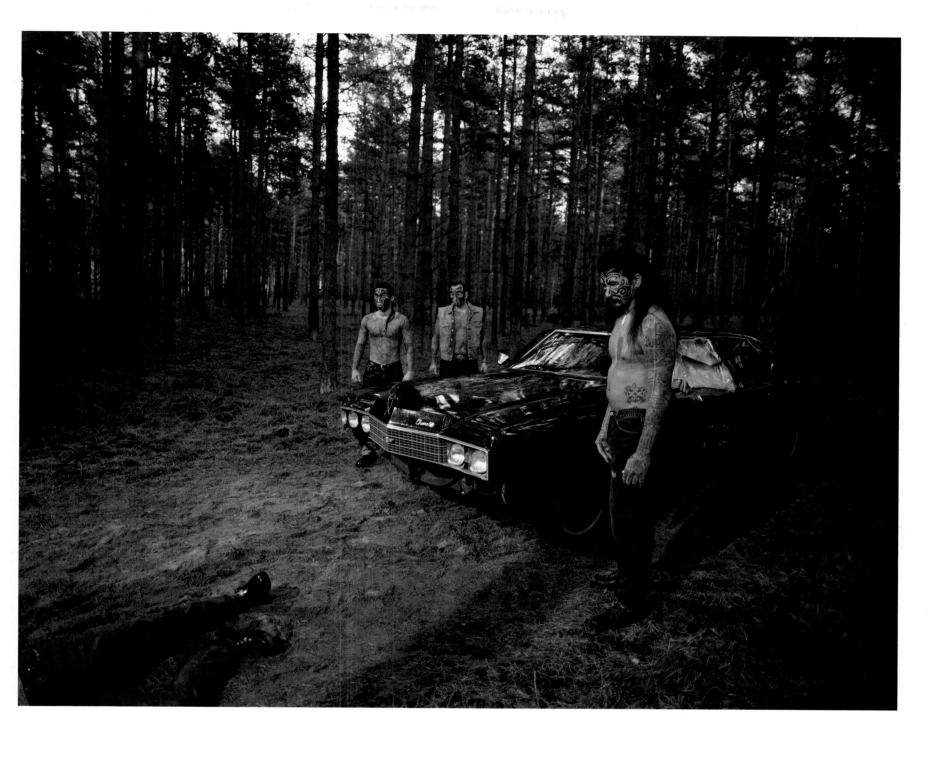

105 . pierre winther . karma, energy jeans . 2001

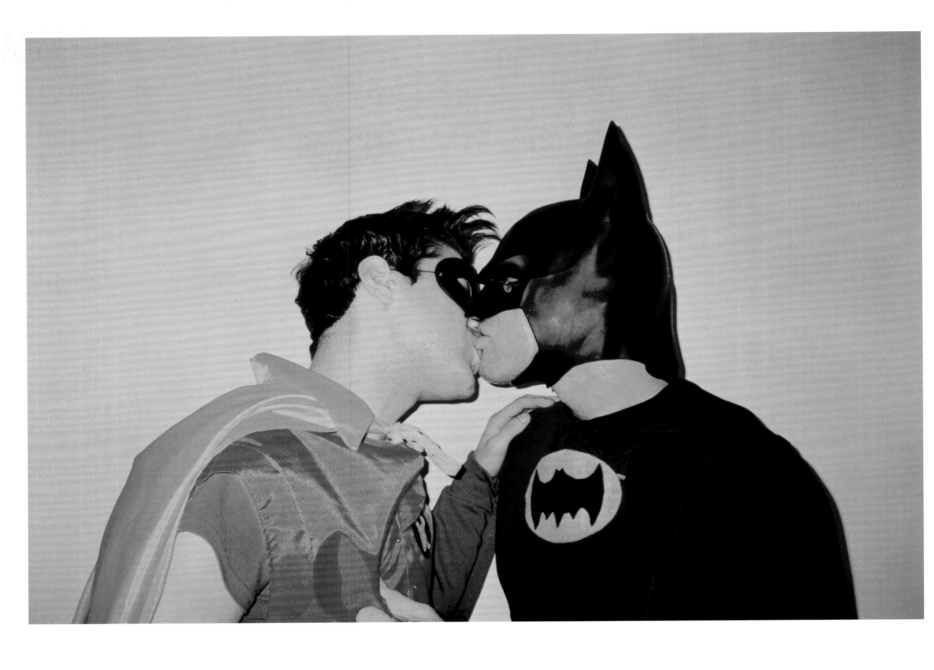

106 . terry richardson . batman and robin . 1998

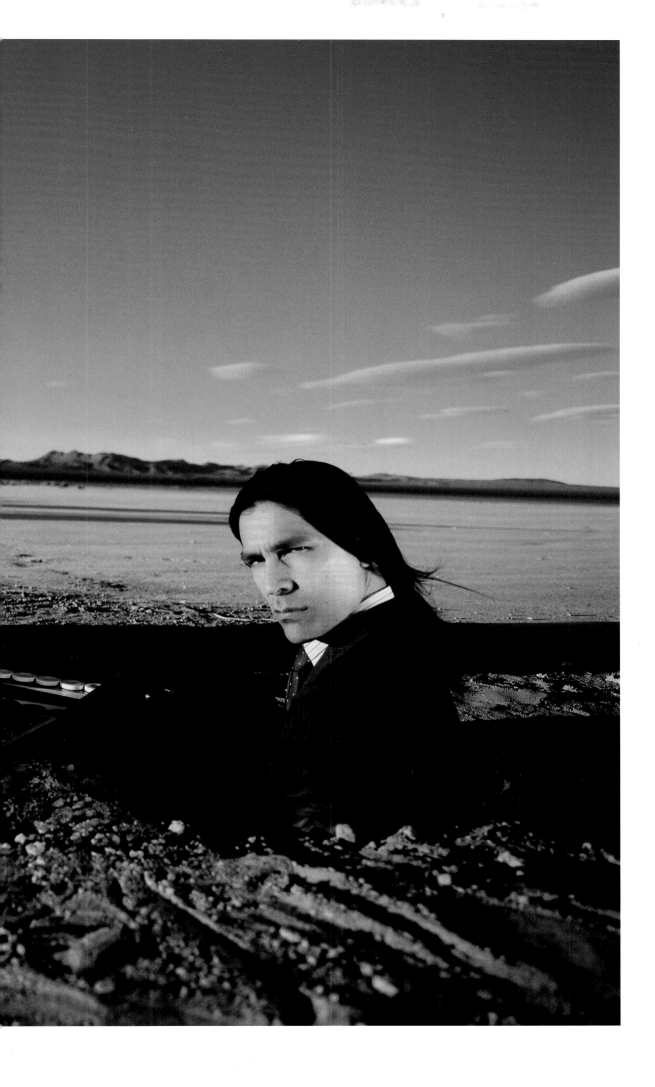

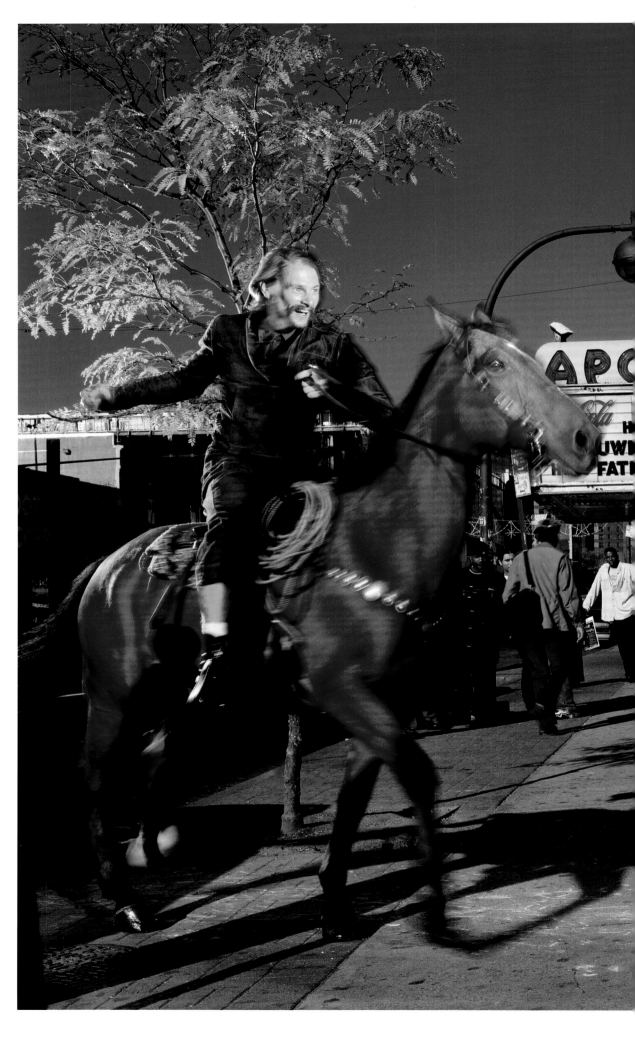

109 . taryn simon . harlem, new york . l'uomo vogue . 2000

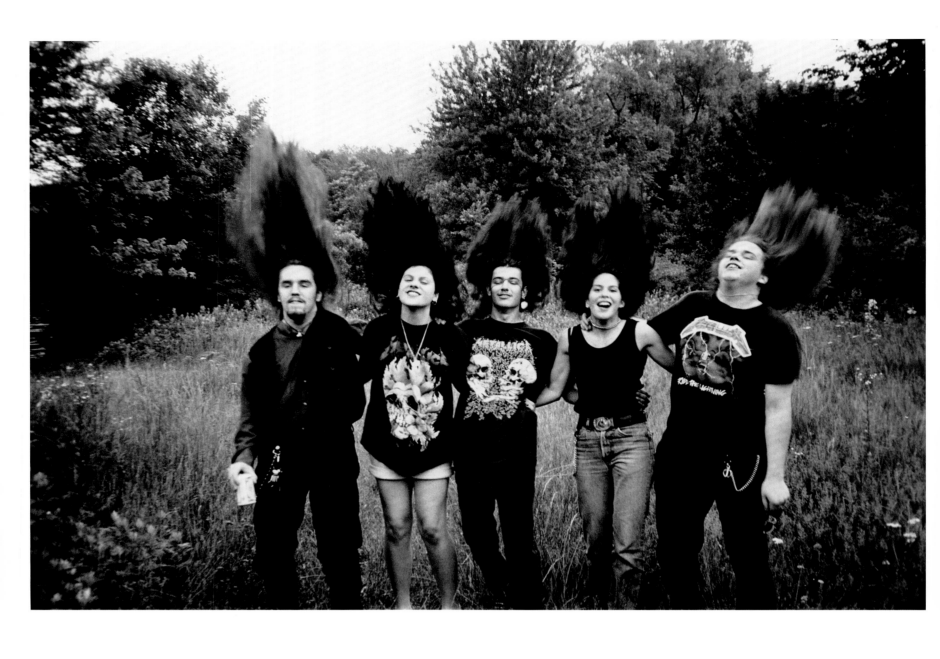

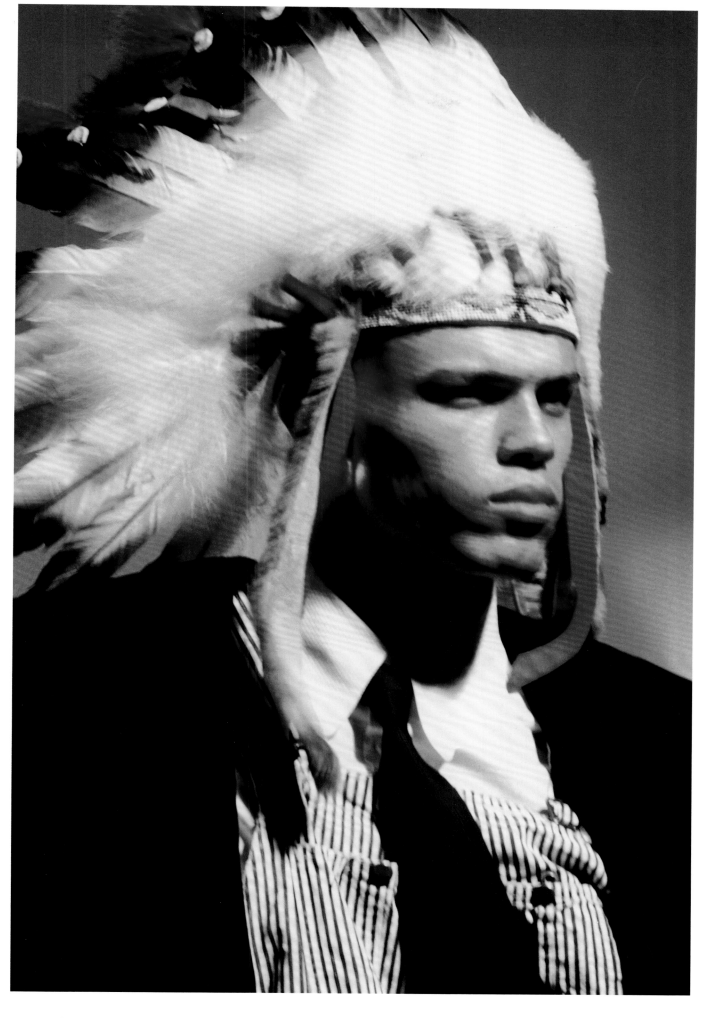

111 . jamie morgan . simon de montford . the face . 1985

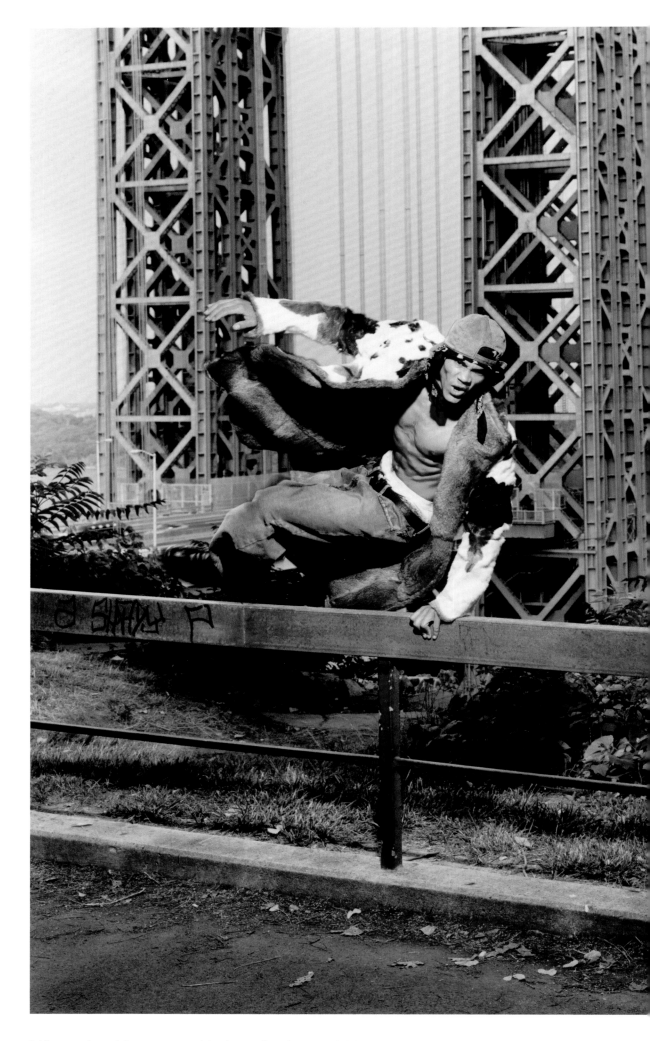

112 . alexei hay . untitled . dutch . 1998

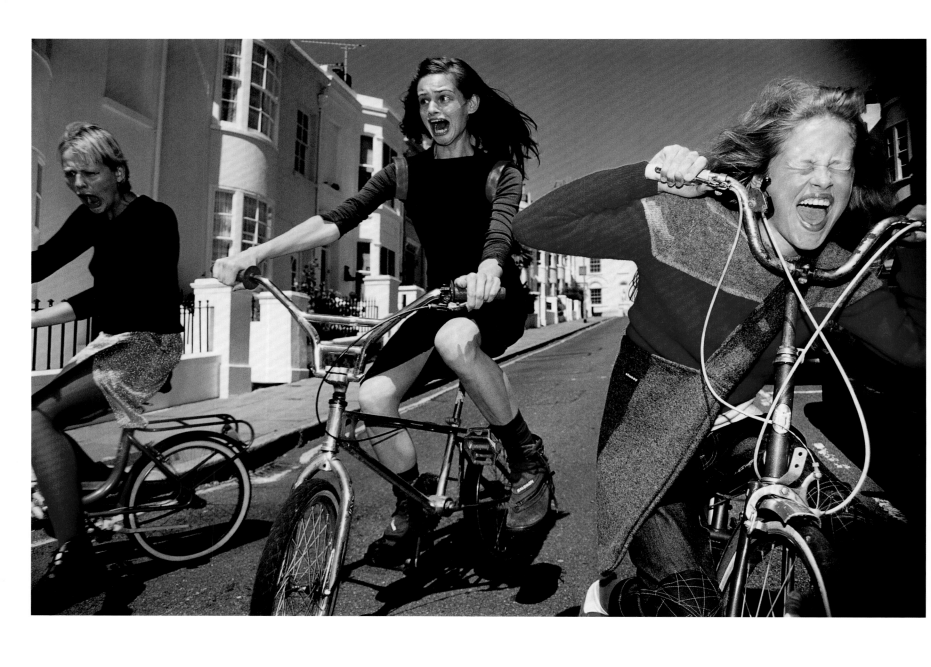

113 . elaine constantine . girls on bikes . the face . 1997

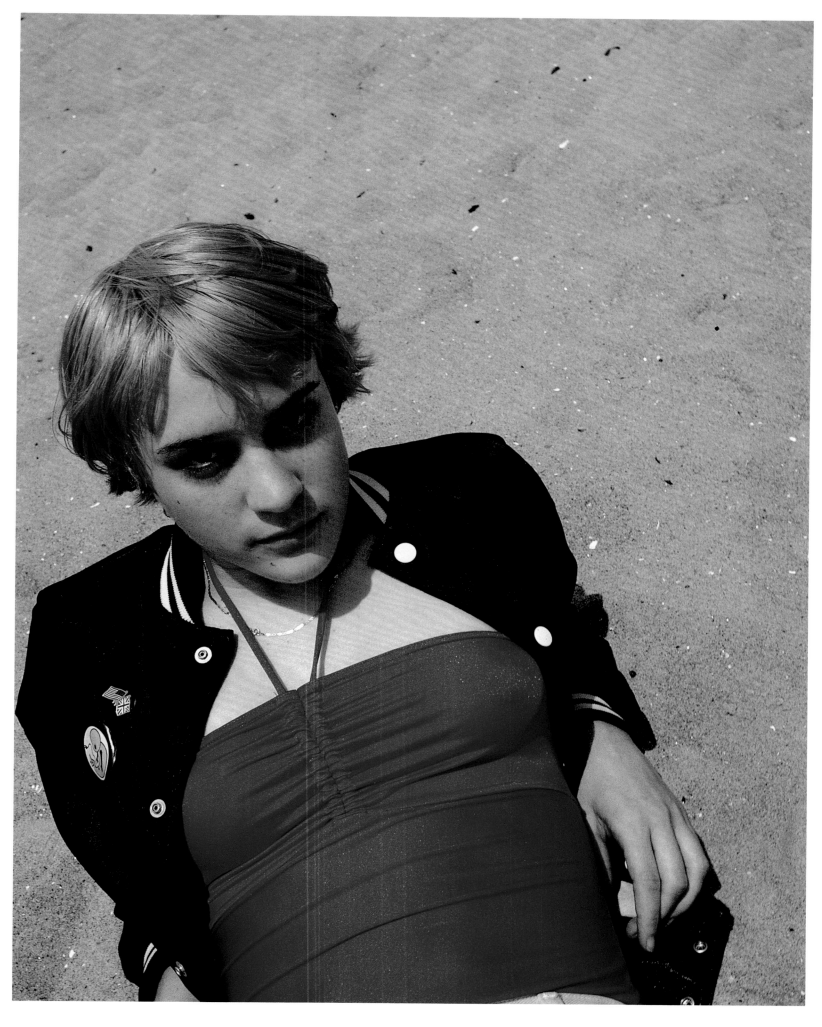

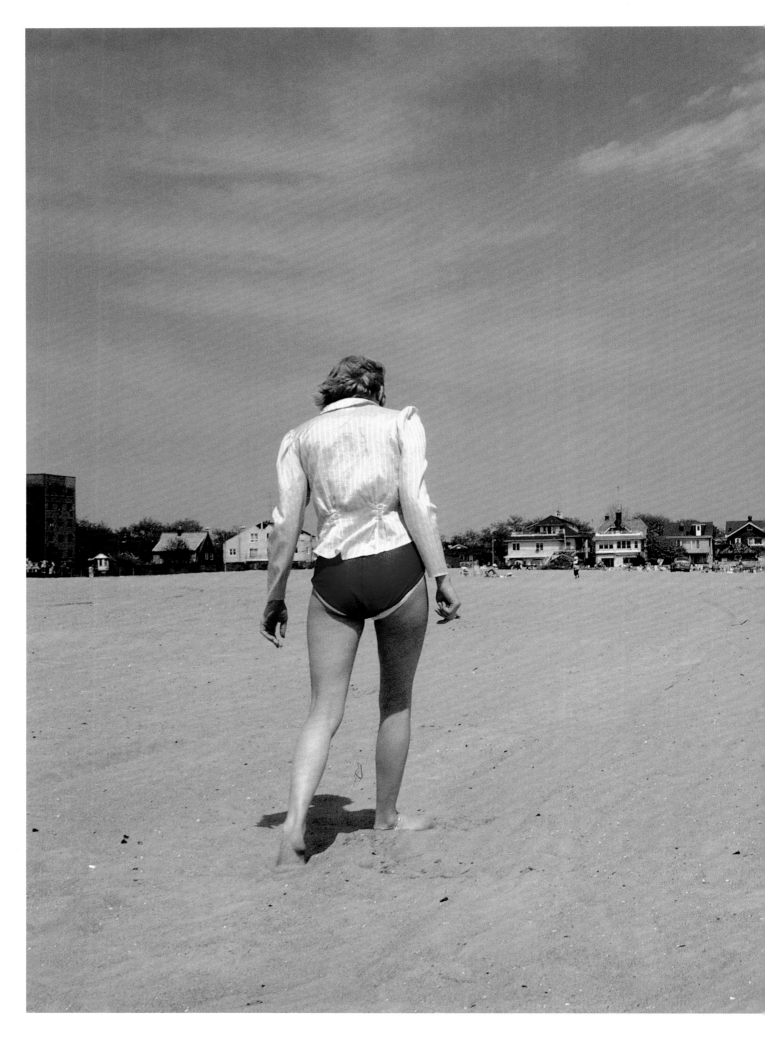

115 . mark borthwick . untitled chloe II . i-d magazine . 1995

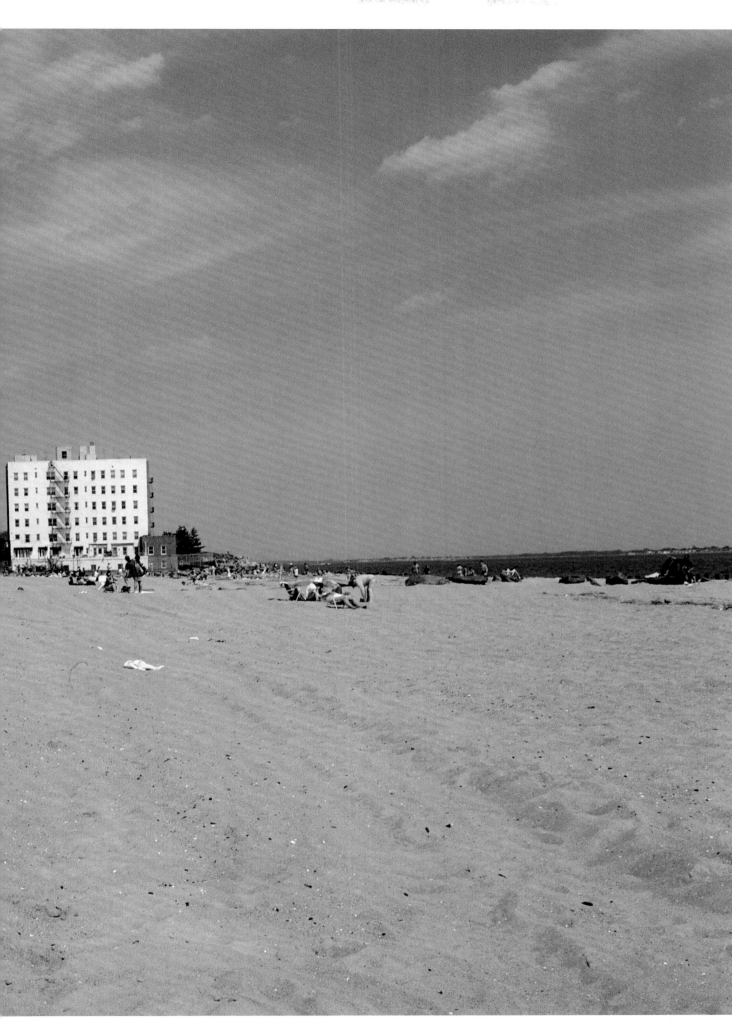

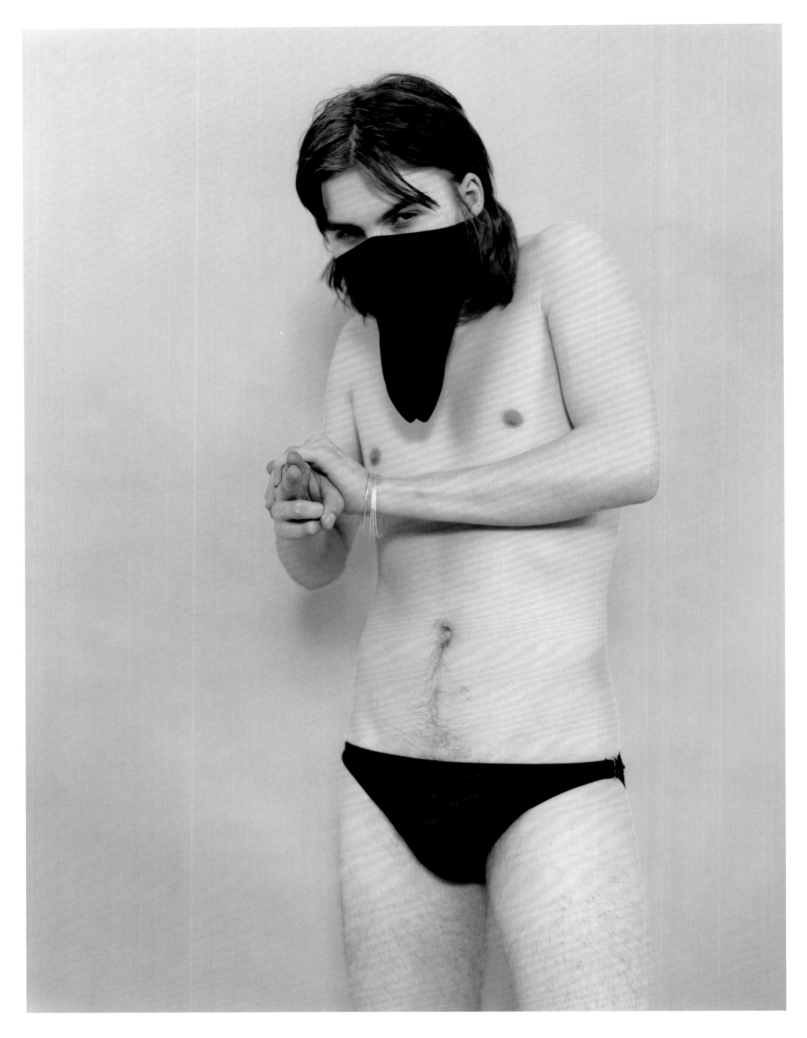

116 . david sims . tom . 1994

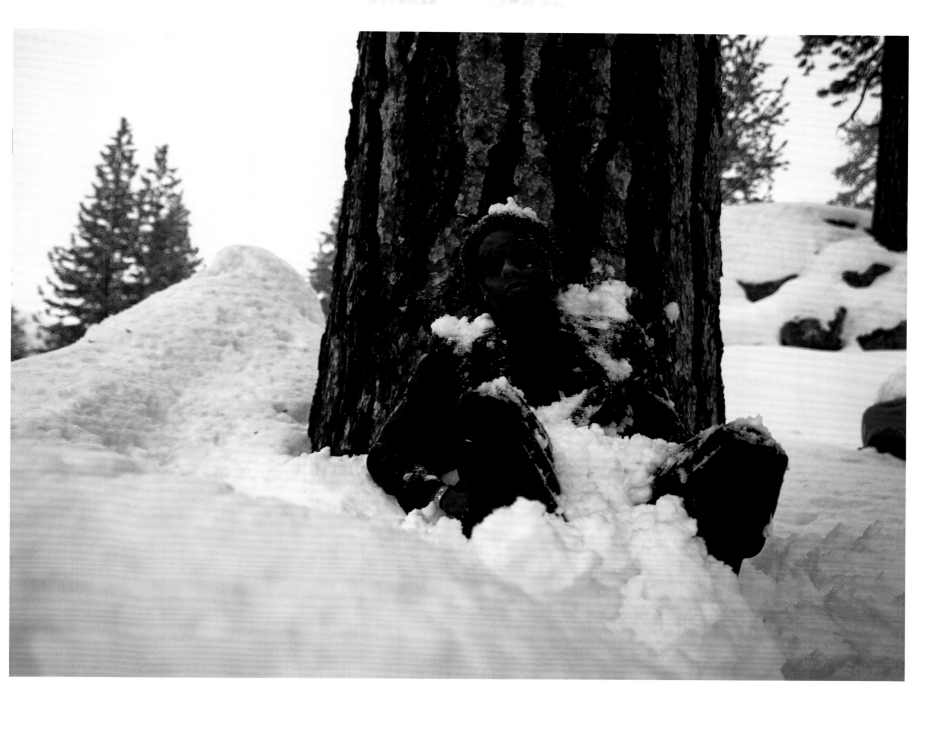

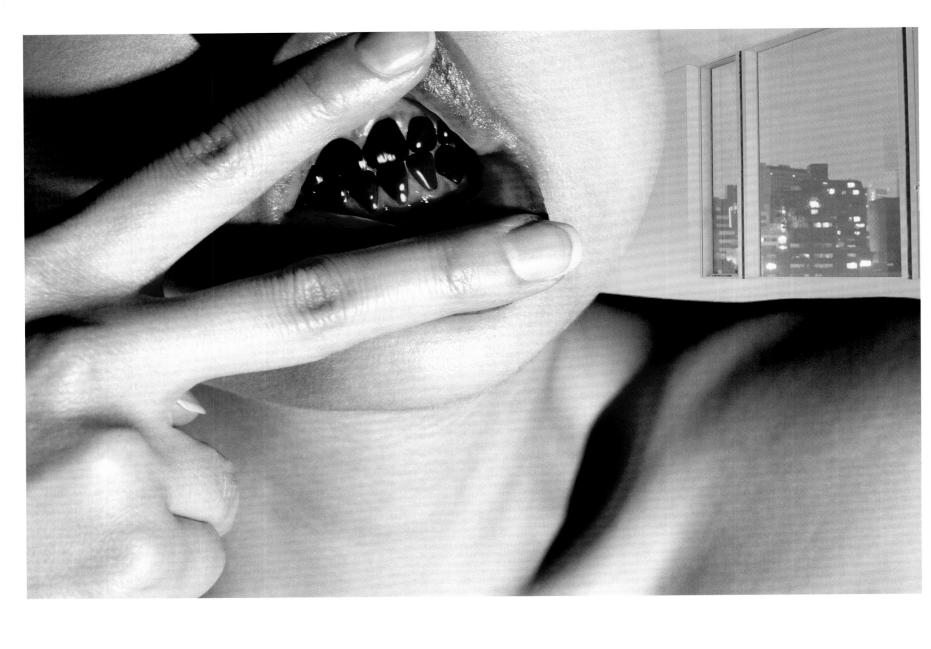

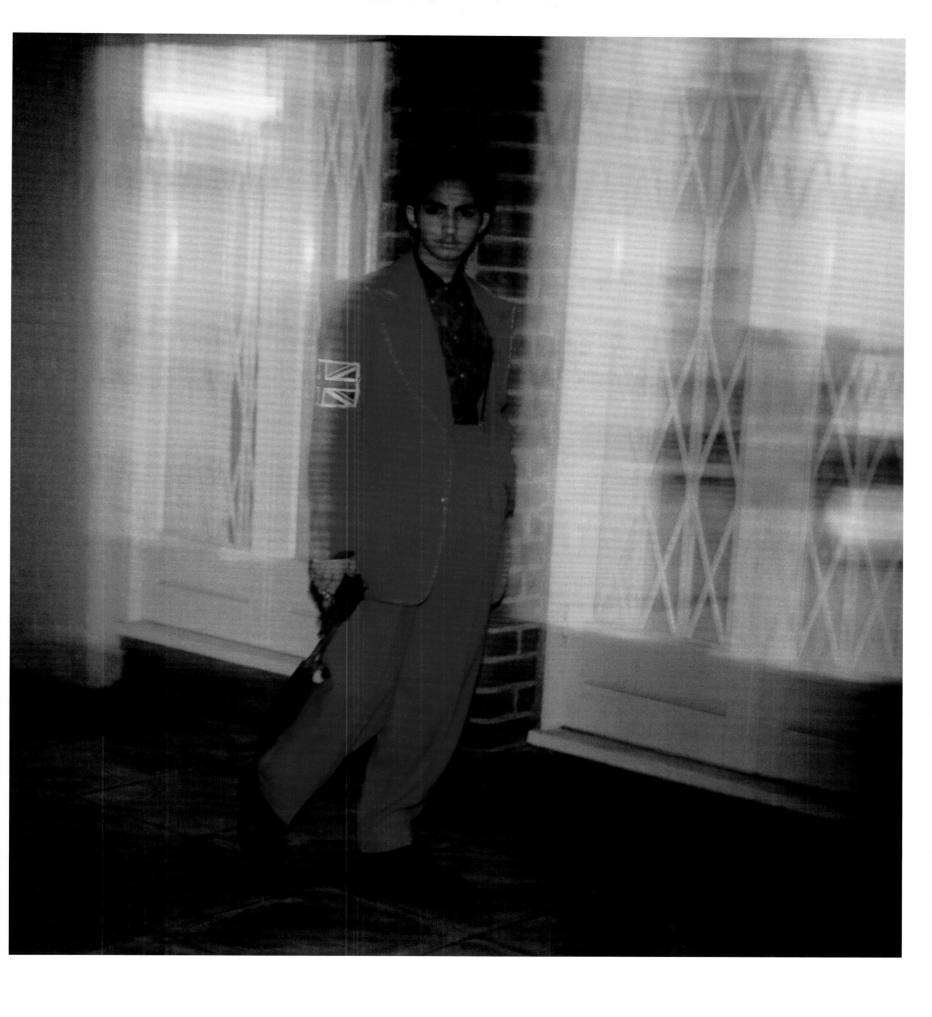

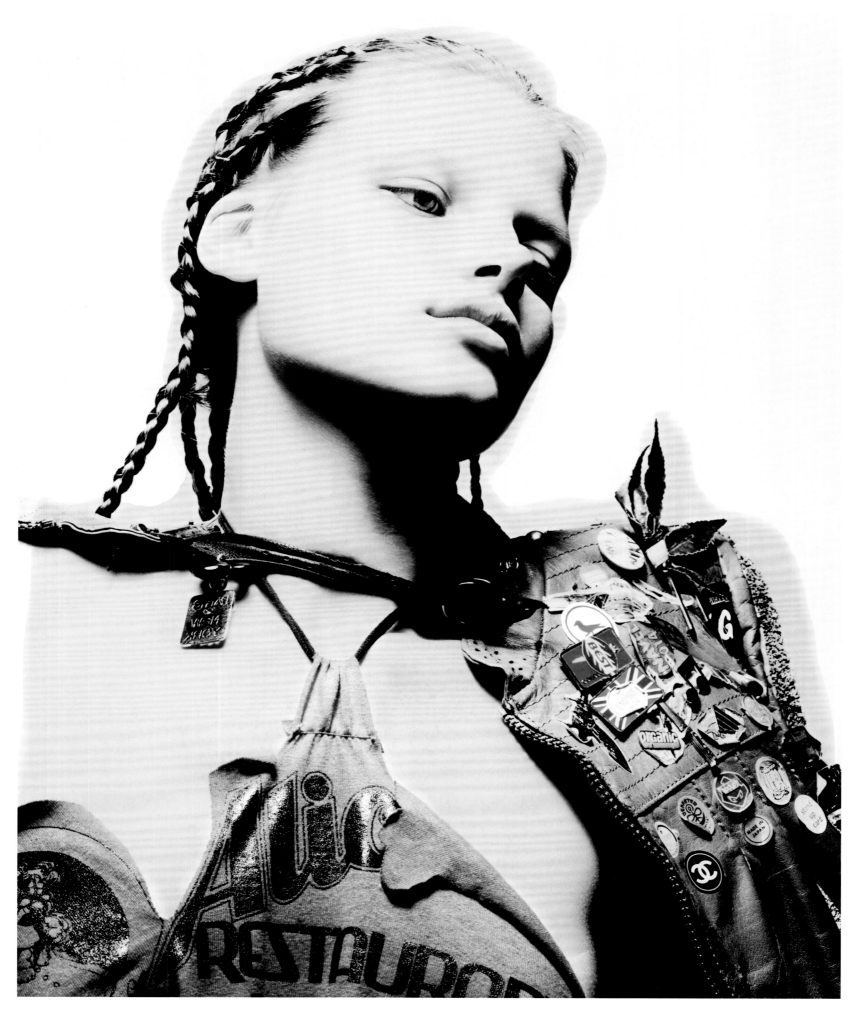

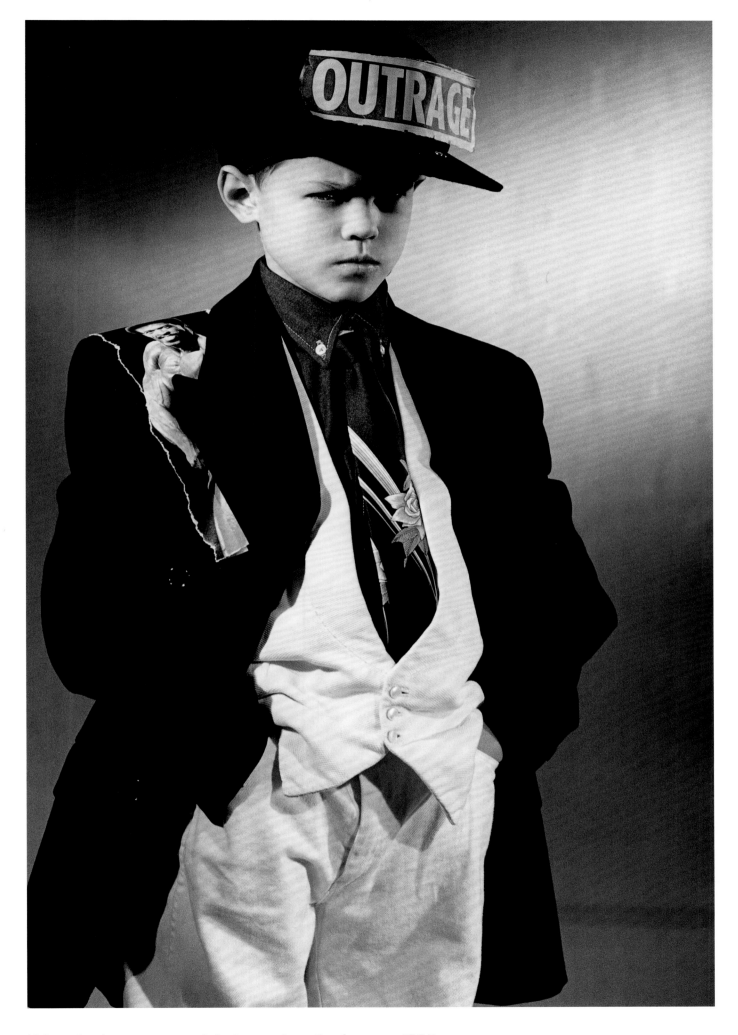

121 . jamie morgan . felix howard . the face . 1985

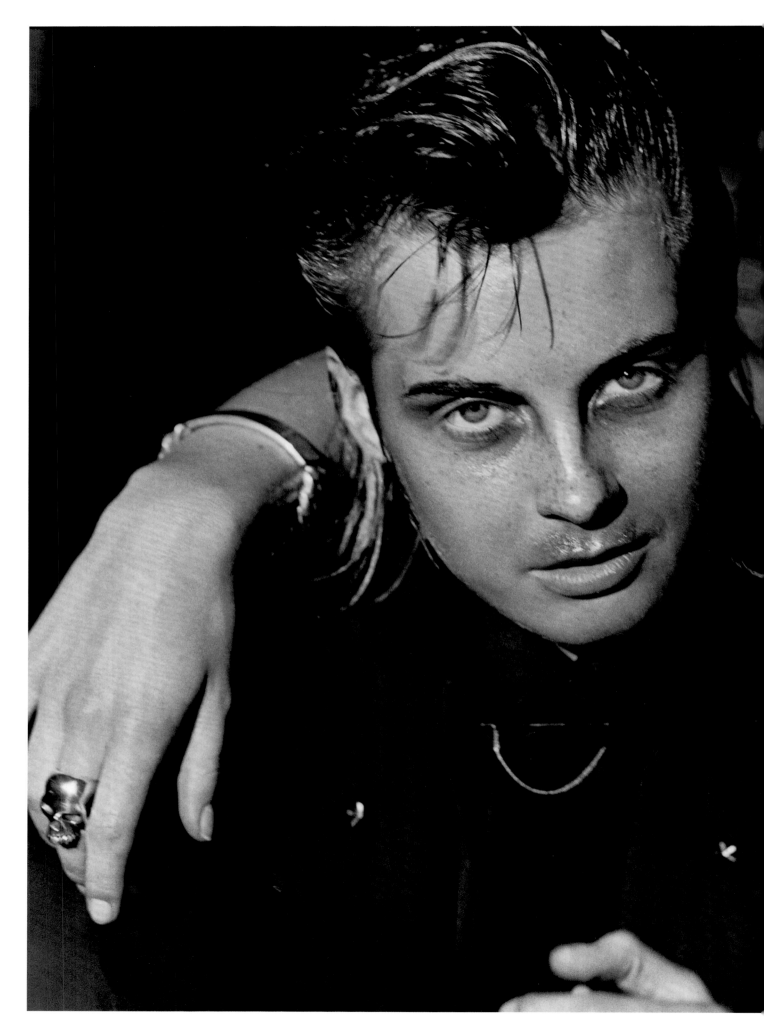

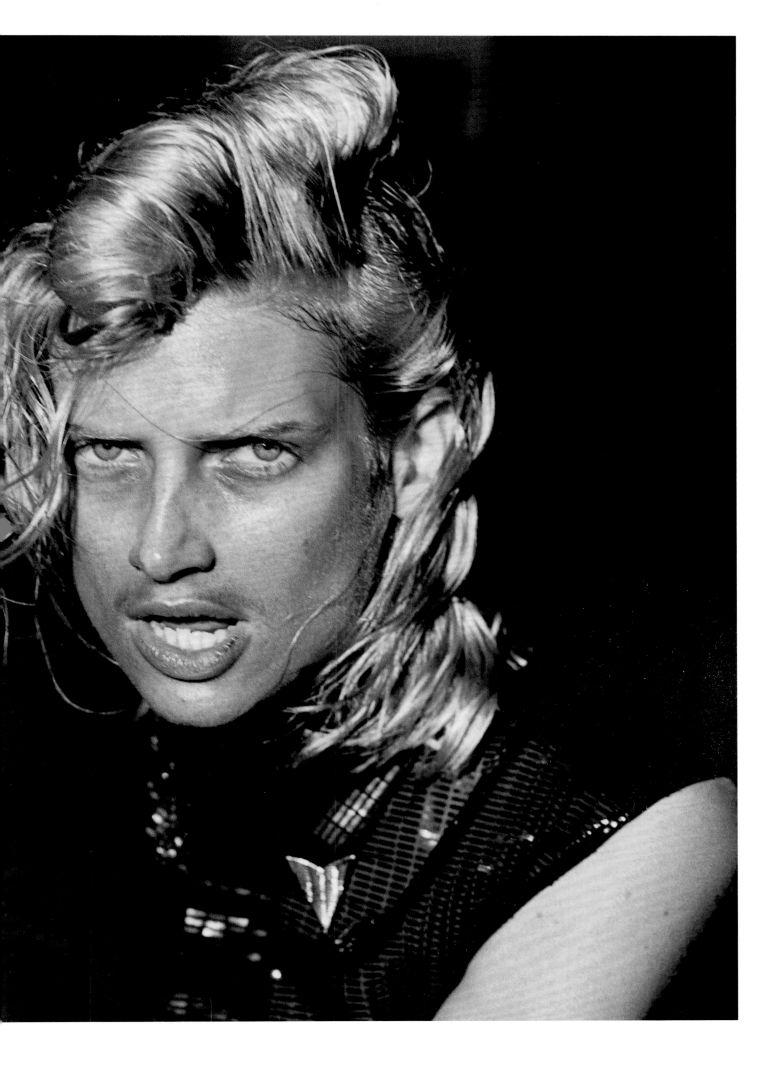

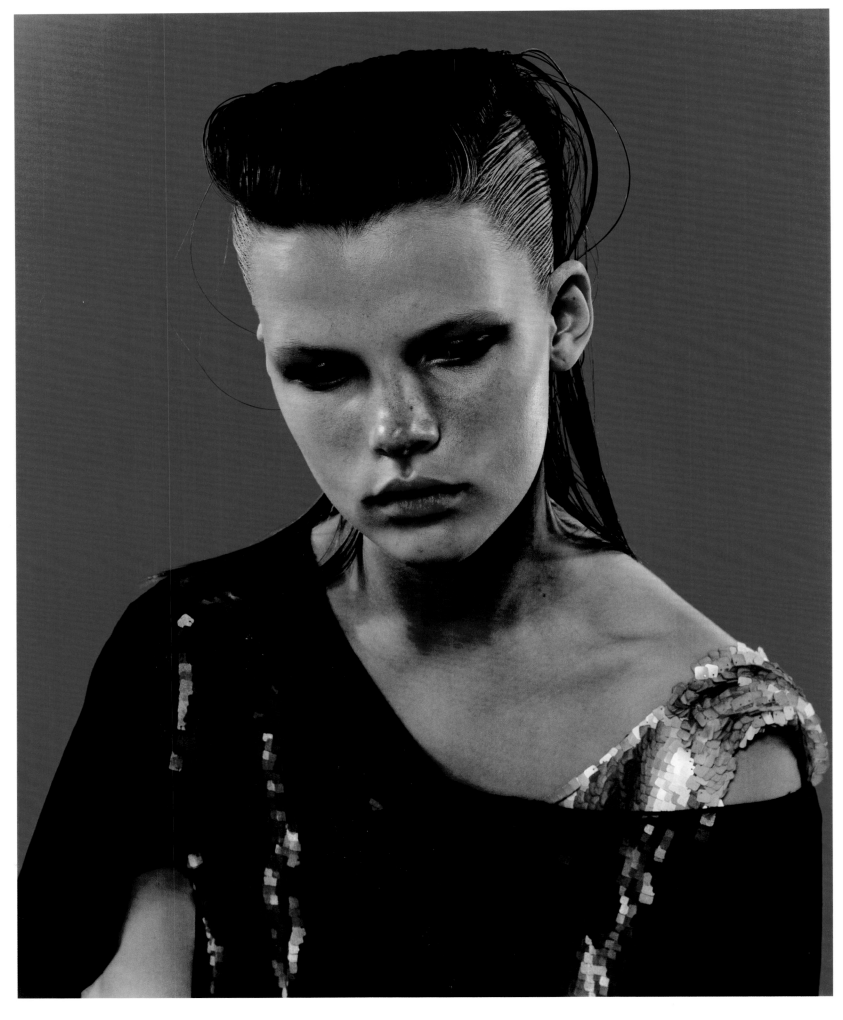

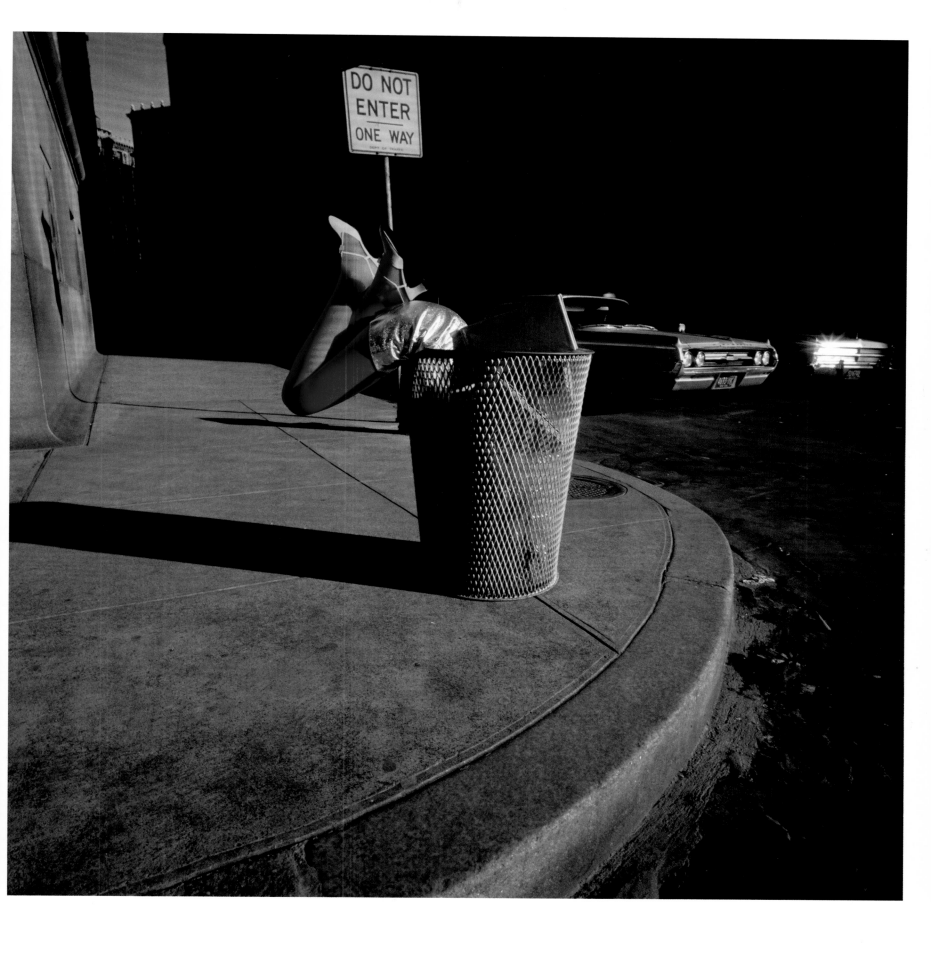

124 . guy bourdin . charles jourdan . 1968

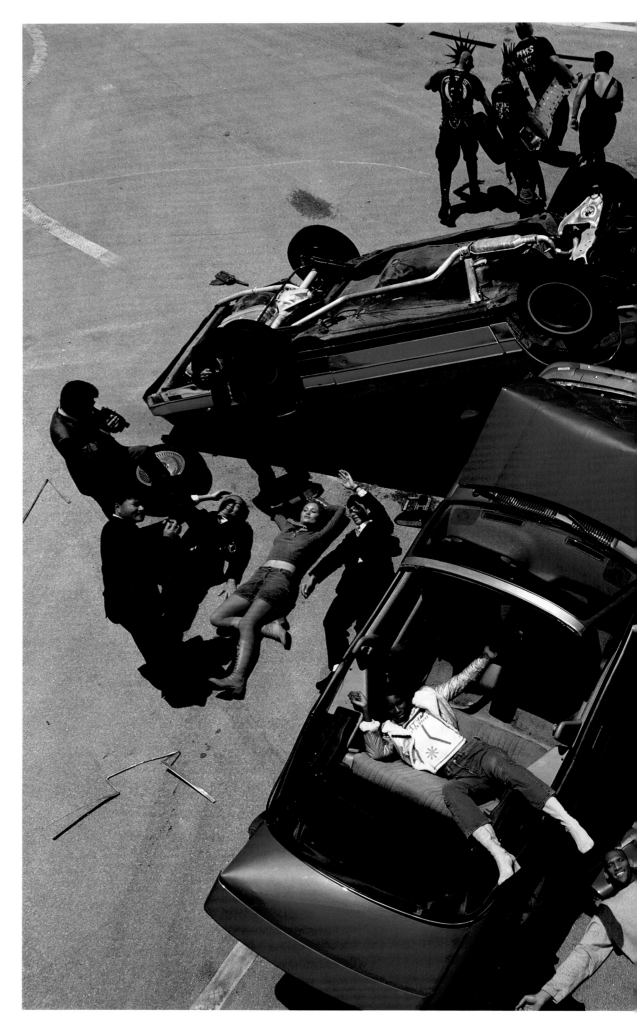

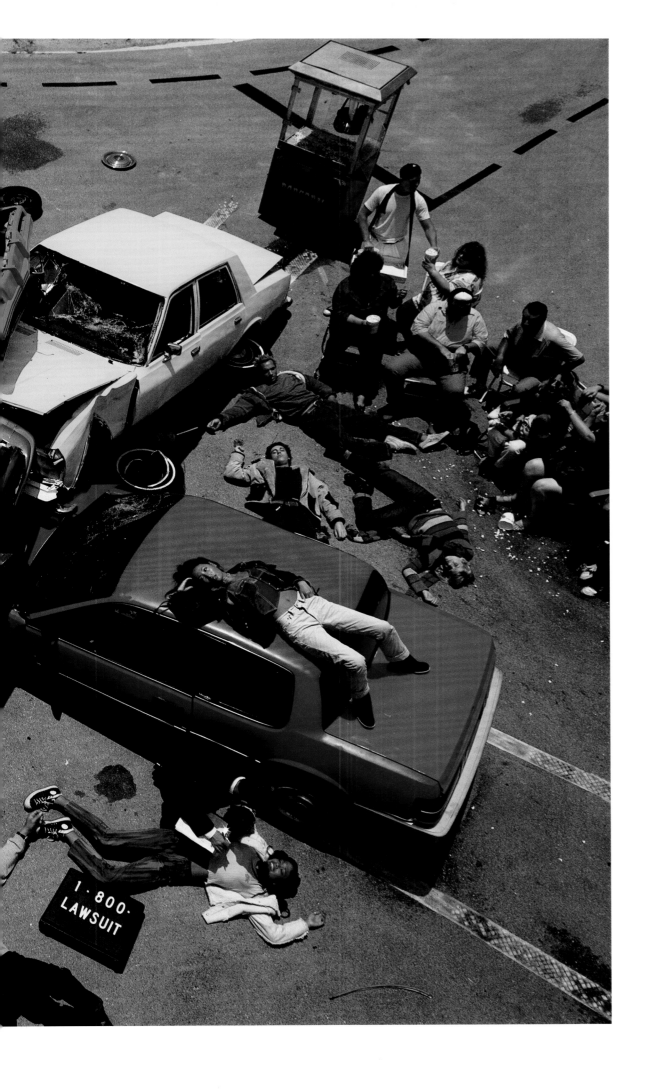

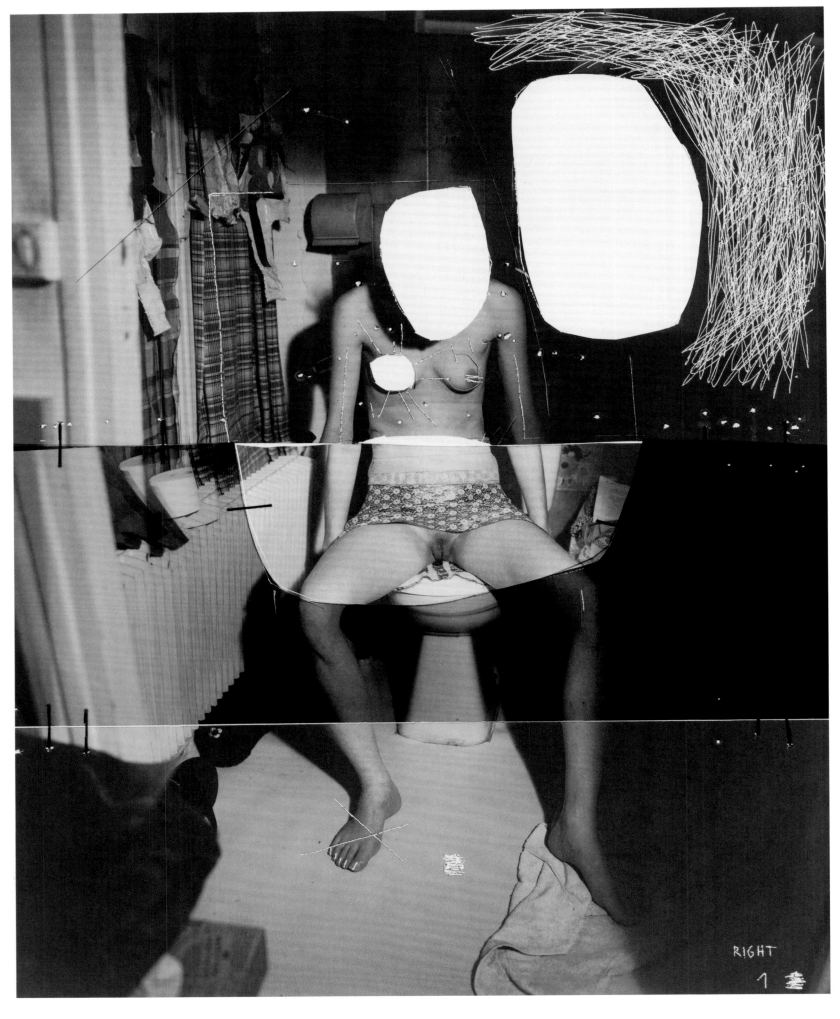

126 . jean-françois lepage . untitled I . spoon magazine . 1999

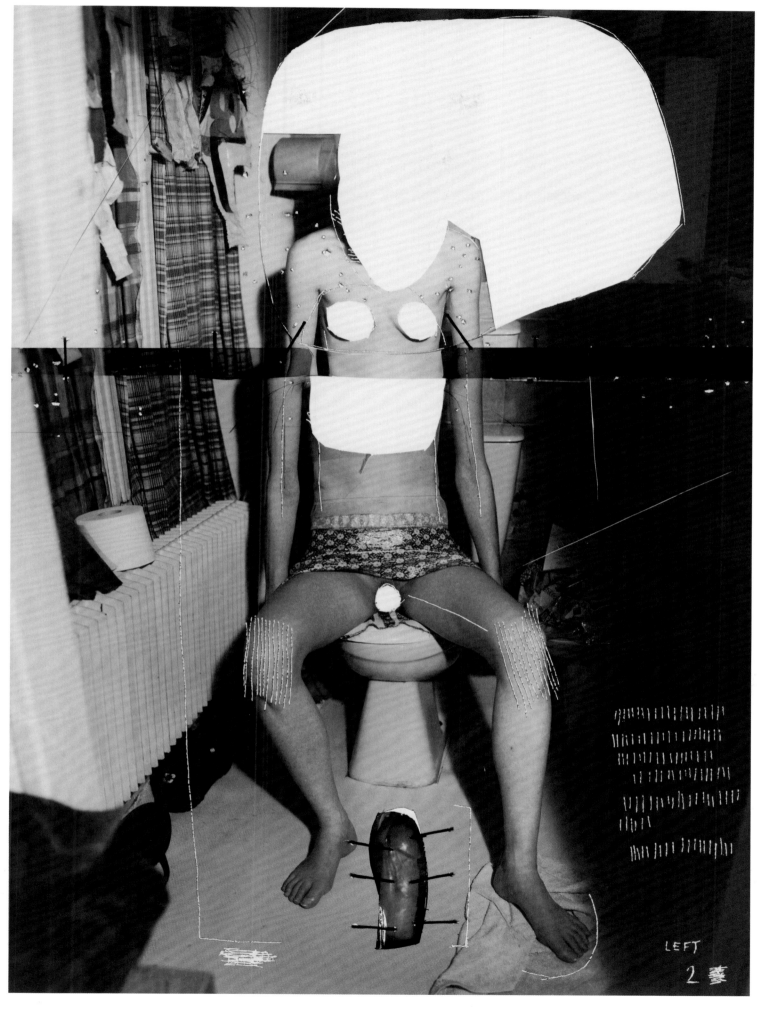

128 . dino dinco . untitled (joe I – hannsy I – joe II – hannsy II), gucci . *surface magazine . 1998

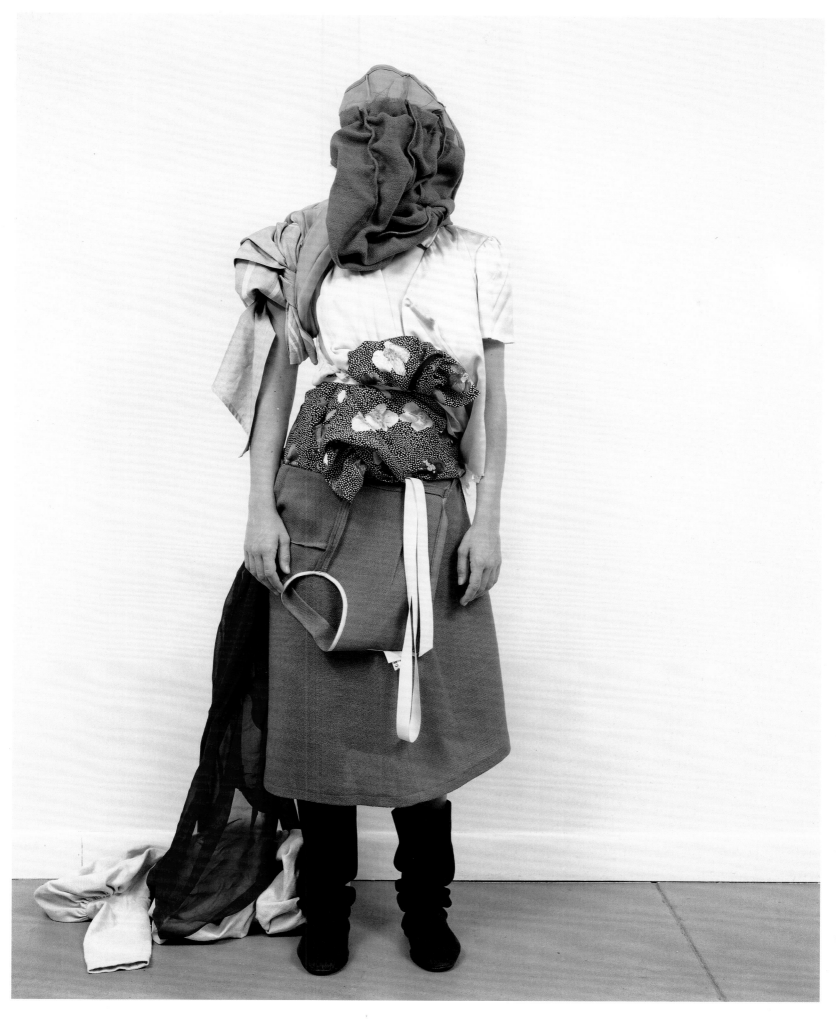

129 ▪ mark borthwick ▪ untitled chloe (fashion show) ▪ purple ▪ 1999

High-tech or futurist fashion photography attempts to make use of state-of-the-art technical production methods in order to tease out the limits of new aesthetic forms. Just as Stanley Kubrick's *2001: A Space Odyssey* was sci-fi not just in terms of its theme but also the production technology used, so too high-tech futurism anticipates the coming images and production technologies at two levels. The coupling of production technology and subject matter has enabled the genre of sci-fi images to develop in leaps and bounds. Things lose their identity ever more swiftly in order to be able to don new identities on the spur of a moment. The digital *panta rhei* ('everything flows') causes all that seeks stability to bounce off the visible surfaces of things. Contemporary fashion photography renders the interim stages of metamorphoses legible.

Whereas classical fashion photography functioned like a magic mirror in which the viewer was transported into wonderland or suddenly found themselves in a remote fairytale – be it glamorous or cerebral, rebellious or even punk – digital fashion photography is only the display of a wide variety of prospective projections: the ego is zapped away and watches itself march by at a vertiginous speed – the 'army of me', as Björk sang. In the cinemas, faces morph from one appearance effortlessly into the next. The liquefaction of identity, as presented in *Terminator II*, challenges photography, which is per se not to do with process. It solves the problem by presenting variety in a single frame – such as the throngs of people in Stéphane Sednaoui pictures, or identity fragmented to the point where it is open but does not seem violated; a mere torso, but where each hole provides a point for projection: *Imagine your identity right here!*

The image-makers are 'people-jockeys' as Frédéric Beigbeder put it: they 'produce a human patchwork!'[12] You take a girl with a great ass, give

12 Frédéric Beigbeder, £ 9.99 London 2002.

her someone else's face, the legs of a third person, the hands of a fourth, the breasts of a fifth. The potential of the new technologies are used in advertising and in editorials to forge posthuman identities. Cosmetic surgeons lend this people-mix a material form. While the twentieth century presented egoism and narcissism as key forms for constructing individuality, the twenty-first century will mark the paradigm shift to self-design. The ego will only be loved if the desired metamorphosis has succeeded, thanks to bodybuilding, bodyshaping or simply cosmetic surgery. Self-hatred is sublimated in an obsessive search for the new ego. To this end, the subject requires models for its potential developmental prospects.

The individual in the age of self-design reactivates a mimetic awareness and the related abilities which enabled human beings to survive from the very outset. Both phylogenetically and ontogenetically, a mimetic capacity has a history but is only vaguely present in twentieth-century human beings. It was used by the individual for identification by enabling the human being to recreate possible role models. Photographic models are construction plans for future egos and high-tech photography defines itself as just that. The images are hardly seductive as construction sketches, let alone instructions for auto-mimesis. Instead, these pictures provide a commentary on the human condition at present and – more importantly – they are a self-reflection, in particular on the consequences of our own endeavours. The medium becomes aware of its own power and at the same moment rejects it.

In the last twenty years, high-tech fashion photography has therefore mainly furnished role models by mistake. It was actually interested in shaping those visionary forces that contemporary culture required at

that time. The goal was to imagine a future that was truly about to happen. For this reason, the pictures seem different, specifically quite unlike those from the orbit of punk rock: they seem anemic and lacking in experience. They show something that knows of no experience. Futuristic high-tech images function precisely at that point where they reflect on a future experience already announced in the present. Its future echoes and outgrowths remain a matter of speculation. The audacity of speculation usually also determines aesthetic innovation – which itself requires that unlabelled experience – in order to be depicted. Benjamin spoke of new, congenial barbarians who construct things at the drawing board without basing anything on experience.[13] In the best of senses, poverty of experience is a call to start anew. To this extent, these are the first pictures of what is probably New Man.

The fact that it was possible, indeed imperative, to construct this person strengthens the significance of cultural speculation. The fact that the artistic and photographic models became blueprints for the imagination of cosmetic surgeons, biologists, doctors and engineers transformed the aesthetic construction into an entelechy of the organic. Art is not only the aesthetic of pre-semblance but the ring master of the future. To this extent, the sci-fi subject matter is part of an empowerment strategy that is the attempt to define sovereignty not only over the culture but over society as a whole.

The choice of subject matter was no coincidence, for culture in the years 1980–2000 was in a state of permanent shock – paralysed by the seemingly magical quality of the years' numerals, such as Orwell's 1984, and the trio of the change to the new millennium: 1999, 2000 and 2001. 'Tomorrow starts today,' was a slogan in Sony ads in the mid-

13 Benjamin, 'Erfahrung und Armut', *Gesammelte Schriften*, Rolf Tiedemann und Hermann Schweppenhäuser (eds), Frankfurt/Main 1991, vol. II.1, p. 214 ff.

1990s. And Microsoft added: 'Where do you want to go today?' Tomorrow became a topic for the present in the sense of a task that had to be mastered. In futuristic fashion photography, fashion, itself always the product of a necessarily trailblazing and pre-empted present, was taken seriously as a visionary cultural form. Back at the beginning of the 1980s, the codes chosen both for fashion and for photography largely obeyed the definitions set by sci-fi films and comics. The trivial nature of the images made them seem old, for all the stress on future as their theme. Lindbergh's romantic history with the small extra-terrestrial that does not belong in this segment of high-tech photography, is a good example for the drollness associated with the future.

In fashion photography, the question as to the narcissistic other was more pressing. What was supposed to become of the ego if the 'human' person disappeared like some drawing in the sand washed away by the waves? The threatened loss of the category of the human was processed in a flood of images depicting dolls and anthropomorphous figures. These were so evidently lacking in life that they attested to the death of human beings – the way for the death of human beings is paved by figures that seem dead. Or to go even further: the people are already dead.

At this point – and it almost appears as if this is the location of fashion photography over the last two decades – the staging of glamour, art and high-tech photography occur simultaneously: the old images of man are taken to the grave as they obviously have no future. In the First Surrealist Manifesto of 1924, Breton stated that one of the achievements of the Surrealist image was 'to lend the abstract the mask of the concrete.'[14] This succeeds in all pictures which, in retrospect, in the

[14] André Breton, *Manifestes du Surréalisme*, Paris 1946

present and with a view to the future, question the crisis in the category 'human being'. The striking innocence of fashion photography and its tendency to be decorative address the pending or actual death of the human being, outside the critical discourse that usually deals with it.

Mondino, Laurence Sackman, Nick Knight or Seb Janiak photographed people like dolls and dolls like people in order, on the one hand, to dissolve the categorical difference between the two visually and, on the other, to arrange the same lifelessness in both subjects. Here, again, fashion photography logically becomes critical of prevailing ideology. Just as thousands of photographers previously used their models like dolls, the reverse is no longer attempted – to transpose extinguished life back into some semblance of life. Instead, the last traces of animated gesture and expression are frozen and dehumanized. Surfaces gleam and shine. They only give people the hope that their simulations and avatars can at least assume the underlying traits of the beauty of original creation.

At the same time, the subject thus becomes an object and dons its special form of passion: non-differential and static; the passion of indifference, or as Baudrillard construes it – as the antithesis to the differential, dynamic, ethical and heroic passions of the individual.[15] In the same context, Baudrillard speaks, incidentally, of the enigmatic desire of the individual subject to become object. The desired indifference, yearned for by the Futurists via Warhol to Detroit Techno, borrows from the post-human notion of stoic ataraxy, by which the latter comes into conflict with basic humanistic principles. As irreconcilable as the being that is part human, part doll, is likewise the yearning to abandon subjectivity, which is at the same time the highest level of subjective decision-mak-

[15] See Baudrillard, *L'autre par lui-même*, Paris 1987, p. 74.

211

ing: the will to a loss of will appears to be a self-contradictory construct.

With reference to Jacob Burckhardt's *Cultural History of Greece*, Adorno emphasized that the point at which the individual disappears is of a 'untrammelled individualistic' nature.[16] Adorno's admonishment can be read as the subtext of futuristic fashion photography. The form of posthuman individuation prepares the fracturing of the individual subject into isolation. For this reason, alongside the dolls, cloned ego-multiples constantly occur, the so-called 'army of me', as if this were able to avert the attacks launched by alienation and dehumanizing technology.

16 Adorno, *Minima Moralia*, p. 169.

The most extreme image of alienation is that of the transformation of life into lifelessness, of animation into de-animation, of warmth into cold. The flight into the posthuman as a response to this is as resigned and fatal as it is rebellious. The will to be completely an individual is raised here, perhaps for the last time (in the old form). Photographers and theorists alike use almost identical stratagems to consider the paradoxical thrust of this desire, to formulate its content and visualize it. The transition of the person into the serene loss of destiny of all objects is as enticing as it is depressing. And the loss of moral voice resulting from this process is exploited by aesthetics in order to emerge victorious from the fray, with all the opaque lines of battle, a partisan beyond all the declared parties to the conflict. Where linguistic, moral, and philosophical inconsistency prevent decisions, aesthetically convincing images make tempting offers. The beauty of the future presented in a visionary manner strips the threat of its awful mask. 'Welcome to the future,' promise most of the pictures, simply by spreading the illusion that they offer an overview of things.

The advancing control function of photography from the outset, owing to its ability physiognomically and physiologically to pinpoint

things, promotes the yearning for the non-identifiable. There is a broad cultural resonance beyond fashion photography. The wish of the mass murderer to coat himself in the skin of another (*Silence of the Lambs*) is just as much part of this as is the actor's desire to merge with the make-up and mask of his role and no longer appear as a person. This is an ancient cultural phenomenon, long before the invention of photography, that is repeatedly lived and celebrated with the current state of technology. Schizophrenia represents this rupture which Hegel considered in his *Phenomenology of Spirit* as the challenge to the balance between the *in itself* of the individual and the *for itself* of the individual as separate entities. By virtue of the fact that the *for itself* becomes essential and is meant to be divided from the *in itself*, in order then to throw this round its shoulders like an old scarf, the mask is covered with an alien skin that becomes a new, personal skin. Fashion and photography offer a lightweight version of schizophrenia: a *panta rhei* of roles and ego-masks. The respective appearance is the time code for our visual image of person and identity. The syndrome of schizophrenia is now transcended: syndrome and pathological approach originate in a form of discourse in which identity is defined less through flexibility and more through rigidity. The dissolution of roles into any number of role models is synchronous with the digitalization of identity in photography – especially if it focuses on fashion, i.e. the playful use of identity.

The claim by the pastiche spy Austin Powers – 'It's great to be me' – is only funny because the person himself is a fake: alternating between ironic double and distorted sample of James Bond. The sentence only functions as a joke and is only acceptable with reference to a figure who is a joke. The outsized human figures in pictures by Thierry Le Gouès or

Andrea Giacobbe should be understood in the same way. The super-models as high as houses are an ironic commentary on their exaggerated appreciation and an indictment of the excessive assessment of people in the age of their relativization. Extinct dinosaurs or King Kong become the prototypes for a projected process of extinction. They occur in similar fashion in music videos: where people don the guise of superhumans, their end has already been tolled.

The idea of harmony between the inner and outer worlds is revoked. The refusal to accept one's own flesh, own skin and physiognomy, and very often the refusal to accept one's own gender, can also entail a more radical thrust to that anthropological conception that seeks to distinguish between the individual's inner and outer reality. Harmony as expression on the outside and satisfaction on the inside is replaced by alien visual samples in the form of computer-retouched identity. Physiognomy, physiology and environment blur in a harmonized cosmos of sign and signification, Kodwo Eshun's 'syntaxcapes'. Many high-tech fashion photographers therefore rely on sharper contours of the outlines of the model/doll, as seen in pictures by Sølve Sundsbø or Nick Knight. As with the border lines drawn between countries whose landscapes merge, this delineation seems somewhat arbitrary. Other pictures by Sølve Sundsbø, Mondino or Nick Knight foreground the contours of the human body by removing the background. The constructed human image threatens to dissolve otherwise.

The yearning for metamorphosis led in the twentieth century to moulting rituals, so cruel as to highlight this compulsion to change. The fact that the human body is not simply able to mutate from within by means of some organic process in order to achieve the desired body is demon-

[17] Editor's note: the film *Manhunter – Red Dragon* directed by Michael Mann (1986) is based on the novel *Red Dragon* by Thomas Harris, whose second novel about Hannibal Lecter, *The Silence of the Lambs*, was made into a film by Jonathan Demme (1991). Harris's third novel *Hannibal* was made as a film by Ridley Scott.

[18] Given his dislike of physiognomics and craniology, Hegel proposes taking their limited determinism to the point of absurdity in the one case with a clip to the ear and, in the other, by cracking the skull, thus presenting the narrow-mindedness of these doctrines.

strated scornfully by the scarred, coarsely sewn, tanned masks and skin suits of an Ed Gain. Hannibal Lecter's revenge on Will Graham, the investigator in the *Red Dragon*, is exacted on his face.[17] Lecter disfigures Graham's face so badly that he can hardly endure seeing himself. And in so doing he violently implants in Graham the desire to mutate into a being that no longer looks so ghastly.[18] In a James Bond film the retina of a soldier is implanted into the eye of a criminal agent – the soldier in question can control nuclear weapons with his eyes. This upgrading of a part of the face accords with an instant increase in the value of the physiognomy over responsibility. The biometric data for the control and supervisory functions that rely on physiognomy lead to a conscious and subconscious head-over-heels hunt for a way of reproducing the relevant face. While cinema had already introduced the moulting of flesh before the advent of Lara Croft and *Final Fantasy*, fashion photography used digital processing at an even earlier stage in place of manual retouching in the darkroom. Photographers' efforts with computers are more closely related to genetic engineering than to cosmetic surgery, for in terms of its corporeal level, the engineering seems more closely in discursive line with skin masks, photomontage, and retouching. The development of the artistic photography of Claude Cahun via Cindy Sherman through to Vanessa Beecroft is likewise structured along a line of increasing dematerialization and virtualization, which both offer and increase artistic control and flexibility.

The emphasis is here on the face as the means to preserving identity. Physical changes to the body are subordinate to the explosive issue of identity policy. Genetic breeding of ersatz-faces is now not so far away. In John Woo's *Face Off* the face becomes the display of a convertible

identity. In Jonathan Demme's *Silence of the Lambs* Hannibal Lecter surprises the prison warders by laying the face of one of them over his own like a mask, having peeled the skin off the man. Here, the body of the murderer and of the policeman seem robbed of any significance in creating identity.

Hannibal Lecter becomes anonymous by donning another person's face as a mask. He then becomes the victim because his face stands likewise for the danger of intelligence and a pathological outlook. In the case of pop culture heroes considered morally good, in videos and comics the heads are inflated: they mutate to become disproportionate to the body, as with Mickey Mouse, the Simpsons or Alf, whereas the extremities shrink. Behavioural scientist Eibl-Eibesfeldt attributes this to the associations of niceness it triggers since the portrayal brings to mind the immense head of a baby compared with its body.[19] In *Come To Daddy*, a Chris Cunningham video for Aphex Twin, the body of adult Richard James is grafted onto babies' bodies in order to invert precisely that inevitable association and thus generate as nauseating a feeling as possible. The normal face-to-face situation is subverted and with it a central form of interpersonal communication that is predicated on the face and the position of the eyes. If this possible level of contact is lost owing to the partial destruction of the perceptual system, then the syndrome is termed visual agnosia, or 'soul blindness'.[20]

The illusion of the doppelgänger, as encountered in film noir and which introduced the fear of mistaken identity as a symptom of modern alienation, receives its contemporary equivalent in the form of the multiplication of the face. Anything and everything can become an identical image of your own face. However, the 'army of me' is more an ally of the

[19] See Irenäus Eibl-Eibesfeldt, *Die Biologie des menschlichen Verhaltens, Grundriß der Humanethologie*, Munich/Zurich 1995, pp. 94–99.

[20] Ibid., p. 619.

216

ego than a threat to it as the traditional doppelgänger usually was. The notion of a 'transparent human' that has arisen in the age of genetic fingerprinting fuels the primordial fear that inside and outside can be seen through. If nothing can remain concealed and everything seems visible, then it is the task of photography to render the transparency of things and people inscrutable. The multiplicity of identities such as can be created on-screen becomes the time code of the fantasies that the respective individual (as the object of the image) could have, or rather it displays the possible self-designs that people today could imagine.

high-tech
and futurism

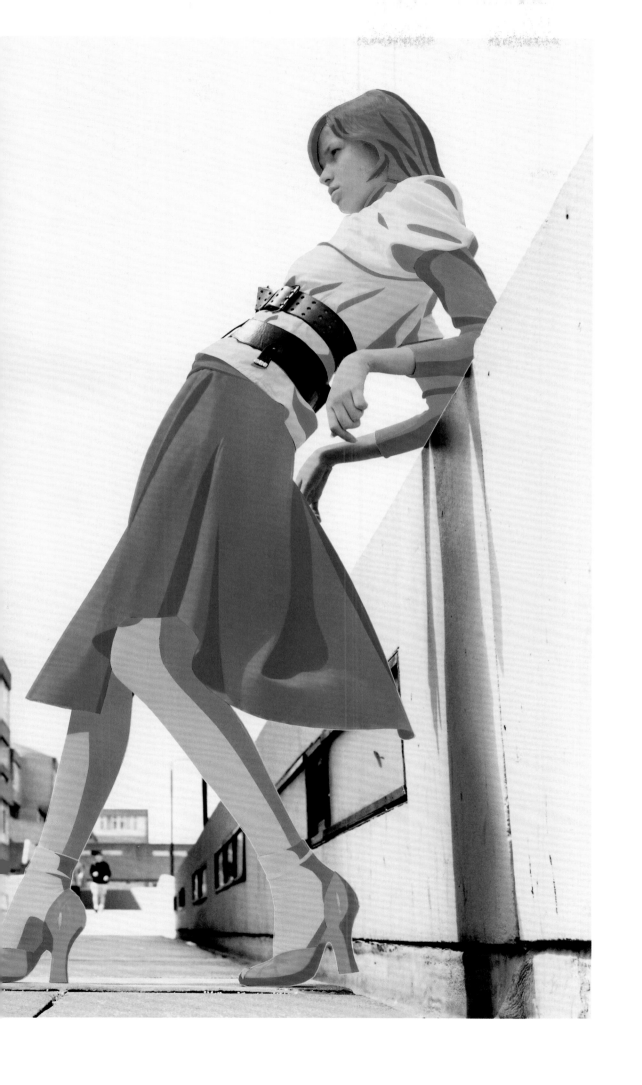

131 . sølve sundsbø . headscape . dazed & confused . 1998

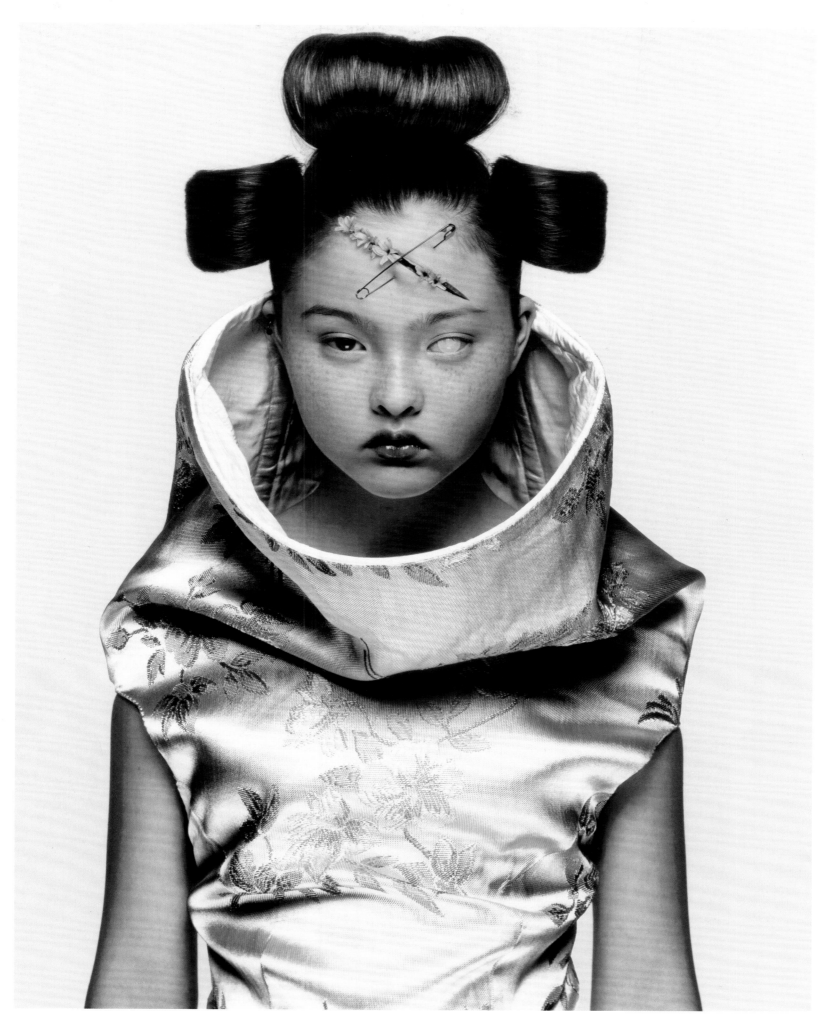

132 . nick knight . devon . visionaire . 1996

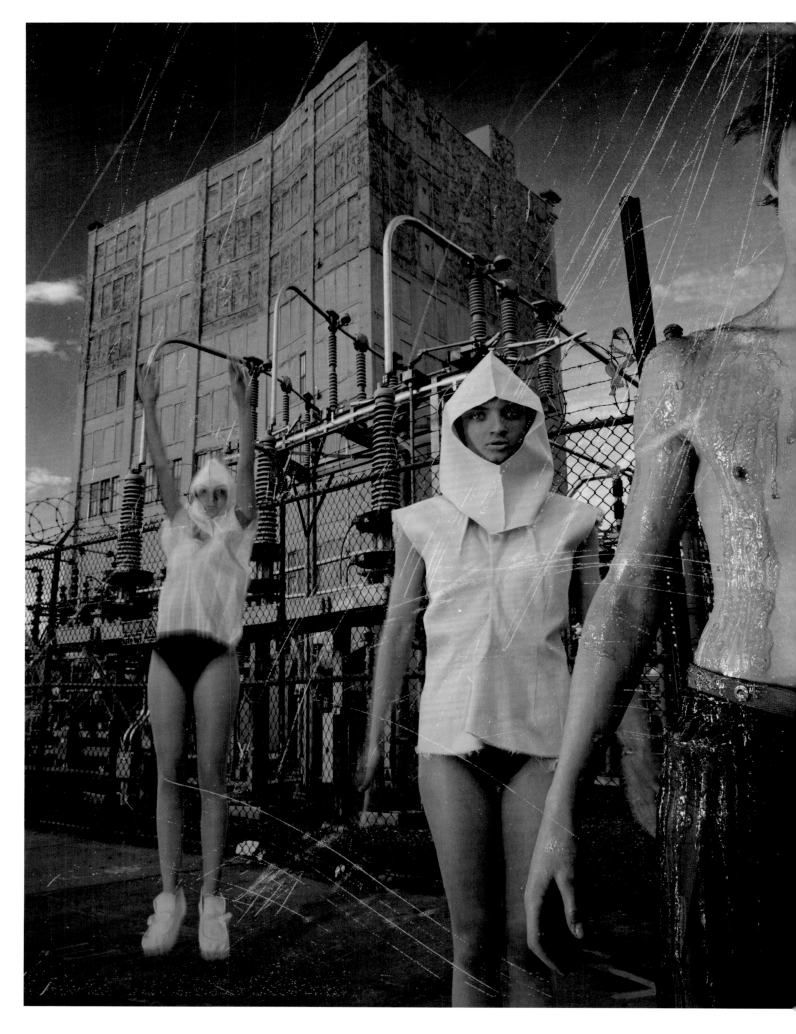

133 . andrea giacobbe . brooklyn 1996 . cube . 1998

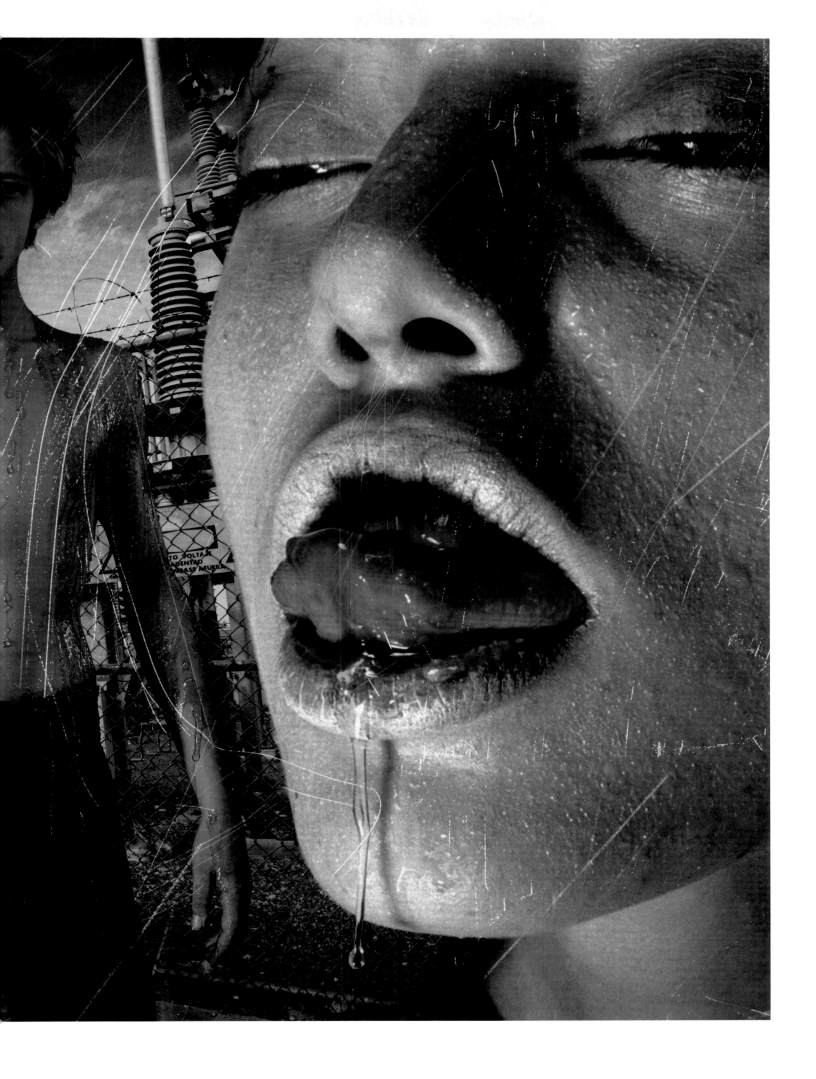

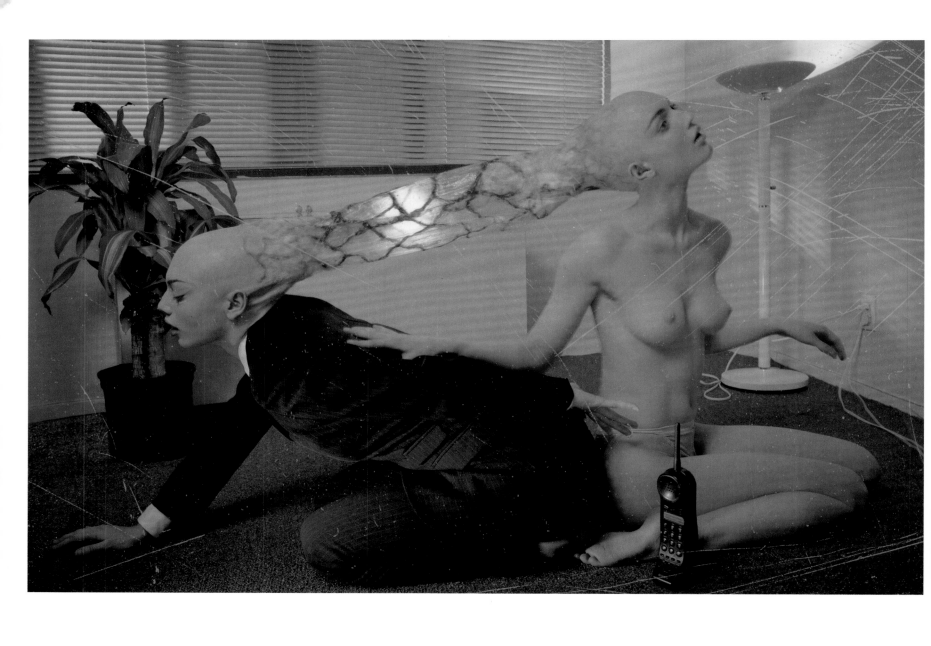

134 . andrea giacobbe . manhattan 1996 . cube . 1998

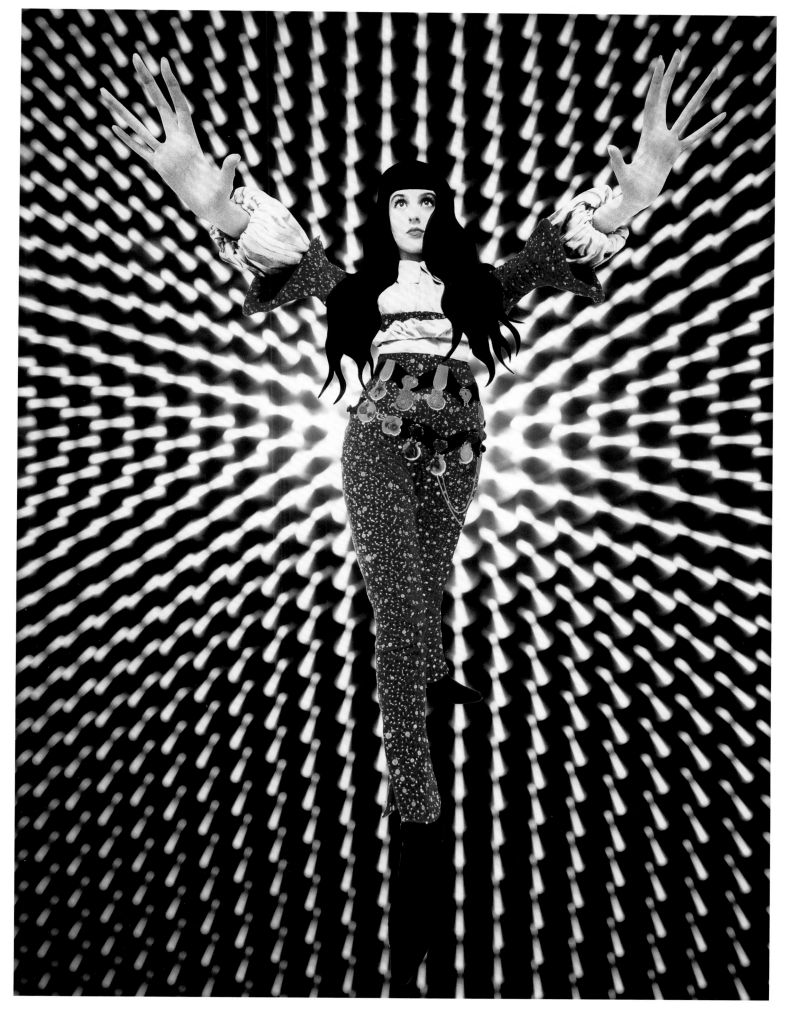

135 . stéphane sednaoui . suzie bick! . the face . 1988

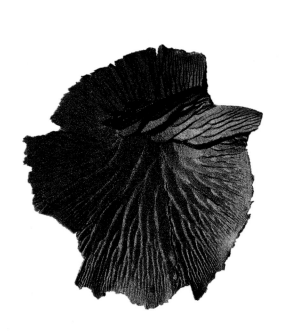

136 . guido mocafico . make up I–VI . citizen k . 2000

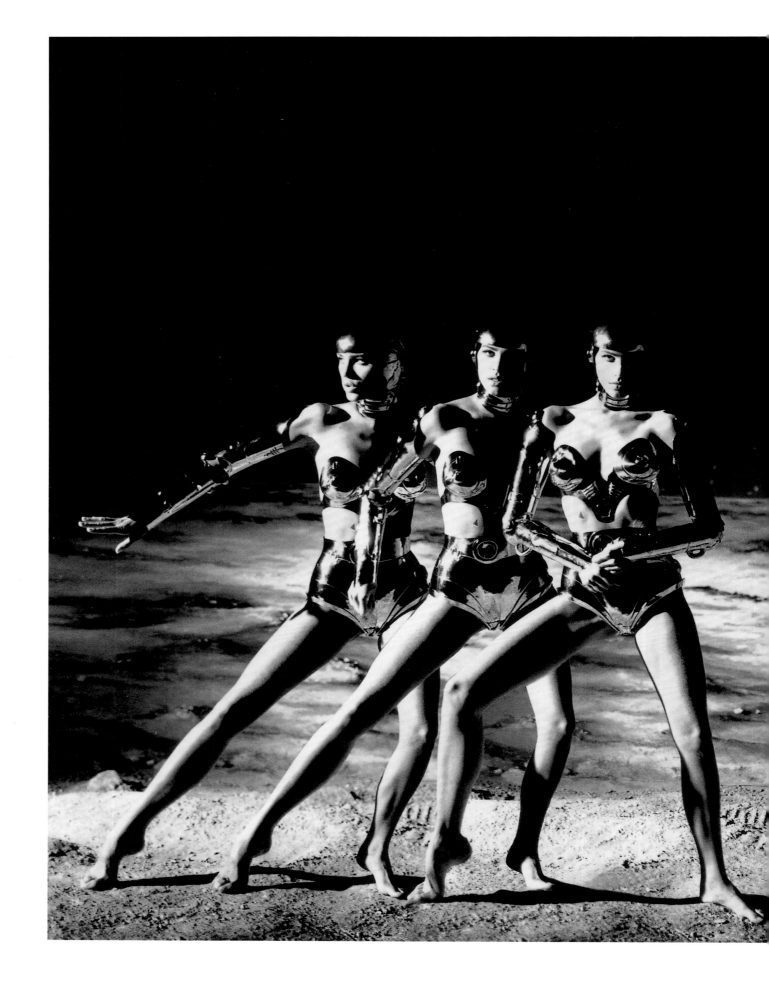

137 . thierry le gouès . robot emma s . glamour france . 1991

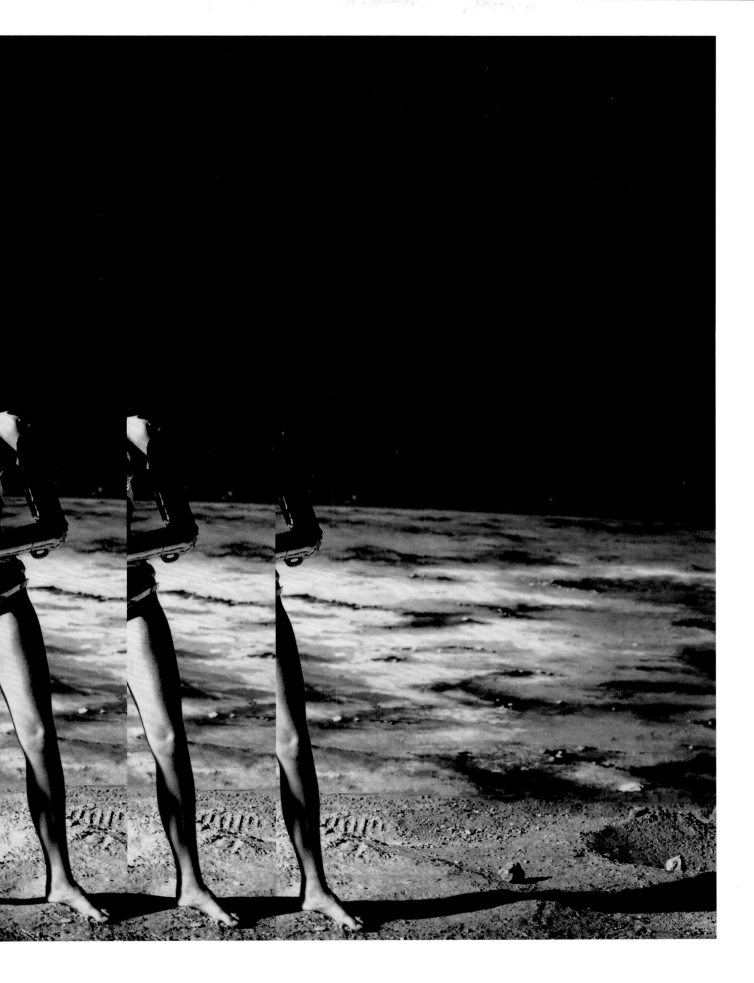

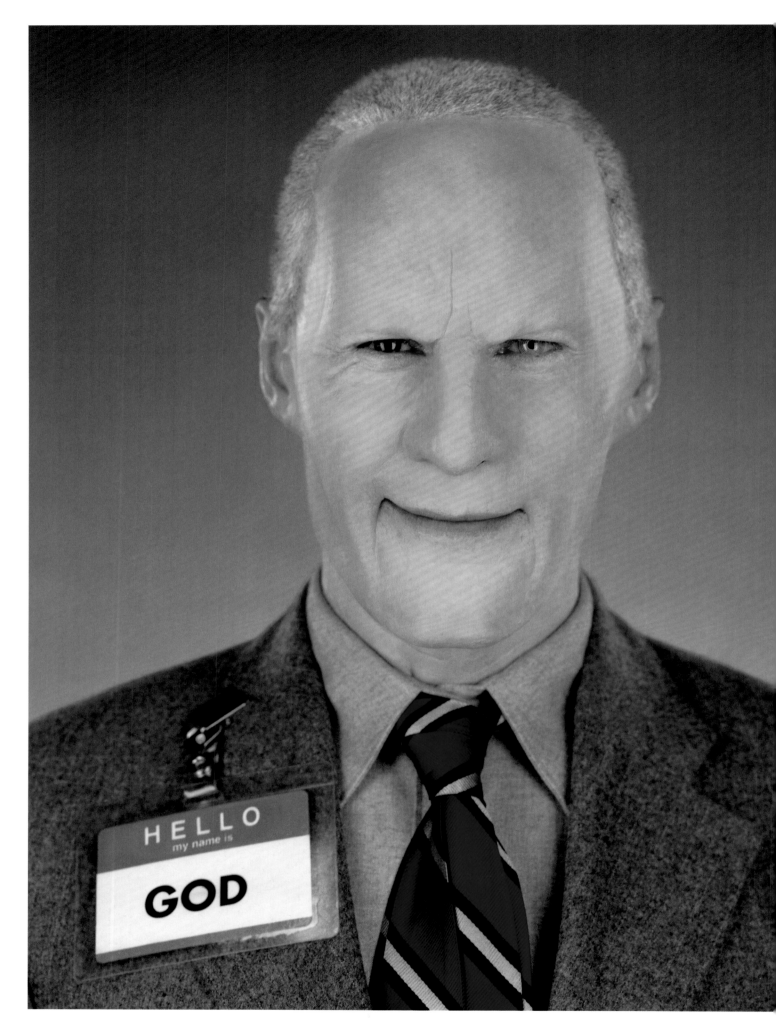

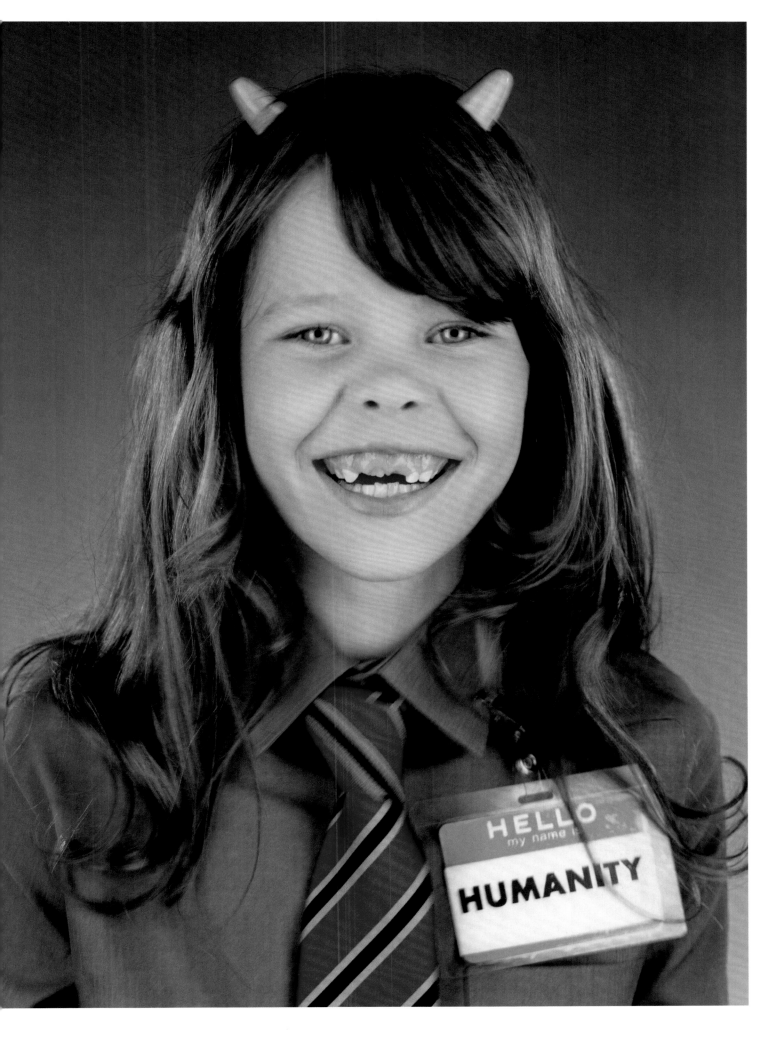

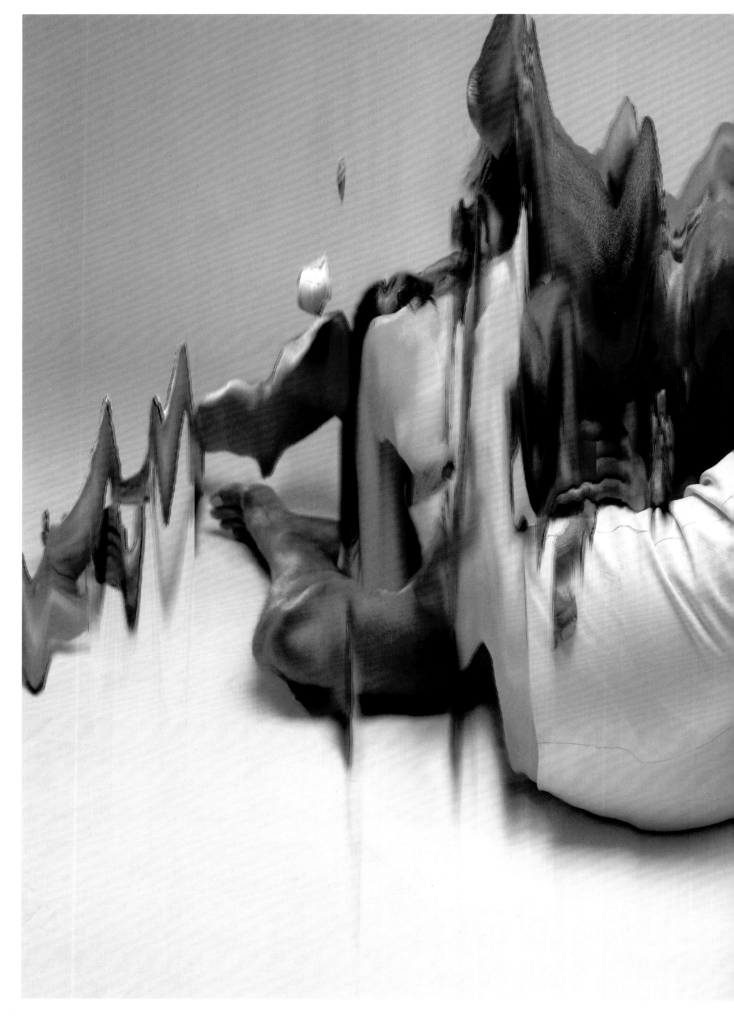

139 . stéphane sednaoui . mary ann . jalouse . 1999

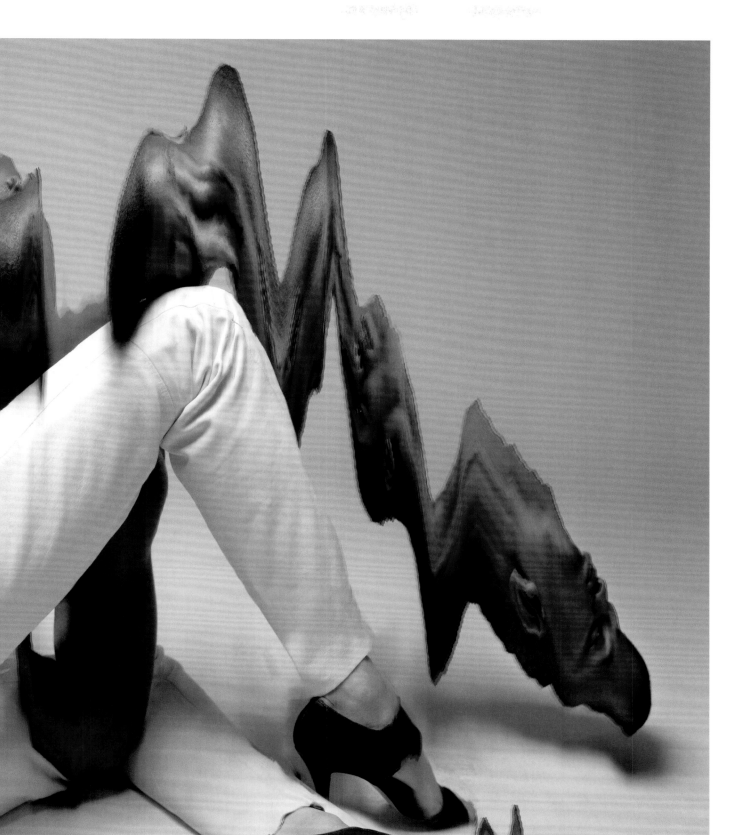

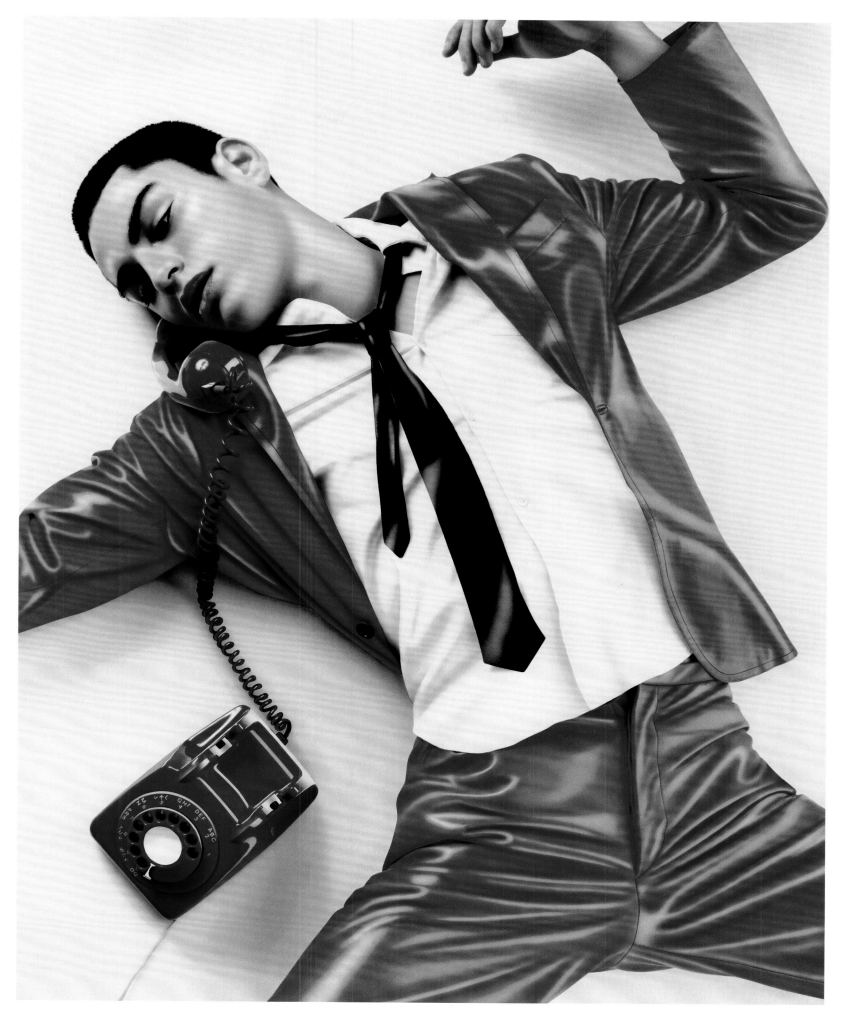

141 . sølve sundsbø . tyson cover . the face . 2000

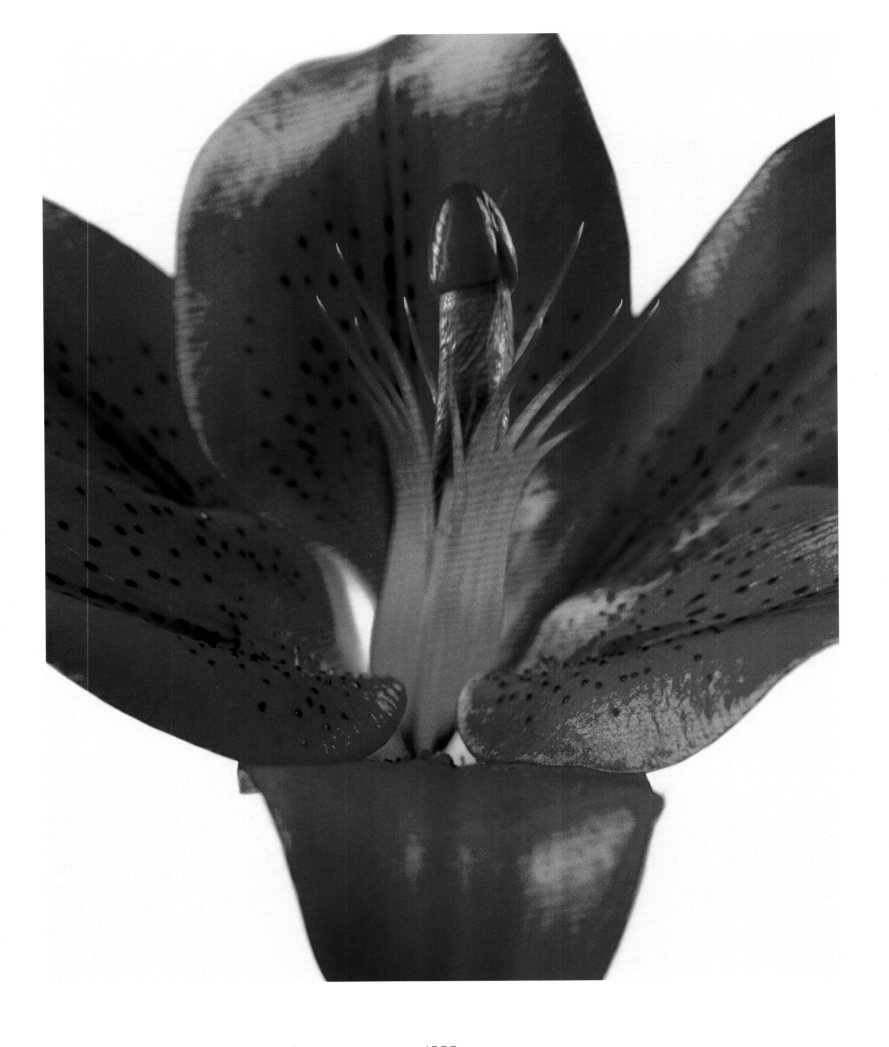

142 . jean-baptiste mondino . viagra . arena . 1998

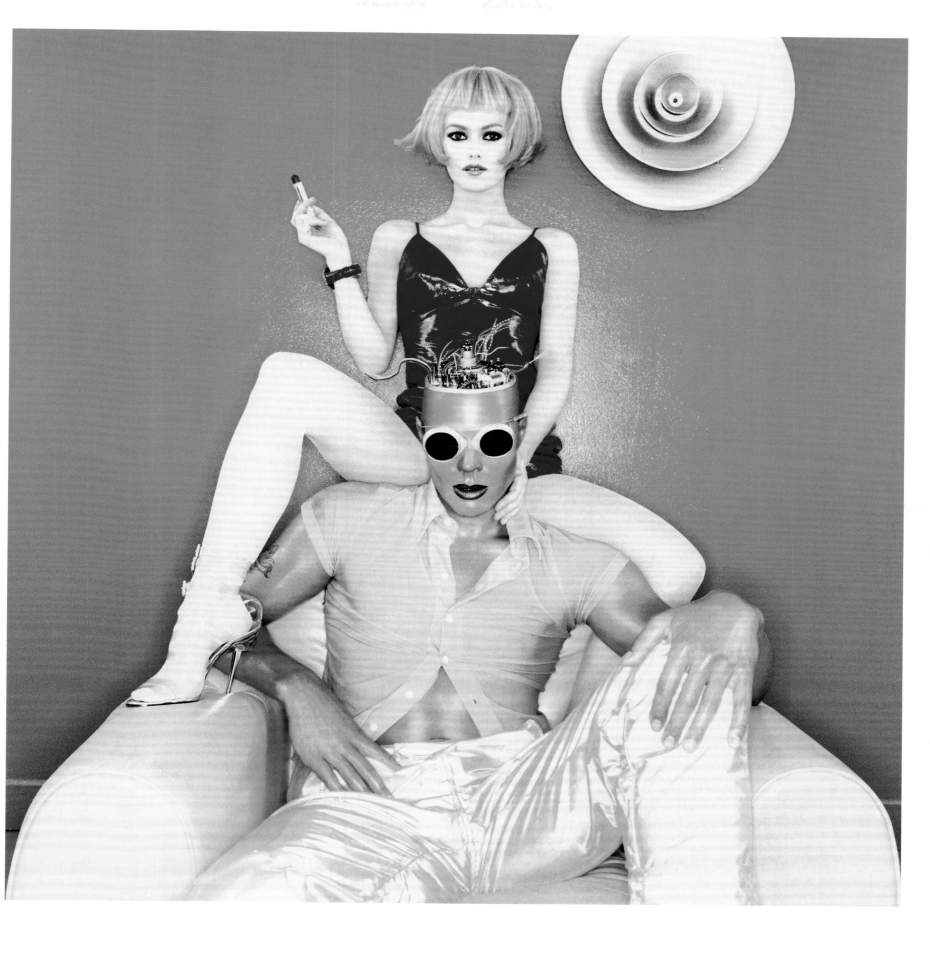

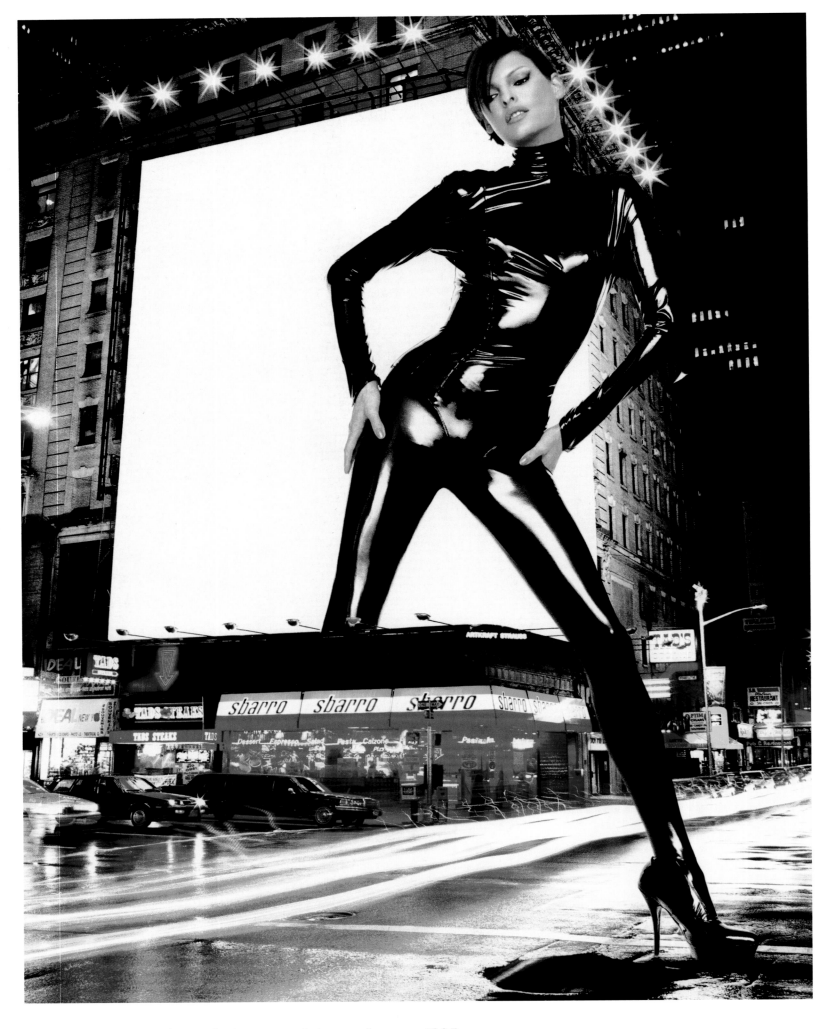

144 . thierry le goués . linda evangelista . allure . 1995

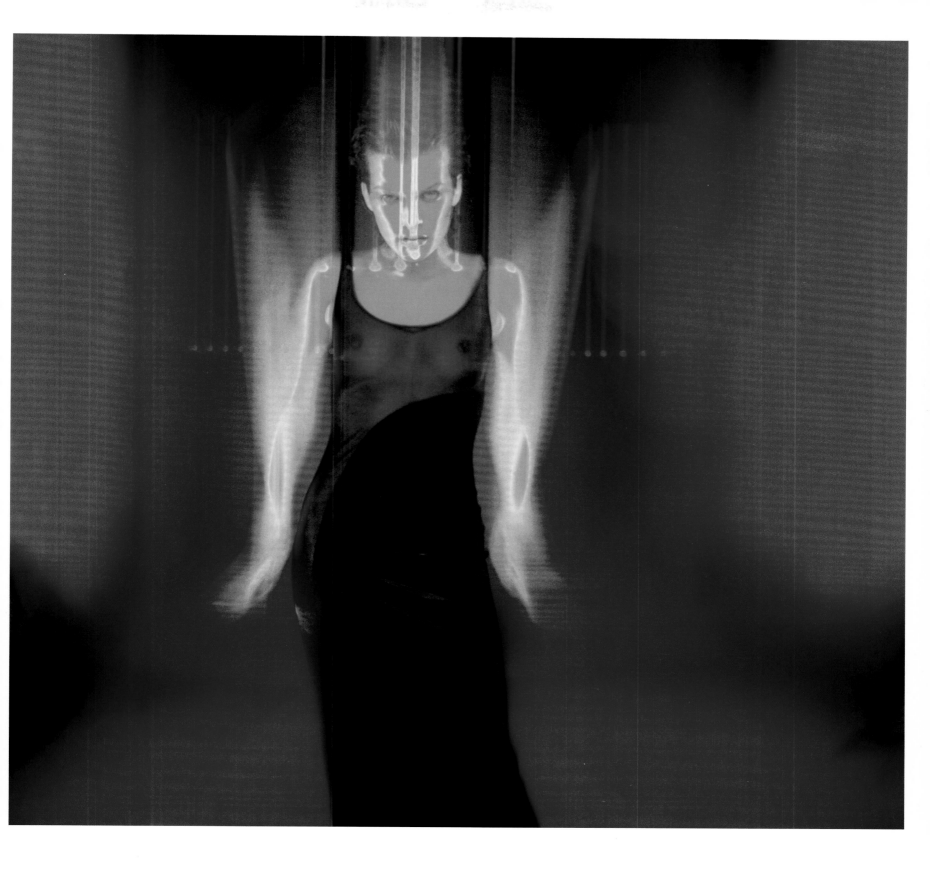

145 . stéphane sednaoui . milla jovovich . campagne plein sud . 1996

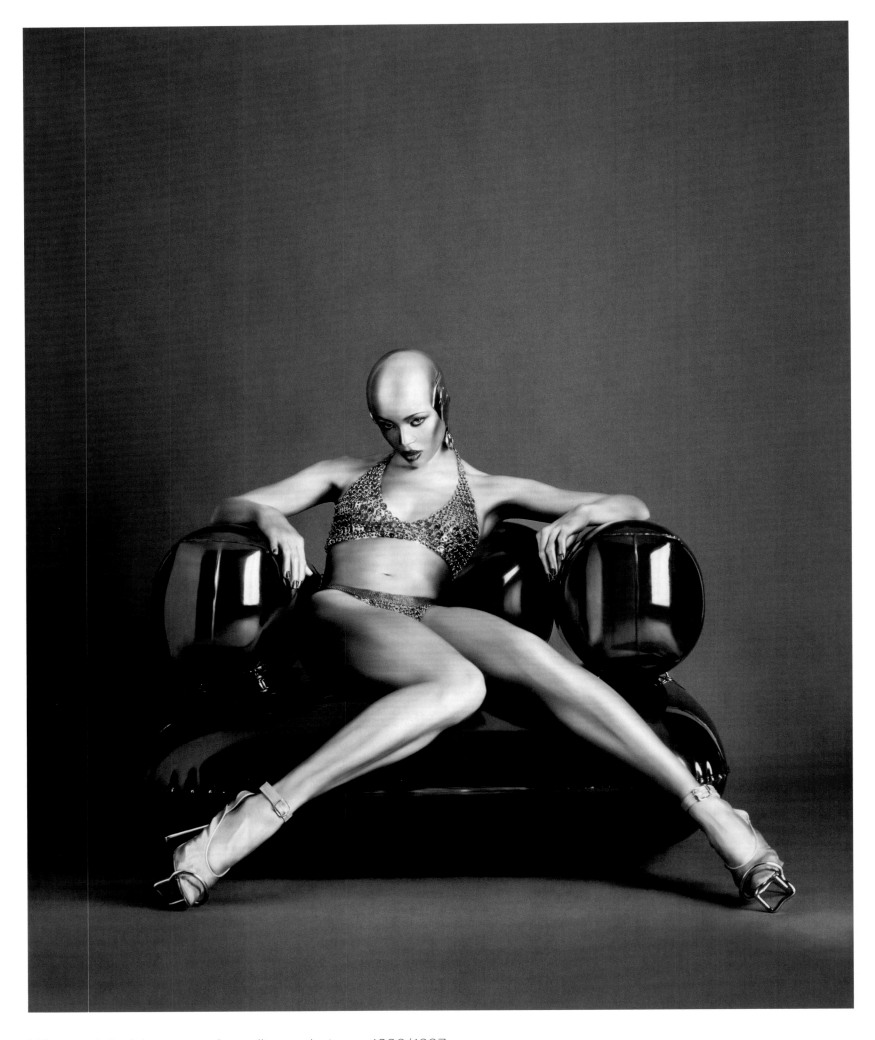

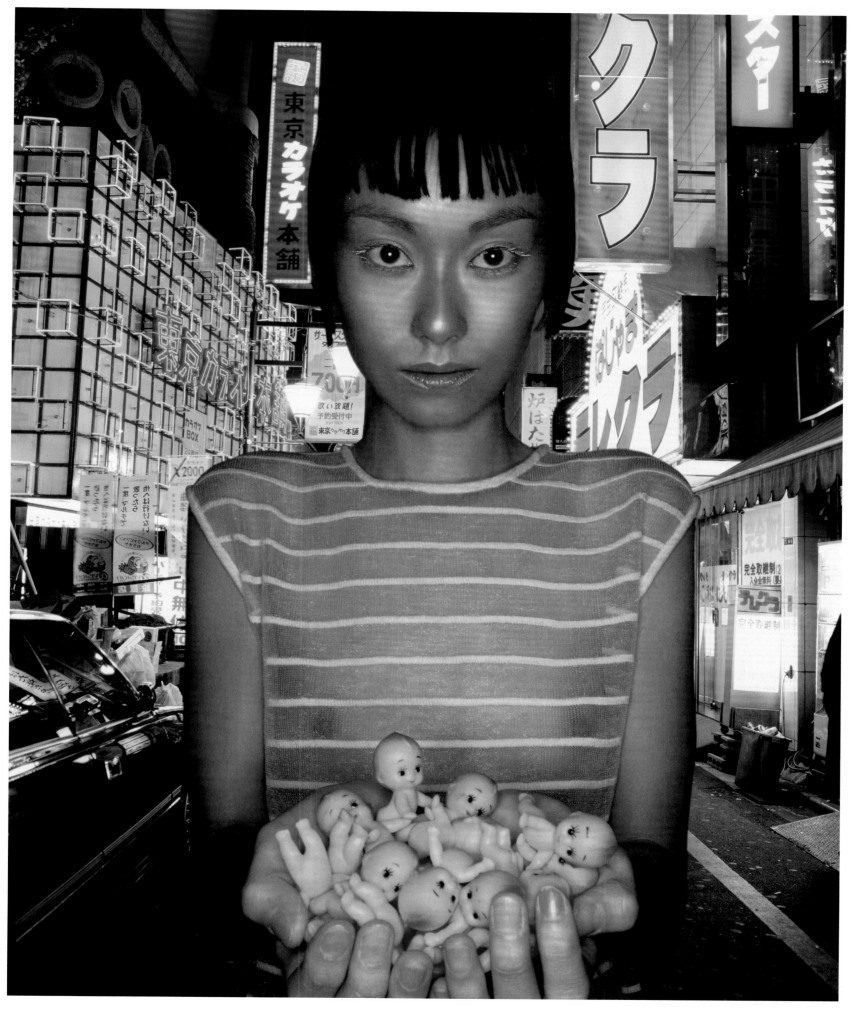

147 . andrea giacobbe . tokyo 1992 . citizen k . 1993

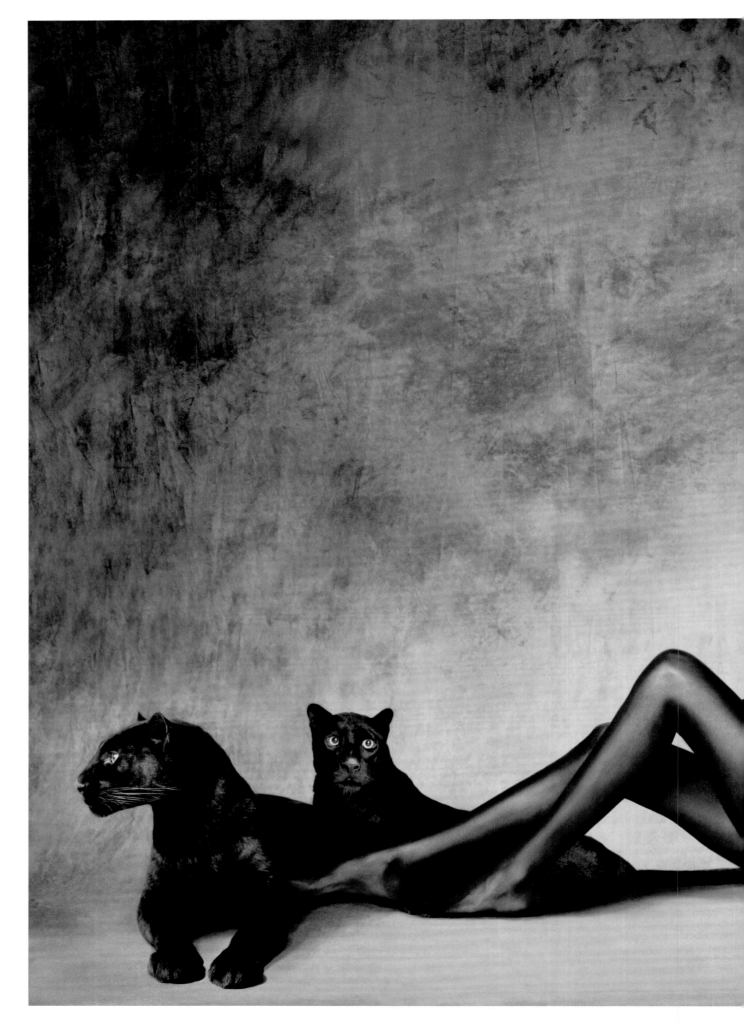

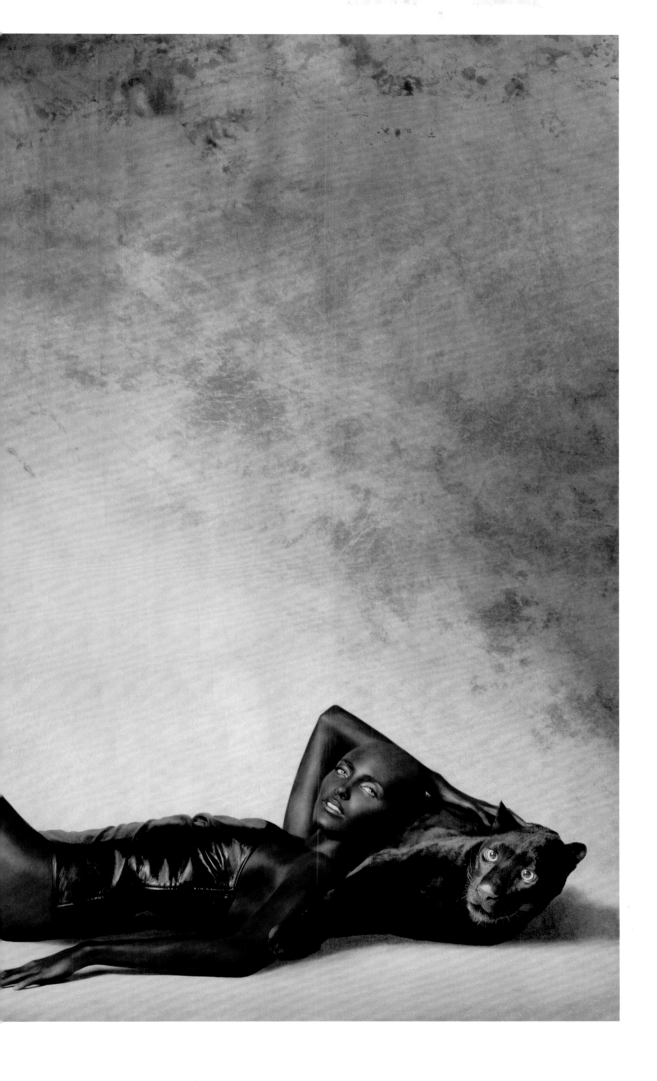

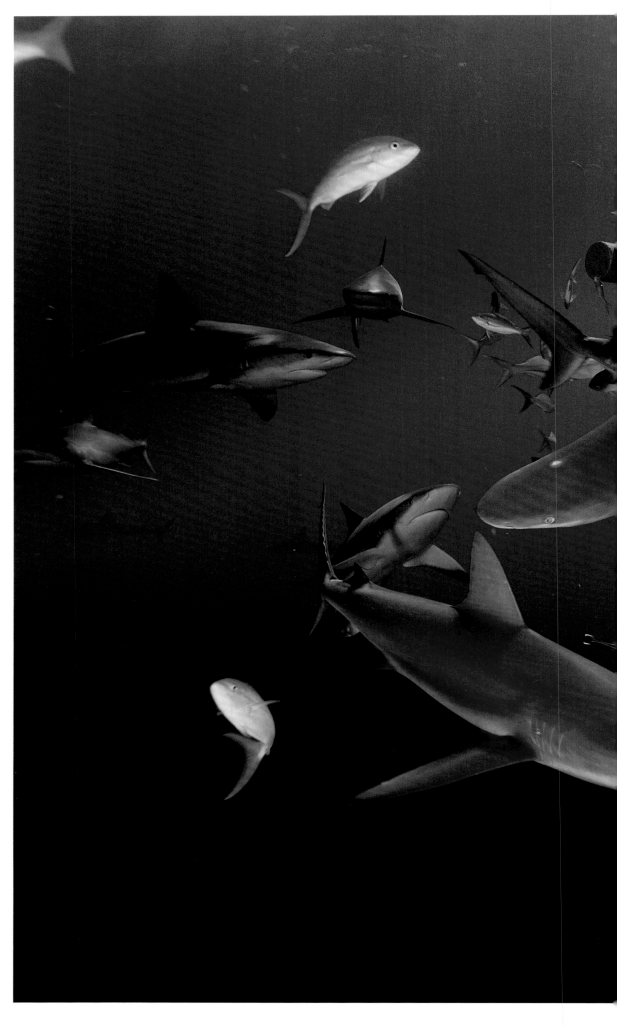

149 . taryn simon . sharks, nassau bahamas . the fashion . 2001

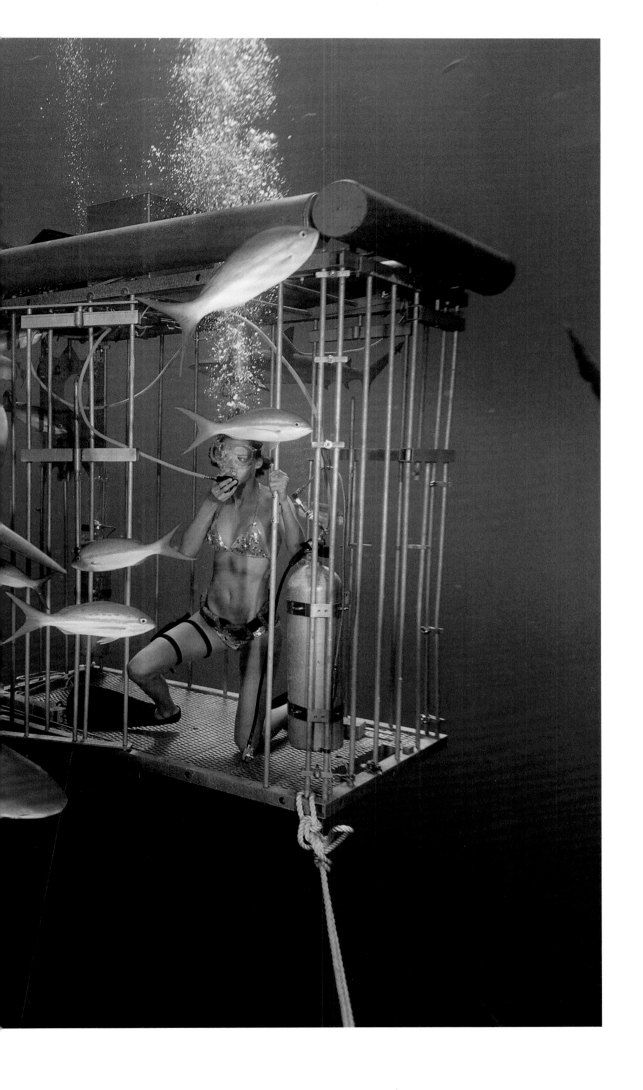

150 . sølve sundsbø . david new wave . the face . 2000

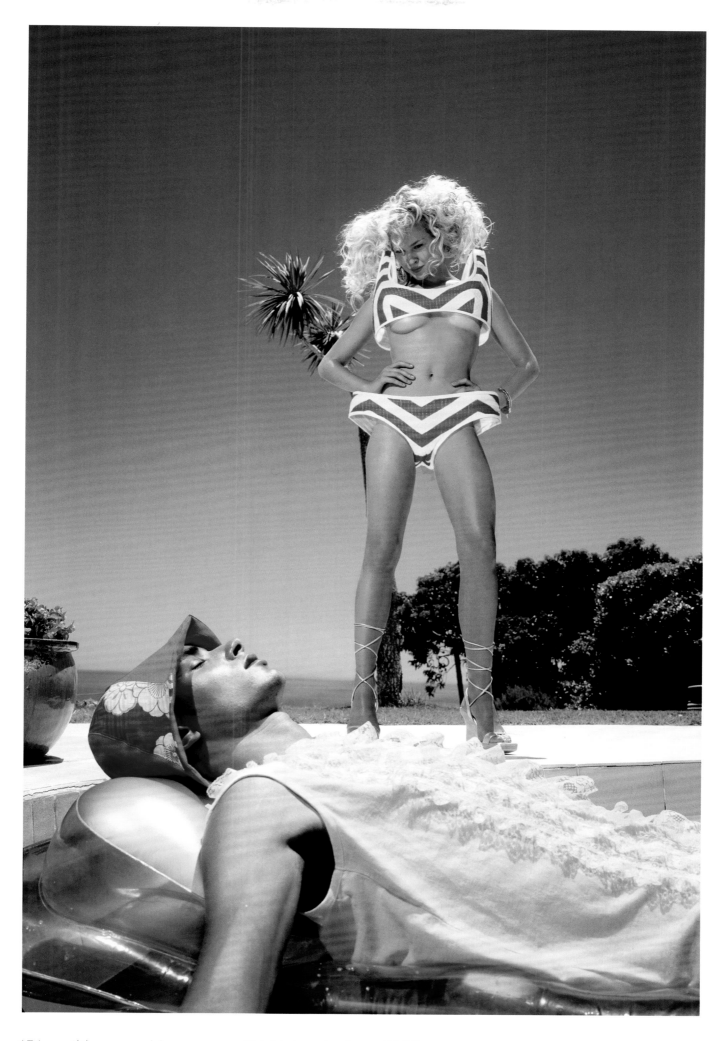

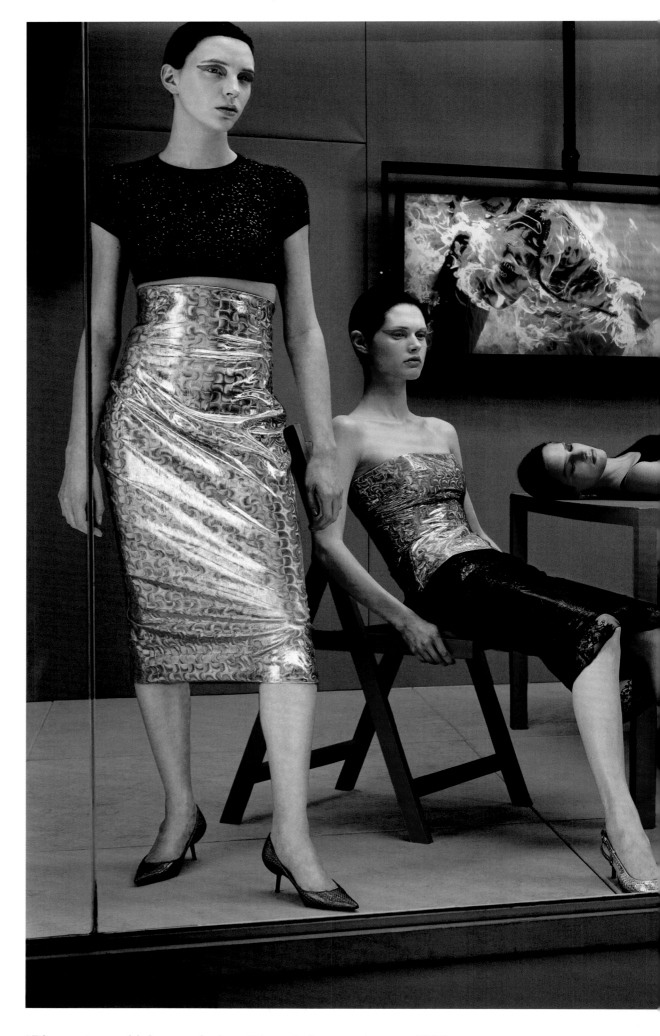

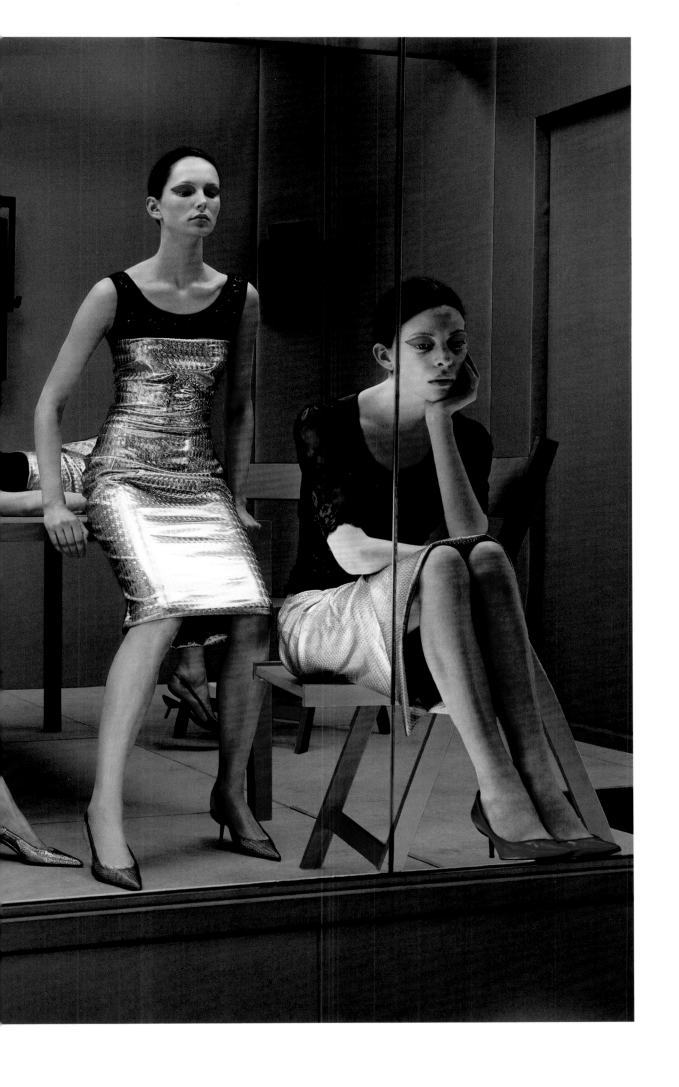

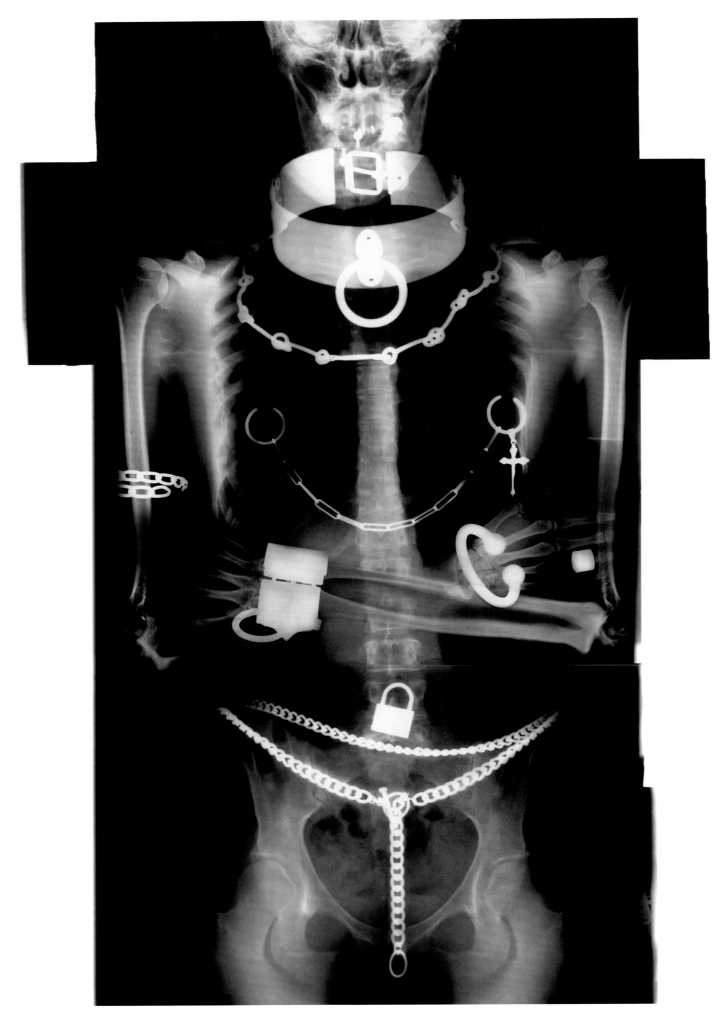

153 . jean-baptiste mondino . xx ray . the face . 1990

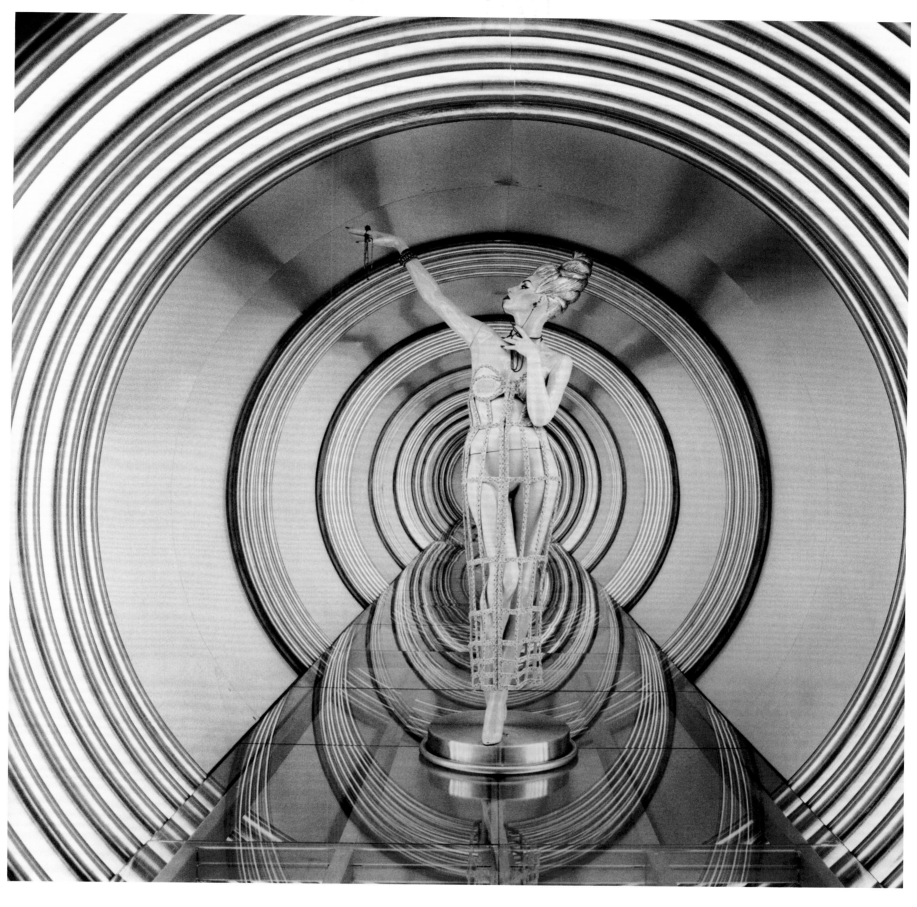

154 . jean-baptiste mondino . parfums jean-paul gaultier . 1993

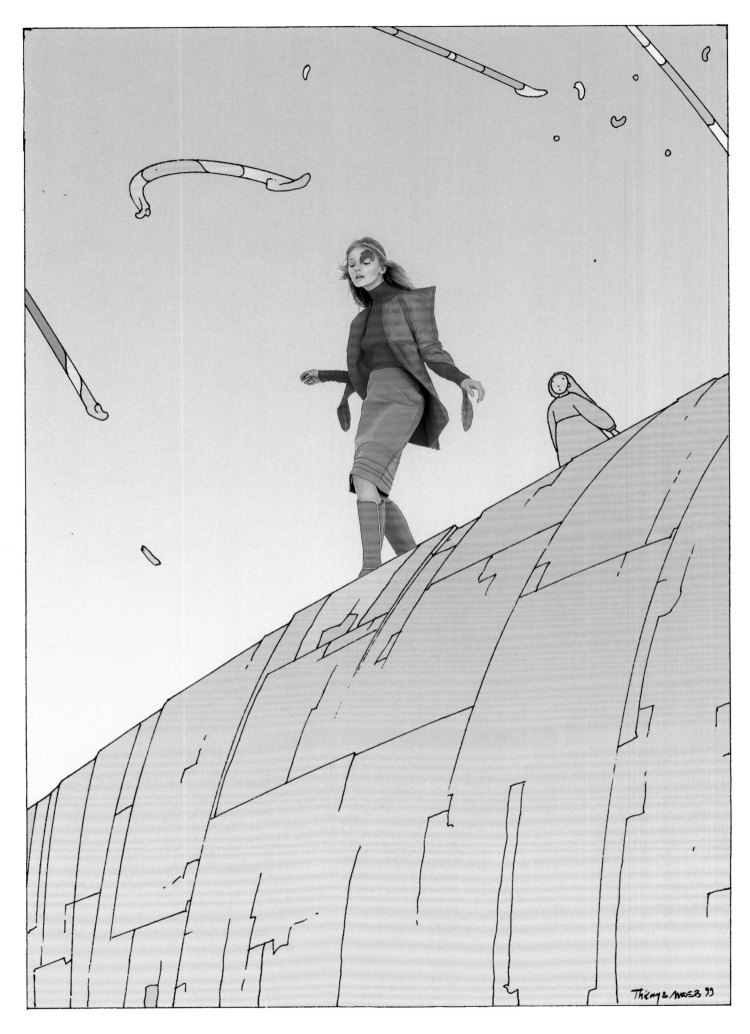

155 ▪ thierry van biesen ▪ le bord du monde ▪ sleazenation ▪ 1999

art

Since its invention in the nineteenth century, photography has been art's nightmare, only to become, in the course of the twentieth century, the sensitive part of the liberal arts. The history of photography during the last century has progressed in step with art history. Indeed, in the last two decades of the twentieth century, the overlap between photography construed as art and fashion photography has increased. Less defensively bent on delimitation and instead focusing on an internal pluralist dialogue, fashion photography has developed a relatively bold shamelessness in plundering art history, its holies and its follies.

Art-oriented fashion photography aspires to achieve the greatest possible artificiality. The non-authentic quality of fashion is taken to a higher degree. The hypothetical and the overstaged, exaggeration by stridency, these have all prescribed for photography – a medium formerly considered realistic – a dose of artificiality that impatiently opposes any form of authenticity. When André Breton drew up his First Surrealist Manifesto in 1924, he set it apart from the realist doctrine and its innate positivism as well as from its denial of the imagination. 'Descriptions,' he groaned, 'Nothing can be more vapid.'[21] Logic and rationalism were Breton's bugbears, the destroyers of art and liberty. This Surrealist battle against the heyday of classical Modernism fought out its last skirmishes in photography – a medium of expression defined from the outset as *the* realistic medium, then as *the* realistic art form. The history of Surrealist photography starts with the photographic experiments of Hans Bellmer and Man Ray, who continually subvert the otherwise prevailing 'wakened state' of photography and its perceptual capacities. Surrealist photography endeavours to liberate the medium from its complacent

21 André Breton, *Manifestes du Surréalisme*, Paris 1946.

263

self-obstruction, in order to capture dreams that document the surreal beyond all documentation of the real.

Much of the fashion photography of the last twenty years is evidently influenced by art, even quotes and copies it; it resembles a second chance for Surrealist motifs and De Chirico's *pittura metafisica*. The quality of colour film and colour processing that has evolved over the last thirty years affords surrealist photography (hitherto exclusively black-and-white) a new feel and visual idiom. The clear, heady and radiant colours and the new gloss prints change the sensuous feel of the images. The latest photography plays the whole register, whereas classical Modernity had to be satisfied with the abstracting contrasts of black and white – kindling enthusiasm among painters who dripped in colour. 'Photographic imagination; more agile and swifter in finding things than the dark processes of the subconscious,' Dalí cheered in 1927, 'Photography that captures the finest and most uncontrollable of poetry!'[22]

Fashion photography acts like a magnet – all the impressive motifs and mechanisms of constructing images to be found in the more recent arts are imitated, quoted or exaggerated. The seductive originality of Surrealism especially, as well as the subconsciously effective theatre of the absurd, defines the grammar of its iconography. The master of the bizarre was Frenchman Guy Bourdin. A Parisian, fifty-two years old in 1980, he had always drawn and painted, and had trained as a photographer in the army. For Bourdin bringing together painting and photography was a lifetime's project. His first photographs pay homage to Man Ray. Man Ray had emphasized in his texts on photography that it had the ability to visualize what had, prior to the advent of photography,

[22] Salvador Dalí, 'La fotografía pura creatió de l'esperit', *L'Amic de les Arts*, no. 18, 1927, pp. 90–91.

remained in the subconscious without an imago. The work of Bourdin, and that of his most idiosyncratic successor, David LaChapelle, clearly shows how far this subconsciousness has been infiltrated and decomposed by images from the mass media. The contemporary production of films, ads and video art is defined by our familiarity with their images and the shocking confrontation of familiar images. By repeatedly interpreting an infinite number of images from art history, the photos become more readily consumable. A clear distinction is made in photography between archiving and restructuring the mountain of images of Modernity.

The euphoria of Surrealism and *pittura metafisica* has vanished, leaving more modest attempts to introduce poetic structures into photography, in particular into fashion photography. In this context, the grammar of the absurd is largely taken from Surrealist painting (women who hold fish; reclining beauties bleeding, faces in splintered mirrors, men as women, lipsticks as sausages, etc.). However, the painted style and signature are erased and the products of the imagination become all the colder, more lifeless, harder and perhaps less animate in some manner that is easier to consume. Fashion photography slowly but inexorably strips Surrealism and *pittura metafisica* of its rebellious, humanist thrust. Yet it was precisely that character for which Walter Benjamin held Surrealist photography in such high regard: that the world does not seem lonely, but bereft of atmosphere, emptied 'like an apartment which does not yet have a tenant'.[23] Surrealist photography, or so Benjamin claimed, prepares 'a healthy alienation between man and his surroundings'. Surreal fashion photography does this deliberately in order to create the final impression of an exceptionally high-brow and

23 Benjamin, 'Kleine Geschichte der Photographie (1931)', *Gesammelte Schriften*, p. 379.

intelligently dressed window. The world becomes the shop window and photography the window dresser.

'Extricating the object from its wraps, the destruction of the aura, that is the signature of a form of perception,' writes Benjamin, 'whose sense of the universal equality of things has grown to such an extent that by means of reproduction it even succeeds in generating the unique from within it.'[24] What Benjamin has in mind is the trend in such perception to transform everything into fashion; he sensed this and finds sharp words for it. 'The creative element in photography is that it entrusts [the unique] to fashion. "The world is beautiful" – precisely this is its policy. This reveals the stance of a form of photography that can splice an image of cans of preserves with one of outer space but cannot grasp one of the human contexts in which it arises, and thus in those of its subjects which are most given over to dream, remains more a precursor of their price tag than of an understanding of them.'[25]

That fashion photography is a suitable seller has to do with the need for placing fashion on a stage beyond all everyday life and normality. Much of what advertising and editorial copy demand of photography is mere exaggeration and thrill, with all reference to the known severed. No vapid descriptions, to quote Breton, of jackets, coats and clothes, by a veritable showcase of decorative, if often distracting illustrations of associations that tend to locate fashion more in the realm of the imagination than in reality. Both the emancipation of fashion from utilitarian art and the fact that photography no longer wished to be the servant of fashion led to mushrooming extravagances, which only rarely met any artistic standards.

The art academy as the venue where photographers are socialized is

[24] Ibid.

[25] Ibid., p. 383.

not the rule, but neither is it rare. Discovered as the medium of representing and preserving reality, the methods of montage, collage, multiple exposures and technical refinements became important for photography in the course of the twentieth century. It became the new painting, when art distanced itself from canvas as the preferred medium. To the degree to which painting becomes relativized by performances and objects, multimedia installations and sculptural architecture or land art, the significance of such photography grew that captured and promoted stage settings.

Stage setting was used in fashion photography especially. In the last third of the twentieth century, flowery, dramatic fantasies were increasingly set photographically, in the tradition of the printed advertisements in the Art Deco, Bauhaus and Surrealism. Photography was utilized as a storage medium, to capture opulent scenery in the studio or on the catwalk, with post-processing of images becoming increasingly important after the shutter is released. Benjamin's warning of 'entrusting the unique' to fashion is also strengthened by another element in Benjamin's aesthetic, namely that of the development of the technologies of reproduction. The process of extrication and of the creative can be infinitely expanded on-screen or in the lab. Photography thus itself becomes the joker in the pack: what is depicted is always also *tabula rasa*. It can be made into anything. Thus, reality is bidden farewell.

Freud identified the camera as the instrument that could capture fleeting visual impressions – in the sense of materializations of memory and thought. Many fashion photographers used their cameras specifically in order to reproduce impressions from art history, seldom by capturing them in reality as encountered by means of the cropped section

of image shown, but instead by re-creating them in the studio or the lab. Alongside the Surrealist genres, Dadaist motifs, Fluxus and Arte Povera's heaps of clothes, Bellmer's dolls are all given a new interpretation, re-issued by Mario Sorrenti and Jean-Pierre Khazem; constructivist architectural drawings are sampled by Serge Lutens and Claude Cahuns' gender-specific deconstructing collages are brusquely touched by Jean-François Lepage. Young and old photographers alike skim off a veritable tub of art history, in order to place its images – as shameless as they are inspiring – in new barrels. The quotations become especially exciting where the art cited is itself an echo of photography's threat to art. For example, the photo realism of painting is quoted in the disturbingly stiff photographs of Taryn Simon. Photography apes a type of painting that itself suffered as a stigmatized form of art at the hands of the dominance of photography. Here, visual culture enters an echo chamber in which all the impressions and resonances interfere so much that at the end they are synchronized and superimposed in a striking multi-layered entity. Precisely these fine allusions to art show that synergies can be tapped not only at the iconographical level, but that syntheses are de rigueur: the idioms of art and photography must intermingle to such an extent that a new art idiom emerges that over-arches the different media. Even if photography has apparently effortlessly shed any claim to producing something exclusive of its own, it is precisely its relativized authorship given the seemingly effortless and non-academic nature of its reference that constitutes the new quality in plundering art history.

Here, again David LaChapelle is a past master, arranging his surreal worlds of images with a baroque sense of enjoyment. Like dolls' houses

crammed with perverse fantasies, one picture blends with the next to form an architectural labyrinth in which there are no linking roads. *Hotel LaChapelle* was the title of the second of his monographs, published in 1999. Hotel rooms are places where people are guests only for a while and analogously his photographs were intended to make the viewer feel at home for a moment in an alien world. His pictures are not fully defined by the discourse of fashion but themselves create fashion, for everything in and about them is fashionable: the type of make-up, the colour, the light. They act with models who are exaggeratedly artificial, embedded in the settings as if to become part of an allegory. In the age of decomposing old linguistic systems of communication and the emergence of new systems of understanding each other, the signification of things becomes a slippery matter. Semantics becomes a black hole. And LaChapelle and his colleagues Nick Knight or Mark Borthwick place their allegories directly within this uncertainty of meaning. Allegory by definition has something abstract about it, and in fashion photography it becomes an attitude rendering abstractions that are conceivable and imaginable, without the ability to specify them any more closely. In other words, the level of abstraction is only simulated. Here, again, fashion is a successful model for what are now only simulated processes of signification: be it noisy message T-shirts or the incunabula of fetishes or polit-radicalism – all the meanings used are wired up in a black box that is not actually powered. Everything remains a game of form and colour.

The way in which still lives are seized is equally a matter of simulation. *Natura morte* is taken on as a form from art: De Chirico defined still life as a peaceful life devoid of noise or motion, an existence expressed by

volume, form and three-dimensional qualities. The *memento mori* of skulls and wine carafes is brought up to date in the form of the models' rigid shrouded legs or torsos, and the melancholy rags of contemporary design especially uphold this heavy-hearted trait of classical still lives culled from painting.

In Pop culture, the New Wave movement peaked in the early 1980s. Its central message was to declare the entire world and all life to be a still life or – to put it dynamically – a sequence of still lives. By exaggerating ennui and resorting to stylistic extravagance, in New Wave everything became a rigid, cool arrangement intended to illustrate the artificial nature of existence in general and of all friends of fashion in particular.

New Wave was, if not the end of all desire, then at least its decadent trivializiation. Yearning was misunderstood as a craving for visions. Since it was impossible to be happy, the misery of existence had at the very least to look nice. This was the battle plan of New Wave, and many photographers of the last twenty years underwent their socialization exposed to its styles. The melancholy thus promulgated, and narcissistic paranoia, again thrived on the images of fashion magazines such as *Vogue*, where the photos by Guy Bourdin also inspired musicians such as Bryan Ferry of Roxy Music or Debbie Harry of Blondie. In the mid-1970s, Ferry's love song to a plastic doll that floats in his swimming pool was quite trailblazing in its forced affirmation of the artificial and ahuman. It was not until much later that this attitude reached the visual and aesthetic mainstream, only to slide back immediately into the opaque world of ambitious postcards and wall calendars.

The surreal alienation effect becomes the tool of a visual culture of kitsch. And it is precisely with this that contemporary fashion photo-

graphy interacts, whereby the latter is relatively sure of itself in terms of style. In other words, the photographer's sensory array enables him to pick out those elements of kitsch that evolve new traits and evoke the current zeitgeist. The result is a camp strategy for reclaiming the most beautiful stereotypes that had been lost to kitsch.

Glamour and art meet in the estrangement between representation and reality. In his Versace campaigns Steven Meisel so overdoes the realism and glamour that in the end the arrangements seem surreal and self-contradictory in their opulent glory even though they were shot at *real* showcases of luxury. Be it in North Italian palazzi or in Los Angeles – wherever Meisel combines models and real surroundings, the representation of luxury becomes an unreal totality whose ghastly wholeness seems robbed of alternatives. The world is, in both senses of the word, finished, left to its own devices, lost. The women's gestures and expressions are resigned. How things will continue is both unclear and not yet considered. The figures become dolls, the houses stages, the hyperrealism of a seemingly endless depth in focus and the brilliance of colours in the prints gives this luxury that touch of unreality which identifies the Surrealism of decadence. All beauty becomes mysterious.

Aragon once spoke of the enemies of order who spread the magic potion of the absurd; now they are the ones who are paid as image-makers to glorify that order who make use of the absurdity of the real. This occurs less obviously than in the overly clear unreal or surreal scenes. Granting the abstract real presence is not the task of the glamour photograph but a generous by-product. Breton termed the dissolution of dream and reality in Surrealism a kind of 'absolute reality'.[26] Here, the dream was the agent of political and social rebellion – it embodies

[26] Breton, *Manifestes du Surréalisme*.

an unredeemed emancipation, a tangible utopia. Modern glamour photography is the dissolution of nightmares and reality in a kind of sur-reality that depicts estrangement – that cannot be pinpointed on behalf of the bourgeoisie using the categories of social-documentary photo-graphy but, in line with bourgeois categories of distinction, only by visualizing bourgeois material dreams and hopes. In other words, the Romantic element of Surrealism has disappeared and has been replaced by a capitalistic eschatology. The dreams are not the expres-sion of some individual subconscious, but of society's consciousness. The new surreality functions analogously.

Fashion photography professed to be art and equally the liberal arts professed to be fashionable. Both US art of the 1980s and 1990s as well as British art of the 1990s flirted with fashion or allied with it. Fash-ion, art and photography give rise to a mixture as attractive as it is repul-sive. The fact that photography purports to be so masterful and casual in the process stems often from the laborious endeavours of fashionably affected artworks and artists. The modish semi-cultured nature of these artists makes many of the works only interesting in a gallery and only rarely in settings where fashion experts and fashion victims spend time. The poverty of the radical chic in which the art of fashion dresses itself goes unrewarded. A glance in an issue of Italian *Vogue* of the time, with its wide-ranging ads and editorial sections, shows just how paradise-like the blossoming radiant garden of ideas is that fashion cultivates. As an artist, trying to top it or cast it into question, to sample it or reinterpret it, could mean running the risk of falling from a great height.

art

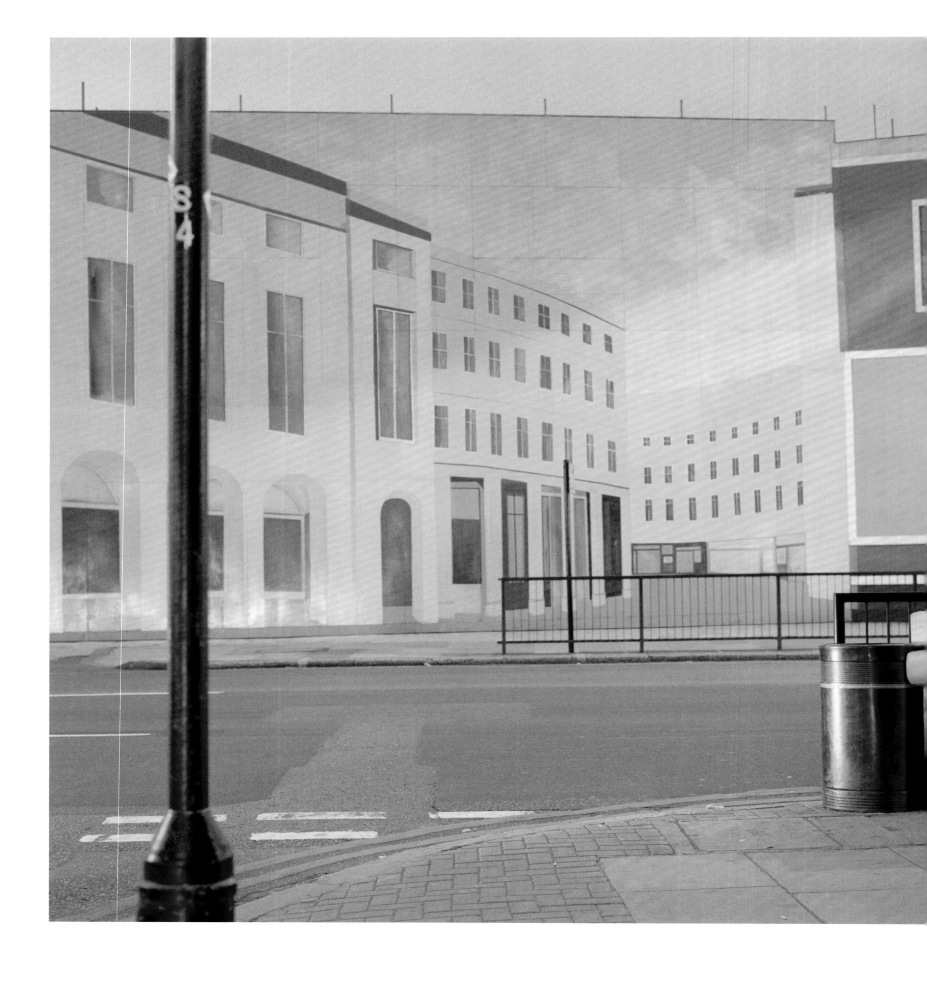

157 . norbert schoerner . the picture i never took . 1999

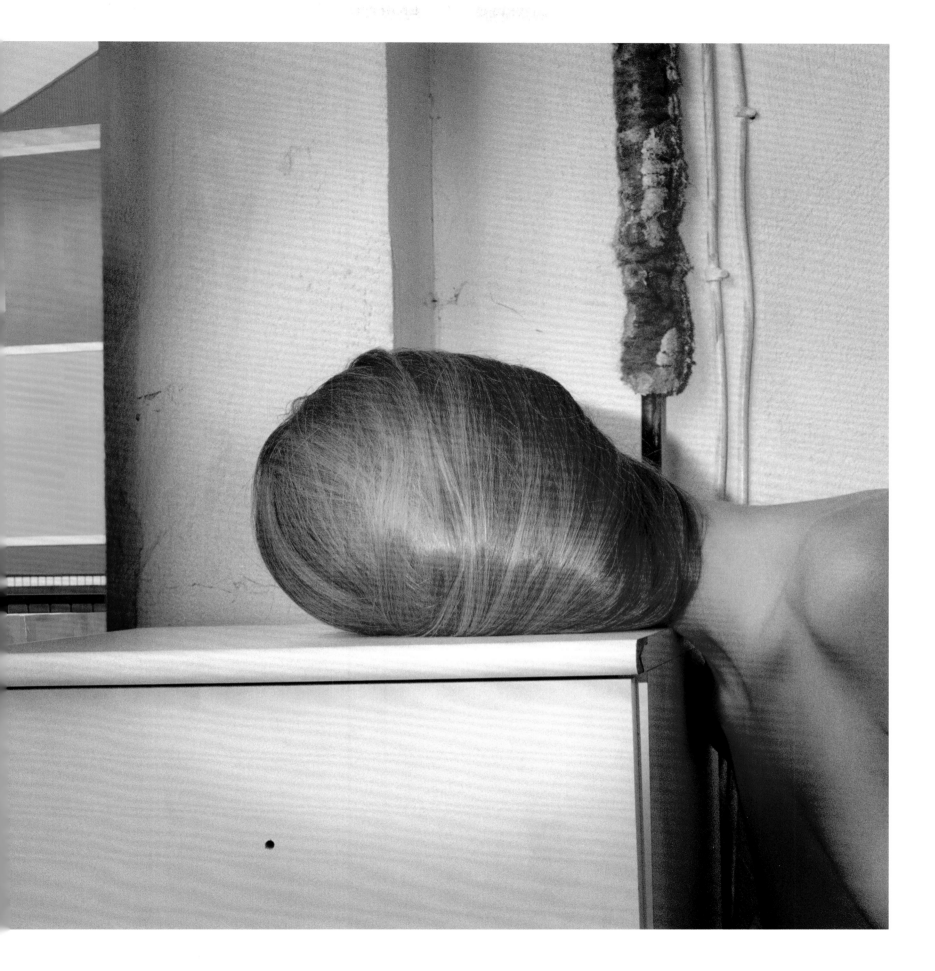

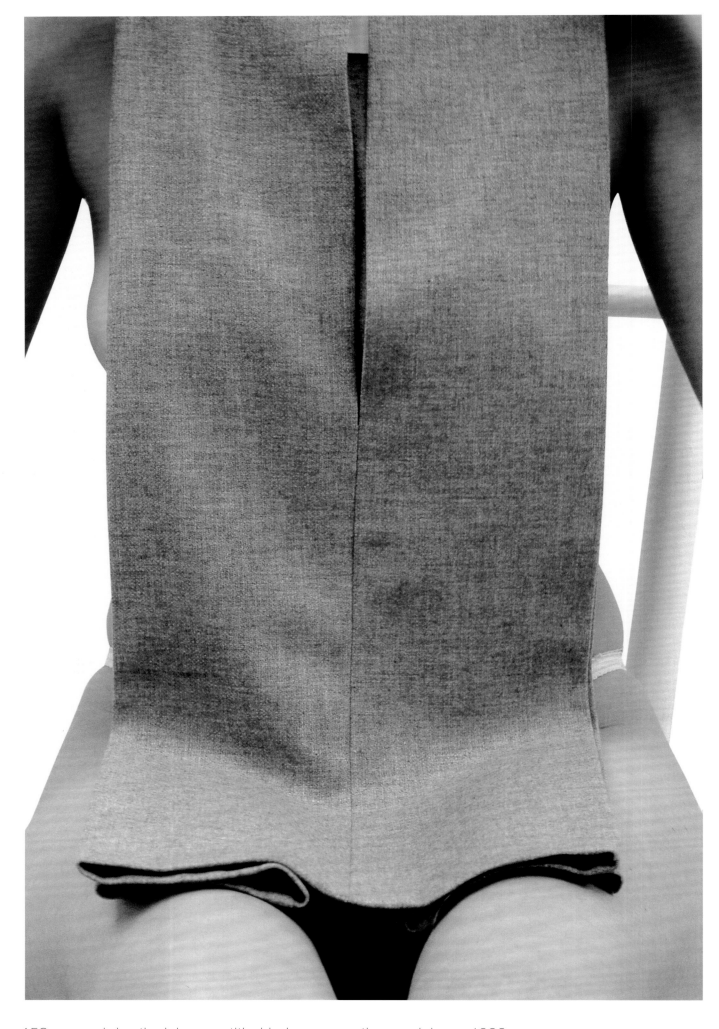

158 . mark borthwick . untitled helen . martin margiela . 1999

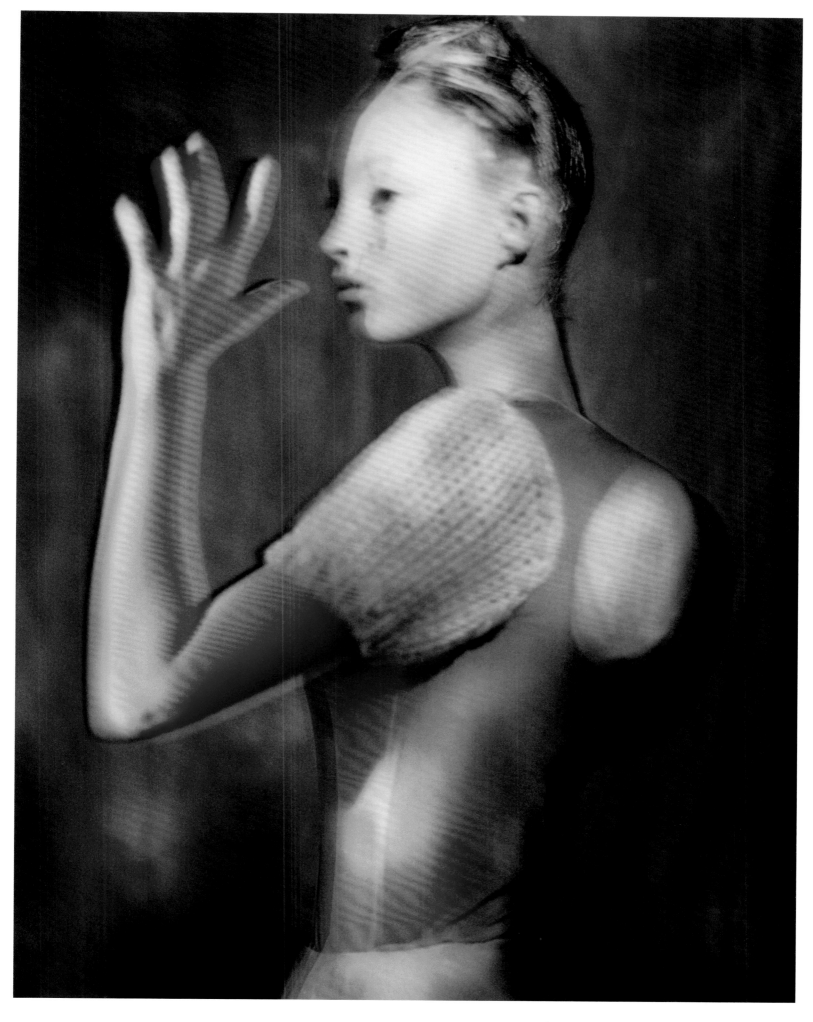

159 . paolo roversi . audrey . libretto . 1996

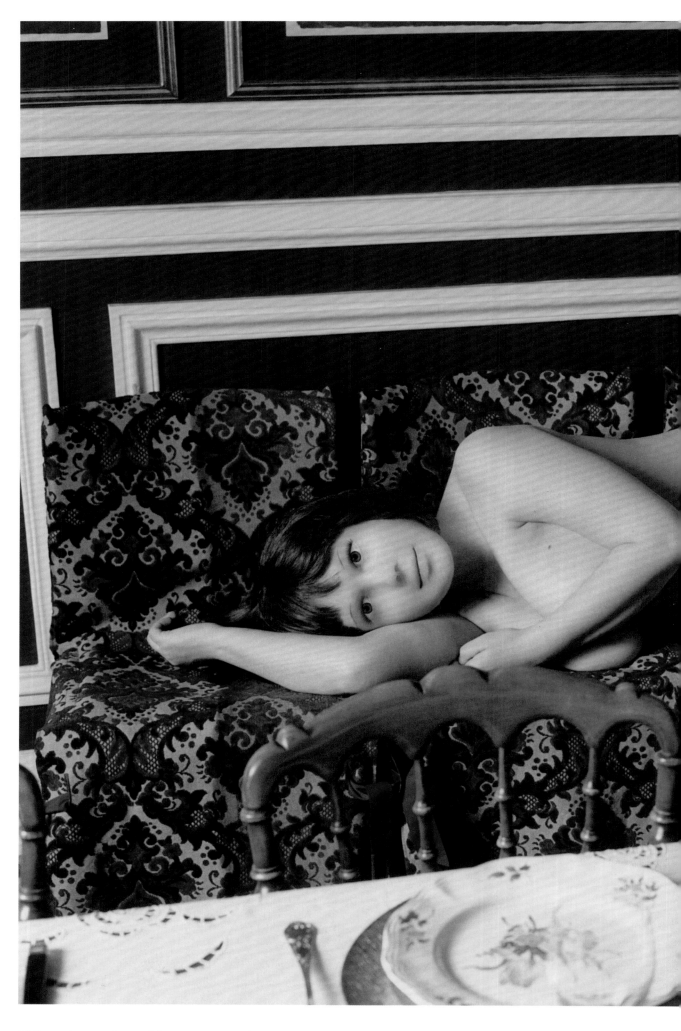

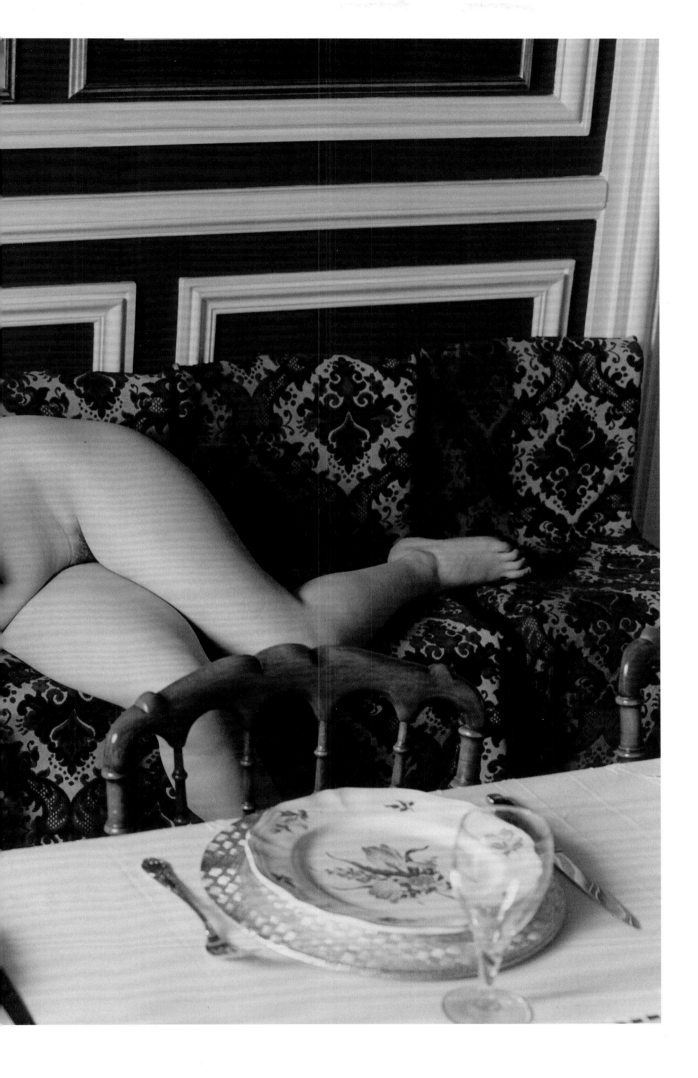

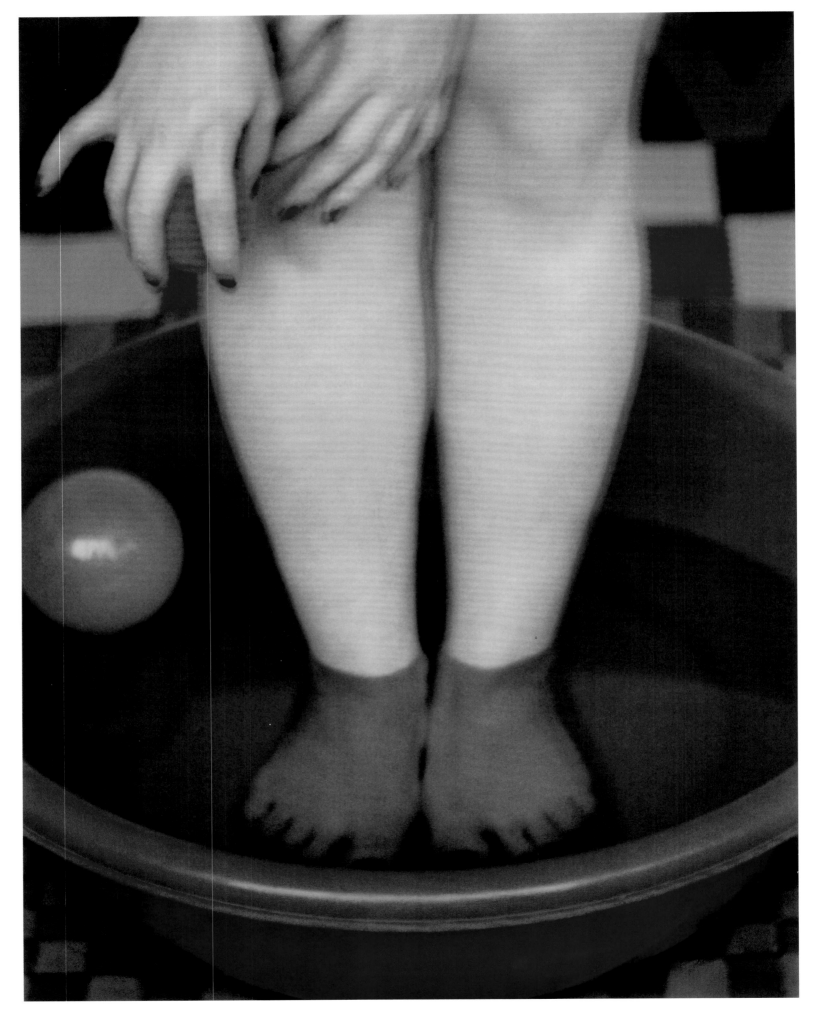

161 . sarah moon . le bain de pied . 1998

162 . sarah moon . l'oiseau . 2000

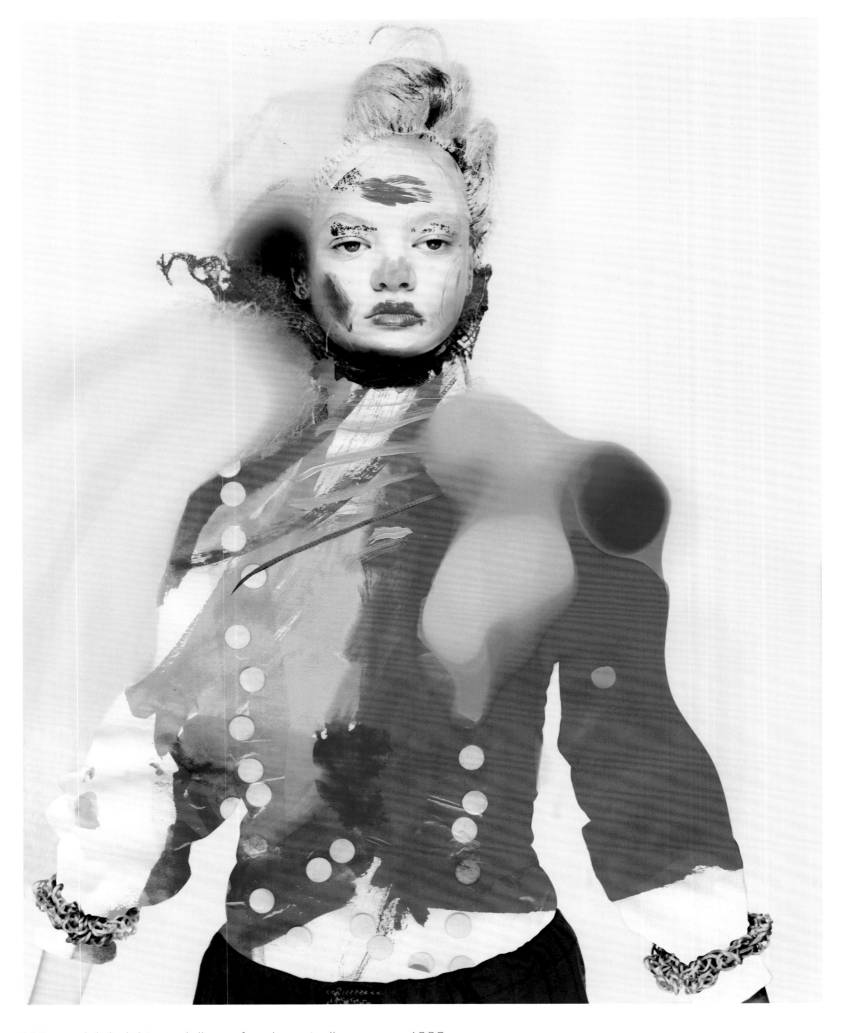

163 . nick knight . dolls . for showstudio.com . 1998

164 . camille vivier . untitled . libération supplément n° 2 . 1999

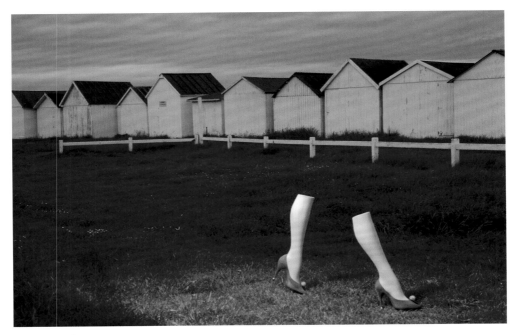

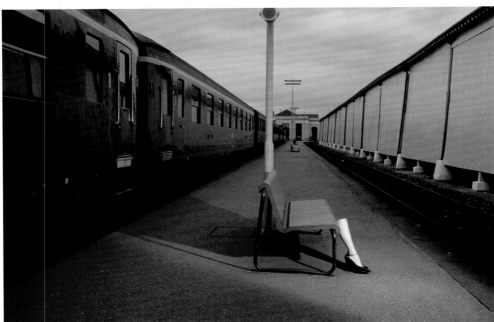

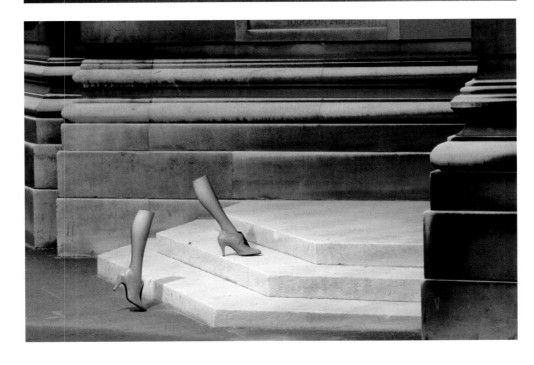

165 . guy bourdin . charles jourdan . 1979

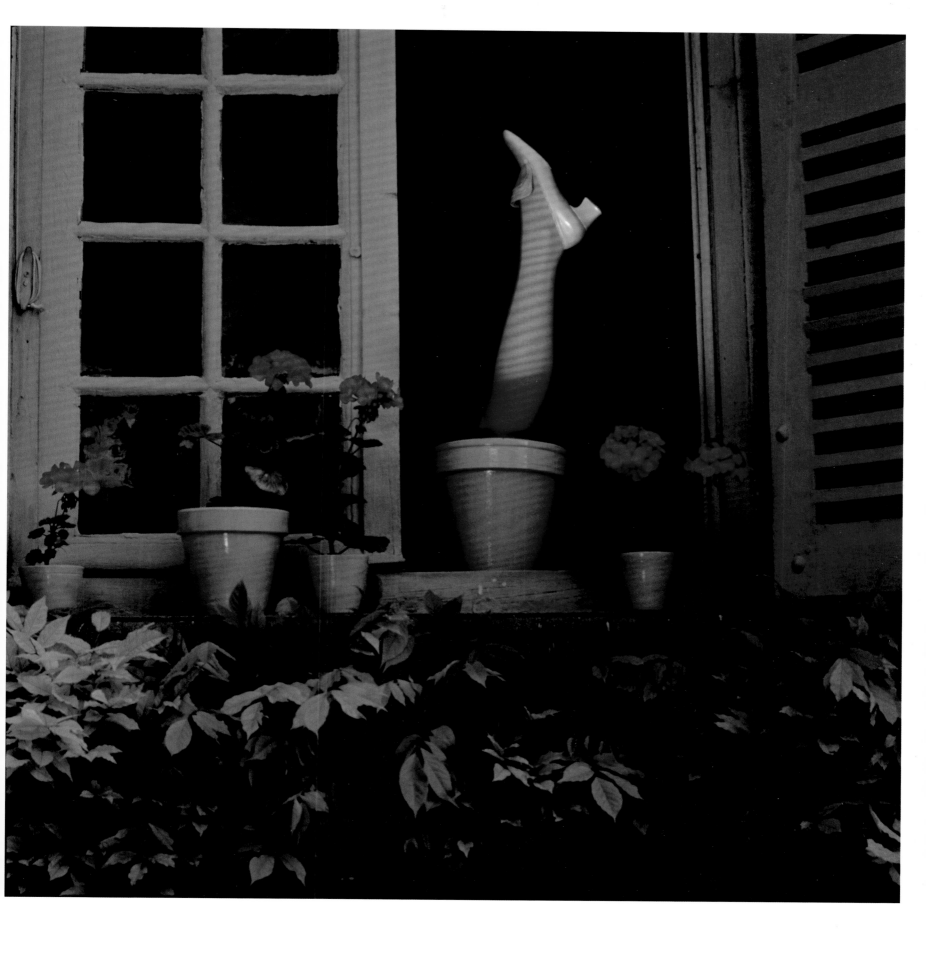

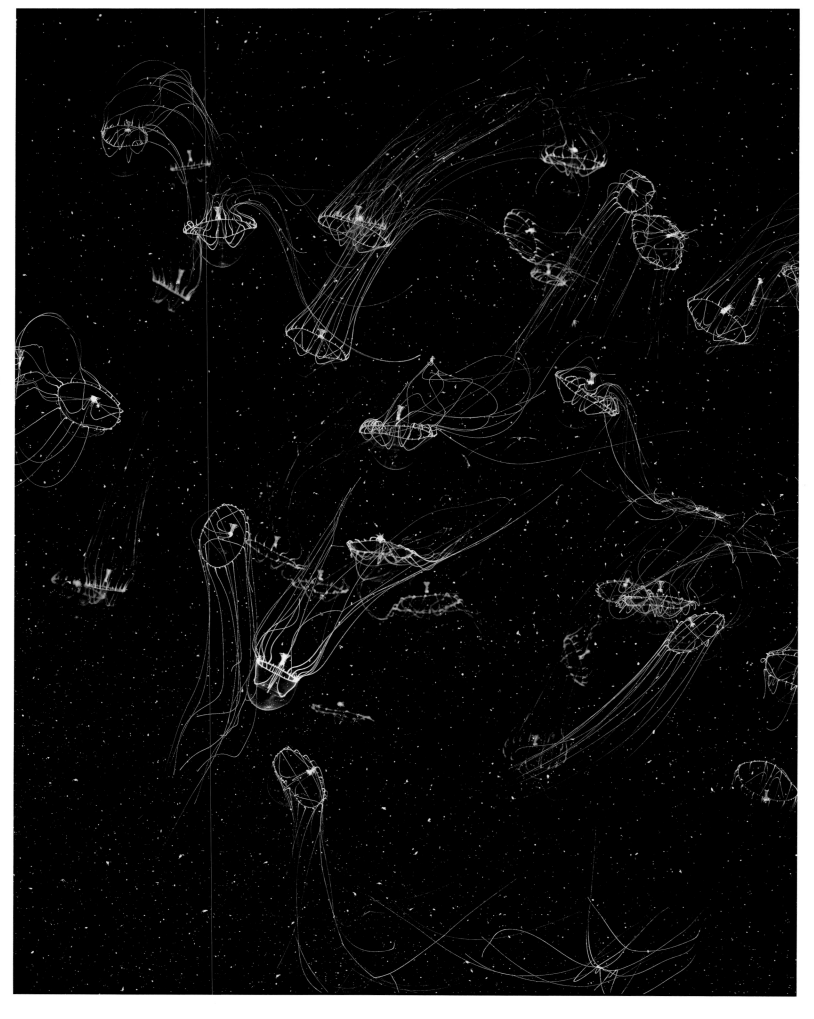

167 . guido mocafico . jelly fish . tina formosa . 2000

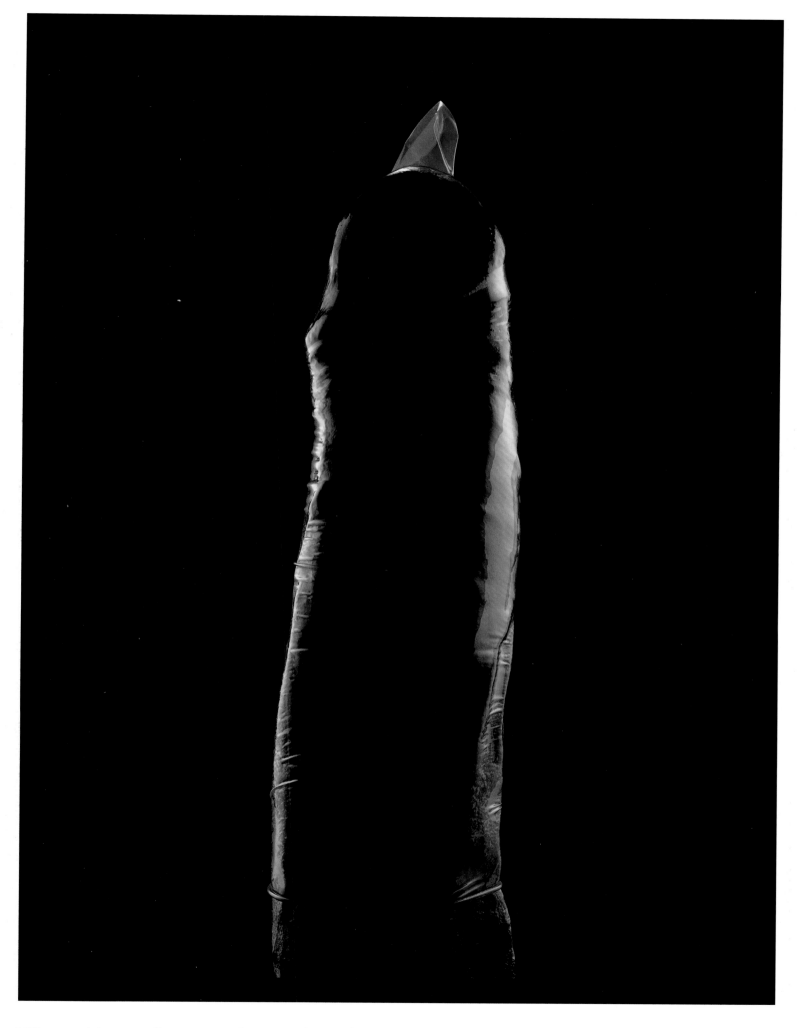

168 . guido mocafico . condom, manix . têtu . 2001

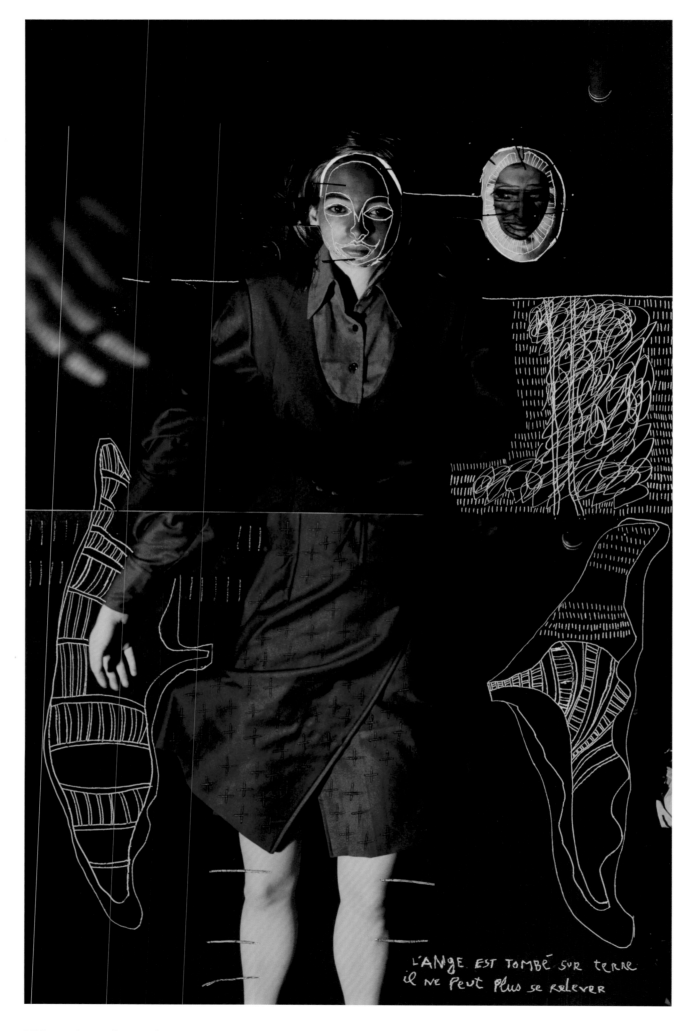

L'ANgE EST TOMBÉ SUR TERRE
il NE PEUT PLUS SE RELEVER

169 . jean-françois lepage . dorothée . collection gigi calo . 1992

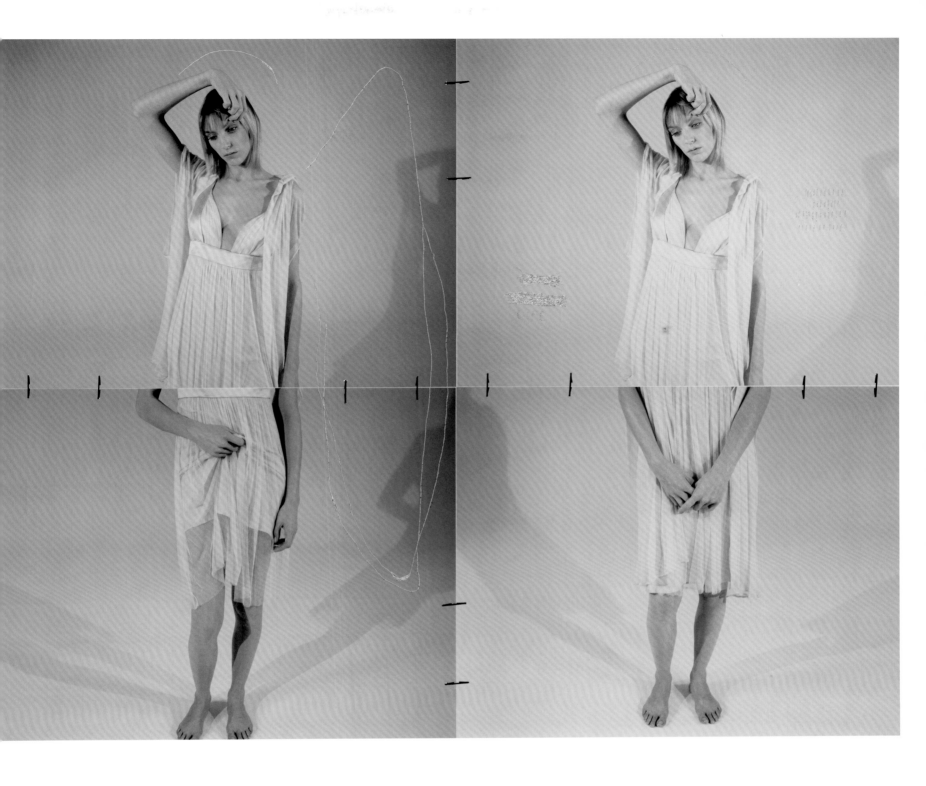

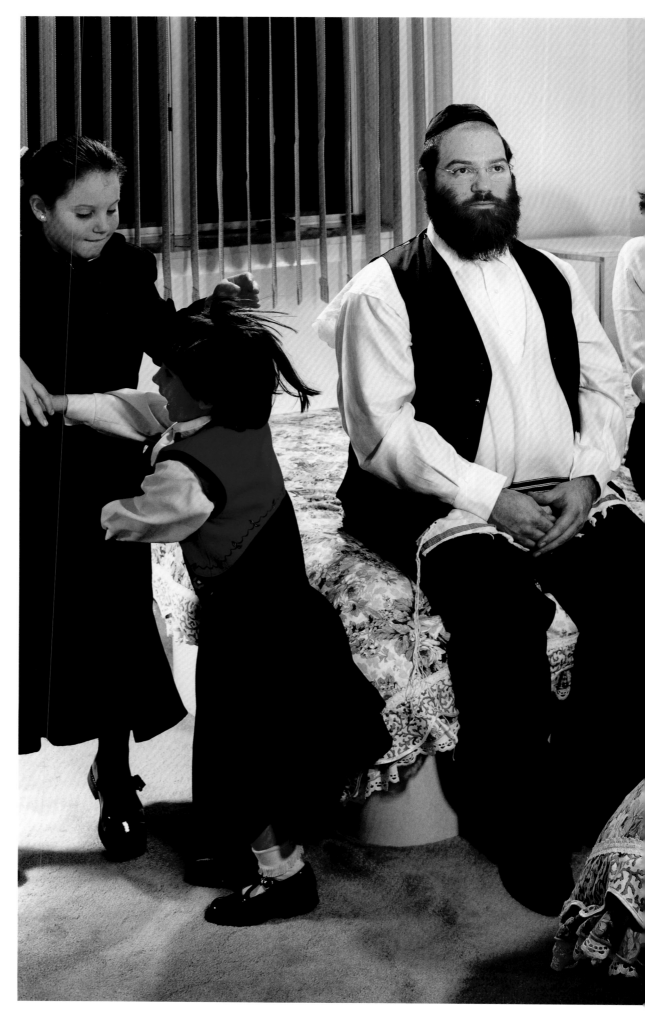

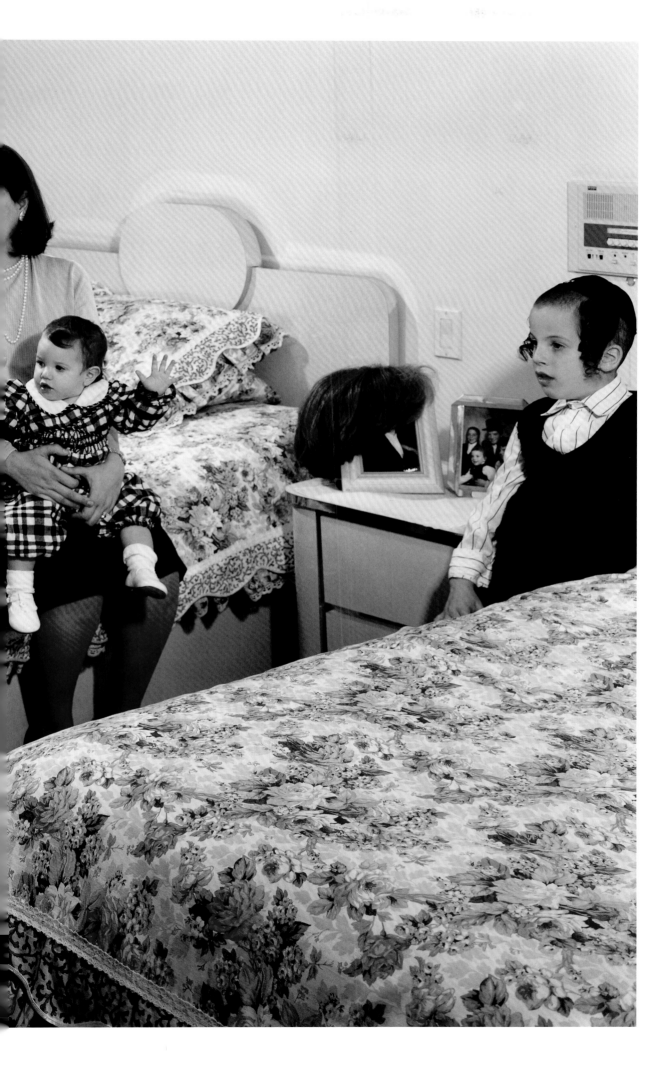

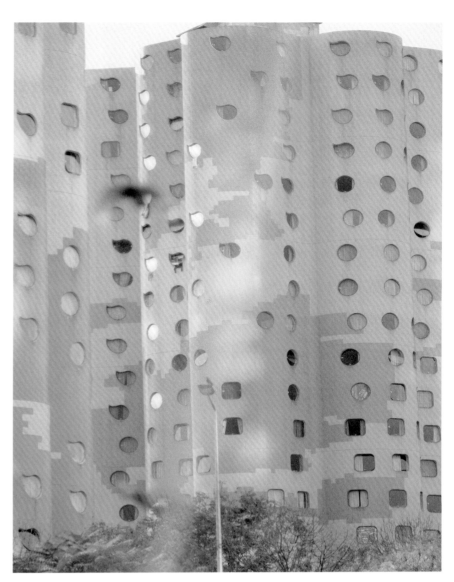

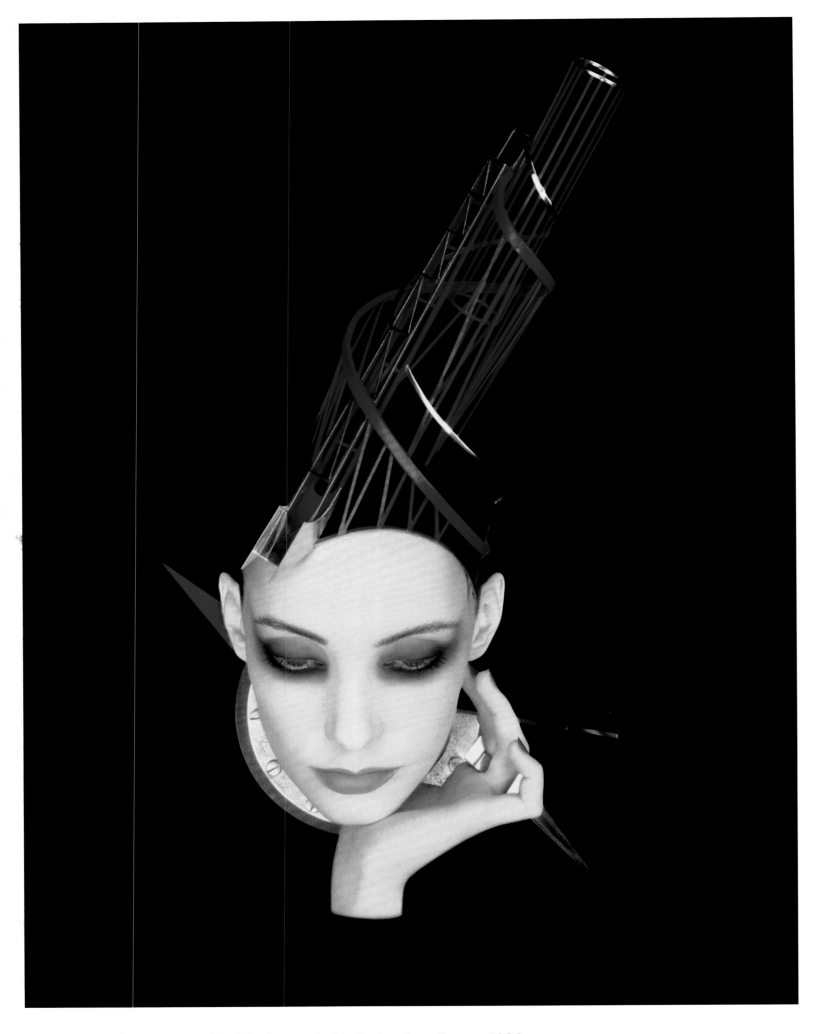

175 . serge lutens . coiffe à la façon de "tatlin tour", cathy . 1989

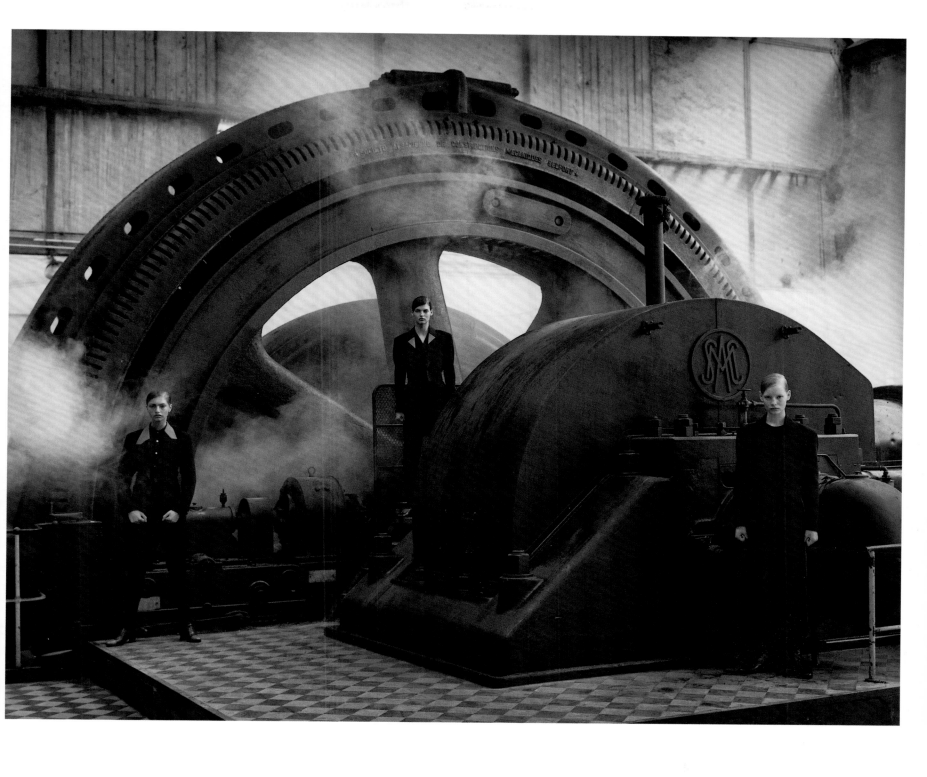

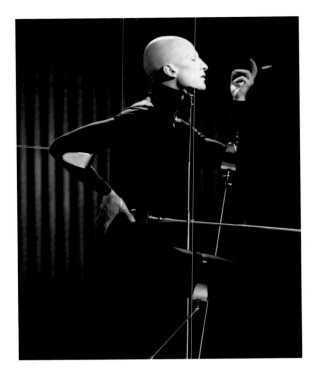
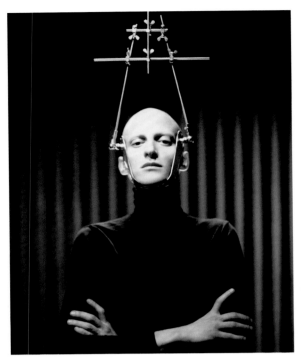
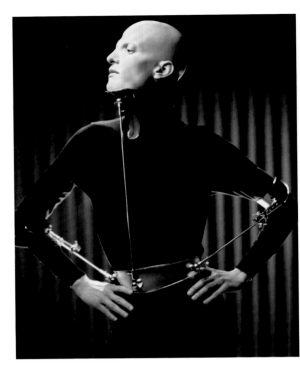
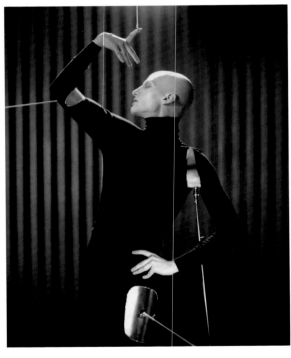
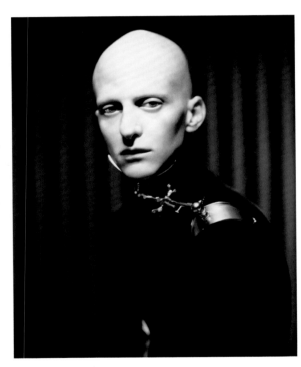
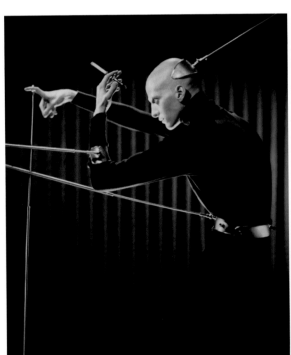

177 . ali mahdavi . as you desire me . 2000

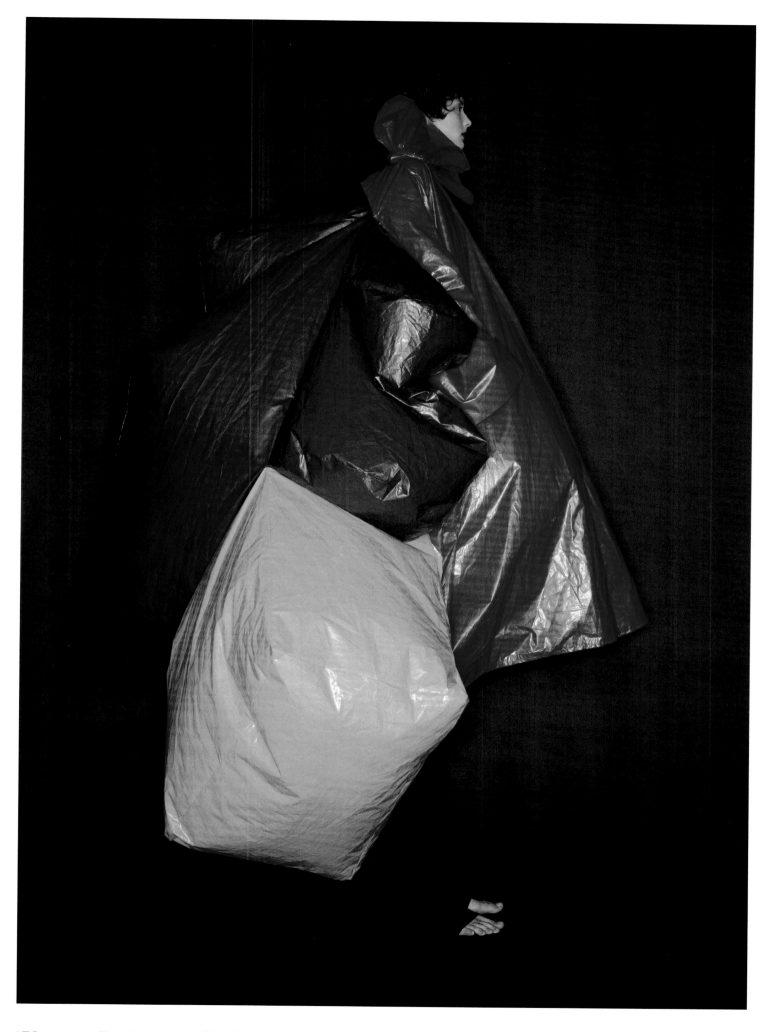

178 . camille vivier . untitled . zoo . 1999

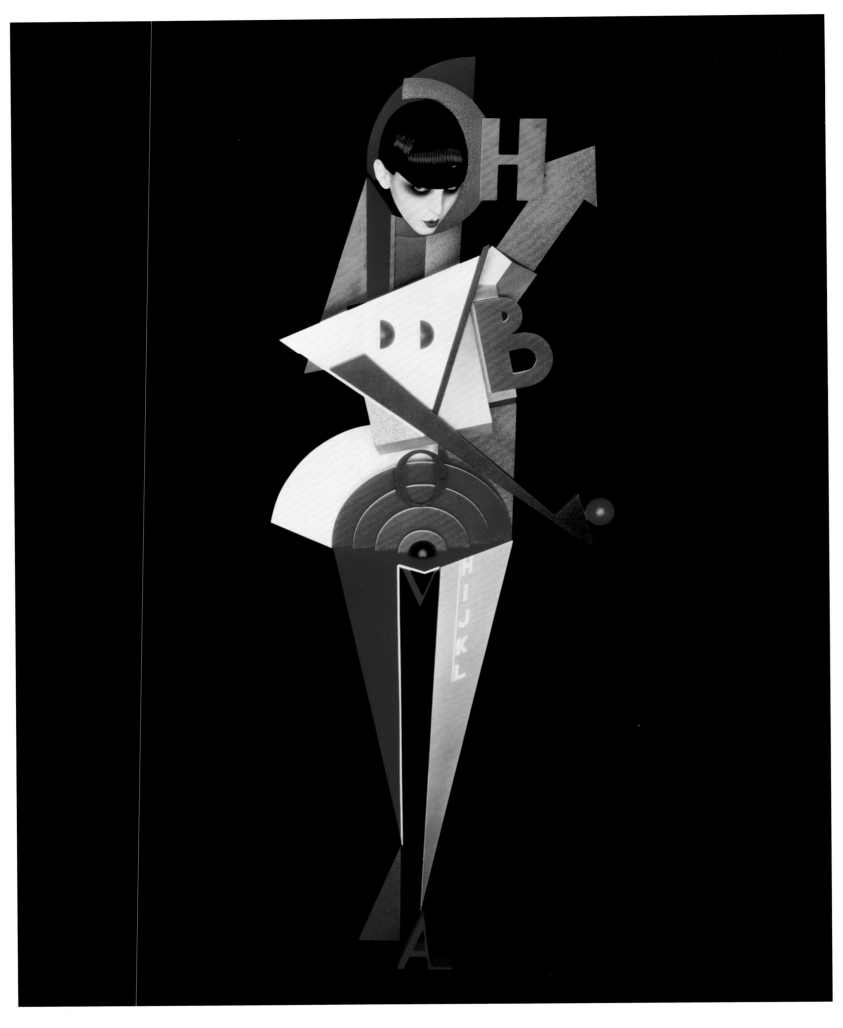

181 . serge lutens . composition lettriste noir, rouge & blanc, louise . 1989

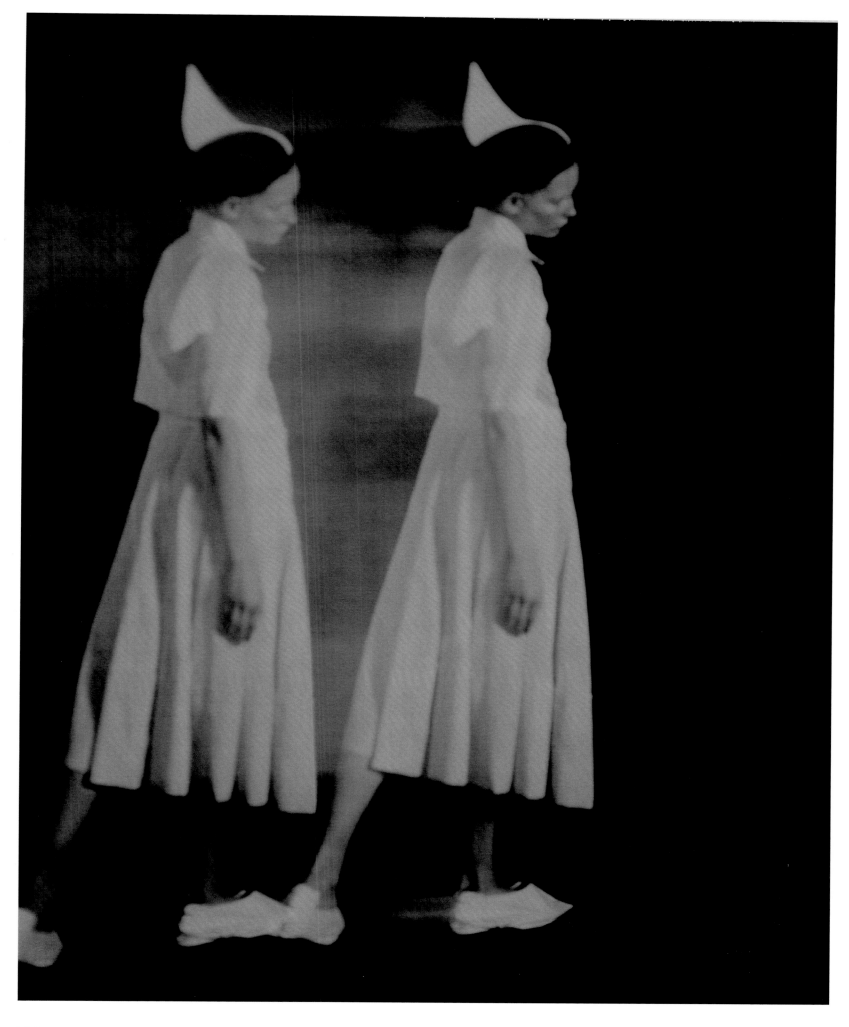

182 . paolo roversi . sasha, paris . english vogue . 1985

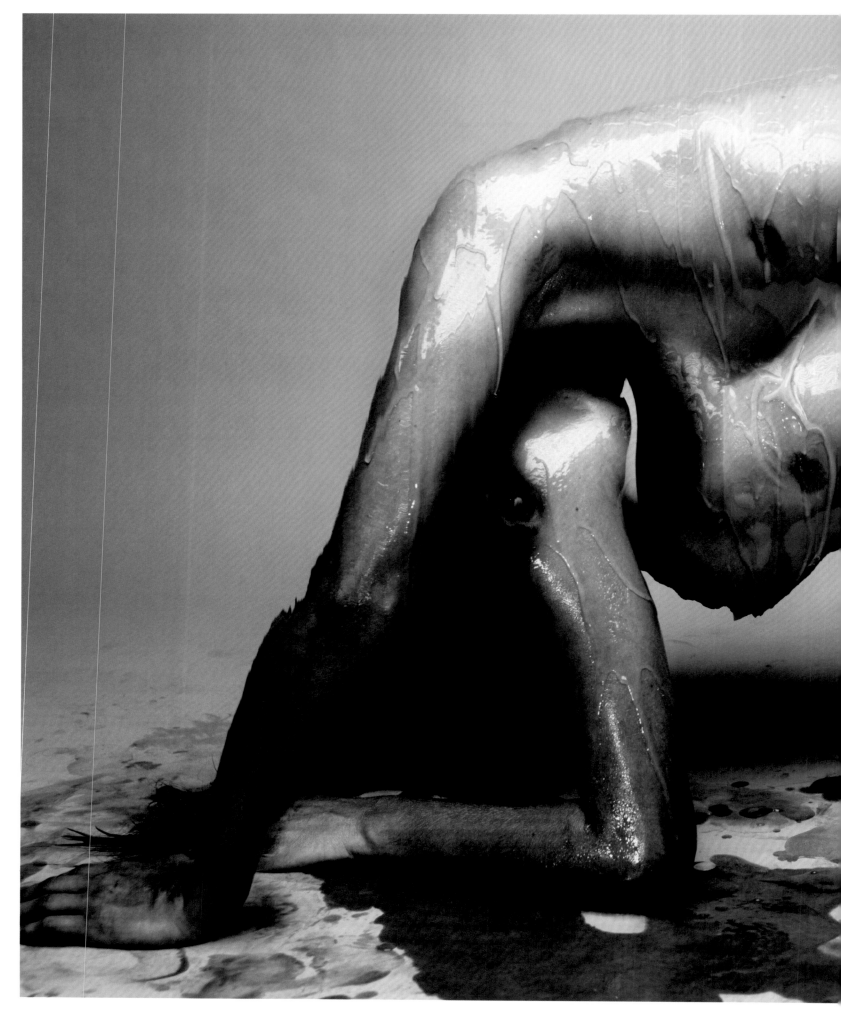

183 . stéphane sednaoui . daniela urzi . black book . 2000

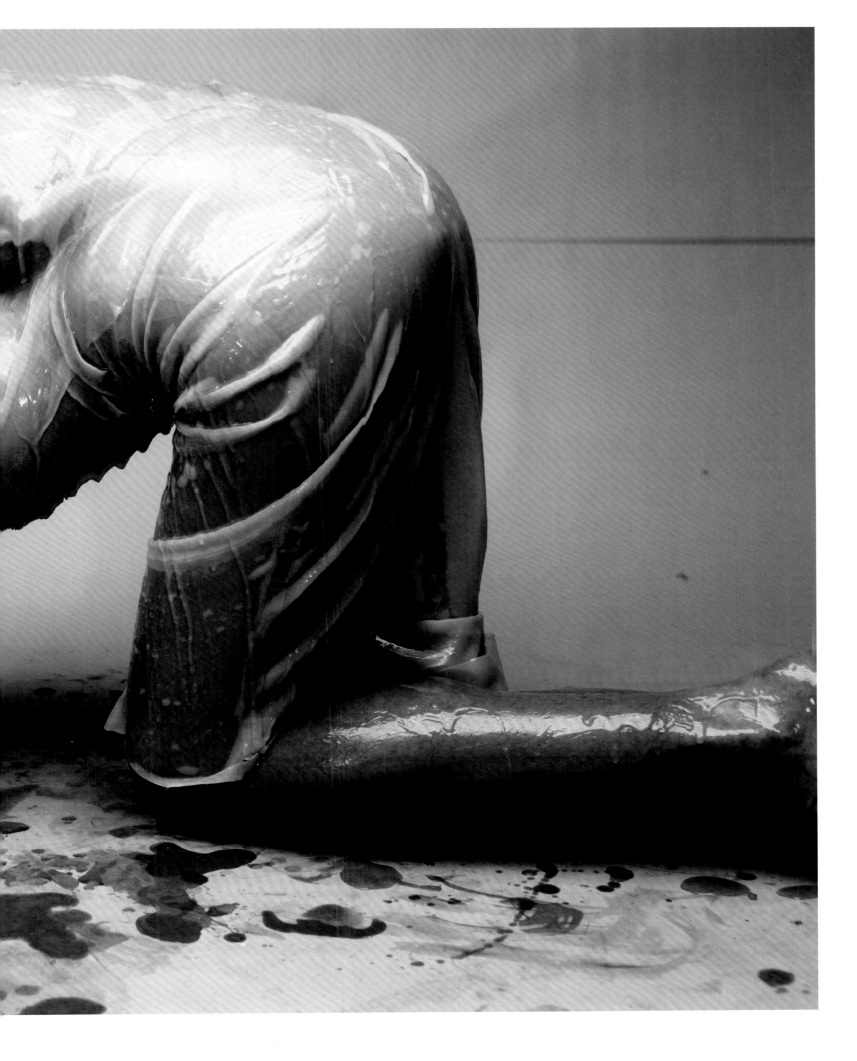

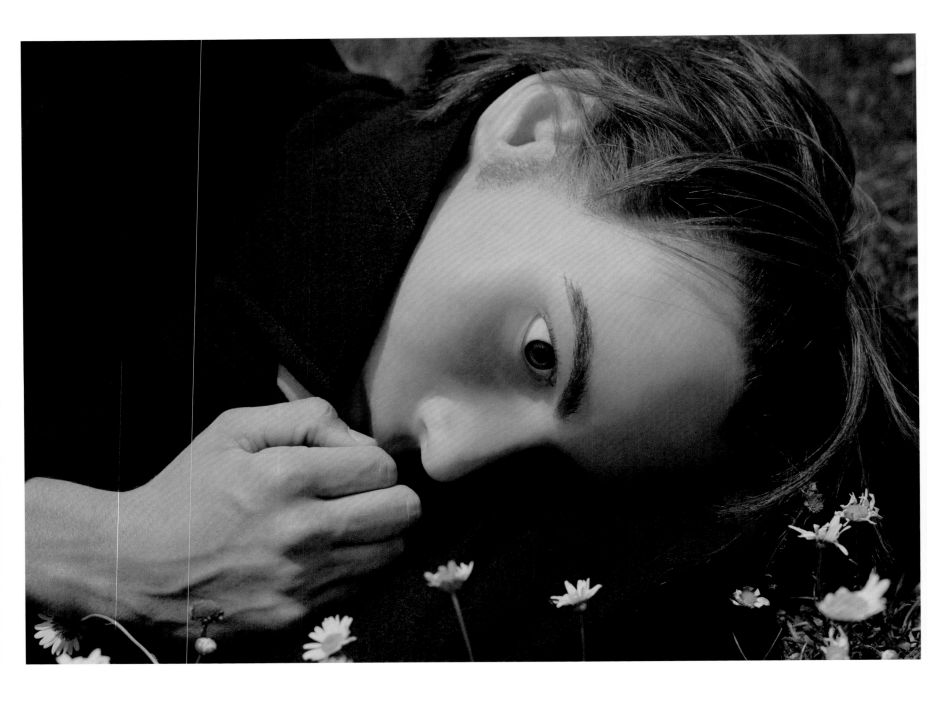

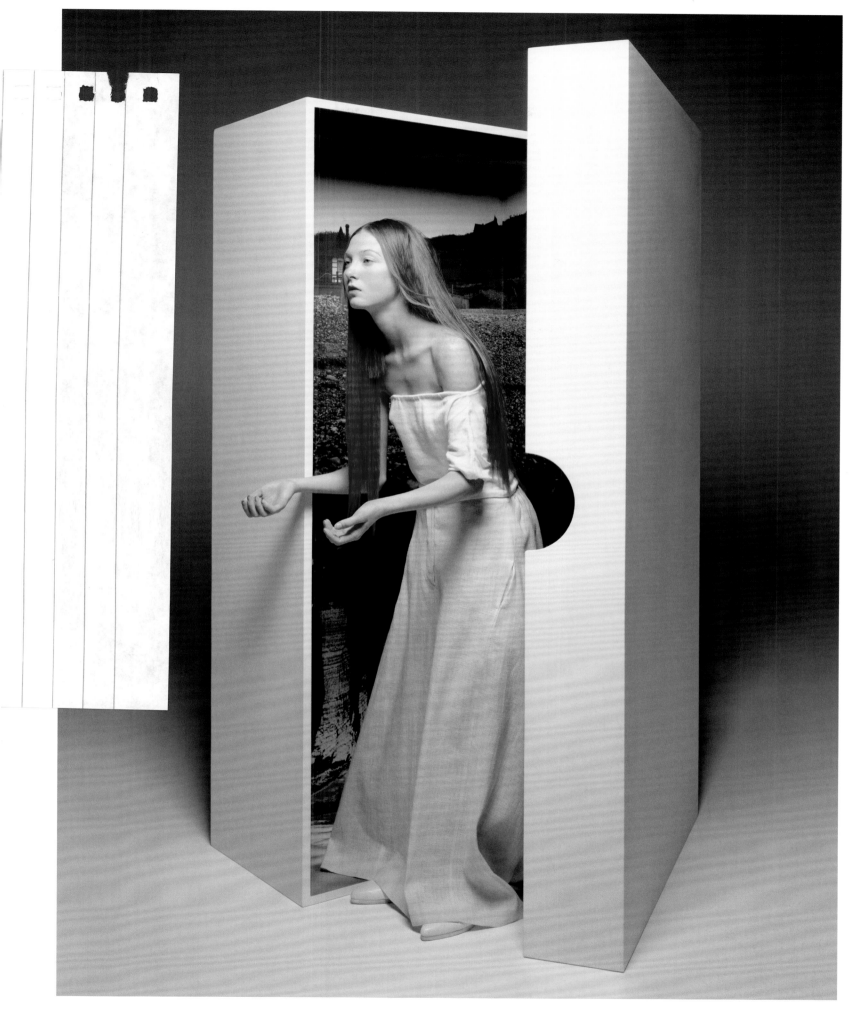

185 . inez van lamsweerde & vinoodh matadin . yamamoto, maggie's box . 1997

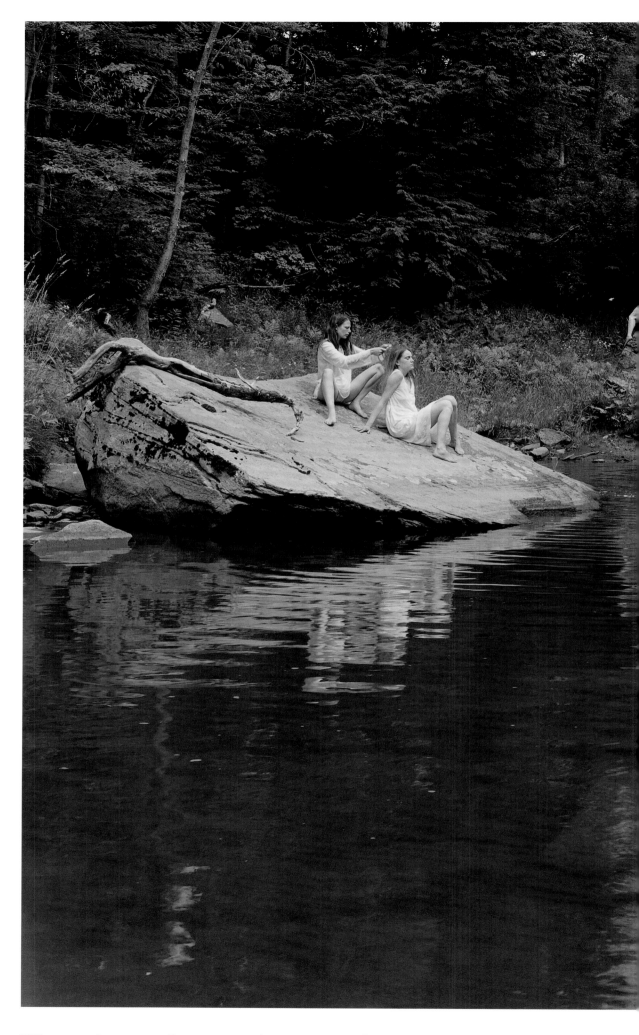

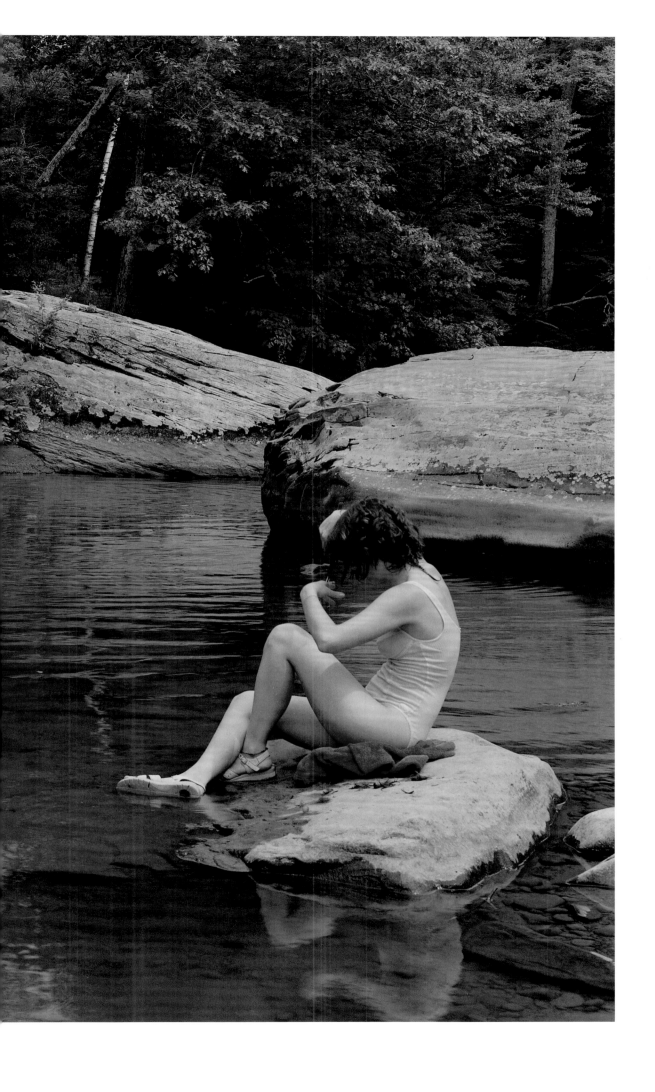

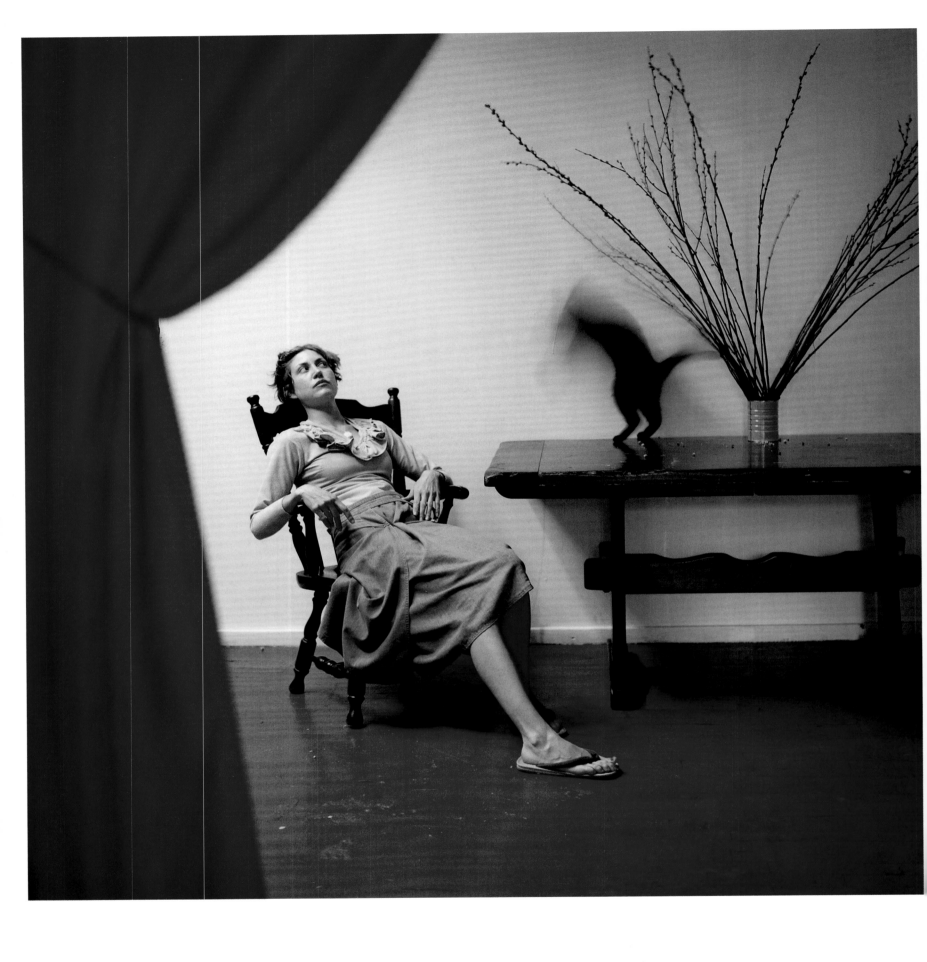

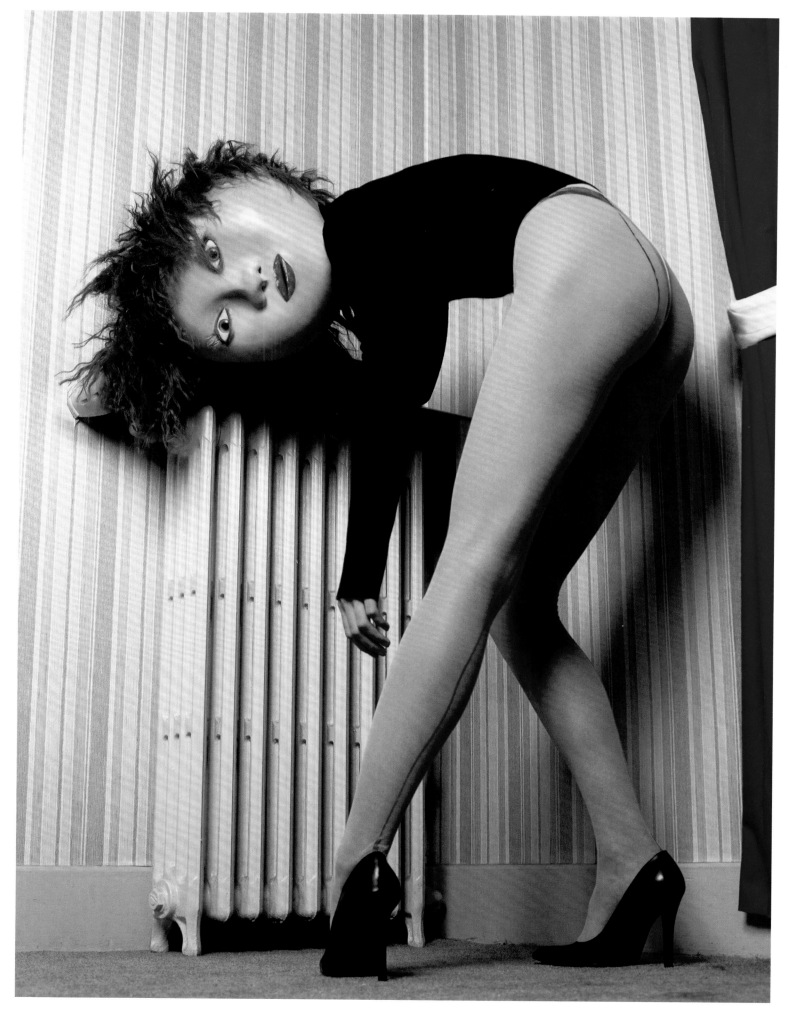

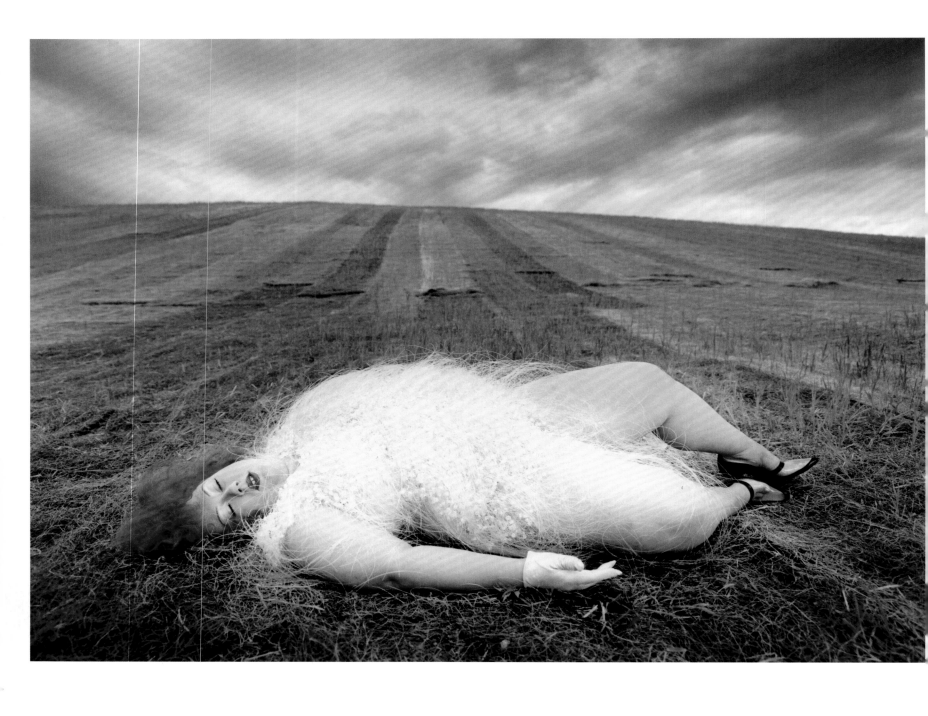

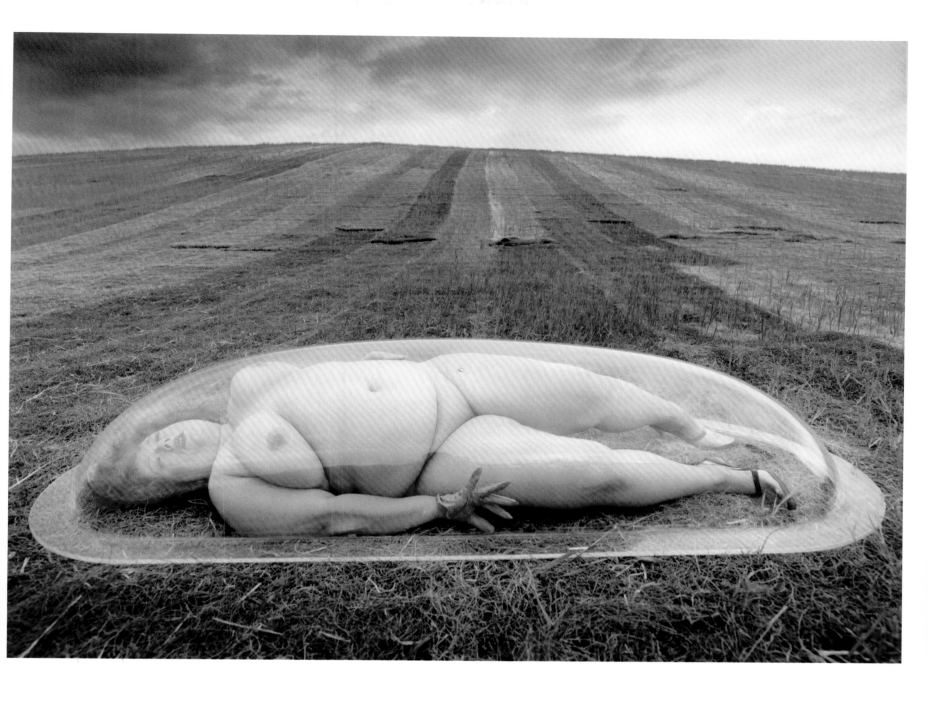

191 . pierre winther . holiday on earth II . dunhill . 2001

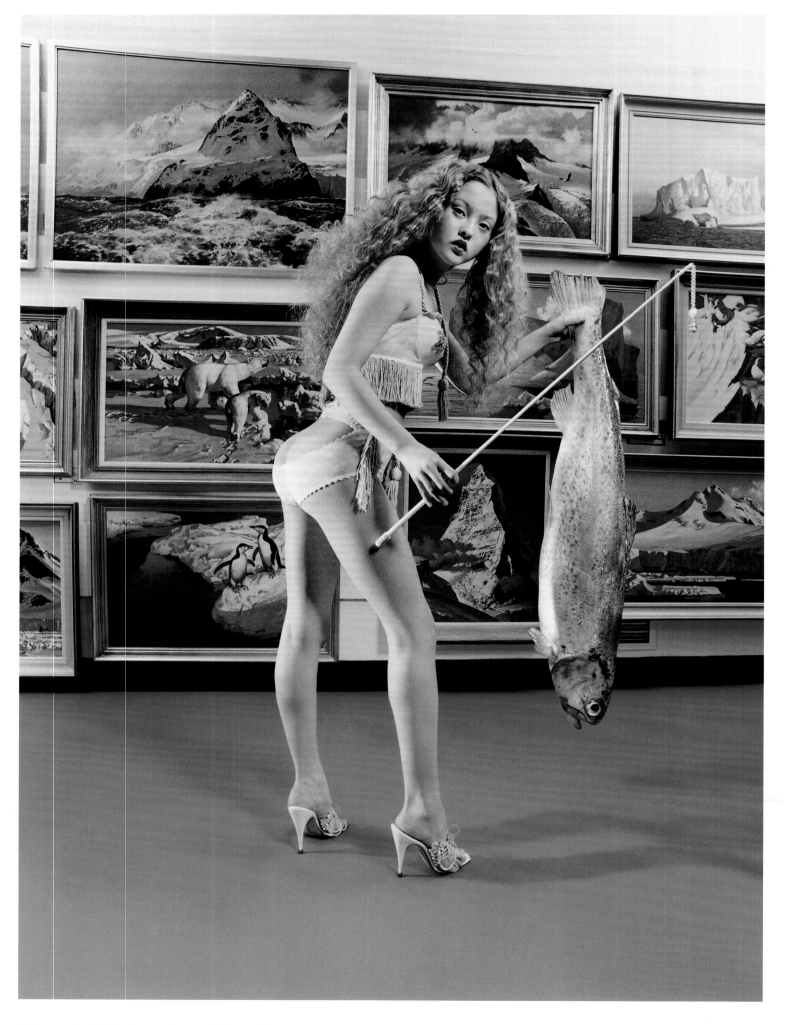

192 . david lachapelle . fish stick . sunday times magazine, london . 1998

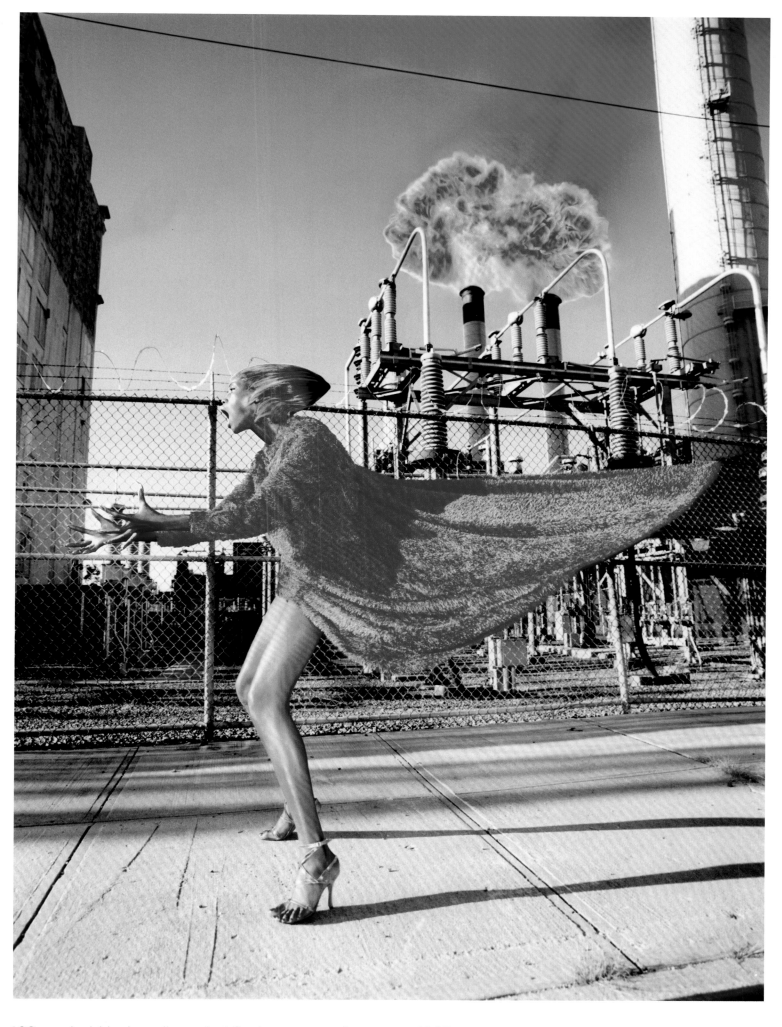

193 . david lachapelle . hot flash . vogue france . 1998

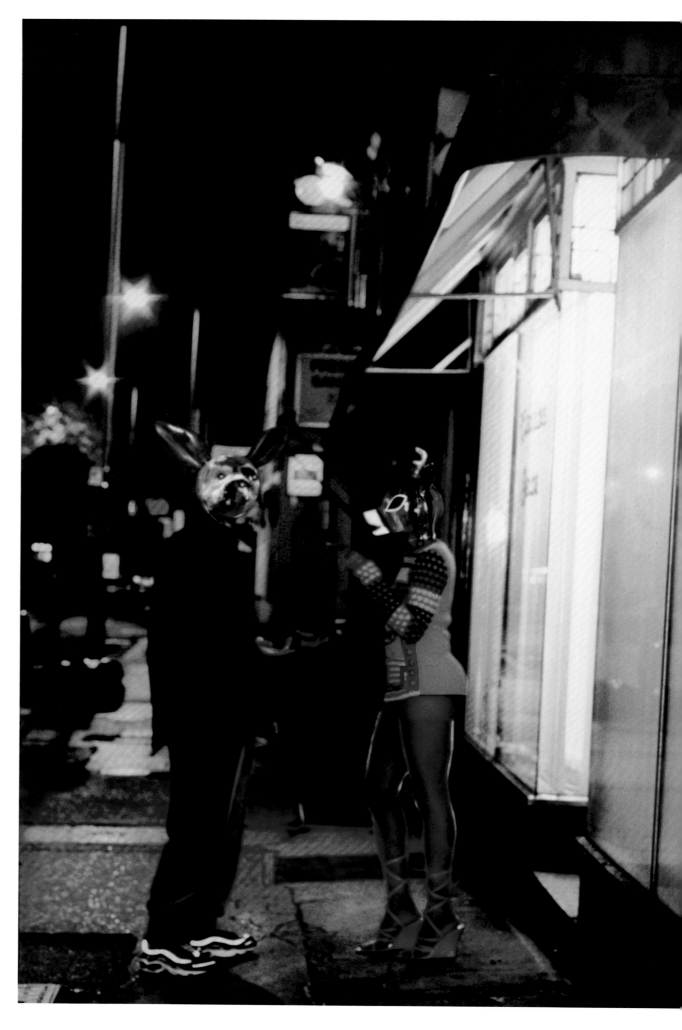

194 . jean-pierre khazem . massage . the face . 1998

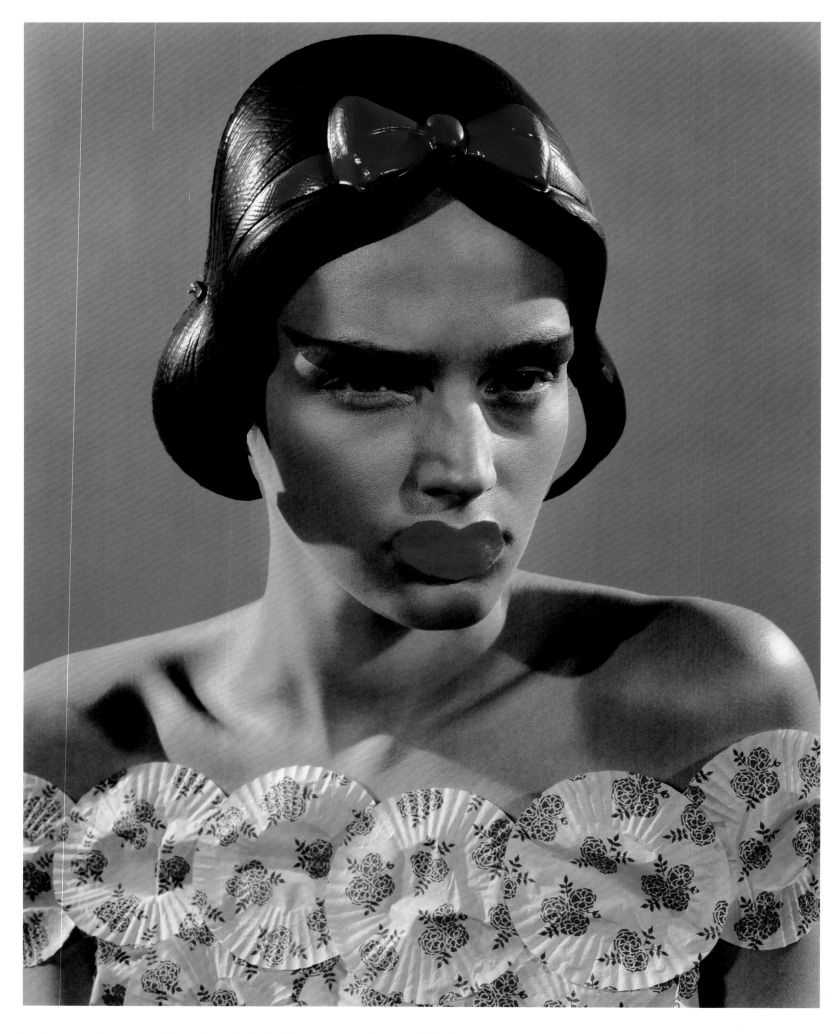

195 . mario sorrenti . beauty hair, lips . numéro . 1999

196 . james wojcik . lipstick sandwich . unpublished . 1995

197 . james wojcik . lipstick belt . i-d magazine . 1997

198 . ellen von unwerth . barbie and ken, new york . 1994

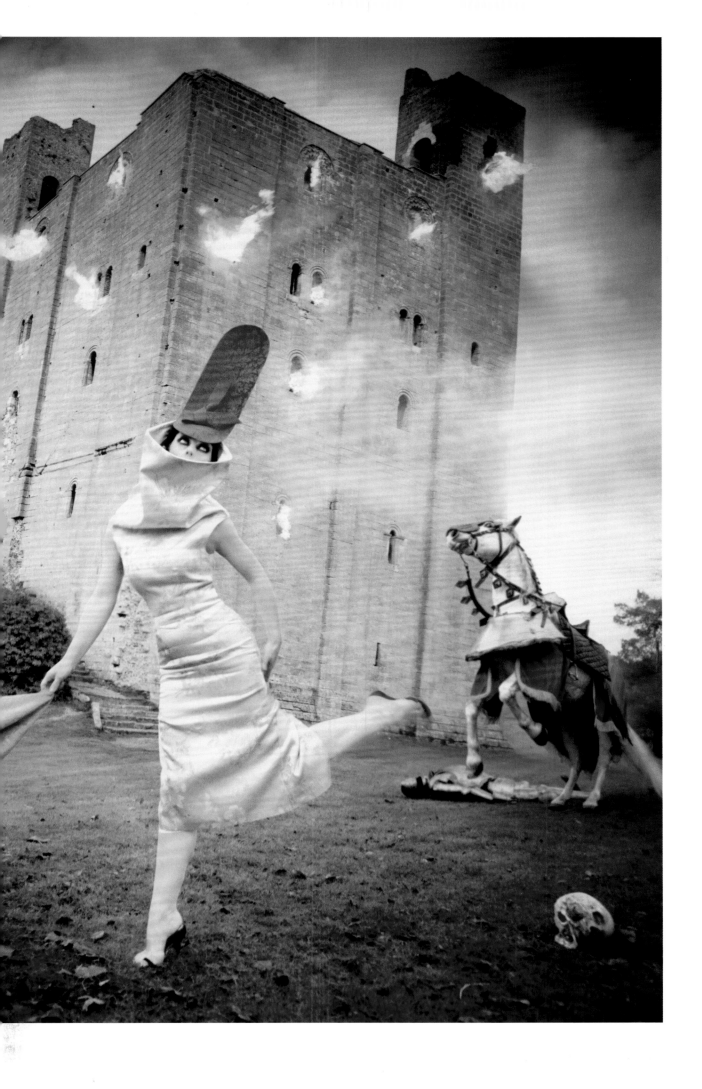

200 . norbert schoerner . constable's line up . 2000

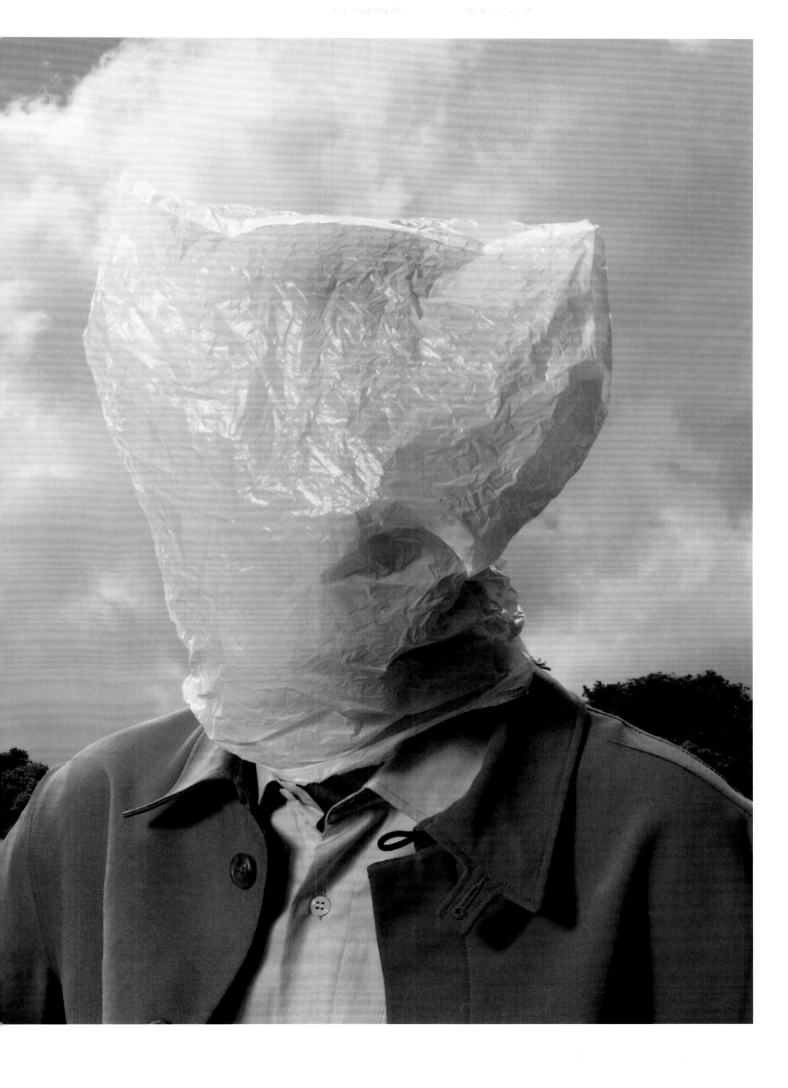

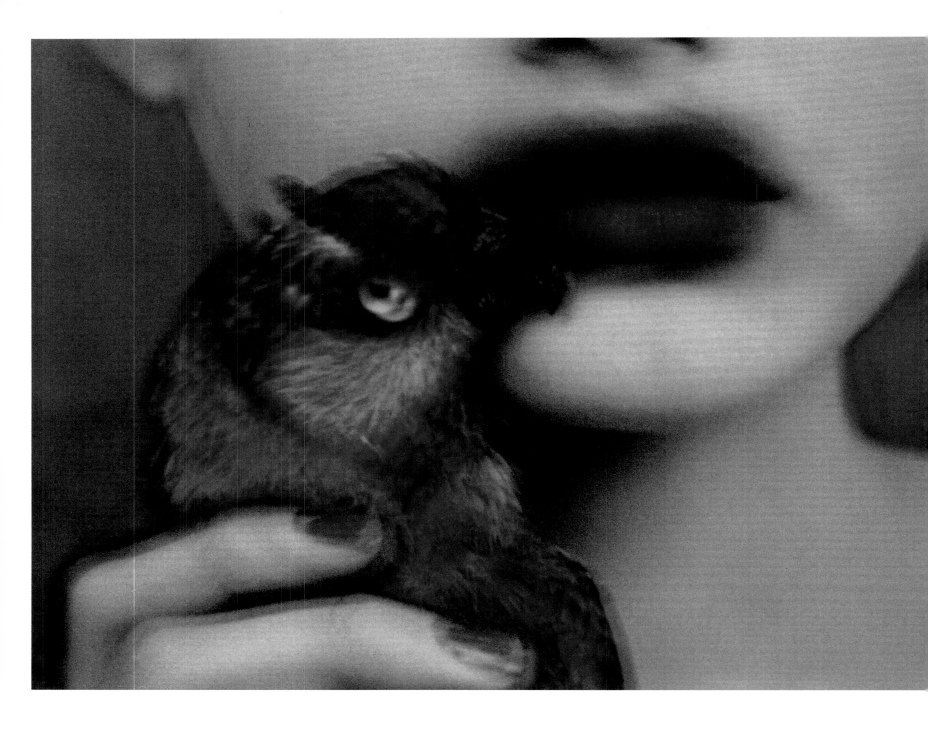

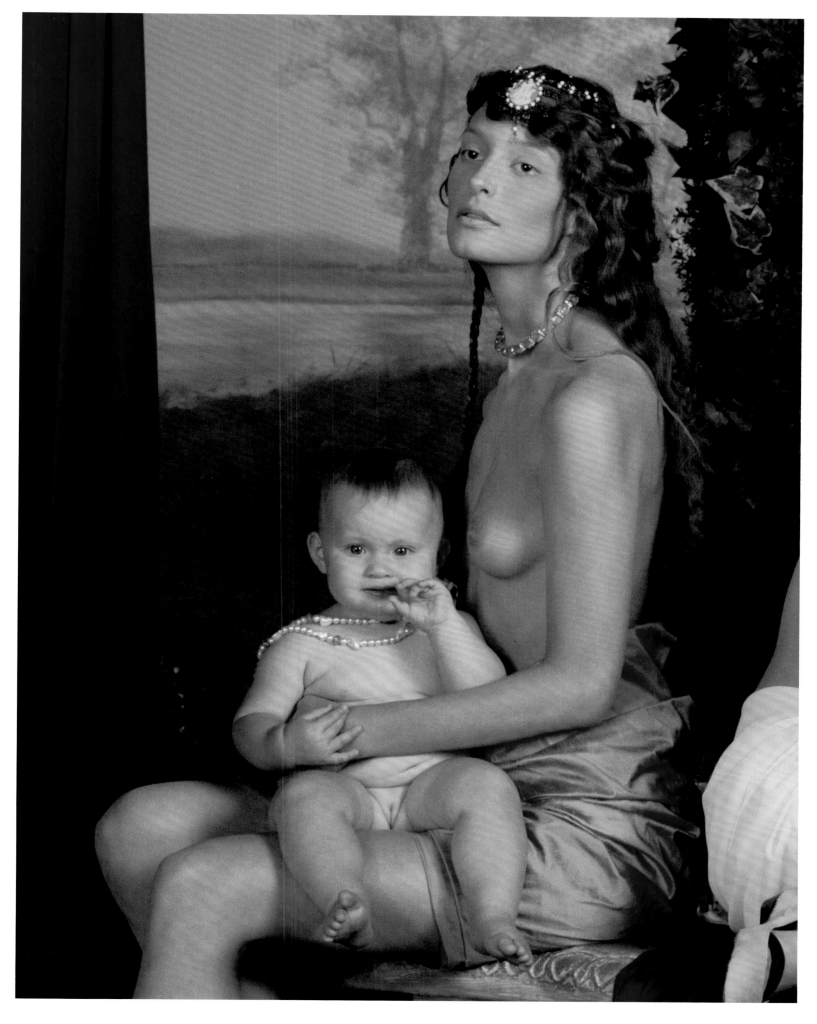

205 ▪ sean ellis ▪ the dark knight returns, alexander mcqueen ▪ the face ▪ 1998

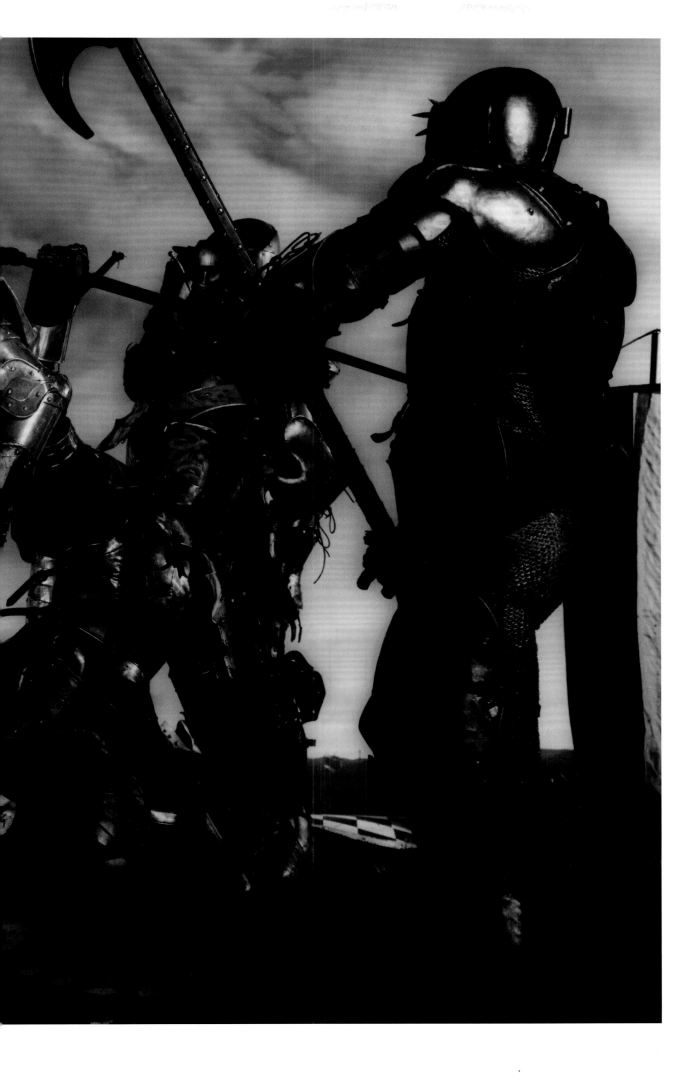

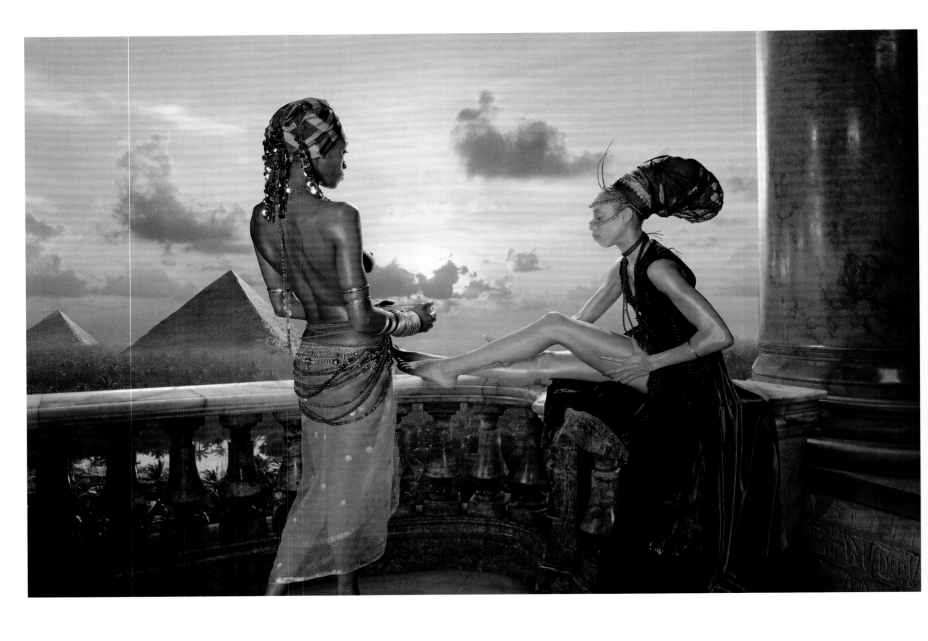

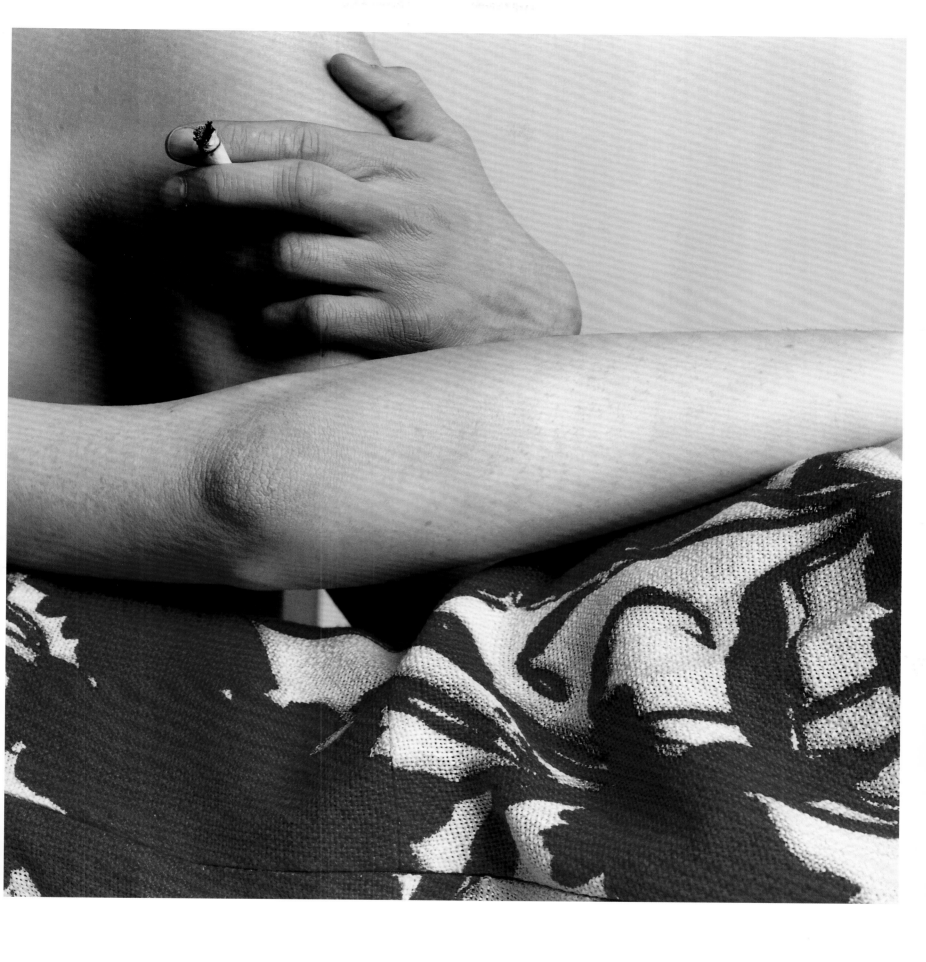

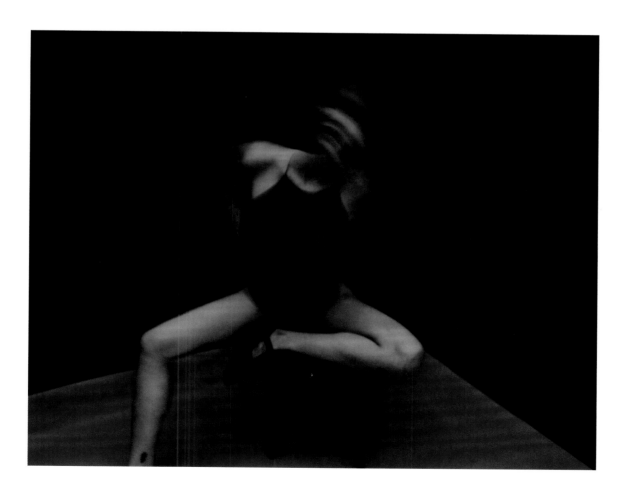

211 . mario sorrenti . francis bacon III, IV . w magazine . 1997

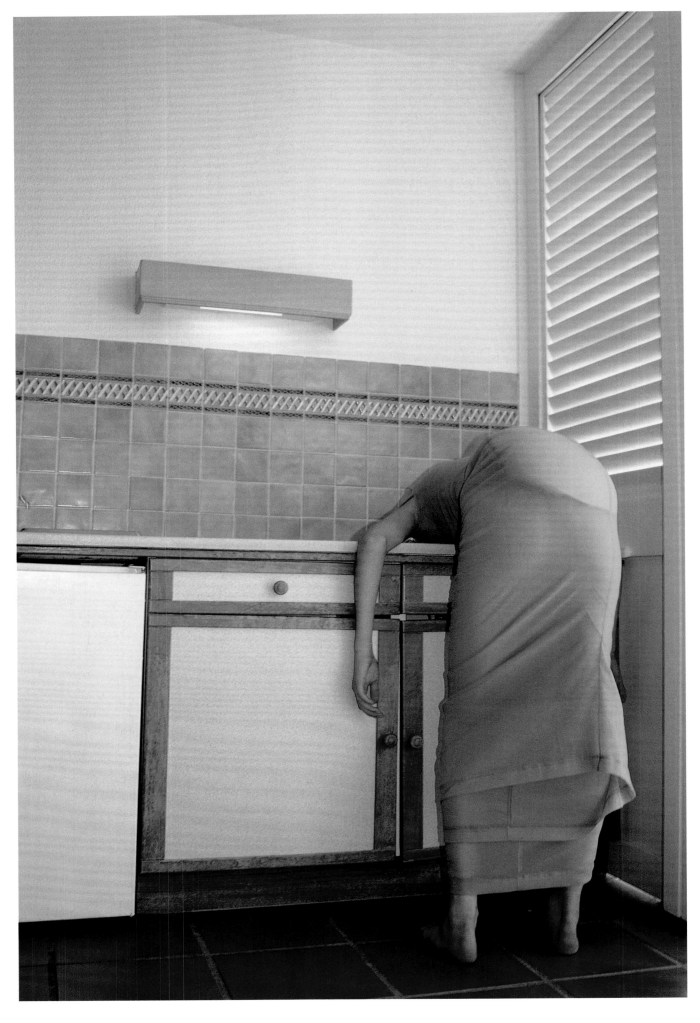

212 . mark borthwick . untitled zora, comme des garçons . big . 1997

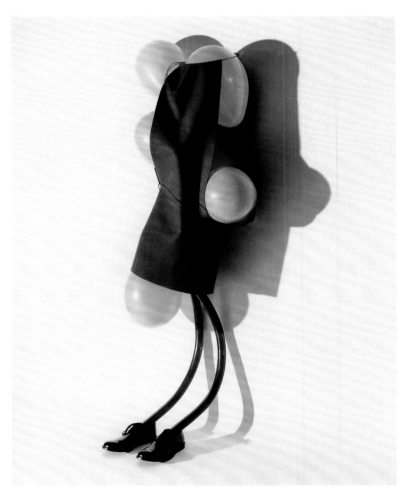
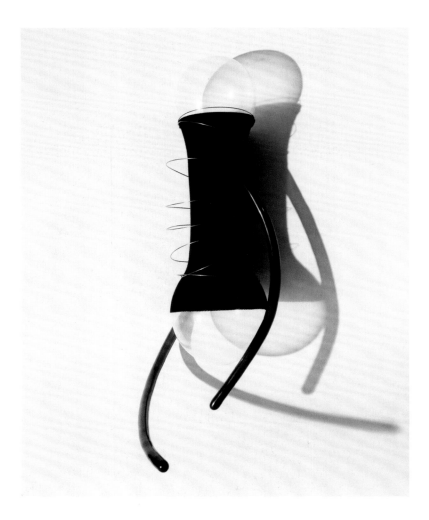

213 . mario sorrenti . comme des garçons I–IV . visionaire . 1998

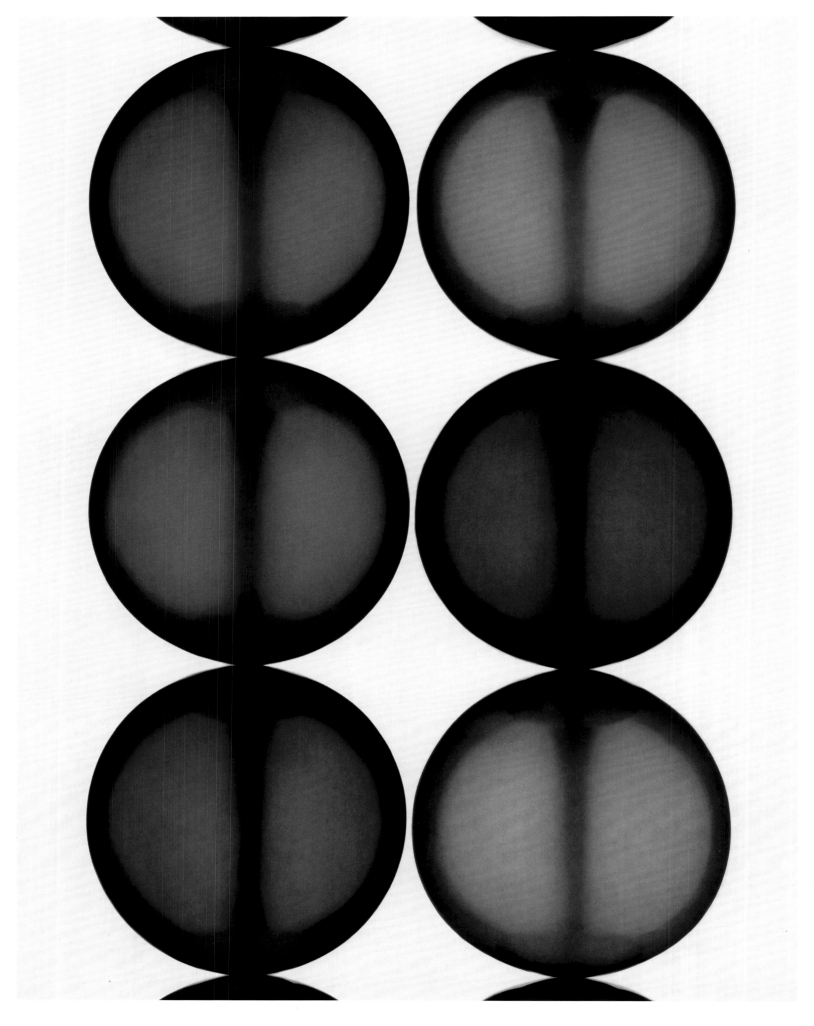

214 . guido mocafico . pearls, mikimoto necklace . numéro . 1999

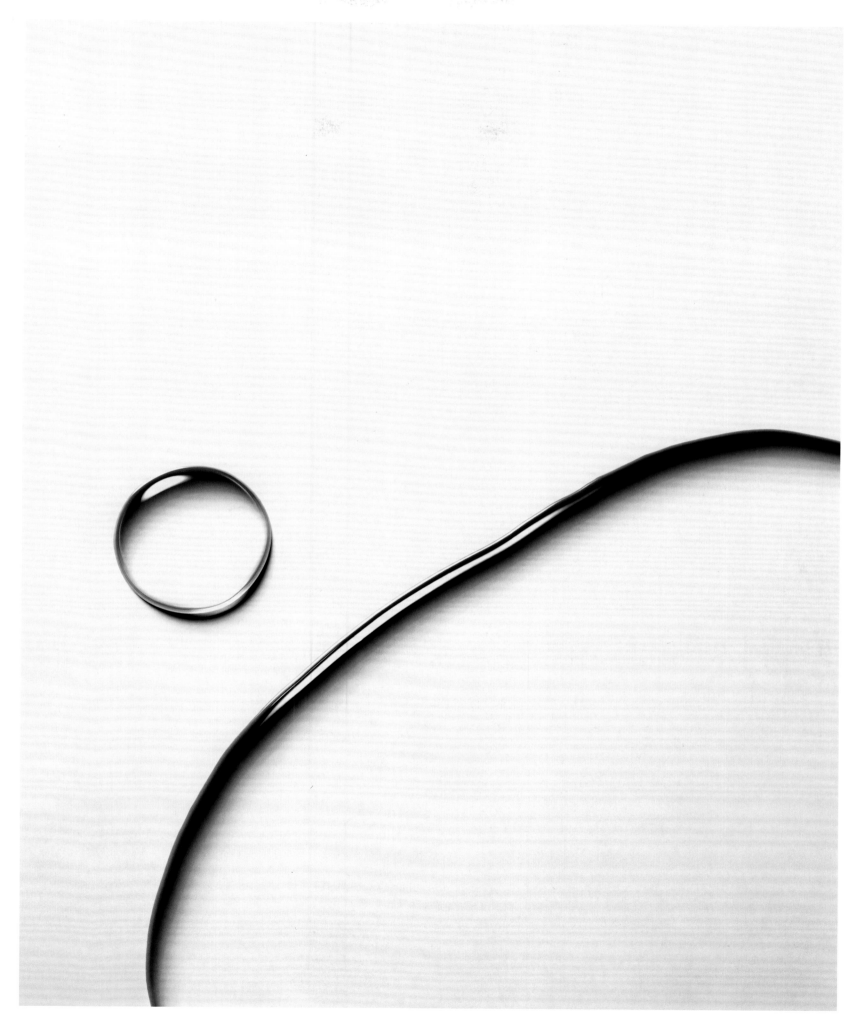

endpoint All fashion photography is a mirrored surface. It mirrors our wishful images, and the four different force fields are four different mirrored surfaces, each of which is set at a different angle to the others and cast images, colours and silhouettes back and forth, waiting for feedback. The four mirror surfaces communicate repeatedly with one another according to their own respective motion. What links them is one and the same time code, a kind of imaginary dating of the picture, legible by all those who know the signs of the time. Visual culture then becomes a trap for it is a narcissistic culture if one's own desired images are no longer fractured and advanced, but are simply depicted unashamedly. Poetry is meant to avert the bane of self-bondage by the mirrored surfaces. Fashion photography has forfeited these opulently.

The desired images have become foils for the real mirror as is to be encountered in ever larger dimensions in contemporary living rooms, bathrooms and bedrooms. The foils of the real mirrors become instructions for mimicry en route to the quest for self-image. The foil judges the state of your efforts down the path to becoming your own desired image. Progress, regress, standstill are all noted by checking things with a glance in the mirror. It is no longer the actual state that is to be discovered on the foils, but the look desired. Fashion photography produces these foils. It produces dreams, wishes and hopes – and as with all dreams, it spawns the terror and the horror that go hand in hand with their realization. *Protect me from what I want*. Jenny Holzer's phrase has lost none of its appositeness. How robbed of protection we are when faced by our dreams is evident from the careers of the dream makers. The care we devote to nourishing our hopes is now exceeded by the fear of having deceived ourselves. Seen like this, fashion photography is also the poison cabinet – the right dosage is invaluable, but an overdose is lethal.

biographies

like harper's bazaar, french vogue, jalouse makes video clips and advertising films . **jean-pierre khazem** . born 1968 in paris . published in magazines like the face, arena homme plus, numéro, taste, details . advertising campaigns for dockers, big issue, mustang, diesel, canal +, heineken, mcdonald's . **steven klein** . is traditionally trained in fine arts and carries a degree in painting . currently lives and works in new york city . contributes to w magazine, l'uomo vogue, french, italian and american vogue, the face, pop magazine, v magazine, visionaire . exhibitions in new york, london, milan, lausanne, berlin, seoul, tokyo . **nick knight** . born 1958 in london, where he lives and works . many awards for his publications in vogue, dazed & confused, i-d, the face, visionaire and for his work in fashion and advertising for alexander mcqueen, calvin klein, christian dior, levi strauss, yohji yamamoto, yves saint laurent **david lachapelle** . born 1968 in north carolina . moves to new york at the age of 19, where he meets andy warhol . 1995 awarded best new photographer of the year by both french photo magazine and american photo magazine . 1996 vh-1 fashion award as photographer of the year . 1997 the international center of photography's applied photography award . many publications in fashion, music and entertainment magazines like i-d, arena, the new york times magazine, rolling stone, vogue, the face, vanity fair works for jean-paul gaultier, mtv, pepsi, levi's, lavazza **inez van lamsweerde & vinoodh matadin** . working since 1993 for fashion magazines like the face and vogue . artistic cooperation with the fashion designer yohji yamamoto . **felix larher** . born 1971 . lives and works in paris and london . photographs for the magazines wad, vogue, jalouse, perso, spoon, têtu **mark lebon** . born 1957 in london . describes himself as: not french, despite his name, born and lives in london, but from russian stock, working mainly in london for i-d magazine, in semi retirement looking after a young child, creating art inspite of himself .

dior, armani, hermès, among others, and for magazines like the face,

dazed & confused, citizen k, harper's bazaar, big and vogue . **jean-baptiste mondino** . born 1949 in aubervilliers, france, italian parentage . designs record covers at first . makes video clips for artists like björk, neneh cherry, missy elliott, u2, rem, garbage, alanis morisette and madonna . works for international fashion magazines and for fashion designers like yves saint laurent, jean-paul gaultier, kenzo . advertising

campaign for dior parfums, kodak, schweppes **sarah moon** . born 1941 in england of french stock . film director since 1970 . published in elle, the magazine of the frankfurter allgemeine zeitung, graphis, harp-

er's bazaar, marie-claire, nova, photo, zoom, time-life, vogue **jamie morgan** . lives and works in london . became known with buffalo, inventor of street fashion . published much during the 1980s in the face

and arena . **marcus piggott & mert alas** . live in london, and work in london, paris and new york . 1997 they start working together for the face, visionaire, v magazine, i-d and numéro . international advertising campaigns for missoni, gucci, sergio rossi, levi's, hugo boss, yves saint

laurent **bettina rheims** . born 1952 in paris, where she lives and works . worked as model, journalist, gallery owner, and finally photographer . her photographic work became known through a nude series of striptease dancers, published in photo and égoïste . makes portraits of actresses and other personalities for international magazines . exhibi-

tions of her work in many art galleries . **terry richardson** . born in new york . first reportage sequences in the 1990s . much discussed advertising campaigns in europe and asia . responsible too for campaigns of costume national, levi's, sisley and atsuro tayama . published in w magazine, harper's bazaar, english and russian vogue, the face, arena, arena homme plus, allure, vogue hommes international, i-d, purple prose and

self service . **herb ritts** . born 1952 in los angeles . lives and works in hollywood . studies at bard college, new york . known for his portraits

tion of his photographs at the end of the 1980s in the english magazines i-d, the face and arena . international advertising campaigns for marc jacobs, helmut lang **ellen von unwerth** . born in germany . 1986 launches career as photographer . publications in: american, italian, english vogue, l'uomo vogue, arena, numéro, vanity fair, the face, i-d, interview . **max vadukul** . british national, born in kenya . lives in new york . published in: french and italian vogue, numéro, l'uomo vogue, i-d . **javier vallhonrat** . born 1953 in madrid . studies painting at the uni- versity of madrid . since 1984 photographs for fashion designers and works for international fashion magazines . teaches photography at var- ious spanish universities and continues to take photographs that are exhibited regularly . **camille vivier** . born 1977 in paris . published in many newspapers and magazines like purple, dutch, self service, dazed & confused, big 1997 receives first prize for photography at the 12th festival des arts de la mode in hyères . **matthias vriens** . born in ams- terdam . lives and works in new york . former chief editor and creative director of dutch magazine, international creative director for giorgio armani and gucci . works today exclusively as a photographer . pub- lished in the face, dazed & confused, arena, numéro, italian vogue, mag- azine of the süddeutsche zeitung, interview, vogue hommes internation- al . **pierre winther** . born 1963 in copenhagen . art director, advertising campaigns for levi's, hugo boss, nike, camel, diesel, dunhill published in the face, spin, vibe, dutch, arena, details, detour videos and covers for inxs, tricky, björk, massive attack, neneh cherry **james wojcik** . born 1959 in detroit, michigan, usa . studies at the art center college of design in pasadena, california . lives and works since 1981 in new york . photographic still life .

marion de beaupré . born in germany . studied photography at the folkwang academy under otto steinert . has lived in paris since 1968 . agent for photographers: jeanloup sieff, peter lindbergh, paolo roversi, ellen von unwerth, thierry le gouès in 1997 she opened galerie 213 for contemporary photography .

stéphane baumet . born 1971 in france . studied art history . 1993–1997 collaborated on the festival de la photographie in arles . 1997 head of the salon paris photo, carrousel du louvre . has worked as a freelance curator since 2000 as well as a gallery organizer in collaboration with marion de beaupré .

ulf poschardt . born 1967 in germany / lives in berlin . 1996 through 2000 editor-in-chief of the supplement of süddeutsche zeitung . since 2001 creative director of the welt am sonntag newspaper . teaches art theory as a visiting lecturer at the berlin academy of the arts . author of the books dj culture (1995), anpassen (1998), cool (2000), über sportwagen (2002) .

acknowledgments . we would like in particular to thank **erich von endt** . 1971 to 1998 professor for photography at essen's folkwang university . and a freelancer who worked for both the cultural and business worlds . . we would like to thank them all for the trust they showed in us . for their kind support we thank . art & commerce – vincent simonet . art department – patrick o'leary . katy bagott . katy baker agency . antoine de beaupré . blanpied-rubini . angela de bona . thomas bonouvrier . samuel bourdin . laurent bosque . box ltd – jennifer steffencin . laurent buttazzoni . jean-paul claverie . crapule – patrick couratin . clm – nick bryning . béatrice dallot . patrick demarchelier inc. – wendell maruyama . benjamin durand . michele filomeno – susan oubari . renate gallois – montbrun . pace-mac gill gallery – alissa schoenfeld . susan günter . astrid harel de jong . nk image ltd – philippa oakley-hill . janvier . vernon jolly . sara kendall . steven klein – mark mayer . mark kriendler-nelson – herbert e. nass . david lachapelle studio – sandy arrowsmith . inez van lamsweerde – vinoodh matadin ltd – jasper bode . patrice lerat-nagel . lighthouse – tiziana trischitta . peter lindbergh studio – anne srack . camilla lowther . mitzi lorenz . studio luce – anna hagglund . maison européenne de la photographie . m.a.p. – julie brown . the robert mapplethorpe foundation – michael stout – launa beuhler . frédérique monfort . mother – héléna de signori . yannick morisot . kasumiko murakami . ninette murk . pascal narboni . l'office dominique issermann – pascale perez . the office – kate ellis . ninety one – sabrina hamida . watch out – lecerf – maud hasard . emmanuel perrotin . louise des pointes . claire powell . herb ritts studio – griffin r. lauerman . remi sackman . marco santucci . walter schupfer management – barbara schlager – theresa farrell . david sims photography ltd – steve smith . smile managment – kim sion . francesca sorrenti . susan sone . solar . sreeters – beverly sreeter . peter sterling . tagadaboomboom . juergen teller ltd – amanda handbury . torch gallery amsterdam – adrian van der have . max vadukul inc – damian vincent .

edited by **marion de beaupré** . **stéphane baumet** . **ulf poschardt**

art direction & design : **philippe de beaupré** . **olivier bolla sina**

Translated from the German by Jeremy Gaines

Cover illustration: Camille Vivier, Untitled, 1999

First published in the United Kingdom in 2002 by Thames & Hudson Ltd,
181A High Holborn, London WC1V 7QX

Authorized edition, with the kind permission of
Marion de Beaupré Productions SARL, Paris
All photographs © 2002 the photographers
Text © 2002 Ulf Poschardt
English language edition © 2002 Thames & Hudson, London
and Schirmer/Mosel Verlag GmbH, Munich

British Library Cataloguing-in-Publication Data
A catalogue record for this book is available from the British Library

ISBN 0-500 54256-2

Printed and bound in Italy
A Schirmer/Mosel Production